CHILDREN'S LIFEWORLDS

Working from a conscious commitment to bridge the gap in knowledge between the world of childhood and that of adulthood, *Children's Lifeworlds* moves beyond the usual concern with child labour and welfare to a critical assessment of both boys' and girls' daily work in the context of the family in a village in southern India. Questioning why this work is apparently morally neutral, this book discusses how class and kinship, gender and household organization, state ideology and education combine to define children's work away.

From the roots of children's position in society, *Children's Lifeworlds* shows how working children face the challenge of combining schooling with home life and contributing to the household income. At a time when many developing countries are extending children's education, the author focuses not just on the persisting inequalities of gender or class, but on the way children balance the demands made on them by the adult world, how they view childhood within that world and how, ultimately, children too make history.

This book stands to make a major contribution to our understanding of children's lifeworlds, with children in the developing world negotiating the value of their work rather than being in need of compassion.

Olga Nieuwenhuys is senior researcher at the Institute for Development Research at the University of Amsterdam (InDRA).

CHILDREN'S LIFEWORLDS

Gender, welfare and labour in the developing world

Olga Nieuwenhuys

London and New York

First published in 1994
by Routledge
11 New Fetter Lane, London EC4P 4EE

Simultaneously published in the USA and Canada
by Routledge
29 West 35th Street, New York, NY 10001

© 1994 Olga Nieuwenhuys

Typeset in Garamond
by LaserScript Limited, Mitcham, Surrey

Printed and bound in Great Britain by
Biddles Ltd, Guildford and King's Lynn

British Library Cataloguing in Publication Data

A catalogue record for this book is available from the British Library.

Library of Congress Cataloging in Publication Data has been applied for

ISBN 0–415–09750–9 ISBN 0–415–09751–7 (pbk)

CONTENTS

PLATES

ILLUSTRATIONS

FIGURES

MAPS

TABLES

ACKNOWLEDGEMENTS

A book is always being written and rewritten in dialogue with others, and this is particularly true of this book in which I have relied so much on the ideas and experiences of my surroundings. It is impossible to mention all those from whom I have benefited over the years, whether in agreement or disagreement, but some cannot be omitted as I find it hard to express the real depth of my indebtedness to their help, comments and criticism.

Thanks are due to my supervisors Peter Kloos and Loes Schenk-Sandbergen. Peter Kloos's original views on the philosophy of anthropology have been a great source of inspiration for the style and approach adopted in this book. His close reading and encouraging suggestions have been crucial in helping me carrying through the various stages of writing. Loes Schenk-Sandbergen's concern with poor women has been invaluable in helping me bringing the gender aspect of children's work into focus. I am very much indebted to Kristoffel Lieten for his critical comments and editing work on various drafts. I would also like to ackowledge his help and that of Jojada Verrips and Rob van Ginkel in editing parts of earlier versions of Chapter 4, 5 and 6. The first drafts of Chapters 3, 4 and 5 were also valuably criticized by Ot van den Muyzenberg. Dick Kooiman has made a thorough review of an earlier version and offered many useful comments. I would also like to thank Nico Vink and the anonymous reviewer of the manuscript for offering suggestions for improvement. I am grateful to Ot van den Muyzenberg and the staff of the Anthropological-Sociological Centre of the University of Amsterdam for offering me the opportunity to participate in the research project 'Labour and Poverty in India and the Philippines' and for their support during the various stages of the research. I also acknowledge my debt to Han Blom, Rosanne Rutten, Pieter Streefland, John Wiersma, Hein Streefkerk, Humphrey Lamur and Willem Wolters for their critical suggestions in the initial stages of the research. The Netherlands Foundation for the Advancement of Tropical Research (WOTRO) and the Minister for Development Co-operation of the Netherlands generously supported me

during the period of field-work and of data analysis. My colleagues at the Institute for Development Research at the University of Amsterdam (InDRA) patiently endured my absent-mindedness while I was preparing the final draft of the book.

I have acknowledged my debt to the people of Poomkara and to the research assistants in the prologue. Here I would like to thank C. Ramesan, Toon Schampers, Marion den Uyl and Peter van der Werff for their warm friendship and support while I stayed in Kerala. The unreserved comments on my views expressed by P.N. Varughese and K.P. Kannan during their stay in the Netherlands and my stay in India, I consider a special token of friendship. Among family and friends who may recognize in this book some of their own ideas, I would like to mention my mother, who has confidently and patiently endured long sessions of loud thinking over the telephone and my father, who supported me in critical moments and demonstrated, by his example, the value of creative work. My husband K. Yesodharan and my two sons Emile and Maxim are, however, the only ones who have had to endure personally the consequences of the daily process of writing.

Olga Nieuwenhuys
Amsterdam, February 1993

GLOSSARY

Note: The transliteration system follows the most common English usage and reflects acceptable procedure in India, where Malayalam names and words are frequently written, officially registered and published in their particular English form.

amma	literally 'mother'; the fixed wheel used in spinning
anna	an old monetary measure, equal to 1/16th rupee
appam	rice pancake
asan	teacher
asan-school	locally-managed village school
Beppukars	a community of Mappila fishermen using dug-outs and hooks and lines
bunk shop	a tiny roadside shop that sells cigarettes, matches, soap, lemonade, etc.
catamaran	a small fishing boat made of four or five logs of unsinkable logs of wood tied together
chackram	an old monetary measure, equal to 1/28th rupee
chakara	a mud-bank that forms at the beginning of the prawn season
chakkiri choru	residue of coir fibre
chatta	traditional long-sleeved jacket worn by Muslim women and girls
Chovan	name of a central Kerala caste cognate to the Ezhava, now in disuse
cooli	daily wage or piece rate
Ezhava	Generic caste name of castes whose customary occupation was associated with processing the products

	of the coconut palm
gnondu kali	hopscotch
izha	a single coir yarn
kachakkaran	cloth pedlar
kaili	loin-cloth
kalari	locally-managed village school; also used for nursery school
kallu kali	fivestone
kambavala	beach-seine
kambu	long ropes used for beach-seines
kanji	rice gruel
karikkadi chemmeen	large type of prawn (*Palaemon stylifera*)
kavadi	the game of tag
kayar	a length varying between 9 to 13m, obtained from twisting two threads of coir yarn
kettuvali	a small seine used for seasonal fishing
konaan	G-string worn by small children until the early 1960s
kottuvadi	heavy club used to defibre retted husks
kudikidappukars	hutment dwellers
kuppayam	model of blouse worn by Muslim women
kunju	literally 'child'; the moveable wheel used in spinning
madrasa	modern Koranic school
Malayalam	Kerala's national language
Mappila	Malabar Muslim
marggakalyanam	circumcision-ceremony of Muslim boys
mehar	Muslim bride-price
Methan	old Poomkara term for Muslim (impolite)
molali	contraction of muthalali, meaning trader
Moopar/ Moopathy	respectful form of address amongst Thandans
mudi	a measure of coir equal to six kayars
mukri	mosque servant
mullaka	traditional Muslim religious preacher
musaliar	modern Muslim religious preacher
muthalali	boss or trader
naran chemmeen	large prawn (*Munida Dobsoni*)
ottakan	an attached fishing crew labourer in north Kerala (Tanur)
pallipura	traditional Koranic school

panchayat	administrative village
pennukannaan	modern part of the betrothal ceremony in which a prospective bride and groom are asked for consent
piri	a large bundle of spun coir yarn
podimeen	small fry
pola	a third or quarter of a retted coconut husk
porotta	a kind of bread
raja	a local ruler in the pre-independence period
ratt	set of spinning-wheels used to spin and twist coir yarn
tankavala	encircling net
tankuvallam	sea-fishing boat
thampuran madom	palace of a lord or prince
thandaper	registered persons
Thandan	caste name of an occupational group who specialize in the climbing of coconut palms
Thiya	caste name of a North Kerala occupational group cognate to the Ezhavas
thyccavu	traditional Koranic school
ummumma	Muslim form of address to a grandmother
Vallakars	a community of Mappila fishermen who use dug-outs in pairs with large nets
vallam	a large countryboat
vattu kali	marbles
Vishwa Kharmas	name for the artisanal castes
Yogam	religious association

LIST OF ABBREVIATIONS

INP	Indo-Norwegian Project
MES	Muslim Education Society
MWC	Minimum Wages Committee
PSP	Praja Socialist Party
SNDP	Sree Narayana Dharma Paripilana
SRS	Sample Registration System
SSLC	Secondary School Leaving Certificate

PROLOGUE

Rajeena stood staring at me with a resolute look in her eyes. She had come alone all the way from her house to see me on her mother's instigation. Her father had told her the previous night that he had no money for her notebooks. It was his way to say that she now ought to stop going to school. With her 11 years it was inappropriate for her to walk all along the main road alone to the upper primary school. Men would start staring at her soon and the neighbours would gossip, so he feared.

But Rajeena's mother and aunt were of a different opinion. And they had sent her to me, to tell me that with fifteen rupees I could save her school career. In Rajeena's maternal family some had obtained degrees and white-collar jobs. They were not illiterate labourers as her father. They had experienced that a clever girl could achieve through schooling for herself and her family more than by complying to norms that accorded with Muslim traditions and values.

She was not only a bright pupil but a hard worker as well. She worked along with her mother making coir yarn before going to school and on holidays, minded her two younger brothers and helped in the house with cleaning, cooking and fetching water. Her father collected her mother's and her own wage, as he felt it improper for females to handle money. Now everything seemed to depend on my willingness to help her. If I were willing, so she pleaded, to help her buy the notebooks, she could remain in school. Her teacher had threatened her to remove her from the classroom if she came back without the required notebooks. I had come to know Rajeena quite well. For more than one year I had visited the family's dilapidated old house regularly, as part of my field research. They were poor but proud people. They were not the type that would take to begging unless they had no other choice. I knew that Rajeena's plea had not been an easy step to take. She had come only because she believed that I cared. I had demonstrated sympathy for her going to school in the past, as she was one of the few poor Muslim girls attending the upper

primary. To continue her schooling she was ready to bear any sacrifice, going as far as turning against her father's will.

I had noticed Sharif on the beach while he was haggling about the price of a basket of fish. He was a lively and keen fish vendor of 15 and I had decided to ask him a few questions about fish trade. He answered, to my astonishment, in English. While in primary school he had already been a very gifted pupil. He loved going to school. But he was a poor boy and had therefore, by the time he was 9 or 10, started to work in the early mornings and on holidays. He joined some neighbouring boys who had formed a small gang for vending fish. They used to pool a small amount together, haggle for a basket of fish, divide it in equal parts and by the evening share whatever they had earned. But while his friends would spend most of their profit on snacks and gambling, Sharif had always had more serious concerns. He had invested his earnings in schooling. He was in good health and had a strong will. Coupled to his keen mind, he managed to achieve the Secondary School Leaving Certificate. This was no small matter, as the chance that one would complete the high school course and succeed in the examination was less than one in ten. Only after this personal victory did he realize that he had been pursuing a chimera. A fish vendor had no use for a diploma, he was told. If he had wanted to change his job, a diploma alone was not sufficient. He lacked everything else to continue his studies in college or obtain an office job: finances, well-placed kinfolk, an influential patron and even access to the media. Suppressing his rage but with a heart weighted with bitterness, he was still struggling to accept that his dreams had been shattered.

I myself lived, when I was a child, for a short period in a situation somewhat similar to the one in which Rajeena and Sharif grew up. I was 8 years old when my parents had to leave me in the care of a childless couple in a village near Savona, on the Italian Riviera. Although their absence lasted but six months, it would have a decisive impact on my life. Berto was an industrial worker. His wife, Teresa, hailed from a small peasant family. She possessed a number of small fields where she grew olives, strawberries, potatoes and grapes, and she was also used to collecting fruits, chestnuts, grass and firewood in the woodlands owned by absentee-landlords.

In the morning I would go to school while Teresa quickly finished her household chores. After our midday meal we would change clothes and set out with sickles and hoes wrapped in a jute sack to the woods and fields. My working with Teresa during these expeditions was a matter of fact, and, a

2

sturdy girl as I was, I enjoyed it. She would normally not exhort me to increase the pace of my work and would not object to my taking rest or playing with other peasant girls whom we met on our way. Still, I recall that there were tedious tasks which I disliked but from which I was not allowed to withdraw: gleaning olives, weeding strawberries, planting potato sprouts, picking up vine clippings, dragging firewood to the road . . . Teresa would persuade me to help her in performing tasks which I did not feel inclined to do by promising me money. She was paying me, for instance, a piece rate of 10 lire for each tree-trunk I managed to drag down the hill to the road. To cheer me up she kept a careful account of my earnings. By the time my parents came to take me, I could proudly show them that I had earned by myself the first piece of the dowry I would, as a peasant girl, necessarily need in future: a small golden brooch with my name.

'Normal' life in that same village, where I lived with my parents for some more years, was never the same again. I was now looking with entirely different eyes at my school comrades. Before my experience of work, I must confess, I had had no high opinion of the peasant girls in my class. They did not wear neatly ironed and fancy clothes, like the daughter of the local policeman. Having to deliver their milk on their way to school, they were always late. They had little time for play and hardly any stuff for conversation as they hurried up the hill after school. But after having shared their life I started admiring them. The work and responsibilities they shouldered made them appear so adult. During school holidays I would go to their houses, just to see them at work. At times, I would imagine them to be rich, possessing dowries of golden jewellery and embroidered white-goods. It then did not occur to me that they would be anything less than important and respectable persons.

I was soon to be disillusioned. Even before completing the fifth grade, the peasant girls disappeared from school. I recall hearing people whispering that their parents were 'primitive peasants', who, by withdrawing their daughters from school and putting them to work, were eluding the law. It soon became clear that in the world of school that was to become mine for the rest of my childhood, these girls did not matter at all. They simply did not exist.

By the time that I, together with a small selected group of other girls, was preparing for the entrance examination to the middle school, the cleavage that existed between the children of the village had come out even more clearly: on the one hand there were the 'students', as we were called, who would continue schooling after the fifth grade, and on the other the 'workers'. The 'students' were privately tutored in the afternoons. They were to be the future notables. It was a fact of life that the 'workers' were to be inconspicuous. Their fate, whether they became apprentices in shops and factories or would work at home or on the land

of their families, aroused in those that surrounded me in school only indifference.

My early experience with work has been, though not always consciously, the driving force behind my concern with the working children in India. From the onset, the spirit in which I have approached them has been attuned to the very same sense of fascination. I have not reconciled myself with the common wisdom that working children, whatever they do, are either inconspicuous or pitiful. This is not to say that in this book I have not continuously questioned the candour of my early images of the life of peasant girls in Italy. But in the end I must admit that, without this early experience with working girls, I would probably not have written this book in the same, sympathetic vein.

Feelings of sympathy and solidarity are uncommon in the literature that has been gathering momentum around child work. The dominant mood is rather marked by indignation and a feeling of compassion. I feel that this attitude betrays a lack of empathy. It leads too easily to deny working children a feeling of self-esteem and of accomplishment. It is a free ticket for not taking the crucial issues they face seriously, and in particular their right to struggle for a more equitable distribution of benefits within the family and society; for denying their role in the emancipation movements of Third World societies; for silently sanctioning work that is imposed upon children, as long as it is disguised as socialization and training.

In the Italy of the 1950s I knew from my childhood, the destiny of the children of workers and peasants was still unquestioned. They were in school only to master a minimal amount of knowledge a worker or peasant was then required to command. There was no middle school in the village and the diploma obtained from the elementary school was not valid for pursuing studies in the middle-school. One had to appear for an entrance examination and had to pay for private tuition if one wanted to have a reasonable chance of succeeding. So, working children did not dream of becoming 'students'. The difference between themselves and the children who pursued their studies in the middle school, was clear cut.

In Kerala, the Indian state with which this study in concerned, the situation is radically different. It is not only the poorest state in India in terms of its per capita income, but is also the one in which children stay the longest in school. There are marked differences between communities, but the dominant trend is to have children from all social backgrounds going to middle school and many also to high school. Though the levels of schooling of Kerala children are exceptionally high, in many other parts of the Third World the trend is no doubt towards increasing levels of schooling. In the rural areas of the Third World, to use

4

Dore's expression, going to school has become a normal feature in a child's life, in a world in which 'literacy, the ability to deal with government officials, to speak properly and to use the sorts of words one learns only in schools has become part of the definition of a self-respecting citizen' (Dore 1982: 41). But schooling does not, as this book will show, substitute work. In poor peasant households there are hosts of tasks that remain children's responsibility even when they go to school.

This seems rather a paradoxical situation. For, though poverty has currently been associated with a high incidence of child work, the latter is believed to be incompatible with schooling. The questions that have preoccupied me from the start of the research on which this book is based, were therefore these: Why do poor children in rural Kerala go to school and even pursue their studies after the lower primary level? Does going to school mean that they do not work? If they do combine school with work, as they indeed appeared to do, what are the implications for our understanding of the modalities of rural children's work in Third World countries?

I chose for my enquiry a locality inhabited by fishermen and coir workers, not too distant from the town of Alleppey, a situation that somewhat reflected the one I had lived in in Italy. However, I was now no longer a child, but a social anthropologist from a distant country, and this proved a very crucial difference. I could not take part in the intimate relationships that develop between children that share the same lot. I had to take great pains in finding credit even with their parents. They profoundly distrusted the childless white woman I then was, as I showed, in their eyes, a more than healthy interest in their children. I therefore had to remain an observer for most of the time, and had to collect much of the information presented in this book through the research assistants, of whom three were young women who had grown up in the village. In the fourteen months spent in the village I made many good friends, and they often confided in me their childhood experiences. But most of them belonged to the families of stature in the village, and reflected therefore another experience than the one in which I was interested.

Adults were in general hardly convinced of the relevance of my work. As long as I showed an interest in their problems, I could count on eager co-operation. When it came to their children's performance in school, their eagerness would slacken. Their children were their future and this was not a subject to be discussed lightly with an outsider. The potential for the failure of schools gave even the parents of children who performed well a vague feeling of apprehension. But when my questions turned to their children's work, I could expect our conversation to come quickly to an end. Their only reply was often a mere sigh: 'What do you want them to do, they are so small!'

I found, nevertheless, support from the children whom I met while they were at work. They did not think it awkward that I would show some interest in what they did. The thought that I was interviewing them to write down what they said even excited them. Some became spontaneously my

5

informants, reporting to me all the news that used to go from mouth to mouth. A few even sought in me their patroness, asking me for small amounts with which to start a business or for loans to buy the necessities for going to school, as Rajeena did.

I feel that most of the children I met took my questions very seriously, going, as far as they could, into the details of their work arrangements, and disclosing their conflicts, frustrations, desires and future expectations. No doubt many questions did sound strange in their ears, and I will not easily forget the confusion aroused by my enquiring about feelings in respect of corporal punishments. Some high school children had revolted against their teachers' beatings, so that this could happen was not new. But the idea that a child of 8 or 9 could harbour antagonistic feelings against the daily spanks his or her parents meted out 'for his or her own good', was quite unusual.

One of the most striking results of my research is that girls considered their housekeeping chores as work. Some persisted in giving me all the details of what this implied, even in the presence of protesting or mocking parents. They often also admitted to being envious of boys who were free to go out to work and came home with food and money. As girls came to understand what my research was about, they often supported me in front of adults who objected that performing all these petty tasks was not 'working'. When talking about going to school, they candidly described how housekeeping interfered with their results, notwithstanding their parents' allegations that their failures were on the account of laziness and carelessness.

Breaking through walls of silence and ignorance is an exercise that constantly confronts one with the legitimacy of research questions. Is children's work indeed so relevant as they themselves often say it is? Are children at all able to judge the place of their work in the livelihood of their families and of society at large? How far did my own experiences and preconceptions influence the outlook of Poomkara children as the research progressed and they understood which type of information I was keen on collecting? As it became clear that the children's views clashed with those of their parents and of adults in general, to which one should I give more weight? If children's work was indeed so crucial as I believed it was, how to explain that social scientists failed, to date, to appreciate its importance? In short, how much of the research results were owed to my personal conviction and how much reflected the actual state of affairs, and is such a reflection at all possible?

It was not easy to adhere to my original views on the importance of children's work as the time spent in Poomkara progressed. As my presence gradually became accepted, I found it more difficult to persist in critically approaching the world of adults to which I, of course, belonged. The attitude towards children of those who became my friends, did influence me, and I often felt with them, that one should not attach too much weight to the opinions of youngsters. Children were believed to be very much subject to

6

changing moods and to be too easily influenced by fashionable trends. Their immaturity would preclude their being able to distinguish sharply between fiction and reality. One could not expect them to act according to the moral standards of adults. 'They are just children' was a commonplace used to brush off the responsibility of children for their acts as well for the opinions they ventilated. In this, the opinions of my Kerala friends did not substantially differ from those I had heard previously elsewhere, and would gradually start to endorse, when I became, after my return to the Netherlands, a mother myself.

I think that without a conscious will to bridge the gap in knowledge and experience between the world of adulthood and that of childhood, being a middle-class, western intellectual and a mother myself, I would have been unable to portray the world of working children in Poomkara the way I have done it in this book. In this effort I might have at times overstated the importance of their work and perhaps distorted reality. To some extent, when one seeks to disclose what is invisible, this is unavoidable. But I did make a genuine attempt at depicting, keeping the huge differences in power, freedom and wealth between classes, but also between adults and children in mind, how the working children themselves see their own lives. This is not to say that I have contented myself with capturing children's subjective views of the world around them. What I have rather done, is to take this view as my starting point, and relate it to the picture obtained from quantitative and qualitative data provided by adult informants. In a later stage I have sought to underpin my analysis with what social scientists, economists and historians have written about the working children of Kerala. This has been admittedly somewhat problematic, as few of them have envisaged the possibility of children being protagonists of social history. Adding up the piecemeal information I have come across, I have attempted anyhow an interpretation of the role of children in social movements and in the processes of transformation undergone by Kerala society. I believe that the combination of personal experience, of quantitative data and in-depth anthropological methods, and of the reinterpretation of written sources, has enabled me to shed some light on the world of those who, though they hold the future, have been left in the dark too often.

1

THE CHILDREN OF THE RURAL POOR

The children of the rural poor engage, by and large, in a variety of activities that, though seldom remunerated, are necessary for the livelihood of the family. These activities have little in common with child labour in its accepted meaning of remunerated work undertaken under an employment agreement. Studies of children's work therefore rightly make a basic distinction between work in waged employment and that undertaken within the context of the family. Though acknowledging that in peasant societies the latter is the dominant form, these studies have, however, surprisingly neglected its social and economic meaning. The obvious reason is that in spite of its vital importance for poor households, economic theory attributes little value to this type of work (Wadel 1979: 366ff). For both neo-classical economic theory and conventional Marxism it creates mainly use value, in opposition to exchange value that is the source of profit and capital growth (Folbre 1986: 247–8). An added reason for its neglect is that normally it is felt not to impair the healthy development of children or to detract from such essential activities as education and play. While waged employment is generally agreed to lead to the objectionable exploitation of children, work undertaken under parental supervision is conceived of as part of the household's moral economy and an essential aspect of socialization. Typically, poor parents are believed to be able to effectively protect their children from excessive drudgery when the latter work under their supervision. That poor children are often able to combine this work with schooling is taken as an additional proof of its suitability (Bouhdiba 1982: 17; Bequele and Boyden 1988: 2; Fyfe 1989: 3ff). A more deep-seated reason still is the reticence, if not hostility, harboured by economic and political elites towards a critical reappraisal of this type of work, particularly if treated in terms of exploitation (Morice 1981: 132).

Central to this book is that the assumption that children's work, in the context of the peasant family, is morally neutral is preposterous. The assumption rests on an inadequate understanding of the social and cultural

9

modalities of this work. In-depth studies of children's work in peasant societies, which attempt to understand how their work roles come about, how they are organized and how they acquire their meaning, have been few and far between. Little is also known about how this work is articulated to the economic system in which it is undertaken or how it relates to education and play. The common view that this type of work is unproblematic, therefore, cannot be said to rest upon a firm theoretical or empirical base. In this chapter I develop my argument by, first, discussing the contemporary views on the work roles of children in the context of the household and in particular in peasant societies. Approaching the notion of child labour as a social construction, I suggest, second, broadening the framework of analysis used in the study of children's work so as to give a more central place to the process through which work is undertaken and acquires its meaning. The articulation of seniority and gender within the domestic domain appear crucial here. I conclude by describing what this entailed for the methods adopted in the research on which this book is based.

CONTEMPORARY THINKING ON CHILDREN'S WORK

The understanding of children's work has often been clouded by moral considerations. Three main perspectives from which the problem has been approached may be distinguished: the legal, the demographic and the neo-classical. Though they have lost much of their academic credit, it is important to trace how they have contributed to today's perception of the problem. The legal approach emerged in nineteenth century Europe in response to a growing public concern about the need to control the disruptive effects of the employment of children by the factory system. The legislative changes proposed had the dual goal of prohibiting children from working in factories and workshops ('child labour') and providing, as an antidote, a national system of basic education (Fyfe 1989: 30ff; Weiner 1991). A broad spectrum of activities not directly connected with factory work were, however, left untouched by legislation: housekeeping, child-minding, helping and assisting adults for no pay on the family farm, in small enterprises and shops, domestic service, street-selling, running errands, etc. They were necessary for the livelihood of the family and remained morally unquestioned. To contrast them with child labour, they were defined as training, help and socialization (Davin 1982: 644). In Victorian and Edwardian England, domestic service, for instance, was lauded, not merely as a provider of much-needed cheap female labour, but as an ideal training ground for working-class girls (Walvin 1982: 72). The legal approach introduced a dichotomy between harmful and unsuitable work on the one hand, and suitable work which would not only not impair a child's healthy development but had an additional socializing value, a dichotomy that persists in contemporary governmental and bureaucratic approaches to the

10

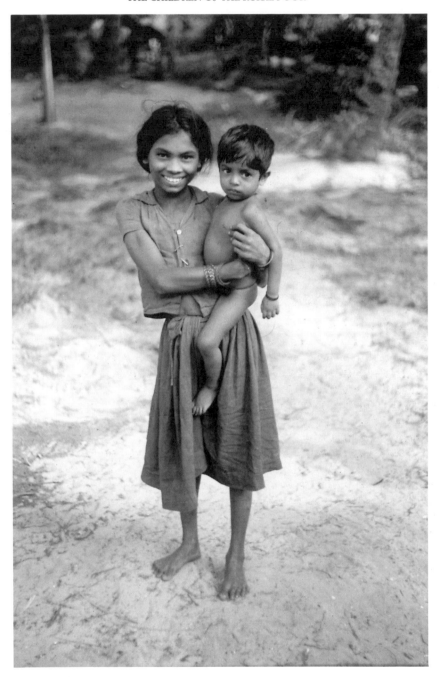

1 Work that just 'happens' in the course of everyday life

problem even today. In the industrialized world there are indeed vast areas of work which are left out of child labour legislation. In the USA children still make up for 25 per cent of the total labour engaged in agriculture, and their work is excluded from regulations (Challis and Elliman 1979: 69ff). In the Netherlands, 74 per cent of youths between 12 and 18 work regularly in agriculture, shops and domestic service. Though what they do is mostly prohibited by law, there exists no efficient system of enforcement and the general attitude is one of tolerance (Neve and Renooy 1988: 111). Recent reports have shown that anything between 50 to 75 per cent of European children perform outside school hours, with their parents approval, a wide range of unskilled, underpaid, irregular and unprotected jobs (van Herpen 1990). Even more widespread is children's work in and around the house, which is, as research has evidenced, a ubiquitous and value-laden feature of family life in most parts of the world (Morrow 1992: 6).

The legal approach to children's work is also popular with respect to child labour in the Third World. In the absence of industrialization, the question of children's work in the colonies has been from the onset very much romanticized. One of the reasons may be traced to anthropologists' understanding of child-adult relations in terms of socialization patterns that were based on 'learning by doing'. The activities performed by children in the colonized societies they studied were indeed not child labour in the sense given to it by European law. As they depicted how children were brought up in the company of women, who in turn they saw as housewives and mothers rather than workers, anthropologists too easily confused the issues of socialization and work. As pointed out by Hull:

> The reformer seldom paused to ask whether factory discipline passed on cultural norms and values to young children, and anthropologists seldom remarked on the effect of repetitive activities on children's intellectual development or evaluated the danger of accident or illness attributable to child work. Hence the horrifying accounts of the former, and the rather romantic renderings of the latter.
>
> (Hull 1981: 49)

But the reporting had also political connotations. While children in the west were primarily viewed as in need of protection against the exploitation to which the factory system exposed them, the very likelihood of such a development in the colonies was ruled out. Colonial policy discouraged industrialization, and sought to protect the household and the corporate local group, the pillars on which the social edifice rested. While working under the control of kin was praised as a form of socialization, factory work was energetically opposed and ultimately prohibited.

The emergence of newly-independent nations in the Third World after the Second World War saw a fresh interest in children from the demographic perspective. Working from the ingrained assumption of the children of the

poor as non-working dependents, development economists and population experts cited the high 'dependency ratio' of Third World countries as a factor that inhibited development. In the 1960s and early 1970s a burgeoning literature on the 'population explosion' tried to show that the human race was outgrowing the capacity of the planet to support it. The children of the poor, non-workers with escalating expectations in terms of education and consumption, were held responsible for using up the developing nations' scant resources. These allegations often masked the fear that their growing numbers, and the failure of populist governments to realize the pre-independence promises, would turn children into 'power-hungry troublemakers', a threat to the interests of the new elites in controlling natural resources, raw materials, investment and markets (Michaelson 1981: 16ff). Large-scale foreign-funded research programmes were launched in high-fertility countries to find a remedy for what was seen as the major catastrophe towards which the world was heading. The solution seemed to lie in vigorous and far-reaching campaigns for birth control.

Acceptance of birth control by Third World peasant families soon appeared problematic. Though results were booked by using conviction, subterfuge and even coercion, reaching a lasting solution remained a far cry. By the mid-1970s the idea that the demographic explosion was the main source of the world's problems started losing credibility (Michaelson 1981: 24ff). A World Bank report of 1974 acknowledged that high fertility was part of a wider socio-economic environment in which: 'parents expect children to contribute to the family income rather than be educated' (King *et al.* 1974: 3).

Mamdani's seminal work on the importance of children's work for the Indian peasant contributed to undermine established notions on rural children's roles. A variety of waged and non-waged tasks performed by boys and girls were complementary, he argued, to those of adults, and were necessary for the reproduction of the peasant family (Mamdani 1972, 1974 and 1981). His, and similar arguments, cast an entirely new light on high fertility, suggesting that a peasant economy simply needed large numbers of working children.

The critique of demographic approaches to poverty prompted fresh research from the perspective of the utility of children for the peasant household. The approach was primarily inspired from the depiction of fertility determinants in terms of a neo-classical cost-benefit analysis (Becker 1960). It documented how very young children are set to work in agriculture or in the household in ways which are not only beneficial but essential to the well-being of the peasant family (Hull 1975; Mueller 1975; Nag, White and Peet 1978; White 1975 and 1976; Nag 1972). In the Indonesian village studied by White, for instance, children as young as 5 were baby-sitting, fetching water and looking after small game, thus helping with their household's livelihood. By the age of 8 their contribution to the sustenance of the household was, according to White, often equal to that of adults (1975:

13

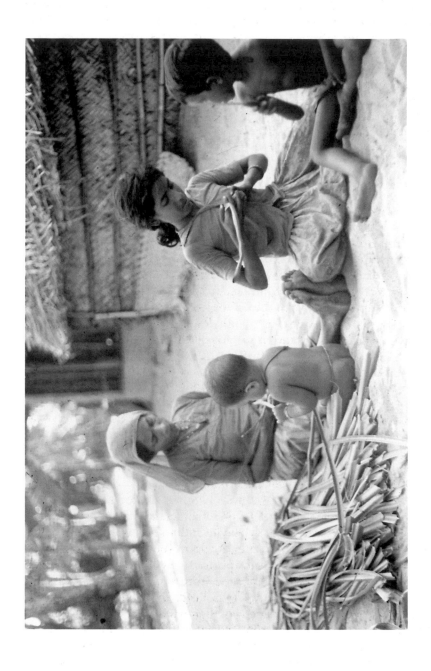

2 Girls and young boys share the tasks and responsibilities of women – in this case by helping them to weave sleeping mats

135ff). The commitment of the research on fertility determinants to understand 'from within' the value of children through the painstaking collection of time-allocation budgets provided a detailed account of the extent to which the activities of children vary across spatial and temporal settings and documented its highly-fragmented character.

A lively debate ensued on the causal relation between high fertility and the utility of children for the peasant household, that evidenced that such general assertions are premature (Vlassof 1979, 1982; Vlassof and Vlassof 1980; White 1982: 588ff; Krishnaji 1983; Nag and Kak 1984; Datta and Nugent 1984). As rightly pointed out by Caldwell, a cost-benefit analysis of the importance of children for the rural poor overlooks the historical, social and cultural role of children in society (Caldwell 1976 and 1981; see also Epstein and Jackson 1977). Also the use of the concept of the household as an unproblematic unity, has generally led to the negation of internal contradictions within the family, in particular those among male and female and seniors and juniors (Folbre 1986). Another major weakness of the approach has been its focusing quite exclusively on the micro setting of the peasant household, failing hereby to provide an overall analysis of the wider socio-political parameters in which the actions of its members are embedded (McGuire, Smith and Martin 1986; Martin and Beittel 1987; Lieten and Nieuwenhuys 1989).

These different views on rural children's roles have had but little impact on recent contributions on children's work, few distinguishing themselves by a genuine attempt at understanding its modalities (Challis and Elliman 1979; Rodgers and Standing 1981; Goddard and White 1982a; Myers 1991). True, the decade between the United Nations' Year of the Child in 1979 and the adoption of the International Convention on Children's Rights ten years later, has seen a burgeoning ethnography that has helped somehow to fill the gap in empirical knowledge. But this ethnography has failed to come to terms with the contextual situation in which children's work is embedded and continues to refer to factory work as the universal standard for concept-ualizing child labour (Bequele and Boyden 1988; Fyfe 1989; International Labour Office 1991). It is particularly striking that crucial issues such as the historical analysis of the process of transformation of children's work and the structural setting in which children's work is undertaken and contributes to the reproduction of a society, remain heavily under-researched. This may be, as reflected in official statistics, on account of governments' and bureaucratic elites' continuing to adopt a legalistic approach to children's work. Though poor children are known to be engaged from a tender age in work for marginal returns or no pay in the household, in small trade, in home industries or in the fields side by side with their parents, in most Third World societies the mentioned incidence in official publications and statistics of child labour is indeed surprisingly small. For example, whereas in India more than 100 million rural children in the age-group 5 to 15 live in circumstances that make their contribution to their family's livelihood mandatory, only an

estimated 16 million, comprising a mere 5.9 per cent of the total active population, are enumerated as 'child labourers' (Government of India 1979: 13). As pointed out by Standing, the popularity of the legal approach is largely on account of its apologetic value for legitimizing existing international and national relations of production, in which children's work plays a crucial, though unappreciated, role (Standing 1982: 612; see also Wright 1990).

DECONSTRUCTING AND RECONSTRUCTING CHILDREN'S WORK

As said, the notion of child labour is inadequate to analyse much of the work performed by children in peasant societies. The notion works from the ingrained assumption of an immature specimen of the human race being exposed to a certain type of undesirable activity. The difficulty lies essentially in the fact that, at the empirical level, not only activities undertaken by children vary from one society and from one time to another and also according to class, gender and age group, but their valuation as well. The notion disguises major difficulties which I will discuss in more detail below: first, the distinction between suitable and unsuitable activities and its underlying valuation of work; second, the assumed universality and gender neutrality of ideals of childhood. Research on children's work in peasant societies has seriously suffered from the use of a priori judgements about which activities are suitable for children and which are not. These judgements have been made on the basis of moral considerations which can be traced to the ideals of socialization introduced by colonial powers in the former colonies and which were reflected in their own child labour legislation. As long as activities undertaken by children did not appear to clash with these ideals they have, by and large, not been felt as unsuitable or even conceived as work at all. The ideals of parenthood shared by social researchers and the children's kin, have also contributed to constructing a notion of child labour in the Third World that discards as suitable those activities that, if called real work, would contradict the image of the loving parent. An article by an Indian economist with the telling title: 'Child labour: do parents count it as an economic asset?' leaves, for instance, no doubt about the perspective adopted by the author (Dandekar 1979). It comes as no surprise that his adult respondents share with him the belief that what children do for most of the time is indeed not work in the economic sense. As noted by Folbre, parents in the Third World, in spite of their wielding considerable power over their children, are often not satisfied with the level of economic assistance their children provide (Folbre 1986: 249).

This cognitive aspect of work reflects the undeniable problem of the value of the everyday activities performed by children in the setting of the rural household. One may distinguish three categories of work:

(a) activities that extract resources from the physical and social environment;
(b) activities concerning the 'unpaid' allocation, preparation and distribution of these resources;
(c) activities that concern the care of human beings.

Though a number of these activities are directed to the production of socially-valued goods and services, many are not recognized as such. This is particularly the case with the activities that fall in the last two categories, that are both considered, in common parlance as well as in economic theory, something else than work and often dismissed and ignored, particularly when performed in the context of the household. The reason may be traced to the fact that this type of work is less organized and planned, that it is only indirectly connected with an economically-valued 'product' and, finally, that it is often so mundane, to appear to just naturally happen in the course of everyday life. Not conceptualizing these activities as work in anthropological theory would, however, produce a distorted view of the social context of work, and in particular of how widely-valued institutions come about and are reproduced (Wadel 1979: 379). To highlight their importance it is sufficient to point at the fact that, when falling within the market, these activities are, as a matter of fact, valued as 'real' work. For instance, when children are not available for child mending, doing the housekeeping, running errands, etc other services would have to be bought and domestic help would have to be hired. It is clear, then, that the household-based work of children, though difficult to value exactly, represents in itself an important asset (Schildkrout 1981: 93).

In peasant societies, moreover, the distinction between productive work and work that is concerned with distribution or the care of human beings, may not be as sharp as suggested by the market approach to work. The work undertaken by children in the household context can indeed acquire an economic value in the interaction between households and the larger society. There is therefore a great deal of overlap between the allocation of work within the family and the needs of the economy. Parents are obviously not autonomous in deciding which activities are desirable for their children, the sets of options from which poor parents can make choices in the allocation of work being limited. It is well known that employers are often able to solicit labour from children by employing the whole family and pay them less than when they are adults. This is common practice with agricultural labourers who are contracted with their families for harvesting work or with small domestic industries where the piece-rate system is the norm (for an Indian example see Breman 1985). When small peasants, as argued by Mamdani (1974), have to sell the produce of their land at depressed prices, it is again children's labour that is insidiously drained off to the market. This may not be a big issue in an industrialized country where the share of this type of work is comparatively modest, but in Third World

countries, with overwhelmingly agrarian populations depending on the production and sale of raw materials, it is. Incomes are, moreover, at such a low level that the survival of the Third World peasant is made possible by a considerable amount of unpaid domestic work, undertaken in view of servicing household members who are engaged in productive work on the one hand, and on the other, of raising children, who constitute the next generation of workers. It is clear then that children's work in the context of the peasant family is wrongly considered economically worthless and that though in itself often not directly productive, it is transformed into economic value in the interaction between the children's households and the larger society. It is my contention that in this process of transformation lies an undervalued, but important aspect of the exploitation of children in the Third World.

In the conceptualization of exploitation the higher value attributed to productive activities above reproductive ones proves particularly problematic. Few would disagree that a child in waged employment may easily be exploited. Some would go as far as admitting that a peasant economy often solicits children's work in agriculture and that these children are therefore also exploited. But applying the concept of exploitation to children performing domestic work for the family appears highly problematic. The reason is that the notion of exploitation is intimately linked to production. If we define exploitation as the unilateral extraction and appropriation of the product of a child's work by a third person, it is clear that there must be a product for exploitation to be at all possible. Children who are not employed or engaged in producing goods for the market, and they happen to be overwhelmingly girls, but engage in housework and child care instead, do not produce a surplus that can be extracted, and would therefore not be exploited (Morice 1981: 146). Anthropologists have recurrently also pointed out that the extra-economic value of much work undertaken in the peasant household, for instance that which is undertaken in the realm of subsistence, poses serious obstacles for conceptualizing and measuring exploitation (Firth 1979: 81ff.; Friedmann 1980). However, this is not a sufficient reason, I feel, for not attempting to incorporate rural children's work within the context of the family into the notion of exploitation as this would amount to withholding from the analysis a very vital aspect of these children's everyday life.

Some useful propositions may be derived from the 'modes of production' controversy, a debate about the structural constraints of small-scale peasant production in the Third World. The debate dates back to the early 1970s and challenged conventional Marxist assumptions about the gradual disappearance of the peasant in the face of capitalist expansion. The rediscovery of the works of A.V. Chayanov and their translation and publication in 1966 had a considerable influence in starting the debate. Chayanov challenged the Marxist assumption that with the expansion of capitalism non-capitalist

categories of economic life, typically those of the peasant economy, would become insignificant or on the verge of extinction. In Chayanov's theory the peasant economy is based on other principles than the capitalist firm: it uses predominantly the labour of the producer and his family, it produces mainly use rather than exchange value, and is aimed at satisfying consumption needs, that is, subsistence, rather than at realizing profit. The basic thesis of Chayanov is that the final goal of the peasant household is to achieve an equilibrium between labour and consumption, which is determined by the size of the family, the proportion of family members who work or do not work, and the area and quality of the land. This internal equilibrium may make very low returns per labour units acceptable, and these enable the peasant household to exist in conditions that would doom a capitalist farm to undoubted ruin. This would explain why the peasant can accept remuneration so low as to deprive capitalist agriculture with its competitive power and why the peasant economy has been able to survive expanding capitalism (Chayanov 1966: 89).

The renewed interest in Chayanov's theory would start off a lively debate about the persistence of the peasant economy or, as termed by Marxists, precapitalist modes of production under capitalism. The debate soon centred upon three main regions of the world: Latin America, Francophone Africa and India. While the Latin American debate concentrated on the issue whether agriculture was becoming increasingly capitalist or not, the Indian more specifically sought to devise whether the Indian landowning class was to be typified as 'feudal landlord' or 'capitalist farmer' (see for reviews, Foster-Carter 1978; Harriss 1979). The African and, to a lesser extent, the Latin American debate came up with a position that was to be of eminent importance in later conceptualizations of the peasant household, that is, the idea of articulation of modes of production. Expanding capitalism would not displace or destroy precapitalist forms of production, but would transform them in such a way that they would not only be subordinated to capitalism but also preserved and consolidated. The main exponents of this position would seek to show how the articulation of these precapitalist modes of production, of which the peasant economy would be but one mode to the capitalist mode of production, was at the very core of the domination of the rural Third World by the industrialized west (Jalée 1965; Emmanuel 1972; Amin 1973). The crucial aspect of underdevelopment, in this view, is the unequal exchange that takes place between industrial goods produced in the capitalist firm, where labour is valued according to its exchange value, and the raw materials produced in the precapitalist peasant household, where the use value of labour dominates. The domination of capital and its accumulation in the core areas of capitalism is made possible because the value of the peasant family labour is not included in its entirety as a cost of production.

Working from this paradigm anthropologists set out to analyse the

19

historical process of articulation under the impact of colonial and later neo-colonial domination, of precapitalist modes of production (Rey 1973: 11-60; Meillassoux 1977: 139–205; Kay 1975: 87–104; Kahn 1980: 188–210). Central to the theory is the concept of 'social formation' denoting the process of economic production which rests on specific class alliances and a dominant ideology, both crucial for their reproduction over longer periods of time. The role of class alliances is particularly interesting for understanding the ideological dimensions of children's work in the rural household. Rey (1973) has pointed out that, while the ownership of the means of production is of crucial importance in a production process based on pure capitalism, this is not the case in societies in which the production process is still partially based on precapitalist relations. To understand these societies he proposes to use the concept of mode of exploitation, distinguishing between the lineage and the feudal modes of exploitation. In the lineage mode, common in parts of precolonial Africa, neither land ownership nor that of the means of production seems to have been economically valuable. Economic wealth could only be realized if one controlled women and juniors. The control over women determined the flow of prestige goods, in the form of payment of bride-prices, towards the elder males. For junior men to be able to marry in these societies, they had to perform work for the seniors and produce the prestige goods required for the payment of the bride-price. Exploitation was realized through the 'unequal' exchange, on the one hand of wealth produced by junior men, and on the other, of junior females, who were not 'produced' by senior males at all (Rey 1971: 49; see also Meillassoux 1977). Class relations in the lineage mode were shaped according to gender and seniority, and the marriage system was the central means by which the dominant class of lineage elders exercised its power over the dominated (see also Rey 1979: 51ff). Other modes, such as the feudal mode of exploitation, believed to have been dominant, though in a somewhat different form, also in Asia, was based on the power of the lord over the land and expressed in terms of the rent and the forced labour imposed upon the tiller and his family.

The relevance of identifying these, now extinct in their original form, modes of exploitation is, as said, that colonial domination did not entail the destruction of the conditions under which they worked, but often their reinforcement and their transformation into a specific colonial mode of exploitation (Rey 1973: 158ff). Colonial domination may be seen as often having been a kind of settlement, or in Rey's terminology, alliance of classes, between the colonial power and ruling elites which were able to retain a great deal of their power for instance over the flow of bridewealth (Africa) or over access to land (Asia), in exchange for their co-operation in realizing the colonial revenue. In Rey's view, the economies of Third World societies are still largely shaped by the overruling role played by this type of alliance, though in a neo-colonial setting no longer based on colonial revenue but on

unequal exchange. It is their dominance, and not some mysterious internal logic of the peasant household as believed by Chayanov, that helps explain why unremunerated work within the context of the family is the ubiquitous way in which Third World labour is exploited today (Rey 1973: 49ff). Rey's interpretation of how modes of exploitation are articulated has, I believe, the advantage of de-linking the exploitation of children from work valued in the capitalist sense, and allowing for an analysis of its modalities in the broader context of colonial and neo-colonial societies. It illuminates the point that the work of children should be placed in the context of the mode of exploitation in which it is embedded and should particularly be seen against the different sets of class relations by which the mode is reproduced. The focus on articulation, and in particular on class alliances, clarifies why employment is not the typical feature of children's exploitation in Third World societies but unremunerated work within the family context. It also evidences that it is not necessary for children to engage in activities that directly add to the marketable surplus for their work to be transformed into economic value, nor need their work be performed with that express purpose.

A similar conclusion about the role of unremunerated work has been reached by another Marxist school of thought that has focused upon global wage inequalities as the root of underdevelopment. This school has particularly been at pains to explain why most of the households in the Third World can survive on wages that do not cover the cost of reproduction, that is, that are insufficient to feed children or maintain the worker in sickness and old age. These households, whether surviving on peasant farms or in urban slums, typically pool incomes from a variety of sources of which subsistence and domestic manufacture are the most important. These activities, typically those undertaken by children, enable employers of Third World workers to save on their labour costs (Wallerstein, Martin and Dickinson 1982). The household's capacity for pooling and reallocating resources is in this perspective critical for explaining the structure of the modern world economy and not a separate precapitalist realm of social action (Martin and Beittel 1987: 217). Though the view helps to bring out the common patterns that lie at the root of family and household formation in the modern world, it also evidences the similarities between the Marxist and the neo-classical economic theory on the household. Both theories work from the assumption of the household as a wholly co-operative, altruistic unit and fail to recognize the importance of conflict and inequality. There is now a growing feminist literature, both from the neo-classical and the Marxist perspective, that casts serious doubts on approaches that treat the household as a purely altruistic unit. Central to this literature is the importance given to conflict and bargaining power within the family. The neo-classical approach has, for instance, acknowledged that legal and political institutions lend adult males considerable bargaining power within the family and gives them leverage, not only to engage in remunerated work outside the ambit of the home, but

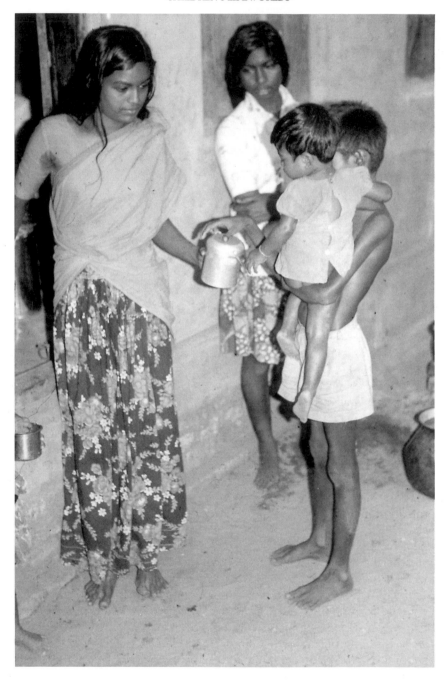

3 Food distribution to young children has been a significant help in lowering child mortality rates

also to dispose of the cash returns of their labour. By contrast, women and children are at a disadvantage in the labour market and have to concentrate on the less rewarding tasks within the home. Feminists that work from a Marxist paradigm have rather concentrated on explaining the structural constraints of inequality and conflict and have identified patriarchy as the system that places women and children in different social and economic positions to men. In this analysis gender and age differences became analogous, though not identical, to class relations (Folbre 1986: 250ff.).

Some recent research undertaken from this perspective has highlighted how gender and age differences interact to contribute to children's subordination. Feminist anthropologists have, for instance, argued that children's work is often belittled because it is performed under the supervision of women (Schildkrout 1980; Elson 1982; Wyers 1986). In peasant societies young boys who are as yet incapable of working alongside their adult male kin spend most of their time in the company of their mothers and sisters. So do the girls irrespective of their age. In this female world in which children live they share the tasks and responsibilities of women, which are primarily those of child care, housekeeping, caring for small domestic animals and the orchard and producing goods for the market. Women have to perform these tasks as a matter of fact in addition to their productive work which for poor women may be quite substantial. Analysing the analogy of women's and children's work roles, Elson proposes to view the subordination of children, by analogy to gender subordination, from the perspective of the seniority system. Seniority is a hierarchical system, she argues, in which those in junior positions are unable to achieve full social status in their own right. It is then not the nature of what children do that is inferior, children's work is valued as inferior because it is performed by children (Elson 1982: 491ff). The gender ideology proves particularly powerful in disguising the value of work performed by girls that is intimately related to women's (Schildkrout 1980). The gender distinction is introduced early in life. In India, for instance, in the process of learning to be women girls are taught to accept and internalize dominant conceptions of femininity and of the place of women in society (Kakar 1981: 61ff. This ideology of gender permits the reproduction of a system based on sexual inequality where women are generally excluded from crucial economic and political activities and their position as wives and mothers is associated with a lower status than men (Dube 1988). The visibility of girls' work is indeed so low, that the importance of work performed by rural girls in India became more or less by accident apparent as a corollary of feminist research (Jain and Chand 1979). Viewed from this angle it is not surprising that children themselves stress the non-economic value of their work. The contradictions of everyday life may be made more tolerable by attributing non-economic value to economically worthless work and concentrating on 'higher' values such as personal or social worth and a feeling of self-esteem. The shifting of values is more likely for those who lack

control over the economic and political field (Wallman 1979: 10ff). The lack of control children, and particularly girls, exercise in this field affects the identity and feeling of worth they draw from their work. Rather than with the economic value of her work, a girl may therefore often seek to identify with the nurturing role of females in the family and a boy with that of a trainee or a schoolchild. There is indeed a sizeable number of children whose work allows them to put themselves through schools and this makes for many forms of work to be perceived as desirable for poor children's education (Fyfe 1989: 160).

The identification with the non-economic value of work is, however, not only a problem of subjective experience, but must be seen against the backdrop of how social systems continuously define and redefine childhood. One of the illusions created by the notion of child labour is that the state of physical and mental immaturity or incompleteness which we call 'childhood' would be equal, in duration and character, for all children the world over. Anthropologists have long pointed at the many-sided aspects of the principle of age classification. Age has a social and cultural rather than a biological meaning. Biological maturity is not in itself associated with an adult status, just as biological senescence does not *per se* entail the loss of power and prestige. While one young person may be considered grown-up in one social setting, in others he may still be treated as a minor, and behave likewise. There exist no obvious age or status categories to be used as a system valid for studying childhood across cultures or even classes within the same society (La Fontaine 1978). Even the range of age categories and the variables used for categorization differ widely. Industrial society has introduced ideals of childhood that accord a tremendous importance to chronological age, in other societies these are far less relevant than, for instance, the attainment of stages of biological maturity which are considered important milestones in the life of an individual. Nor is it so that establishing the age-grading system followed by a particular society tells us that much about seniority as we may be inclined to believe. Age-grading often coexists with rankings based on age and birth order. So it often appears to be of greater importance whether one is the eldest or youngest child or the first daughter to attain puberty in a domestic group than whether one has attained a certain age in years. Many societies do not have a word to designate a person between say, 5 and 15, the word child designating kin-relationship and not biological age.

It is often overlooked that age hierarchies, as a rule, are only valid for specific gender roles. For a girl, it may not be necessary to attain a certain physical maturity to be encouraged to be self-sufficient in her daily routine or to take on domestic responsibilities (Bellotti 1981: 34ff). To control the development of her identity, her training as a 'good' woman and the inculcation of feminine roles, may deliberately be stepped up even before she reaches the threshold of puberty (Kakar 1981: 62). For marriage sexual

maturity may even be irrelevant (Malhotra and Trivedi 1981). A boy's adulthood may, by contrast, be postponed for many years after he has become sexually mature, as is common practice with trainees in artisanal communities (Morice 1982: 515). This does not imply that a boy has therefore less power and influence than a girl of the same age, only that he is preparing to a higher position and that it will take him more time to reach there. The implications of the differential duration of childhood for boys and girls for the perception of what kind of work may be suitable to a child of either sex, are far reaching. Work undertaken by girls is often not perceived as child work for the simple reason that girls' childhood is so short.

Children's subjective experiences and the ways in which childhood ideals are defined and redefined are not separate processes, they are intimately linked and act upon each other. Historians have documented how different conditions of children's lives generate different ideologies of childhood. The impact of emerging capitalism on children's upbringing in the west, for instance, generated a new conception of bourgeois childhood as a separate, biologically-defined stage in the life of a human being (Ariès 1973; Mause 1976; Walvin 1982). In the iconography of the child in sixteenth and seventeenth century France, as pointed out by Ariès, the child had still been portrayed as a miniature adult. It was only gradually endowed with the traits, expressions and postures that were to become the attributes of the bourgeois conception of the child. The social setting in which this new social being was emerging was closely linked to the rise of the industrial bourgeoisie. In medieval France, Ariès argues, there were no schools as we know them today, and the modern notion of education was absent because children learnt by seeing as companions of adults. Bourgeois industrial society, by contrast, was heavily preoccupied by uniformity and segregation, and judged its success by the standard of its educational system, and does so even today. Today children grow up in schools in a world that is effectively segregated from the experiences of adults or, for that matter, the experiences of their peers in the rural areas of the Third World. A whole array of specialists have as sole preoccupation to shape the physical, emotional, moral and intellectual development of children according to the ideals of bourgeois childhood (Ariès 1973: 312). One may doubt, with Gillis, that childhood in pre-industrial Europe was indeed as conspicuously absent as argued by Ariès. Very young children were obviously as completely dependent on adults as they are today, and especially for boys, long periods of initiation, lasting from about 7 or 8 to the late twenties, were common (Gillis 1974: 4–5). But although children and youths may not have been as self-reliant as depicted by Ariès, what matters for my argument, is that as their objective conditions changed, their subjective experiences of childhood changed as well. Importantly, it was with this ideal of childhood that child labour legislation was concerned in industrializing Europe. In this concern child labour and education were viewed as each other's poles and this had the

side-effect of legitimizing the work that could be combined with going to school, that is, that did not contradict the ideal of a childhood in school. The ideal also lent legitimacy to the work of children in the colonies as long as it was associated with the types of socialization that the colonial powers thought suitable for children. As I will contend in this book, it is the identification of working children with this higher western ideal of a separate childhood in school that today makes work in the context of the family not only bearable, but contributes to isolate and restrict children's economic opportunities. The contradiction of poor children's unremunerated work must then be sought in the very make-up of a childhood ideology which simultaneously enjoins children with the primary responsibility of seeking self-realization in school, while limiting their capacity to fulfil this role by negating their need for remunerated work. The objective and subjective dimensions of children's lives are then both important to understand how poor children's work is articulated and reproduced in the modern world. The way in which feminists are criticizing knowledge may hold clues to the way in which children's subjective experience may be conceptualized. Sandra Harding has aptly remarked that western thought has started out from the lives of men in the dominant groups, and is therefore both interested and socially situated. Understanding the lives of women while overcoming these limitations may only be possible as well if accepting that multiple subjects have multiple, often conflicting, systems of knowledge. It is by learning how partial and interested knowledge is generated that the objective theoretical frameworks for understanding the lives of multiple subjects can emerge. An important part of this process is the claim of subjectivity, the possibility of historical agency that marginalized groups such as women and children must achieve in order to start understanding their own lives (Harding 1992: 183ff.).

To sum up, the assumptions underlying the notion of child labour are grossly inadequate to study the work performed by children in a rural setting, where children working in remunerated employment are rather the exception than the rule, and many children can combine school and work. This is, however, not to say that the work of children in peasant societies would be in itself less objectionable or that it would be less exploitative. What we still need to understand is the relation between the taken-for-granted nature of children's work and the differential valuation to which it is subjected. The focus should not only be on the nature and articulation of children's work but also on how it is valued; on the setting in which work is undertaken on the one hand, and on the other, the ideological assumptions underlying it. In this book I consciously question, in the process of observation and analysis, my own notions of work and childhood as well as those professed by those in positions of authority, setting these notions against the day-to-day practice of actually being a child working in a rural environment. The position involves more than simply enlarging upon the notions used in the discourse on child labour. It leads to focus on the

dialectical relation between what children do and how these activities are perceived at different levels of society, on the relation between observable actions and their ideological meaning. My analysis goes, to use Murphy's words: '. . . beyond the empirical structures derived from actual observation to infrastructures that are logical products of the investigator's mind and transformations and negations of the apparent reality' (1971: 4).

Rather than looking for a restricted range of activities of children that fit an a priori definition, I therefore start with an empirical investigation of activities undertaken by children of both sexes. I commence with mapping how children's time is organized and who controls it. The discussion is drawn from an anthropological enquiry in a small Kerala settlement of fishermen and coir workers, Poomkara.[1] I relate the observable activities of both boys and girls to the household's effort at deriving a living, in which class and kinship are key features (Chapter 3). For the poor, gender and age are crucial in the household's division of labour and are closely linked to the perceived value of a member's contribution. While adult men contribute most of the income in cash, boys are overwhelmingly concerned with providing the family with extra food; the women's primary concern is with the well-being of their family, and it is upon the girls to assist them therein. It is their being allotted tasks that are not valued in monetary terms that makes for children's work, and in particular girls', to be held in low esteem (Chapters 4 and 5). A second step is to understand the wider economic implications of children's work, and to look at how it is linked to the regional pattern of production and reproduction, enlarging upon its significance in the two sectors, fisheries and coir, that have been the concern of Chapters 4 and 5. Discussing the value of what children do for the functioning of these two sectors of the rural economy, I come to the conclusion that, in spite of the low esteem in which their work is held, one can ill imagine Kerala's economy without it. The specific way children are inserted into the economy allows for those holding key positions in agriculture and commerce to utilize to their advantage children's work without, however, actually employing child labour (Chapters 6 and 7).

Being aware that: 'nothing is more quixotic than to attempt to change the meaning of a word firmly rooted in the lexicon' (Fried 1967: 114), I will continue to use, rather than child labour, the term children's work, as I have done so far, trying as often as is feasible to specify whether I mean females or males. As already argued, the notion of child labour conveys the idea of an abstract and sexually neutral child doing economically valued but undesirable work, and is therefore too restricted. For all practical purposes, I have adopted the more inclusive definition of work proposed by Schildkrout, for whom it is: 'any activity done by children which either contributes to production, gives adults free time, facilitates the work of others, or substitutes for the employment of others' (Schildkrout 1981: 95).

I have similarly adopted an operational definition of exploitation as 'the

gap between the remuneration of labour or of its product in the market and the income necessary for the maintenance of the worker's family, that is, of household members engaged in domestic work on the one hand, and on the other, of children, who represent tomorrow's workers'. In the interpretation of quantitative data I have had to use age groups and be quite clear cut who to include as a child and who not. I have worked with four categories: below 5, from 5 to 9, from 10 to 14 and from 15 to 19. My book is primarily concerned with the two middle groups between 5 and 14, and when I speak of 'working children' it is to this category that I refer. In all other cases I have taken care to specify the age of the children I am referring to. The problem of choosing an upper limit for being a child, has made a researcher such as Hull propose to put it somewhere between 19 and 24, as this would extend analytical possibilities (Hull 1981: 49). According to Hull, it would be counter-productive to impose on a society where the concept of childhood is not as sharply defined as in the west, a formal breaking-point. In addition, by defining adolescents as adults, one would wrongly suggest that they are also socially adults. This would impair the analysis of the field of interaction between adolescents and younger children, one that is especially relevant in the study of social transformation. Adolescents are often far better equipped to voice their feelings and expectations than younger children, providing hereby models for behaviour. Though this is indeed true, I feel that including adolescents in the operational definition of a child would not add to conceptual clarity, though I have included, in the analytical parts, data on adolescents in the age group 15 to 19.

It should be clear that the study presented in this book has intrinsic limitations that do not allow for more than tentative generalizations at the conceptual level. In view of the dearth of comparable data, it is essentially based on a single empirical case study, though I have devoted a great deal of attention to the economic and historical setting of my material. The exceptional history of the region, the high level of political awareness of the rural poor, and the religious cohesion of the Muslim community that is the object of my study, all contribute to render the case unique. Rigorous conceptualization and theoretical depth may only be achieved with a multiplication of studies along the lines followed in this book. Though not pretending to generalize, I hope this study offers, therefore, a blueprint that may be useful for future research. There is one important question with which this book is not concerned, namely, what to do to combat the exploitation of children. The reason is that I think there is no better way for the moment to serve the purpose than to attempt to unveil its nature. I am too well aware that translating such an exercise into priorities for action, in addition to being preposterous, may also involve unforeseeable consequences. The recent Indian debate around the Child Labour Bill, proposed to legalize work poor children undertake as a 'normal' contribution to their family's survival, illuminates these dangers (for a discussion see Gupta and Voll 1987).

METHODS

The main body of the empirical data discussed in the first part of this study has been collected between 1977 and 1980 and was supplemented by information gathered during follow-ups in 1983, 1990 and 1992. The original field-work was part of a larger study on 'Labour and Poverty in India and the Philippines', undertaken by a team of researchers from the Anthropological-Sociological Centre, Department of South and Southeast Asia, University of Amsterdam. The programme focused on the study of survival strategies and their implications for the working relations of the poor in the two countries. We were from the start very much committed to avoid introducing a 'male bias' into our research, as our theoretical discussions had brought us to the conclusion that the work of the whole family was necessary for survival. As some female members of the team felt strongly about doing research on women, and the others were men planning to research other men, my first impulse was to take up the issue of children's work. This was a somewhat quixotic reaction, as I thought it quite odd to divide the subjects each of us was to research on the basis of gender alone. I had not given the matter very serious thought before. But once I had proposed the subject, I liked it immediately and have kept doing so since. What fascinated me was the possibility of looking at gender relations from a new angle, one that would contribute to resolve what I felt was a rather sterile dualism, namely, the dichotomy male/female. If women are subordinated to men, what about children? This was, however, not the type of question with which I set out, as I feared it would not be found worth funding by the agency to which I submitted my proposal, the Dutch Foundation for the Advancement of Tropical Research (WOTRO). I therefore cast my research questions in a form that seemed more legitimate. The questions related to exploring the 'vicious circle of poverty' in which poor people would be trapped: on the one hand they needed many children to survive, while on the other many children seemed to make them poorer. This method worked and I obtained the grant.

In the course of the field-work, however, I gradually shed the idea that children's work would be related to fertility in the simplistic way stated in my original plan. As I came to understand more and more about children's work, I began to see the whole thinking in terms of people calculating the cost and benefits of children as ethnocentric. Not that people among whom I carried out my research never considered the possibility of preventing or spacing births. But from there, the step towards planning rationally in advance the number of children they would 'have', seemed gigantic. The idea of planning one's children fits into a life in which one makes long-term plans for a career, the payment of mortgages and when to buy a new car. Not into the normal thinking of people whose life is a long series of uncertainties and who can therefore hardly plan what to eat the next day. The people among whom I did my field-work often did not know whether they would have children,

whether these children would survive the first years, whether they would remain unhurt by accidents and the debilitating effects of polio and TB, whether they would be imaginative and tough, and whether they would bring their parents good fortune. I therefore soon abandoned questions about how many children people planned to have, as I felt that they sounded odd. No doubt this feeling was aggravated by the political mood of the time. By the time I came to live in the locality of research, information about forced and indiscriminate sterilizations that had been carried out during the Emergency was slowly coming into the open. People had felt hurt in their deepest feelings as they came to know that the government's policy of population control had led to taking recourse to such fierce methods. It was natural that they would distrust me if I were to start questioning them about birth control.

Initially, the project was planned to be carried out only in the Philippines. However, long discussions about the problems implied by the authoritarian structure of the Philippine's political order in those years for formulating concrete policy recommendations, brought some of us to select a second country where 'the Emergency' had recently been lifted, namely, India. Within India the choice of Kerala was not easy either. We were fascinated by Kerala's peculiar social and political history as well as by the fact that we were to be the first Dutch anthropologists to do research in the state. Kerala was also an example of an area which, according to Professor Wertheim, whose inspiring lectures lay still fresh in our memory, was on the verge of undergoing a profound process of social transformation. It was an example of a very highly-populated rural society that relied on wet paddy cultivation. But what perhaps was just as important were our fantasies, in the middle of the Dutch winter, about the tropical paradise, with her luxuriant vegetation, backwaters and constant temperatures that we had been told Kerala was. These fantasies did help us in carrying on with the tough language course in Malayalam, that our 'guru' Dr Govindankutty Menon gave us in his unique, brilliant way. We spent three months at the International School of Dravidian Linguistics in Trivandrum to improve our still rudimentary knowledge of Malayalam. When we obtained our certificate, we were able to exchange more-or-less simple information. We could read and write, but were not able to read more than children's books. Though learning Malayalam remained rather trying even thereafter, in the long run it proved extremely gratifying. When I opened my mouth to mutter a few words, many times I felt the change, in the eyes of the people, who often gathered in crowds to scrutinize me, from a totally unfamiliar specimen of the human race into a person with whom one could talk. I was never able to talk very fluently, though. I could follow most conversations and reinforce my elementary knowledge of the language with facial expressions and gesticulations. These were more simple to learn than the complicated syntax of the language. Anyhow, once the people got acquainted with my 'handicap', they soon found a solution to it,

and learnt to speak loudly and slowly when they thought the matter simple enough, seeking the help of one of my interpreters in all other cases.

Being part of a project team was a great advantage in terms of insights gained from studies undertaken from different perspectives than my own, but focusing on related problems. The women's perspective proved important in highlighting the different aspects of reproduction and domestic work (Schenk-Sandbergen 1984 and 1988; Den Uyl 1981, 1987 and 1992). Toon Schampers's work on coir workers in Alleppey was equally inspiring in helping me to analyse the differences between male and female, adults' and children's work (Schampers 1984). Hans Schenk's work on the town of Alleppey was important for the regional focus of my study (Schenk 1986). Marion den Uyl's and Peter van der Werff's analysis of the particular problems faced by scheduled castes helped me in clarifying the role of the intermediate groups that were the object of my study (Van der Werff 1991). In addition, a whole programme of joint research and team-work was enacted as part of the project and constituted the backbone of the course of my own study. It made me more aware of problems of definition and comparability and provided a yardstick for assessing the reliability of my data (Nieuwenhuys, Schampers, Van der Werff and Den Uyl 1978 and 1980; Schenk and Schenk-Sandbergen 1984). When it came to formulating the body of my research questions and devising the methods of data gathering, I had, however, to face alone the peculiar problems attached to studying children's work. In this demanding work I have been assisted by five Indian social scientists, without whose help I would never have been able to get into such intimate relations with the children of Poomkara and their parents as I did. They are Ms Seethalekshmi, MA; Ms K.B. Ushadevi, MA; Ms Saraswatiamma; Ms Beefathumma Kunju; and Ms P. Mohanakumari, BSc.

Why did I select Poomkara? I had in mind to carry on research in a coastal area in Alleppey district and happened to come across some data that had been collected about birth-rates in a few areas of the district. So, my next step was to visit those places. One of these, Poomkara, was not very far removed from the house of a gentleman to whom I had been introduced by a Kerala colleague. He was so kind as to accompany me on a few visits to the large village (*panchayat*) of which Poomkara is but a subdivision. I was immediately seduced by its enchanting beauty, its old temple and tiny princely palace near to the seashore, where, to add to my fascination, a group of boys were pulling the shore-seine. Nothing appeared more appropriate to my acquaintance than that I would rent a few rooms in the princely palace. Its owner, who lived in a large town was, in spite of his reservations, so considerate as to accord me this privilege. From the room at the top of the princely palace, to where I was soon to move with Seethalekshmi, who was the first to join the research, I felt grand. But I was soon to realize that I was still very far removed from the locality and the people where I had planned the research, that was about 3 kilometres away. I undertook therefore to find

accommodation in Poomkara itself, which was not easy. We made clear that we would need a place of our own, in order to feel free to interact with the people who would become involved in the research. Of the few who owned such empty buildings, no one envisaged at first to offer it for rent, as they feared that the stay of a foreigner in their midst would bring unforeseen problems. But finally, as Ushadevi also joined the research, and the three of us were now walking up and down daily, some felt they should be more hospitable. So, after two months of field-work, in October 1978 we descended from our princely abode to stay in three empty storerooms in Poomkara itself. In these rooms we were able to form our little menage and receive the many visitors who came to see us without causing too much disturbance to our landlords, who lived in a house about 50 metres away.

I know that I have made many clumsy mistakes and shocked Poomkara people in spite of their immense tolerance with my undiplomatic manners and questioning, which, although not meant as such, must often have seemed odd and improper. But in spite of the freedoms I came to take as the research progressed, they remained surprisingly benevolent. Some would loudly voice their doubts about the value of social research and ask me to find a cure for the coconut pests instead of wasting paper on people's gossips. Others would ventilate their incomprehension that healthy young women, as we were, could spend so much of their time hanging around and chatting without seemingly doing anything useful. I must confess that I often felt that they were right and that my motivation sunk at times deep. But there was also much encouragement and appreciation coming from those who had gone to high school and college. No doubt that much of the credit for changing the attitude of many sceptics goes to Beefathumma Kunju, Saraswathiamma and Mohanakumari, all local graduate women who joined our team later on. The relentless support of educated young women and men was invaluable in overcoming periods of depression and in giving me a feeling of having realized my aim.

The long time-span involved in the research has permitted me to observe changes that were helpful to place my analysis in a dynamic perspective and to bring out some of the underlying social and economic forces at work in shaping children's lifeworlds. Lack of time and means have not allowed me to update the original quantitative data collected in 1978–80. I have had several reasons for not omitting them. The data are to date the only substantial ones ever collected on children's work in Kerala. Moreover, they provide my analysis with a baseline that allows for understanding mutations in children's lifeworlds over time, mutations that are generally as yet imperceptible, and that the collection of new quantitative data at this point in time may very well fail to bring out.

The field-work in Poomkara fell into two parts. The first part was a rather conventional exercise in getting to understand the rural society in which children grew up. It was also an extension of the preparatory work

32

undertaken by the team as it sought to use standardized methods to obtain comparable data. The first such method was a census covering the whole population in which information such as age, work, education, housing and assets was asked. It was carried out with the help of Seethalekshmi and Ushadevi. The second was a year-long budget study undertaken to study the weekly and daily time allocation, food intake and income and expenditure of all members older than 5 in twelve poor households. A total of 79 people were interviewed every eighth day, on average 42 times, about their time allocation, food intake, income and expenditure on the previous day. In addition, a weekly assessment was made of days worked, income and expenditure of the family. The study was mostly carried out by Seethalekshmi and Beefathumma Kunju, though I regularly kept in touch with the families.[2] In addition, I used a few other methods to compose the picture of Poomkara: oral histories, interviews about selected topics, the reconstruction of product columns, the study of land records and informal talks and observations. For the oral history I relied mostly on Ushadevi's work, while Saraswatiamma undertook the tedious work of copying and analysing the land records. All these did yield a more-or-less clear picture of Poomkara society, but told us, in fact, but very little about children. Even the interviews, that were held on such topics as family planning, the role of modern education and 'modern youth', told us more about adults than about children. The same was true of budget studies, in spite of their including all the children above 5 years in the respondent's households. The respondents were mostly women, so that the replies tended to reflect their perceptions about their children's work. We did start getting some understanding of 'invisible' work, but still felt that we were not going beyond collecting information on what most women felt was generally valued as 'work'. This is why we embarked, approximately halfway through our stay, on devising other, additional methods of work.

When we started with 'systematic observation' we had reached, I felt, a crucial moment in the research. The method consisted of spending a few hours recording what we saw, following a method described by Oscar Lewis (1951: 63–71). Generally I was the one who would sit observing and writing, while either Seethalekshmi, Mohanakumari or, less often, Beefathumma, would ask contextual questions. It was in this way that I was able to understand how the children's, but particularly the girls' work pattern, fitted into their mother's and was often complementary. Few women were aware of this symbiotic role of their daughter. We did not limit ourselves to observing the work floor, but soon were found at all hours of the day observing children: in front of shops, near market-places, near ponds and wells, along tracks, on grazing grounds, on the beach, in kitchens, classrooms, Koranic schools, the nursery school, etc. In this way we were able to map a wide range of activities carried out by children without having to decide a priori whether they deserved to be called 'work' or not. Once we

had understood how children's time was organized and, at the same time, had gained a fair knowledge of how the adult world was organized around it, then only did we feel we were ready for the next step, the in-depth interviews of selected children. This was another difficult part, as we had noticed that children felt uncomfortable speaking freely in front of me. Adults never failed to require from children to behave with respect and modesty towards me, forcing them to do so if need be. They felt that going into details about a child's normal routine, was much too mundane a subject to talk about with a foreigner and ran contrary to general notions of etiquette. They would therefore make derisory comments or even scold children who attempted to answer my questions seriously. As it was impossible for me to speak to the children without their parent's interference, it finally was Mohanakumari, herself born and brought up in Poomkara, who took it upon herself to carry on the interviews in our home. I would afterwards discuss with her the interviews she had recorded and translated literally. In this way we started to get more and more testimonies of what the children themselves saw and felt were important issues: their work, the drudgery of housekeeping, the wish to earn money and decide how to spend it, their future. They talked about anger and despair, hunger and disease, but also about games, songs, festivals and, above all, about the intense feelings of love and concern they felt for their parents and siblings. These interviews are the decisive part of my material. They have cleared much of the personal anguish I often felt when confronted with the formidable problems facing Poomkara children. They helped me to appreciate how much they relied on their own resilience and how strongly they were led by their belief in a better future. I hope that this book will elicit solidarity rather than pity.

I am aware that this book is, in spite of my efforts at elucidating the material and economic conditions in which children's work is set, a subjective product. However, I would like to remind the reader that there is 'no knowledge without a knowing subject' (Kloos 1988). It would be an illusion to think that an anthropologist would do anything else than produce knowledge that is, his or her own creation. Knowledge:

> is created first of all in the interaction between fieldworkers and those whose ways of living they try to understand. In a wider sense knowledge is created in the interaction between fieldworkers and the whole situation in which they find themselves. The dialogue is continued after the fieldwork proper is over (. . .). A consequence of this point of view is that without fieldworkers there is no knowledge that we can call anthropological. It means that fieldworkers are part and parcel of knowledge and that this should be recognized in ethnographic description.

> (Kloos 1988: 228)

2

BETWEEN THE RIVER AND THE SEA

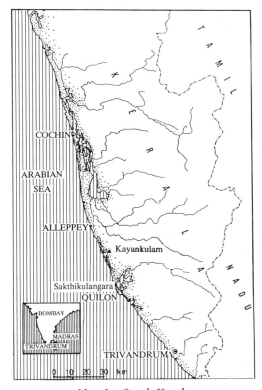

Map 1 South Kerala

It may seem curious to situate a study of children's work in Kerala, which, of all Indian states, has achieved very high degrees of schooling and is internationally reputed for its remarkable record in equitable development and, in particular, in improving the health and educational situation of poor children. But the state's redistributive policies have persistently accommodated high levels of social and economic inequality. At the local

35

level of society, powerful divisions of class, caste and kinship have hereby operated to effectively neutralize attempts at achieving a sustainable improvement in the lives of the rural poor. Here I want to explore, by taking a closer look at the immediate society in which rural children grow up, what this situation has meant for the children. I begin by reviewing what makes Kerala such an interesting case for studying children's work.

THE CHOICE OF KERALA

The state of Kerala occupies a narrow strip of land on the south-west coast of India, bounded to the west by the Arabian Sea and to the east by the Western Ghats. By virtue of its tropical climate, Kerala is visually distinctive from the rest of India. The characteristic scenery is a luxuriant patchwork of coconut palms and paddy, laced together along the coast by backwaters and lagoons. The region benefits from both the north-east and north-west monsoons and has more rainy days and a higher average rainfall than any other part of the subcontinent.

Kerala was formed as a state in the Indian Union in 1956 on the basis of the Malayalam language, which was spoken by the inhabitants of pre-independence Malabar (part of the Madras Presidency) and the princely states of Cochin and Travancore (see Map 2). Kerala's three natural divisions run longitudinally: coastal lowlands, midlands and highlands. By contrast, pre-independence political divisions ran latitudinally, with the result that they represented geographical microcosms of today's state. The highland zone is wet, relatively cool, and naturally forested. It is relatively sparsely populated. The midland zone is characterized by fertile valleys where paddy is grown, alternating with arid hills, where little more than tapioca may be cultivated. The coast is low-lying, alluvial and fertile. In some parts the rivers and backwaters provide the only channel of communication. It is densely populated, with a population rising in its most populous district, Alleppey, to 1,486 per square kilometre. It is in this district that one also finds the economic, political and cultural characteristics that are distinctive of Kerala in their most extreme form.

Kerala is, like India as a whole, overwhelmingly rural. Despite a generous definition of urban settlements, only 18.74 per cent of the state's more than 25 million people lived in urban areas in 1981. Only three centres exceed 200,000 inhabitants: the major port of Cochin (513,000), the administrative capital of Trivandrum (483,000) and the chief town of the former British province of Malabar, Calicut (394,000). In contrast to the rest of India, Kerala lacks the nucleated village which marks Indian settlement patterns, and this applies particularly to the densely-populated coastal fringe. The village is more an administrative concept than a physical fact, as ribbon settlements extend along roads, tracks, canals and rivers.

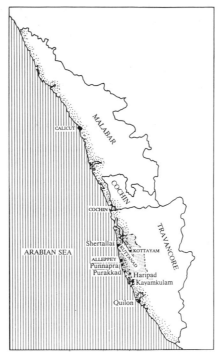

Map 2 Kuttanad region in Travancore

The Hindu caste system achieved in Travancore, the native state that came to form today's southern Kerala, the highest degree of elaboration, while at the same time departing from the typical Hindu ritual ranking. Until the end of the nineteenth century matriliny predominated among all castes and communities but the wealthy Syrian Christians. Caste reform was an early phenomenon among high as well as low castes, and today there are but few vestiges of the highly-visible type of caste distinction that used to prevail in the past. Kerala is, apart from the Punjab, the only Indian state where two-fifths of the population are non-Hindu. This population is fairly divided among Muslims and Christians. Religious enclaves are exceptional and all three groups interact frequently, and harbour, in their daily intercourse, a high degree of tolerance and respect for each other's beliefs and practices.

The state's achievements in the sphere of education are another feature that contribute to its distinctive tradition. Seventy per cent of the population is literate, and the small difference that exists between male and female literacy (respectively 75 per cent and 65 per cent in 1981) is, when compared to national figures, exceptional. No other state in India has achieved a female literacy rate of more than 35 per cent. Virtually all children attend the lower primary school, and one-third achieve the tenth standard. Moreover, in general, the quality of life of children in Kerala is markedly better than in

37

other states, as suggested by a rate of infant mortality that is as low as 41 per thousand, against the all-India average of 124 (Panikar and Soman 1984: 19).

In spite of these distinctive features, Kerala would probably have remained largely neglected by the outside world, doomed by her geographical position on the periphery of India, but for a political event that could not remain unnoticed. At the height of the cold war, in March 1957, Kerala became the first state in the world to elect a Communist Government through the polls. Overnight the state became the object of studies on the strategy of the Communist movement in the Third World (cf. Fic 1970; Lieten 1982; Mammen 1981; Oommen 1985; Nossiter 1982). Successive Communist governments were particularly successful in enacting substantial land reforms, culminating in the Kerala Land Reforms Amendment Act of 1969, that made the landless the legal owners of the sites occupied by their huts. Quite a few hypotheses have been advanced to explain the success of reform movements in Kerala. The combination of high literacy, high status of women, low birth-rates, a relatively good 'quality of life' and a very high degree of rural political involvement, with low per capita income and high unemployment rates, has led a number of authors to speak of a 'Kerala model' of development (Ratcliffe 1978; Nag 1983 and 1984; Franke and Chasin 1991). The model's linkage to an exceptional low rate of fertility has particularly appealed to population experts. What has attracted these authors is the achievement of a certain amount of social equity at costs that compare very favourably to what achieving a comparable level in the classical model would entail.

The 'model' is, however, rife with imbalances and contradictions. The social equity in the distribution of state welfare that makes Kerala so exceptional has been the result of a long history of agrarian struggles that have hardly improved the insecurity of employment of the rural population (Kannan 1988: 285ff). Nor has the heavily politicized movement of school children and college youths helped alleviate the employment situation. Unemployment among diploma holders, more than anywhere else in India, is a problem of gigantic proportions. The high level of female literacy, and women's relative high status and favourable living conditions, only mask the growing drudgery that follows from massive unemployment. Mencher has argued, in this respect, that Kerala women's adoption of family planning should be related to the consequences of lack of employment and undernourishment rather than to a higher level of living (Mencher 1980 and 1982). Kerala therefore faces, perhaps more urgently than any other Indian state, the challenge of overcoming the impasse caused by a stagnant economy.

One may easily and convincingly argue that Kerala is by no means a representative state for studying child labour in India (cf. Weiner 1991). The incidence of child labour, being as low as 1.3 per cent of the active population, against the India average of 4.7 per cent, would argue against

this choice. So would the fact that 88 per cent of 10- to 14-year-olds are in school, against 38 per cent for India as a whole (data for 1977–8, cf. Weiner 1991). But these statistics are based on the simplistic assumption that schooling would be antithetical to work and therefore do not tell the whole story (for recent examples, see Fyfe 1989: 159; Weiner 1991). There are a number of arguments that undermine this assumption. The period in which poor rural children go to school seems to be largely limited to the time in which they are as yet physically incapable of working or till a genuine need for their work arises. Caldwell, Reddy and Caldwell observed that poor rural parents in Karnataka, a neighbouring state of Kerala, sent their children to school one year earlier than wealthier parents, to be able to withdraw them as soon as they were fit to work, generally by the age of 10 (Caldwell, Reddy and Caldwell 1985: 35). But even after children have developed sufficient physical resilience, schooling may be continued and combined with work. Most rural schools adapt their schedule to the seasonal demand for children's work in agriculture. In Kerala schools are actually closed for about 180 to 200 days a year.[1] By comparison, the average number of working days of an agricultural labourer is merely 100 to 120 days a year. The high rate of drop-outs and the low attendance rates suggest that children also often work during school hours (Dube 1981: 205). Moreover, children need not be free a whole day at a stretch to be able to work. Because they are children, their working time is fragmented in a variety of chores and services, a point to which I return at length in the subsequent chapters. The incompatibility of schooling and work has therefore been exaggerated a great deal.

Rather than to a shift away from work, the interest of Keralite children in education should be related to a climate typified by a shared belief in education as a necessary means to uplift the poor. It can best be understood when set against the back-drop of protest movements against the caste system and particularly against how the state embodied high caste interests. Well into the first decade of the twentieth century the lower castes were considered ritually polluting and were barred from government service. Caste discrimination entailed a condition of semi-servility for the lower castes, an elaborate system of rules regulating in detail the obsequiousness to be observed by the lower in rank. In many places low caste people had no right to use roads near temples, were forbidden from constructing two-storeyed houses, from keeping cows, using oil mills, metal vessels, umbrellas and wearing slippers or anything other than coarse cloth. Women were forbidden to cover the breasts (Jeffrey 1976). The rulers of the native state of Travancore belonging to the highest caste, all these restrictions were sanctioned by law. In addition, all government servants being also high caste, low castes had no access to any of the public amenities that had come into existence in the course of the nineteenth century, such as government offices, post offices and railways. This also meant that low caste children had no access to the government schools that were instituted to prepare high

caste children for office. In defence of their social and ritual superiority, the higher castes argued that their ignorance and their 'barbarian customs', such as eating meat and fish and drinking alcohol, would render social intercourse with even wealthy low caste people, impossible (see Pillai 1940, vol. 2: 719; Rao 1979: 29).

By the mid-nineteenth century, strong impulses given to the export of coir and copra by the native government contributed to the emergence of a new middle class of low caste Ezhava traders and coir manufacturers. This class eagerly sought to match its newly-acquired wealth with a higher social status and political power, which crucially depended upon its ability to get rid of caste discrimination and obtain jobs in government service (Houtart and Lemercinier 1977: 89). Leading spokesmen of the lower castes would come to promote the view that all, both the rich and the poor, suffered equally from discrimination by the state, and that schoolroom knowledge would provide them with the means to rise from poverty and obtain jobs in government service. In view of their emancipation, they energetically supported popular education, and helped found their own village schools. These schools imbued the children with the issues of civil liberties and introduced them to a discourse that defied the state's conception of low caste children's fate.

The first advances in the field of education of poor Ezhava boys can be traced to the end of the nineteenth century and were made through the effort of the wealthy families who had the financial means to support their own schools. Very much in the fashion of the higher castes and communities, an affluent businessman would offer an *asan* (teacher) hospitality and food in exchange for his teaching the 'three Rs' to his sons and to a few boys living in the vicinity (Government of Travancore 1947: XIX). While male literacy was as low as 3.2 per cent in 1875, this system helped in raising it to 10 per cent by the end of the century. There is no ground to believe, however, that there was at first much enthusiasm for schooling among the parents of poor children. It is more likely that they would have harboured indifferent, if not hostile feelings towards education, as they felt that schools could interfere with the demands of work at home:

> Many missionaries reported an extreme indifference on the part of parents with regard to their children's education. They did not care to send their children to school and when the master came to collect them – which was usually the case where he was paid by the number present – he was frequently insulted or ridiculed. Attendance was irregular and children were easily taken away from school before they were able to read or kept at home if they could assist in earning some money.
>
> (Kooiman 1989: 89)

Education of low-caste girls would cause even stronger opposition, and often led to the estrangement of the girls from their natal group (Kooiman 1989: 90).

40

Of all issues taken up by the Ezhava elite during the first two decades of the twentieth century, the right of children to enter government schools loomed large. Although by the beginning of the century Ezhava boys had been officially granted admission to many government schools, in practice the high caste Nayars still strongly opposed their making use of this right. Many schools were situated near temples and most teachers and pupils were Nayars. Youth associations, set up by rural branches of the SNDP (Sree Narayana Dharma Paripilana), Ezhava's caste association, actively helped boys who were going to government schools to face the wrath of the Nayars. These associations introduced countryside boys to an as yet unfamiliar form of political organization. A fierce battle waged around the access of Ezhava boys to the government high school at Haripad, only a few kilometres from Poomkara. The right to frequent this particular school had been granted in 1903. In 1905 some Ezhava boys, who had refused to leave the road to allow a few Nayars to pass unpolluted, were beaten up. The incident caused a clash, the first of the Nayar-Ezhava fights of 1905. During the fights Nayars repeatedly attacked Ezhavas for having 'put on airs'. Stripping women of their upper clothing was one of the methods resorted to 'to show them their place' (Jeffrey 1976: 230).

In 1916, when the government was forced to make the *asan* schools visited by low caste children eligible for grants-in-aid, and increased accordingly its educational budget, the SNDP booked one of its first successes. In that year alone 377 private schools were recognized, the number of primary schools totalling by then 2,845. In the following decades male literacy among Ezhavas would show a remarkable growth: being 19 per cent in 1911, it rose to 32 per cent in 1921, and reached 43 per cent in 1931. The growth of female literacy was, however, much less spectacular: it was still as low as 2 per cent in 1911 and 8 per cent in 1921, rising to a mere 12 per cent in 1931 (Kannan 1988: 130). An important following step would be the conversion, in 1928–9, of all schools for backward castes and communities into general schools. Thereafter, that a school be open to all communities was a condition for gaining recognition (Pillai 1940, vol. 3: 735, 756).

There is some indication that the movement for popular education among the rural poor created new tensions in children's lives and that these may help explain the discontent among the rural poor in later years. By the end of the 1930s schooling had come to embody, in Travancore, as in other parts of South India, the panacea for ending poverty and the inequalities of the caste system. Nearly 80 per cent of children in the age group 5 to 10 were going to school (Gopinathan Nair 1978: 46–8). For many children the question was not whether they should go to school, but how to cope during their school careers without food, clothes, money and even time. Achieving a minimum of elementary schooling was not as easy as one would expect when considering the amount of government support that was being provided. In 1933 the Education Reforms Committee acknowledged that

there were many schoolchildren who were starving through the school-day. To alleviate the situation, in the 1940s the government introduced a midday meal programme in primary schools and made notebooks and textbooks available at cost price. The problem of clothing was dealt with by the mid-1940s with the provision of cloth through ration shops. But material want was but one aspect of the problem, as children also shared in the responsibility for their families sustenance. For a coir worker's son, and the more so for a daughter, carrying on studies beyond the lower primary level, that is, beyond the age of 9 or 10, remained virtually impossible till the late 1960s. In 1946–7, of all children enrolled in the upper primary and high school level, only 5.4 per cent were sons and daughters of labourers (Gopinathan Nair 1978: 53).

After independence the 'backward classes', that is, Ezhavas, Muslims, Latin Catholics[2], and their converts to Christianity, were allotted as much as 40 per cent of all appointments in government. This policy would herald the emergence, through the competition for government jobs, of a new phase in the struggle for emancipation. The children of the rural poor came to look at high schools as the places where they hoped their dream of emancipation would be fulfilled, and equity in the access to these schools came to embody their struggle in attaining this goal. Most high schools were, however, run by managements belonging to the higher castes and communities. Their monopoly position made it very difficult for children of the socially-backward castes and communities to qualify for the jobs that had been reserved to them (Sathyamurthy 1985: 391; Miller 1976: 194). When the Communists were voted into power in 1957, they issued, in an attempt at improving the access of poor children to secondary education by enlarging the control of the state over private schools, the Kerala Educational Bill. The Bill, however, met with such violent resistance from the higher castes and communities that it eventually lead to the dismissal of the Communist Government and the imposition of direct rule (cf. Lieten 1982).

With the Communists gone, tables were turned in favour of communal interest groups, which would take part, until the late 1980s, in successive coalition governments and would be given ample room for initiating their own high schools and colleges. Supported by the SNDP, enterprising Ezhavas gathered large sums, bought land and applied for government grants for opening new high schools and colleges. They had little difficulty in convincing their following that their activities would give access to government service to all the members of the caste, and hence influence and power (Rao 1979: 95). Ezhavas' expectation that, through the preferential treatment they were to get in their 'own' schools and colleges, they would gain access to the same avenues of upward mobility as the higher castes and communities had a tremendous political impact. In the 1957 election Ezhavas voted overwhelmingly for the Communist Party. But after the fall of the Communist ministry, the educational policy of the SNDP had helped the

Congress, who came to power in 1962 under the leadership of SNDP leader R. Sankar, in gradually dividing the loyalty of the Ezhava electorate (Rao 1979: 88).

The Muslim Education Society (MES), founded in 1964, was similarly able to capture the loyalty of modern-oriented Muslims and to offset the attraction exercised by secular leftist parties, in particular the Communist (Miller 1976: 287). In a remarkable burst of creative energy, it succeeded in establishing a network of institutions and programmes that greatly helped in improving the educational level of the community (Miller 1976: 212). In the late 1950s, the Muslim orthodox leaders, however, still gave priority to religious training and condemned British-modelled education to children who had not completed the course of the *madrasa* (Government of Kerala 1971a: 89).

The turnover of high schools as measured by the number of passes to the Secondary School Leaving Certificate (SSLC) has shown a dramatic increase, rising from 58,575 in 1961–6 to 84,906 in 1971 and 187,824 in 1981. The children of the rural poor were very much part of this process of mass schooling. In 1975–6 as many as 83 per cent of those aged 15 to 60 in coir-yarn-making families had gone to the upper primary, and 10 per cent had completed high school (see Table 7.1 in Chapter 7). The high rates of schooling were attributed to a decreasing participation of children in work. Survey data seemed to lend support to this view, as they showed that the proportion of non-schooling children was dramatically decreasing. One would, however, search in vain for governmental efforts that may have contributed, directly or indirectly, to render the work of children in the countryside, and more particularly in the context of the family, redundant. As I will discuss in more detail in Chapters 6 and 7, the type of economic development pursued after independence failed to open up new opportunities of paid work, and on the whole adversely affected the position of the rural poor. Attempts of the left-oriented governments, that came to power between 1967 and 1977, to alter power relations in the countryside through land legislation, were unable to alleviate the negative effects on employment these initiatives called forth. Unions of agricultural labourers, though wresting minimum wages legislation, remained powerless in the face of landowners cutting down on employment when prices fell (Kannan 1988: 304). Kerala's economy remained basically oriented towards the household-based production and export of raw materials, and the long-term decline in prices that set in after the Second World War in no way reduced the need for children to contribute herein.

The reasons why schooling has become so popular in Kerala are then quite dissimilar from those that led the industrialized west to introduce compulsory education. In the west the introduction of compulsory schooling was very much related to state policies that interfered in the way parents used to bring up their children, often with a view to checking children's employment in industry (Fyfe 1989; Weiner 1991). The underlying assumption of

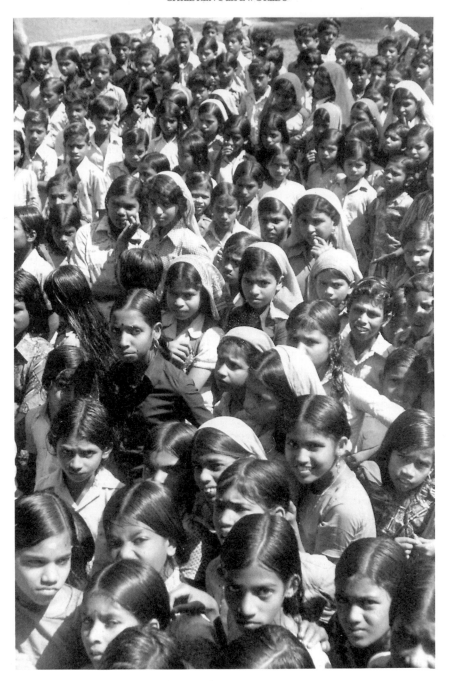

4 Girl pupils of the secondary school

Kerala's educational policies, by contrast, has consequently been that, while in school, rural children would continue to work to support themselves and their families in their spare time. There has indeed been no consistent effort by the state to reduce the involvement of rural children in work, much less to inculcate in rural parents moral values about the undesirability of children working. The state has also never undertaken strong actions to force parents to send their children to school, nor do parents think of schooling as interfering with the intrahousehold allocation of tasks. On the contrary, state and parents alike conceive of education as a matter of personal endurance, gift and the luck of the child, that is, as the children's frontier.

The timing of schools and of work have both been adapted to this situation. In most cases this has not been really problematic. Work that used to be done by children below 12 and by girls within the domestic arena, was seldom incompatible with the timing of schools. In Kerala, this has typically been the case in coir-yarn manufacture for many decades now. In addition, most Kerala rural schools do not keep children busy for the entire day. Many lower and upper primary schools work with a shift system, and tacitly tolerate the absence of children during peak seasons in agriculture and fisheries. Schools open by 10 a.m., while most children rise at about 6 p.m., a.m.? and they close at 4 p.m., four hours before dinner. They function during the hottest hours of the day when people, anyhow, prefer not to work in the open air. So there is still ample opportunity for children to combine work with schooling if and when necessary, even though this makes their life one of intense activity.

The question remains whether children need to work. The dimensions of the poverty problem seem to suggest that this is indeed so. Though the question of Kerala's distinctive poverty when compared to the rest of India is a matter for debate, no one would doubt its seriousness (Van der Werff 1991: 3). Also the existence of widespread nutritional deficiency among children and a high rate of morbidity are pointers that children may need to work for their livelihood (Panikar and Soman 1984; Mundle 1984: 299; Kannan, Thankappan, Raman Kutty and Aravindan 1991). A few authors have argued that the paradoxical low incidence of child labour participation in Kerala should mainly be explained by the high rates of unemployment in agriculture (Mencher 1980; Dube 1981: 205). The figure in fact reflects that stable, waged employment is even rare among adults and that both adults and children rely on a complex pattern of waged and non-waged activities to make ends meet.

These considerations make the choice of Kerala for studying children's work particularly interesting. The peculiarity of Kerala – its high levels of schooling, the exceptional position of women, the existence of combative unions of rural workers – offers interesting material to explore the field of interaction between childhood ideology, child welfare policies and economic processes, and this may be helpful to broaden the scope of the child labour debate. Though a growing literature relates the ruthless

45

exploitation of child labour in the developing world to poverty, few studies have sought to explain why not all poor economies engender a high incidence of child labour (Bequele and Boyden 1988; Lee-Wright 1990; Fyfe 1989; Myers 1991). A few authors have sought to explain this phenomenon by forwarding the proposition that compulsory education can eradicate child labour without a structural improvement in the lives of the poor (Fyfe 1990; Weiner 1991). As said, the proposition is hardly an explanation for the low incidence of child labour, as it is based on the scantily-researched assumption that schooling and work would be incompatible. Only very recently have attempts been made to document how work also continues to remain a normal feature of poor children's lives when in school (cf. Boyden 1991; Oloko 1991). I therefore propose to forget, for the time being, statistical measures of the incidence of child labour and their underlying assumptions, to approach the matter from another angle: that of the real living people of Poomkara.

POOMKARA

Poomkara is situated in Alleppey district, near to Kayankulam, between the Arabian Sea and a river that borders the wet-paddy region of Kuttanad (see Map 2). It is a ward in a populous administrative 'village' (*panchayat*) with more than 30,000 inhabitants. The river flows parallel to the sea throughout the village at a distance of about 1 to 1.5 kilometres, cutting it into a western and an eastern side. Waterways cover the whole area of the village with an intricate network, making communication by *vallam*, a large countryboat, far easier than by road. A narrow tarred road leads to the centre of the village, on the western land-tongue. There we find the village office, a few shops, a large temple dedicated to the popular Hindu god Aiyappan and the palace of the former ruler, the *thampuran madom*. From this centre, the road crosses the river over a bridge and leads to market-places located in the east.

A bus service runs at intervals of one to two hours, carrying people and goods to the markets, medical institutions, and schools, while twice a day a motor-boat service passes through the river. The nearest town, with a population of about 40,000 lies to the east. The town can be reached by bus or car by the southern or northern roundabout, or directly on foot or by countryboat (*vallam*). While people travel overwhelmingly on foot and occasionally by bus or car, most goods are transported by *vallam*, particularly the bulky materials produced locally, coconuts, copra and coir. But traffic along the road is also intense, with men and women carrying loads on the head or by bicycle, children walking in small groups to and from schools, travellers on foot going for family visits and to hospitals, only chased from the middle of the road by the horn of an occasional bus, lorry or car.

Travelling along this road and passing the well-kept houses of the wealthier families, one reaches the new mosque of Poomkara, a large

building constructed in the typical architectural style of Kerala Muslims, that forms with the adjoining *madrasa* (Koranic school), the heart of the locality. The building is about a hundred years old and is distinguished from the old mosque only by its striking height in a landscape marked otherwise only by the top of the coconut palms. This mosque is, together with a tiny Hindu temple and the Government Primary School, located along the road, the only building of significance. That these buildings should be so outstandingly connected with the road is not by chance: religion and education are the two foremost channels of social and cultural communication between the locality and the larger society.

Barely 3 square kilometres in surface, Poomkara is the abode of about 4,500 people, most of whom live in huts on small house-sites surrounded by coconut trees. The locality is but an administrative portion of a densely-populated strip of coast. The existing administrative boundaries have been used since at least the beginning of the century for the purpose of assessing land taxes, for local political and religious purposes and for demarcating areas under special government schemes, and have therefore acquired a special meaning. In addition, Poomkara has been identified with a rather closely-knit Muslim community (68 per cent of the population) that, in spite of its coexistence and intensive contacts with Hindus, has a separate cultural identity (Miller 1976: 119). Hindus belong mostly to the Ezhava caste and make up 27 per cent of the local population. Though they in no way feel as outsiders, they have, in contrast with the situation in surrounding localities, a minority position within a minority community. The position of the small community of Thandans (only 2 per cent of the total population), a caste which specializes in climbing coconut trees, is even more inconspicuous.

Near the new mosque one finds a few tea and '*bunk*' stalls, with a few vendors occasionally displaying their goods, mostly fish or cloth and aluminium pots. It is here that devotees gather five times a day for prayer in the mosque. While the number of devotees answering the call of the mosque servant, the *mukri*, is relatively small, virtually all Muslim children come for religious teaching to the *madrasa* once a day. One can hear their voices chanting the verses of the Koran or the canons of Islam when passing along the road. A few hundred metres to the north an electrically-powered grain and coir-fibre mill enables the women to have rice dehusked and milled into flour and coir fibre cleaned without having to do it all at home.

The Muslims are locally known as *molalis* (contraction of *muthalali*, trader) a group distinct from the Muslims of North Kerala, the *Mappilas*. *Molali* is the preferred term of address. One finds in old records also the term *Methan*, but they take offence when outsiders use the word, because of its pejorative connotations. Also Thandans have their respectful form of address: *Moopar* for a man and *Moopatty* for a woman. The Ezhava dislike on the whole any type of caste identification, and may feel particularly

47

discriminated against when called *Chovan* (or *Chovatty*) as they used to be called in the past. They may, however, use the word occasionally themselves. Until the British period the caste names now so abhorred were used to enumerate the local population, and they were evidently borrowed from the discourse of higher castes. Today, generic caste or community names have come into use as, for instance, Muslim and Ezhava. Local caste names have largely lost their meaning, and I have therefore not used them in this book.

In the topography of Poomkara one may distinguish the sea-shore, the narrow strip between the road and the sea, and the interior. Only coconut palms endure the harsh climate of the sea-shore, and their yield remains low. They provide some shadow to the numerous huts of the poor dotting the white sand. That this part of Poomkara should be so densely populated is even more distressing since it is being slowly eroded by the sea. In the past, cyclonic storms have time and again washed away buildings and fields, filling the ponds with sand and silting the cultivated land. And time and again poor people, in a fragile attempt at facing the mighty sea, have erected their tiny huts of plaited palm fronds and planted a few coconuts. The works undertaken to erect a sea-wall have not been very successful and have hardly reduced the vulnerability of the people to the whims of the climate.

The stretch of land on the eastern side of the road is about half to one kilometre wide. Its luxuriant vegetation creates the impression of a scarcely-inhabited wilderness. The opposite is true. Under the cover of the trees every piece of land and every palm is the object of intense competition. Innumerable branches of the river and ditches make the riverside a marshy, inaccessible area. Loads of sand and coconut waste have been patiently brought to these swamps to construct artificial islands on which huts and houses have been erected. A simple stem of a coconut palm laid across a ditch, over which people swiftly move with bundles of coir on their head, children squatting on their hip or lifting loaded bicycles, forms the common type of bridge.

Life in this part of the locality is hardly more comfortable than on the sea-shore. The atmosphere is sultry, reaching an extreme degree of humidity in the hot season. In the rainy season large tracts are flooded leaving only huts and houses with elevated floors dry. An advantage is nevertheless that palms thrive on these swamps and provide their owners with a small, but steady income. Other crops such as plantain, tamarind, papaya and areca-nut grow well too, but the cultivation of food crops (tapioca, elephantfoot (a type of yam), colocasia, yam) is difficult and risky. Except for the paddy fields that, anyhow, are few and far between, the whole coastal strip is densely planted with coconut trees. Though the initial investment of coconut gardens is high when compared to paddy cultivation, tending them demands but little labour, and they yield a steady income that lasts for about twenty years. The necessary tilling and harvesting of the trees is done mostly by

specialized Thandan workers. In between the trees there is enough space for huts and modest gardens, where a few vegetables and flowers are grown.

Dwellings are scattered in the shade of coconut trees at enough distance from each other to allow each household some privacy. Past land usage explains this settlement pattern. In the past landless labourers built their huts dotted here and there at a respectable distance from the house of their master in order to keep an eye on the ripening nuts. Once he had children of his own and wanted to separate from his father's household, a young labourer therefore had no great difficulty in finding a place to set up a small hut. But now, after the land reform of 1969 granted these 'hutment dwellers' (*kudikidappukars*) property deeds over their small house-sites, a landowner is no longer inclined to allow a labourer to set up a hut on his land, afraid as he is that a labourer will claim, in due time, property rights. The present pattern among the poor is therefore increasingly one of clustered tiny settlements of related households, who have shared their original house-sites as new households were formed.

The economic life of the locality centres around the processing of coconut products on the one hand and fishing and fish trade on the other. Agriculture plays only a minor role and few men cultivate their own land or are engaged as full-time agricultural labourers. Roughly half of the families maintain a reasonable standard of living by combining different sources of income such as coconut cultivation, trading in copra, coir or fish, running a grocery shop or as a salaried employee. A number of them, and they are among those who live most comfortably, receive also remittances from Gulf migrants. The rest live in grinding poverty. The men work piecemeal as fishermen and fish vendors, beedi (a small, cheap cigarette) rollers, porters, boatmen and labourers to the local coir and copra traders as occasions offer themselves throughout the year. Wages are mostly calculated on a piece rate or share system, less often on a day's work. Only a few hundred have permanent employers. The women are less mobile and have little other choice than making coir yarn, a cottage industry which they can combine with domestic responsibilities.

Barely two-thirds of Poomkara's territory consists of land. This brings the actual density of population to 2,300/sq.km. Households, numbering six members on average, tend to be large for the tiny huts in which half of the people are housed. The huts measure about 6 metres width and 3 metres deep and have mostly two rooms, a veranda and a small kitchen. The veranda and the side of the house-site it fronts are 'public' spaces and are male domains. It is there that the men squat to have a chat and a smoke after work, receive male visitors, and sleep when it is particularly hot. The two inner rooms are used for sleeping by women and children, and for hanging clothes and keeping boxes containing books, ornaments and other valuable things. Furniture is uncommon except for low stools to squat on or, more rarely, a bench, a table and a cot. There are usually no sheets in the rooms, and most people sleep on screwpine mats and pillows spread out on the floor.

The kitchen is at the rear and has a door that gives access to the private, female part of the house-site. There one finds the grindstone, pots to keep water, a small shed used by women for bath and urination, and sometimes also a cage with chickens and a goatshed. A little apart women may be making coir. Cooking is done on wood from the coconut palm, most of which is collected by the women and girls, on rudimentary ovens often simply made up of a few stones. A tiny oil lamp provides the light for the whole family at night. Water for drinking and cooking is fetched from public standposts and, by those who live in the more inaccessible parts of the village, from open ponds of which there are quite a few scattered here and there on the land of larger proprietors. Washing and bathing is done in the river and ponds of which there are quite a few scattered here and there. Private latrines are rare, particularly among the poor. Children are trained young to use the spots reserved for that purpose among the trees or on the seashore, before dawn, immediately on rising. The wealthier households live in brick houses, with usually three or four rooms. These are also likely to be furnished with a few armchairs and cots and have an electricity connection, but less often piped water.

As in so many other Kerala settlements, the relations between the three communities and the few Vishwa Kharmas (artisanal castes) are cordial, they work side by side, share public amenities and interact at the political and social level. Although Hindus tend to live along the riverside and around their temple, there is no segregation in terms of neighbourhoods. This is not to say that the communities do not maintain different cultural traditions. They pertain to such widely-different domains as religious belief and practice, marriage customs, childrearing, kinship organization, culinary tradition, house architecture, care of the body and language. These traditions make for distinct tastes and styles that render anyone's caste or community background identifiable, although not for an untrained eye. One should also not mistake the display of cordiality and tolerance for an adherence to liberal ideals. Murmured prejudice and hidden discrimination are just as common in Poomkara as they are probably in any village or neighbourhood of the world. But ventilating such feelings openly is considered an indisputable sign of bad taste or, worse, of lack of culture.

Poomkara may best be viewed as a relatively peripheral and somewhat isolated locality, in a region involved in intense social, economic and political change. The locality is not a 'representative' case for studying children's work in Kerala for the simple reason that such a case may well be impossible to find. Poomkara has an exceptionally high concentration of Muslims (about 20 per cent of the total population of Kerala), a situation only matched by some areas of the southern part of former Malabar (Nossiter 1982: 23). As I will discuss later on, this has a negative impact on the participation of girls in schools. In view of the dearth of data on Kerala's Muslims (the study by Miller is to date the only one available to the larger

public) the choice of this locality has in itself an intrinsic value. However, to make it more interesting, Poomkara has also a sizeable group of Ezhavas. Ezhava children (about 22 per cent of the population), are known for their very high achievements in education. In view of the numerical importance of Ezhavas among Kerala's poor, I have given in this book much emphasis to the position of these children. The combination of Muslims and Ezhavas provides a fair coverage of the 'backward castes and communities', that form, together with the Latin Catholics (3.6 per cent) and the Scheduled Castes and Tribes (9.2 per cent), the mass of the poor. As I shall argue in the next paragraph, it also has the advantage of allowing me to contrast the two orientations that I have typified as 'orthodox' and 'modernist', that are both influential in shaping children's lives. In many other respects Poomkara has nothing exceptional. The combination of fishing and coir is a common feature of life along the coast. The position taken by children therein follows a pattern found all over the state, as I will discuss at length in Chapters 4 and 6. Its position, close to such historical places as Purakkad, Haripad and Kayankulam, has exposed the locality to intensive external contacts for centuries and made it just as much a cultural melting pot as any other locality on the coast. Children's daily routine, to which I turn below, of combining schooling with domestic and productive work, closely resembles what children do in most other parts of the state.

CHILDREN'S FRONTIER

The first impression a traveller would get of Poomkara children is that they are, just as other Kerala children, first and foremost learners. Be it carried on at its lowest level of mastering the Malayalam alphabet by writing letters in the sand and rote learning of the Koran, or at the higher ones of studying in distant high schools and colleges, learning is in Poomkara, as everywhere in Kerala, a highly-valued and respected activity. As soon as a child can talk, by the age of 3, parents start considering the possibility of sending it to the *asan* (teacher), to start learning the letters of the Malayalam alphabet. By the age of 4, if it is Muslim, it has to be sent anyhow to the Koranic school, where the *musaliar* (priest) will initiate it to the Arabic alphabet. By 5 or 6 it will be going to the lower primary and later the upper primary, to remain there, ideally, until the age of 12 or 14 and learn the English and, if Hindu, the Hindi alphabet as well. The possibility that an adolescent completes high school and gains a college degree is rarely ruled out, even by the most inconspicuous of families. Examples of youngsters of very humble origins who passed national examinations first rank are mentioned time and again to demonstrate that a child endowed with exceptional intelligence and will can achieve the highest positions in government service. Many people believe that one simply cannot tell in advance if a child has this potential or not. It is common knowledge that the number of children who reach the

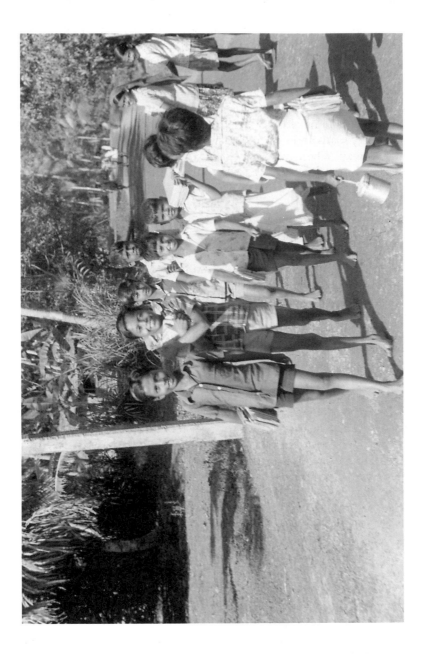

5 Poomkara children on their way to school: a significant step towards working children's emancipation

higher levels of the educational ladder is bound to be quite small. But even then, so strong are the feelings about the virtues of learning, that those who do not achieve diplomas are labelled 'stupid', 'lazy' or worse, 'failures'.

Learning brings swarms of children, both boys and girls of about the same age, together at regular intervals: in the early morning by 6 a.m. in the *madrasa*, between 9 a.m.and 3 p.m. in the government schools and colleges, and some even at night in the 'adult' literacy classes run by volunteers. Their clean shirts, richly anointed hair and a small pile of notebooks, all contribute to contrast their status of learners from that of workers. One may encounter working children half naked, sweating and covered with dust, walking briskly with heavy loads and exchanging but a few furtive glances with those who cross their way. When going to school by contrast, the children display the detached attitude of the scholar and walk with dignity in small groups, conversing gaily in low voices.

The learner's role is, however, but a temporary one, and as soon as the school ritual is over and the children are back home they change into their working clothes and become the natural companions of working adults. There are hosts of tasks to be done before and after school: washing and feeding the small ones, fetching water, sweeping the courtyard, scrubbing pots and pans, cleaning fish, gathering fuelwood, collecting grass for the goat, plucking fruits and vegetables, catching fish, etc. and no child, whatever its social background or gender is excused from performing at least some of them. In addition, there is the work outside the home, coir processing, fishing, making copra, tilling the land, all jobs for which adults not only enjoy, but also require the companionship and the assistance of children. A child 'idling his time away' is by and large conceived of as a good for nothing, and therefore up to mischief. It is upon parents, so is the general feeling, not to spare the rod in order to bring him up the right way. If parents fail herein, neighbours or relatives feel compelled to publicly show their disapproval, not refraining from picking up a stick to castigate a child that does not stand at his elders' beck and call. Childhood in Poomkara has therefore two faces: one is the time spent with peers in the classroom, the other is the time spent working with elders at home and in the neighbourhood.

Of course there is also time for play. During intervals at school and holidays the children play, like all children in the world, at tag (*kavadi*), hopscotch (*gnondu kali*), marbles (*vattu kali*) and fivestone (*kallu kali*). Boys make planes and balls with coconut leaves or pretend driving a bus or running a small shop. Girls make kitchens in which they cook stones and sand in pans made of leaves. Of the existence of dolls they have but a faint notion, having instead ample opportunity to fondle living babies. But all this is just to relax after work, when men gather, before sunset, to converse at the junctions, and women pause after cooking by the kitchen door. For, between the demands of the schoolteachers and those of the elders at home, the room for play is but small.

Religious education is a prerequisite for all Muslim children. It is imparted

53

by a modern type of koranic school, the *madrasa*, although some parents still prefer the old type, and send their children to an elderly woman for that purpose. The *madrasa* is organized like a modern school, with a curriculum, standards, textbooks and examinations. It imparts in the two lowest standards knowledge of the Arabic alphabet, rules of behaviour and knowledge of the life of the Prophet. Textbooks provide in addition a few notions of modern Arabic. In the two higher standards the children have to memorize parts of the Koran. The school opens at 6 a.m. and closes at 4 p.m., and teaches children in batches that last for two hours. There is only one teacher for about 60 children at a time. Children are required to read in unison time and again texts written on the blackboard, the teacher walking up and down with a small rod with which he eventually flogs the naked thigh of a hesitating child. The result is a deafening noise that can be heard from far away. Parents do not object to corporal punishments which they feel is an essential aspect of teaching. Says 8-year-old Sukhail:

Sukhail: My father thinks that caning is the best way to have children obey.
Question: But you, do you agree that teachers need to use the cane?
Sukhail: If a child makes mistakes it has to be beaten. Remembering the pain, it will never repeat the same mistake again.
Question: Don't you feel angry when your parents and teachers beat you?
Sukhail: I do, but not for long. I know that it is for my good.

Teaching in the *madrasa* is organized in accordance to the time schedule of the lower primary school, so that children can attend both. Children start their religious education when they are 4 or 5 and drop it by the time they are 8, as it then becomes too demanding to combine full-time school with religious education. Hindu children start, earlier than their Muslim peers, to learn the Malayalam alphabet. There are quite a few private teachers (*asan*), mostly elderly men, who gather a few children aged between 3 and 5 in their homes for the purpose. They receive small gifts and occasionally also meals in reward, but rarely a fee. The local branch of the SNDP runs a more formal type of nursery school, the *kalari*. The method used to teach the Malayalam alphabet is very similar to the one used in the *madrasa*, though there are no clear curriculum and standards. The only textbook is made, as in the old days, out of a bundle of dried palmyra leaves on which the *asan* engraves the alphabet. The course takes the whole day, from 9 a.m. to 4 p.m. with a pause of one and a half hours at noon. The children sit on the floor and draw the letters with their finger in the sand. The teacher will call them by turns to show him their progress. A mistake or even hesitation to produce the required letter results in the teacher's birch landing inexorably on the child's left thigh. Though allowed to rub the painful spot, a child is required to continue writing without producing a single tear, cry or even sigh. The slightest sign of

54

weakness would only provoke more strokes. The teacher shares the common opinion that, unless corrected, it is in a child's nature to shun all effort:

> On the ninth of October I start my course. The children bring me rice, tobacco and some money. I light a lamp to goddess Saraswati. I take the children by turn on my lap, and help them writing in a dish full of rice and flowers the first letters of a prayer to the goddess. Then we start the lessons. The first months I keep quiet, the children have to get to know me. When they trust me, I can start using the birch. Never before, they wouldn't come back if I started too early. Striking is essential to have them sit quietly. If I wouldn't be strict, they wouldn't learn a thing and they wouldn't obey me. They only work under the threat of punishment.

The situation in the lower primary school is very similar. The school has about 450 pupils crammed in two large halls and divided over four standards. Each hall contains three classes, each with its own teacher. The children sit on long benches and drop on the floor to write. Girls and boys sit separately, the girls on one side, the boys on the other. In addition, the brightest children sit in the front, while those who have bad marks are in the rear. Children of the first two standards have classes for only half a day, for there is not enough room, nor are there enough teachers to give them full-time teaching. They are taught the alphabet, reading and writing and simple arithmetic. There are also classes for modern Arabic. In the third and fourth class they will also be taught general science and social sciences (including geography and history). English is taught in the fourth class. Teaching is very much in the same style as in the *madrasa*, with children repeating in unison lessons written on the black-board and teachers not sparing the birch to incite them to try their best.

The pupils are in theory promoted on the basis of attendance and of marks secured during examinations, but there is a government rule that 100 per cent of the pupils should be promoted in the first standard and 85 per cent in the second and up. Even children with a very irregular attendance can therefore complete, if they want, the course of the lower primary. Teachers are bound to follow a curriculum and textbooks common to all schools in the state, irrespective of the level attained by their pupils and attendance. But few children are able to attend regularly. Some may just be sick too often. Others may have at times pressing demands of work at home or feel irresistibly attracted by occasions of earning a little cash. At the height of the fishing season, on hearing the call of the fishermen returning with a good catch, the children may even leave the classroom *en masse*, a common problem of fishing villages. To ensure a steady attendance the government has provided schoolchildren with free lunches of fried semolina. But few children, as most Keralites have a definite distaste for wheat, would go to school just for this lunch.

The curriculum of the upper primary is a continuation of the lower primary, with Hindi for those children who do not follow Arabic. The course lasts for three years. Here also 85 per cent of pupils have to be promoted, so broadly, it is enough to attend more or less regularly to complete the course. The school is located in a neighbouring locality, about four kilometres to the north, and some girls, particularly if Muslim, may not be permitted to go that far. Other children drop out because they do not have the proper set of clothes, as boys will need a neat shirt and girls a long skirt, or because they lack money to buy the required notebooks. Most poor children in the upper primary seek to earn some money, especially to buy snacks during the lunch break or writing material. By that time most of them lag, for a variety of reasons, behind in their school careers (Tables 2.1 and 2.2). This is an important reason for doubting whether to continue and finish the upper primary. Only 340 out of 478 children in the age group 10 to 14 are still in school, the others preferring to help earn some money for the family rather than continuing to walk with an empty stomach and bare feet to school. Though there are 105 children in the same age group who still struggle through the lower primary, they have no serious chances of ever attaining the secondary level (see Table 2.1). This is also borne out by the high percentage of over-aged children in the first standard (standard five) of the upper primary (see Table 2.2).

Indigence becomes the more poignant in high school, where the tension between work and school is at its height. The adolescents who are by then still in school have now all reached the age at which they are by and large viewed as potential earners. One reason is that the cost of schooling increases, some children needing private tuition to improve their chances of passing the final examination (SSLC). Though teachers discourage children who cannot attend regularly, or have otherwise little chance of succeeding, from appearing, the percentage passing is usually only 10 to 30 per cent.

All along the insecure road towards the attainment of the final certificate, children have to respond to the demands and needs of adults, who are not yet fully convinced that children's primary duty would be anything else than helping and assisting them in and around the house. Many feel that schools do not teach much that is of direct use in daily life, so that it is still upon parents to train their children in the jobs that are anyway essential for their future livelihood. If a child does very well in school, however, few parents would indeed deny it outright the chance offered by protracted education, although it would be easier for a boy, as I discuss more at length in Chapter 5, and much more difficult for a girl to carry on studies in high school and beyond. On the other hand, if a child is perceived as being unlucky, lazy, sickly or stupid, even well-to-do parents prefer to have the child trained as soon as feasible in some kind of trade. The reason for the flexible attitude of parents in respect of

Table 2.1 School attendance by age group

Age group	Type of school			Subtotal	Drop-out	Illiterate	Total
	LPS	UPS	HS				
5–9	330	11		341	12	153	506
10–14	105	172	63	340	92	46	478
15–19		6	85	91	266	69	426
Total	435	189	148	772	370	268	1410

Source: Field census, 1978.
Note: LPS = Lower primary school, UPS = Upper primary school, HS = High school

Table 2.2 Mean age, range and rate of over-aged children in schools

	Class									
	1	2	3	4	5	6	7	8	9	10
Mean age	6.5	7.5	8.9	9.5	11	12	13	11	15.6	17
Range*	7.0	8.0	8.0	7.0	6	7	6	5	4.0	3
Over-aged**	37.0	40.0	49.0	43.0	68	59	53	59	80.0	83

* Difference in years between youngest and oldest child in the class.
** Percentage of children above the age at which a child is normally expected to be in the class.
Source: Field census, 1978.

schooling is that schools beyond the lower primary level have become accessible only after the 1950s. With them a whole new and unfamiliar concept of childhood has been introduced and this has made many parents doubt whether the 'traditional' ways still correspond to the needs of the time. But the acceptance of schools as a helpful tool in educating children stops there.

3

GROWING UP IN POOMKARA

Though parents increasingly recognize that even for the poorest some kind of schooling has become necessary, most do not feel that working interferes with children's ability to perform well. School and work are indeed not perceived as being incompatible, though schools do give rise to competing attitudes towards the behaviour expected from children. While schools have increasingly opened up to children avenues to advance themselves, local society still views them as a source of free labour and security and as instruments of family aggrandizement. Local society itself is, however, composed of heterogeneous social reference groups, ranging from the household, which is the immediate society in which children grow up, the family circle, which links the joint interests of related households, up to complex structures that articulate communities, castes and classes. It is in the ever-changing field of interaction between these reference groups, as the recent history of Poomkara shows, that children are gradually finding a space to assert their individual needs. I begin by mapping the relatively abstract field of class relations, which in the rural society of Poomkara is reflected in land relations.

CLASS AND KINSHIP

As already stated, agriculture is of but marginal importance in Poomkara's economy. Coconut palms, however, represent the only steady source of cash, yielding as they do a more-or-less fixed number of nuts every two months. The land on which these palms grow being the main source of security, prestige and power, access to land provides a fair picture of economic stratification. Classifying people according to land is beset with problems: taking the family group, rather than the household[1] or the individual as the unit for classification, runs the danger of implying a unity of interest and purpose which would be inappropriate for groups as internally divided as in Poomkara. Were I in turn to focus on households or individuals,

too many would be reduced to the ranks of those virtually without access to land, which they in practice are not, as many appear to enjoy the usufruct of family land over which they have no formal ownership rights.

The picture obtained through the census, in which we asked heads of households how much land they owned, showed indeed a very skewed picture of landownership, with as many as 79 per cent of households having holdings below a quarter of an acre (see Table 3.1). This is just large enough for a more-or-less spacious compound around a dwelling, but of little value for cultivation. The picture does not distinguish between those households which enjoy the usufruct or have claims to land, and those which have none and are therefore virtually landless and are likely to remain so in future. In addition, answers to questions about property and income are well known to be unreliable. Not only do persons of means dislike revealing the real extent of their wealth to strangers, also poor respondents tend to underreport the real extent of their holdings. They may, for instance, hope that the research will engender welfare or relief programmes from which they may benefit. The respondents to the field census taken together reported in total only 256.66 acres, while according to the village records, which seems in this respect more reliable, the total acreage of land held by Poomkara households in the locality was 344.06.

A household tends to be always a somewhat ephemeral social institution, subject not only to the cyclical succession of generations upon each other, but also to falling apart in the event of death, abandonment, divorce, remarriage or infertility of one of its founders (see also Kemp 1987: 13). While the fate of households is full of uncertainties, clusterings based on kinship may be less vulnerable to fluctuations, and may succeed in maintaining their privileges across generations. Alliances of wealthy, related households, with a stake in a piece of undivided property, are indeed a common strategy to share risks, face life crises and achieve power. Landownership must therefore also be looked upon from the perspective of kinship clusterings. To this end I have recomposed the picture of land relations by taking individual ownership, as recorded at the village office, as my starting point, and clubbing together the shares of those families that

Table 3.1 Distribution of land between households (1978) (acres)

Size of holding	Number of households	%
0	39	6.2
0.01 – 0.25	470	72.9
0.26 – 1.00	115	17.8
1.01 +	30	4.6

Source: Field census, 1978.

managed their land jointly.[2] The families were identified by a local informant. These families corresponded often with the households identified in the census, and this was particularly true if they were poor. Wealthy households, however, often appeared to have clustered on the basis of kinship around a piece of undivided property. The highly parcellized nature of land-ownership, and the fact that all households do own at least some land, take on a different meaning as soon as the plots and their owners are restructured along existing clusterings of kin. Distribution of land is from this perspective still skewed, but the number of families virtually landless (those with less than 0.26 acres) is nearly half as large, that is, 42 per cent of the families in 1978 (see Table 3.2). These own together no more than 5.8 per cent of the total acreage of the locality, and belong, as they have no claims to land, to the bottom of rural society. A second group, 35 per cent of the families, has enough land for drawing an income from coconut cultivation, however modest that may be. This group owns about 19.4 per cent of the total acreage. The last two groups are formed by the important families, of which 7 per cent (twenty in number) own as much as 43.6 per cent of the total acreage.

The data in Table 3.2 pertain only to the property located in Poomkara. An investigation in offices of neighbouring villages revealed that there existed a narrow correlation between the acreage of coconut land held in Poomkara and that of paddy fields, which were mostly located at the interior. The twenty prominent families, for instance, owned together an additional 62 acres of paddy fields in neighbouring localities, while the property of the 121 poorest, increased by a mere 10 acres when taking land located outside Poomkara into account (see Table 3.3). Paddy fields are held only by rich peasants because the growing costs of paddy cultivation have led small-holders to dispose of their fields. Large owners are better equipped to let their fields lay fallow awaiting higher prices for paddy or limiting their cultivation to domestic needs.

Table 3.2 Land held by families in 1960 and 1978

	1960				1978			
Size	Families (no.)	%	Acreage (acres)	%	Families (no.)	%	Acreage (acres)	%
0.01 – 0.25	29	22	4.10	1.8	121	42	14.18	5.8
0.26 – 1.00	46	35	22.67	9.9	101	35	47.18	19.4
1.01 – 3.00	35	26	66.39	28.9	44	15	76.09	31.2
3.01+	23	17	136.10	59.4	20	7	106.08	43.6

Source: Basic Register (1960) and Register of Assessment of Taxes (1978).

Table 3.3 Paddy fields located outside the locality by size of property in Poomkara
(acres)

Size of holding	1960		1978	
	Poomkara	Elsewhere	Poomkara	Elsewhere
0.00 – 0.25	4.10	2.97	14.18	10.65
0.26 – 1.00	22.67	13.79	47.18	20.36
1.01 – 3.00	66.39	32.62	76.09	22.04
3.01+	136.10	59.83	106.08	40.28

Source: Basic Register (1960) and Register of Assessment of Taxes (1978).

Access to land tallies with the pattern of social stratification. At the top one finds the twenty affluent families which own 43.6 per cent of the total acreage. Their landed interests provide them the financial security to play a leading role in the local trade of raw materials and manufactured goods. At the bottom there are the 42 per cent of families without either property of significance or prestigious kinship ties, who live entirely on the work of their members. For work, the sale of their products, credit, help and support, they depend to a large extent upon the goodwill of the wealthy families. In between there is a differentiated class of small owners, with properties between 0.25 and 1 acre. The poorer section of this class is mostly engaged in coir business, and they are likely to own their tools and some raw material. Although they often do succeed in eking out a modest livelihood, they often lack the strategic combination of land and the support of an influential clustering of kin.

Social stratification is by no means static and, in the long run, even families of substance may find it difficult to retain their class position. A comparison of the 1960 and 1978 data, shows that the number of families possessing more than 3 acres has decreased from twenty-three to twenty, while the total acreage of their possessions fell from 195.93 to 146.36. During the same period, the number of families possessing marginal holdings (below 0.25 acres) showed a phenomenal growth, from 29 to 121, a growth that also encompassed, but to a lesser extent, small (between 0.26 and 1 acre) and middle-sized holdings (between 1 and 3 acres) (see Table 3.2). Though one may be inclined to think that this change is on account of the redistributive effect of the legislation passed in 1969 in favour of the landless, this is probably not really the case. The effect of the legislation in terms of redistribution of land was minimal, and middle and large owners taken together, continued thereafter to hold as much as 94 per cent of the total acreage. It is more likely, as informants in Poomkara recurrently mentioned, that the changes are on account of the partition of properties previously jointly managed, in other words, of the decreasing importance of the

corporate group in the management of landed property.[3] Property had changed hands often, as many as six out of the twenty rich families in 1978 having been families that owned less than 1 acre in 1960. One such family had even been landless and had built their property by dealing in copra. The reverse had also taken place, as in the case of a prominent Muslim tenant who in 1960 owned 11 acres in the locality, in addition to an unidentified number of paddy fields elsewhere. This property had to be shared among ten brothers. Being the eldest, he stayed in the family house, marrying, as his status demanded, thrice. He had to give most of his land as dowry to his daughters in order to have them properly settled. In 1978 he had a mere 0.78 acres, which was his youngest wife's dowry. Partition was often said to be nothing but the symptor of impoverishment, the cluster of kin falling apart because individual members were no longer able, or willing, to share in the repercussions of a succession of calamities.

Population growth was widely believed to have been the prime mover behind partitions, and to have led to an extreme fragmentation of land-holdings. The effects had been dramatic, particularly on those who used to live entirely from the income of their land. Smaller owners had long been engaged in other activities than agriculture, mainly coir-spinning, money-lending and small trade. Many of them had also started investing in education and could rely on additional income from white-collar jobs. Being the entrepreneurs of the locality, they had therefore better opportunities than the landed families to achieve new positions of command. Members of the landed families, by contrast, had seen their income from agriculture over the years decline and had often been reduced, unless they successfully engaged in new avenues of social mobility and invested in the education of their children, to a state of utter poverty.

Political factionalism, feelings of religious and caste identity and the rallying of the poor around powerful patrons, create vertical ties that may add substantially to the power of some families. Clusterings of kin, as reflected in their residential pattern, underlie the dominance of the Muslim community in the locality, and make for networks of related individuals active in a variety of fields, such as local politics, business, agriculture, public facilities and religious matters. As an example I have traced the most out-standing kinship relations of the largest farmer of Poomkara, a Muslim family that held about 35 acres (Figure 3.1). It is therefore among the landholding Muslims that the extended household is the most popular (see Table 3.4).

By contrast, wealthier Ezhavas are less inclined to kin clustering. Residentially, they are even more likely than their poorer caste fellows to opt for the nuclear household (see Table 3.4). The most obvious reasons are their humble social origins and the small number of wealthy individuals nearby with which this type of clustering may be contemplated. Prominent Ezhava families have built their wealth only recently and have as yet been unable to develop into an established elite group with influence in the local and

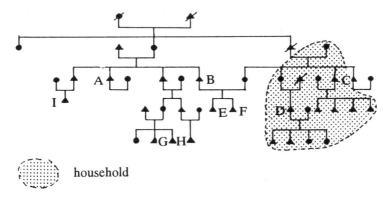

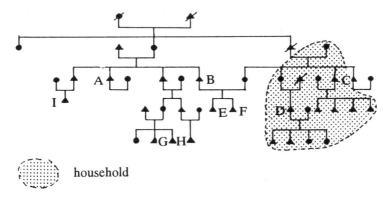

:::::::: household

Figure 3.1 Circle of kin of a well-to-do farmer
A: Well-to-do farmer; owns 9 acres and several shops on the junction
B: A's brother; owns 5 acres
C: B's brother-in-law; owns 35 acres
D: C's sister's son; manages C's property
E: A's brother's son; runs C's ration shop and is the local leader of the Janata party
F: A's brother's son; one of the two main coir merchants
G: A's brother's grandson; local leader of the Congress party
H: A's brother's grandson; son-in-law of the owner of a motorized fishing boat
I: A's brother's son; priest in the mosque.

Source: Field census and informants (1978–80).

regional power structure, as the Muslim elite. Their isolated position makes their acting as a patron for less fortunate family members and caste-fellows rather risky even today.

Another reason is the gender aspect of their inheritance system as Ezhava women can normally often claim a greater share of the property of their parents than Muslim women and are entitled, in addition to a dowry, to a share in the inheritance equal to that of their brothers. Granddaughters may also claim a share of their grandparents' property, while grandsons cannot.

Table 3.4 Type of residence by community and size of landholding (acres)
(percentages)

Type of residence	Muslims		Ezhavas		Total	
	0.00–0.25	0.25+	0.00–0.25	0.25+	0.00–0.25	0.25+
Nuclear	65.4	55.2	58.5	68.6	63.3	58.3
Extended	33.9	44.0	36.1	31.4	34.6	41.0
Single	0.7	0.8	5.4	0.0	2.1	0.7

Source: Field census, 1978.

63

By contrast, Muslim women can claim only half of the share of their brothers. Even among the wealthy, the scope for asserting oneself in the matter of family land policies is on the whole greater for individual Ezhava women than for Muslim women. This gender dimension of access to land has an impact on the vision underlying the roles of children, and in particular girls, and wealthy Ezhavas are therefore more likely to turn to individual strategies than to group-oriented ones. As I shall expand in the next chapter, as soon as educational facilities came within their reach, wealthy Ezhavas opted to have their children try their fortune in schools, rather than seeking to strengthen bonds of kinship.

Sheer numbers are of strategic importance in tilting the balance of power in the cluster of kin towards some households rather than others, and this is reflected in the dramatic increase of Poomkara's Muslim population. It is difficult to trace with accuracy how fast population has increased, but for the period 1971–7 I have estimated its yearly rate of growth at somewhere between 3 and 3.3 per cent.[4] This rate is overwhelmingly the outcome of high natality. The birth-rates of a sample studied under the Sample Registration System fluctuate around the 50 per thousand, against a death-rate of 14 per thousand. The data suggest that the rate of growth of Muslims is significantly higher than that of Ezhavas, and this is reflected in the age structure of the population.[5] The base of the age pyramid of the Muslim population is very broad, with 43.7 per cent of the population younger than 15. For the Ezhava the percentage under 15 is only 32.7 per cent. The pyramid suggests that the Muslim population in the past 25 years or so increased significantly, while during the same period the Ezhava population remained more or less stable (see Figure 3.2). One may safely rule out that the smaller base of the age pyramid of Ezhavas would be on the account of higher mortality. Although I do not have solid quantitative data on mortality on which to base this statement, mortality, and in particular child mortality, is in all probability lower among Ezhavas than among Muslims. I found an indication to this effect in the fact that the 438 Muslim households visited during the field census reported 737 infant and child deaths (1.7 on average) against only 95 (an average of 0.5) reported by the 183 Ezhava households. Other indicators support the differential fertility hypothesis. The average age at marriage is significantly lower for Muslim girls than for Ezhava girls. As many as 57 per cent of Ezhava girls aged 20 and over are still unmarried against only 11 per cent of Muslim girls of the same age. The percentages for women aged 25 and over, are respectively 25 per cent and 3 per cent. There is also a difference in the adoption of contraceptive methods, although their use is not very widespread. As little as 5 per cent of the Muslim women aged 20 to 45 limited births with methods other than abstention and protracted lactation, while this percentage was 19 per cent for the same group of Ezhava women. Finally, there is the impact of marriage customs. By and large, divorced or widowed Ezhava women do not remarry if they have children, a common practice among Muslim women.

64

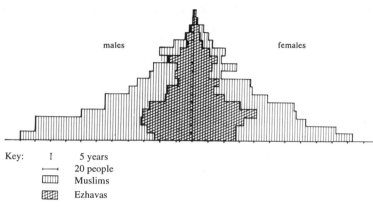

Key:　　I　　　5 years
　　　　　⊢—⊣　　20 people
　　　　　▥▥▥　Muslims
　　　　　▨▨▨　Ezhavas

Figure 3.2 Age pyramid, 1978 (0–85 years)
Source: Field census (1978).

Numbers are just as significant for Muslim families of very modest means as for the wealthier ones, be it for somewhat divergent reasons. At the surface there is the religious motive, vigorously propagated by the spokesmen of orthodoxy, that every child that is born is a gift of God. Cultural heritage, the result of centuries of Muslim resistance to Portuguese, and later Dutch and British, conquest and persecution, reinforces the minority feeling and enhances the importance of numbers. Underneath the religious and cultural justification for high natality, and fuelled by resurging periods of communal violence, there is today's importance of poor Muslims as a vote-bank for the leaders of communal parties. These leaders are wealthy members of prominent families who offer to their followers much more than sheer political brokerage. They are patrons to whom a poor Muslim turns in times of need, from whom he expects preferential treatment in obtaining work or strategic goods and services, and for whom he feels the affection and loyalty that is borne out of a lifelong face-to-face intercourse.

Loyalty between a patron and his clients is strongly related to conceptions of honour to which clients are very particular to conform, as dishonour would put the goodwill of the patron at stake (Eisenstadt and Romiger 1984: 48ff). Defiance comes not only from the behaviour of the male head of a household but just as well from that of women and children. A good client therefore is someone who keeps his children under control, guards their moral standards against influences that disrupt authority and established customs, and has them attend assiduously the religious teaching organised by the mosque congregation. In order not to have the rapport with the patron strained, family heads require from children an attitude of self-denial, obedience and respect for elders and superiors. Children are taught that work is part of their normal, daily routine, and should not be seen as an economic activity to be rewarded according to rational calculations. A child

claiming openly that he or she is 'working', is laughed at, in order to make the child feel ashamed for having stressed the importance of its deeds. This happens also for the simple reason that a client needs his children's co-operation to fulfil the menial tasks more or less tacitly solicited by his patron as a sign of gratitude. These tasks may range from cutting grass for his milch cattle and collecting wood, running errands, cleaning fish, and watching the coconut harvest, to lending support in political marches and community gatherings. For instance, when the Congress candidate of Poomkara, who was backed by one of the Muslim political factions, won a seat in the panchayat elections of 1980, the leaders of the mosque organized that very same night a victory march in which about hundred Muslim boys, all *madrasa* pupils, participated.

Girls, particularly, are imbued with ideas of honour, and are made to internalize how they should safeguard them, by cultivating a spirit of self- denial and performing their domestic duties without muttering. To realize the socialization of girls in this spirit, parents feel that they should not allow them, by the time they become marriageable, to work outside the domestic arena. An obvious reason is that the honour of a maturing girl may be at stake, as working away from home often entails dealing with men without the chaperonage of an older woman. In the case of a younger girl reservations may be less, but even then there is the fear that she may develop a taste for independence while working side by side with a group of peers, and may be encouraged to question the submissive role she has been allotted at home.

As said, patronage turns out to be less pronounced among Ezhavas, the reason being that the better-off Ezhavas have only recently become rich, and that they attach, because of their inheritance system, less importance to clustering based on kinship. For the poor there is, however, the additional reason that Ezhavas have had a long tradition of struggles and massive support for left parties. This tradition has contributed to a mental make-up very much antithetical to acquiescence in the role of a client in a long-standing and diffuse relationship of patronage. This is not to deny the existence of political clientelism, which I would define as a single-stranded and temporary relationship of dependence. What is crucial in clientelism, however, is the exchange of well-defined favours, mostly recommendations or brokerage in getting access to public provisions, against votes and political support. But other connotations of dependency are absent, so that loyalty and allegiance tend to remain limited in scope and in time. The relation therefore has, when compared to patronage, a much milder impact on the socialization of children and in particular the expected demeanour of girls.[6] The peculiar combination of patronage, kinship and class results in the village factions being roughly divided into two camps: the orthodox and the modernists. The two camps roughly correspond to the communal divide, with Ezhavas overwhelmingly modernists, and the Muslims, in the majority, orthodox. There is, however, a significant minority of Muslims that do not

adhere to the norms of orthodoxy and typically express their sympathy for modern values by allowing their daughters to go to school even after menarche. The strength of this group may be gauged from the relatively high percentage of adolescent Muslim girls in high school (see Table 5.6 in Chapter 5).

It goes without saying that economic interests have their role to play in shaping the orientation of Poomkara people. Those who have experienced success in trade and business, feel naturally optimistic about the possibilities offered by the world beyond the locality. Their views are shared by families of repute that have seen their property fritter away as long as they have scorned availing themselves of the skills learnt in schools. But not all members of the elite are convinced that schooling suits their interests, and among them are the largest Muslim landowners in the place. They impute to education what they visualize as the growing impudence of young labourers and their strident political vocality (see also Varghese 1982). The labouring families are equally divided: while some attribute much of their misery to their lack of culture, others see in schooling a threat to the well-tested life-styles developed across generations. Patterns of work are important here. Those who depend mainly on the making and trading of coir for their livelihood, an activity that enables a domestic unit to draw a more-or-less steady, though often extremely modest, income throughout the year, may feel confident that they can operate relatively independently from local supportive networks. As soon as educational facilities came within their reach, these families opted to have their children seek upward mobility in schools. Those who, by contrast, depend for their livelihood on fishing, trade and agriculture, activities that may be subject to rather unpredictable seasonal imbalances, having to rely more on local supportive networks, look at education with apprehension.

THE HOUSEHOLD DOMAIN

The locus where the forces that act upon children come together is the domestic group. In spite of the heterogeneity of family, community and class interests, within the household, the basic belief in the inequality of age and gender reigns unchallenged among all classes and communities. Inequality is manifest in children's appearance. They are dressed even more scantily than adults, wearing merely trousers or a skirt when not in school. Small children are most often simply naked but for a black string, or in the case of the richer ones, for a silver or golden chain tied around their waist. Whereas men wear rubber slippers, an important protection against infection with hook-worms, children normally have none. Adults rarely look as unkempt and disordered as children often do outside school hours. There are quite a few unpleasant diseases common among children such as scabies, lice, eye and roundworm infections, that make them look unattractive. Medical

Table 3.5 Distribution of yearly expenditure of poor households (rupees)

Item	Average	Percentage
Food	2484	40
Clothing	248	4
Medical care	32	1
Hygiene	331	5
Housing	71	1
Transport	130	2
Schooling	67	1
Taxes, bribes, contributions	96	2
Ceremonies (marriage and circumcision)	1571	25
Repayment of debts	135	3
Purchase of land	567	9
Cattle/poultry feed	37	1
Wages	398	6
Total	6167	100

Source: Budget-study of 12 poor households (1978–9).

treatment is freely available at the Primary Health Centre, but for long periods there are no medicines available, especially against these common ailments. The poor hardly spend additional money on medicines and medical treatment (see Table 3.5). The death of a child is still so common that it is largely accepted as one of the inevitable griefs of motherhood. Typically, small children are considered more as 'little angels' who are nearer to heaven than earth. They are given the name they will use in adulthood mostly only after the age of 5 or 6.

Children's diet, too, is far from satisfactory, and there is some indication that they suffer from malnutrition and related diseases, such as tuberculosis (TB) and dysentery, more often than adults. This is important, 40 per cent of the expenditure of a poor household being on food (see Table 3.5). Though smaller children seem to be better off, uneven distribution of food within the home harms, in particular, children in the age group 6 to 18, a phenomenon, as observed in other parts of India, that is not only on account of poverty, but of their inferior status as well (Gopalan 1983: 592; Sen and Sengupta 1985). Children up to adolescence are underweight even when compared to the all-India average (Figure 3.3). The figure also suggests that whereas boys, on becoming adults, catch up with the Indian average, girls continue to suffer from food discrimination.

68

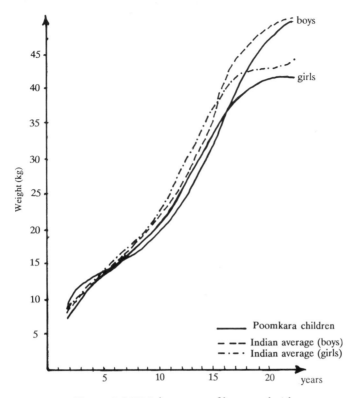

Figure 3.3 Weight curves of boys and girls
Source: Local dispensary, Poomkara (1980) and Indian Council for Medical Research (1972: 18–20).

Age and gender inequality are particularly important for the allotment of intra-household tasks, particularly at the normative level. Female tasks such as cooking and washing children's clothes cannot be performed by a male without incurring the risk of ridicule or, in the case of a man living alone, soliciting pity. Male tasks such as receiving guests and visitors, asking for loans and searching for wage work outside the immediate vicinity of the home, conversely, cannot be performed by females without the entire family losing face. Fetching water, gathering firewood, sweeping, scrubbing pots and cleaning fish are tasks to be done by girls, and a woman would not perform them unless she had no daughter at home to help, and was herself the junior. Nor would a man do errands, collect grass and leaves for a goat or cow, fish in the backwaters and carry loads if he had a son who could do it for him. That it does not always work out the ideal way became clear in a survey I undertook near the ponds. Of all those who fetched water throughout the day, only 60 per cent were children below 15, and among

Table 3.6 Allocation of working time by gender and seniority (hours/day)

Type of work	Men	Women	Boys (5–15)	Girls (5–15)
Domestic*	4	8	4	6
Non-waged**	1.5	1	1	0.5
Waged	5	2	2	1
Total	10.5	11	7	7.5

* Includes, besides housekeeping, also care of human beings, including one's own body.
** Subsistence activities and production for the market such as coir-spinning
Source: Budget-study of 12 poor households (1978–9).

them many were boys. The ideal, nevertheless, makes for both men and women to feel that they need the help of children in their normal daily routine, particularly for the more tedious and time-consuming tasks.

There is no great difference in the total amount of time poor girls and boys actively engage in work (see Table 3.6). Both spend approximately six to seven hours daily, four hours less than adults. But in the nature of tasks there is a difference, and boys have more time to earn money and for personal care, while girls spend most of their time caring for others. This is not a personal choice. Girls are just supposed to comply to what is generally felt to be the 'natural order of things', and if they do not, they should be forced to it for their own good. Podiyamma (12) is in her mother's eyes, for instance: 'lazy and slipshod She is lax whatever she does . . . but of course she helps me at home. Otherwise I'd beat the living daylights out of her.'

Or, as Sukhail (8), quite candidly puts it:

Girls get a lot of beatings from the teacher in the *madrasa*, because they are always late . . . it's because they have to do the housekeeping before they come to school, you see.

The life cycle of a household has, nevertheless, a significant impact on the amount of housekeeping a girl has to do. In a family with many small children, girls spend most of their time in child care, and this leaves very little room for anything else. The combination of poverty, patronage and gender may lead to particularly difficult situations:

Take Ramla (7) and Jasmin (10), the two daughters of Ibrahimkutty, who is a fisherman. Fatima, their mother, has two girls and a boy to look after who are all still toddlers. Fatima breastfeeds the youngest two who are twins. To supplement their meagre income, she defibres husks for the neighbouring small coir manufacturer. Her boss, who is the patron of the household, lends them money when her husband has

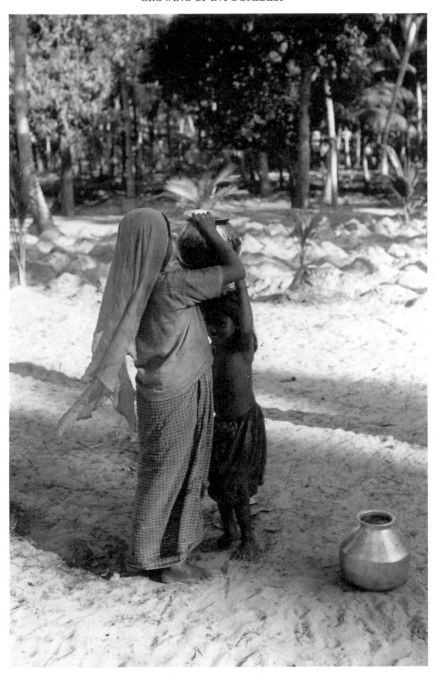

6 Adults feel they need children's help in carrying out their daily routine

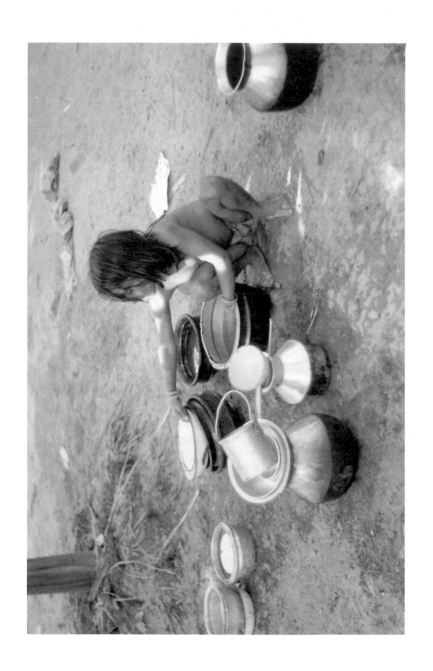

7 Cleaning pots and pans: typically a girl's task

no income, and she repays her debt with her work. The two sisters go to school for five hours a day. But for the rest, they are available to assist their mother. They rise at 6 a.m. and only lay down as late as 10 p.m., which leaves them with eleven hours to devote to work in and around the house. They spend much of this time in keeping a watch on the small ones, who are not supposed to call on their mother while she is at work and bother her by requesting the breast. Each of the sisters devotes on average four hours a day to keeping the hungry toddlers away from their only source of comfort, for they have most of the time but very little food to give them. On some days one of the sisters may even put as much as twelve hours into child care, and this happens when the other has more rewarding work to do.

Then there is the housekeeping. Sweeping, scrubbing aluminum pots and pans, cleaning fish, fetching water and collecting fuel have to be done daily as a matter of fact and nobody cares to call these activities 'work'. But there is more. The youngest sister Ramla, is a kitchen help to her mother's employer. She runs errands and does a few domestic chores. Depending on how much she has done, she is given a certain quantity of leftover food. Jasmin, who is the eldest, does all the fetching and carrying work for her mother when she is defibring husks, replacing her when she has to stop working to breastfeed the twins. Whenever she has time, she may also go to pick up fish or fruits. Fatima manages in this way to keep going when her husband is away fishing.

Jasmin pictured their home situation while her father was away as follows:

Since my father went off to Malabar I dropped even going to the *madrasa*. I have to look after the babies and go to school. My mother is a coir worker, and when I am off from school we can beat together 150 or even 200 husks a day. Otherwise, I beat 50 husks before leaving and she will beat 50 more while I am away. If the babies leave her in peace, she can beat 75 or more. If I am free, we finish the work together before noon, otherwise she has to work until dusk.

Question: Do you have a lot of housekeeping to do?

Jasmin: I have to fetch water, wash dishes and light the oven . . . and also sweep the yard and look after the babies. I do all this after coming back from school at four o'clock. At noon I may come home to eat, if there are any leftovers. Today we had none. The *kanji* (rice gruel) of yesterday, the babies took it. Before returning to school I clean the dishes and fetch one pot of water.

However, the immutability of the division of household tasks should not make one overlook the small but significant deviations from the norm that may be signals of changes occurring over long periods of time. The real,

73

informal set-up in which children grow up is ever changing and there is little that is definite about the role of each child taken separately. It is interesting, in this respect, to dwell on the implications of the preference of Keralites for the nuclear household. Systems of hierarchy and authority become the more complex and difficult to enforce the larger the group that lives together. In the extended household, the hierarchies of seniority and gender are sub-ordinated to birth-order ranking, the elder brother's authority extending over all juniors and women. This type of household requires close co-operation among members who share a subordinate position, with little chance of escape for the individual. The life of most people is so beset with uncertainties that such a complex family arrangement would be an encumbrance. The nuclear household is far better equipped to deal in a flexible and relatively simple way with the division of labour and responsibilities required by ever-changing circumstances. Not only is in such a structure task allocation a matter of fact, there is also more room for improvisation and individual dispositions. This makes the division of labour based on gender and age, as the example of water-drawing shows, to be in practice far less rigid than in the ideal.

For the households that cannot rely on patrons it has become increasingly important to be able to reallocate household tasks in such a way as to allow children, and also girls, to go to school or to earn additional income. This may be easier to carry through in the nuclear household, where children of both sexes are likely to play a more prominent role in decision-making and enjoy more freedom in following their own inclinations, than in the larger one. Even then, the age and gender division of labour is not easily altered:

> Padmanabhan (56), for instance, would like, so he says, that his daughter of 14 worked less in the kitchen, for she is a bright pupil and needs more time for homework. But his wife contends that she cannot manage without her help, and Padmanabhan is unlikely to take some of the housekeeping upon himself. The girl therefore works an average of nearly eight hours a day in and around the home, against her twin brother, who is also in school, who works for a mere four hours.

So, though the rather informal and face-to-face character of relations makes the domestic group the field *par excellence* for the expression of individual needs and inclinations, the room for manoeuvre is limited by the constraints of the larger society in which children's work is set. Many poor parents feel that schools do not teach much that is of direct use in daily life, so that it is still upon them to train their children in the jobs that are any way essential for their future livelihood. While everybody would agree that the school knowledge acquired broadly in five to seven years of schooling is today indispensable, the final level attained by a child remains largely a matter of personal endurance, gift and luck. If a child does very well few parents would indeed outrightly deny it taking the chance offered by protracted

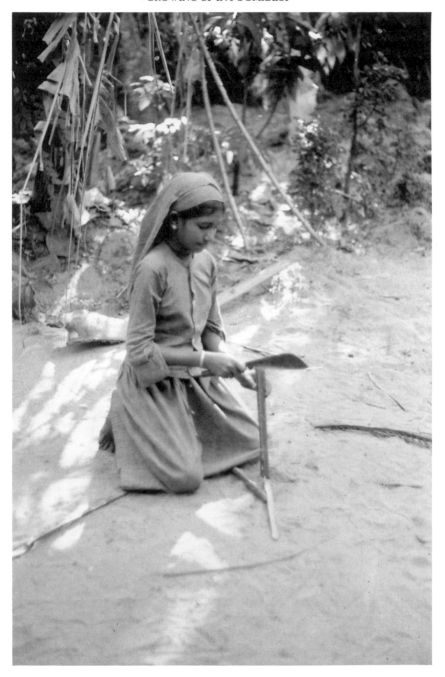

8 Cutting wood for cooking

education, although it would be much easier for a boy than for a girl to do so. On the other hand, if a child is perceived as being unlucky, lazy, sickly or stupid, even well-to-do parents prefer to have him or her trained as soon as possible in some kind of job.

AMBIGUITIES OF CHILDHOOD

For many Muslim families in Poomkara, it is a new experience to have their children going to school.[7] Rukkhyaumma (63), a grand old lady from one of the prominent Muslim families, recalls:

> In my childhood, only very few people went to school . . . we girls would divide our time between household chores and going to the *thyccavu* (a kind of Koranic school) . . . we would go in the morning and return home after the call of the *mukri* at noon. After prayers, we would go again, until evening prayers. After returning home at sunset, we were reciting the Koran We started going to the *thyccavu* by the age of 5, till the age of about 13. After that [that is, on reaching menarche] girls were not even allowed a glimpse beyond the fence. That was the custom. In daytime, you wouldn't see a single [Muslim] woman or adolescent girl in the entire village. Women left the house only under the cover of darkness.

Her childhood, she feels, was very different from what it is for her grand-children today. Like her, most elderly people in Poomkara recollected their childhood in the pre-independence period as steeped in domestic concerns, only occasionally stirred by village festivities such as the yearly visit of the Edapally *raja*, a small ruler to whom the village belonged.

Muslim children were trained early and at length in the tenets of Islam, to which the community, in spite of its relative isolation from the mainstream tradition in Malabar, adhered with great devotion. Elderly Muslims generally agreed that they had a very short, but pleasant childhood. As small children they were free to play, clad in a simple G-string (*konaan*), in and around the compound, nobody bothering them with schooling until they became fit for Arabic education. Between the ages of 5 and 7, depending on their physical growth, children of both sexes would start following for a few years the Koranic teachings imparted by *mullakas* in a local koranic school, a *thyccavu* or *pallipura*. The teachers were appointed by the notables, and to be able to support a *thyccavu* was a source of great prestige. Says Sainabeevi (70):

> My father had his own *thyccavu* and his own *musaliar* (religious teacher). Nowadays the mosque congregation meets the cost of the *madrasa*. But when I was a child, the parents had to take the initiative, make a shed, appoint a teacher, feed him and pay him a salary. If the

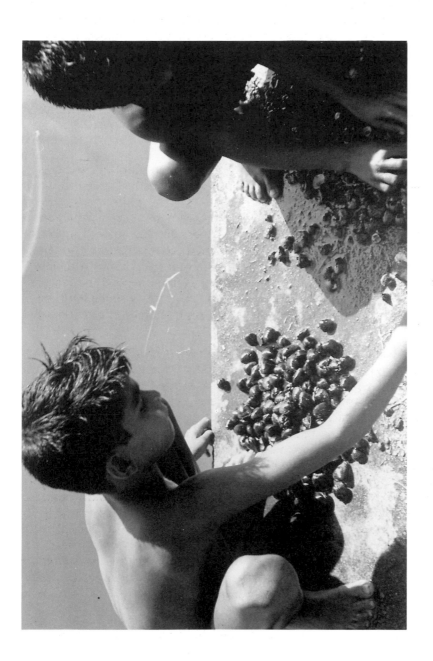

9 The boys' primary duty towards their families is foraging for food. Here boys collect mussels from the backwaters

10 Many children earn a little additional cash from their wealthier neighbour's cows

musaliar came from outside, we had to lodge him as well. Contributions were at will, depending on the economic status of the children. Whatever he received from the other children, father would always pay the *musaliar* the salary he had been promised.

In the Koranic schools learning was by rote, and this was not experienced as being particularly demanding. The philosophy of this sort of teaching was that comprehension would naturally follow upon memorizing, and that rote learning had an intrinsic value in itself (see also Wood 1985: 4).

But their childhood ended quickly and abruptly. For boys, the passage to adulthood, marked by circumcision, was a painful and enduring experience, though alleviated by the festive atmosphere surrounding the initiation into the world of men. Boys underwent the *marggakalyanam* (circumcision-ceremony) at about seven if they were sturdy enough, or later. From then onwards they would wear, during prayers, or when leaving the vicinity of their homes, the long loin-cloths (*kailis*), towels or caps and long-sleeved shirts used by adults. Boys would then also start working outside the ambit of the home, and be initiated into a trade. They married by the end of their apprenticeship, between 16 and 20. Marriages were all arranged and the consent of the spouses was never asked. Even glimpsing at each other before marriage was considered rather indecent, if not a display of insolence. Muslims gave no dowry to the bride, but followed the Arab tradition of giving a small bride-price (*mehar*) instead. Sadder was the sudden and radical loss of freedom of movement that followed a girl's coming of age, quickly followed by marriage and the first pregnancy. After menarche, and this could be as young as 9, a girl had to observe strict seclusion and was expected to prepare for marriage by taking on her domestic responsibilities. She would start using the long-sleeved *chatta* and the *kaili* worn by adult women. The married life of an adolescent girl was often experienced as gloomy and full of anxieties. The recurrent diseases and deaths of her children and the interminable succession of pregnancies and lactation periods, often turned her life, as many an elderly woman confessed, into a vale of tears.

Maintaining a distinct cultural tradition did not imply that Muslim children were entirely cut off from the mainstream developments of the Travancore state. In the 1920s modern reformers such as Seethi Sahib successfully bridged the fears orthodox Muslims had been harbouring against modern education. He endeavoured, with like-minded moderate reformists, for the participation of Muslim children in vernacular education and for the development of Muslim-managed elementary schools. Through these efforts, and the effect of the zeal for education of the lower Hindu castes, Muslim male literacy in the vernacular in Travancore made its first advances and compared favourably with that in Malabar (Miller 1976: 205).

In the 1920s, a recognized school, in which Muslim boys could learn to read and write Malayalam and make calculations was started also in

79

Poomkara. A provision had made the costs of schools in which the majority of children were Muslim to be borne entirely by the government. Boys only went to school, however, to master the knowledge required for trading activities. Those who were destined to become simple labourers, and they formed the majority, seldom went to school. Says Rukkhyaumma (63):

> Women were not the only ones to be uneducated, the men were often just as uneducated. . . . Men studied only to be able to carry on their work [as traders], not to get a white-collar job as they do today. It was like that for all castes.

Very different was the childhood experience of Ezhava children, who belonged overwhelmingly to the landless families. In the 1930s the idea that a boy ought to go to school was already firmly established. The interest in schooling was overwhelmingly on account of the endeavour of local activists who opened an aided primary school across the river, and actively enrolled Ezhava boys therein. These boys' parents had little objection against their sons spending a few hours daily in school, the more so that it seemed the only way to improve their future. Women had generally also little time to spend on the personal care and education of their children, as coir manufacture kept them busy for most of the day. Typically, elderly Ezhavas did by and large not recall their childhood as having been particularly pleasant. The contrast with the Muslims, who remembered the intense emotional tie which the continuous care of their secluded mother provided, was striking. Elderly Ezhavas' earliest memories were often connected with work, and particularly with coir-making. Even about their later childhood, one is struck by their not recollecting having experienced periods of particular comfort, with the notable exception of the short period between betrothal and the birth of the first child, which had been a kind of vacation.

A reason for the perceived dullness of their childhood may, however, also have been that the contrast with their adult life was less dramatic. Ezhava adults were generally not as much burdened by the responsibility of breeding and feeding a large family later in life as was the case with the Muslims. The nature of their initiation rites reflects this continuity between childhood and adulthood. There were few rites marking the different stages of childhood, and they were usually performed on a scale in keeping with the economic and social status of the parents. The simplicity of initiation rites was largely on account of SNDP activities, as is clear from the fact that none of the elderly women I interviewed recalled having undergone the matrilineal initiation rites which had been, until the first decade of the century, compulsory (Gough 1955, 1961; Sanoo 1978). Girls knew a short initiation to sexual maturity connected with menarche, in which they had to retire from public life for a few days and which was the occasion for preparing special food. Thereafter they were marriageable, and their demeanour had to be in accordance with this new status. But marriage would

not take place before 15 or 16, and before that they were allowed to move freely although not unchaperoned. Boys were less restricted in their movements, but differences between boys and girls were less pronounced than among Muslims. Though both worked they were not, according to some informants, forced to start as young as they are today.

It would only be during the 1950s that the growing popularity of education would start changing the climate in which children were raised. The policy of reservation had opened, as already said, such bright prospects for upward mobility that taking advantage of the opportunities offered by schools appeared long overdue. Until then, nobody had bothered to have the old school, that was taken by a cyclone during the 1940s, rebuilt. In 1951 a delegation of Muslim and Hindu notables, however, took the initiative of approaching the director of the Education Board in Alleppey to request a new school. There exists an amusing anecdote about how they succeeded in convincing the director to agree to their request. As the director had at first refused, one of the members of the delegation exclaimed: 'But then, did we come here only for ' and candidly used an obscene word of the parlance of Muslim traders, meaning as much as 'being cheated'. On hearing how far the language of this venerable man was removed from respectability, goes the story, the director suddenly changed his mind. As can be gauged from the levels of schooling of the adult population, obtained through the field census, during the 1950s and 1960s, schooling rose quickly, with Muslim girls attending the lower primary, and boys starting in numbers to go to the upper primary and high school.

After independence the perceived need of gathering knowledge and experiences in the world beyond the locality broadened. Newspapers, the radio, political rallies, study classes and books from the village library, opened up the world beyond the immediate vicinity of one's living place. Experiences gathered from such diverse organizations as cultural associations, women's and youth clubs, trade unions, co-operatives and political parties were becoming part of the shared culture of the countryside. The kind of knowledge gathered in schools had become so fully part of daily life, that being unable to participate because of unfamiliarity with the written word had come to be viewed as a serious handicap. It meant being unable to understand and to put into use provisions intended for the advantage of rural workers, or having to depend on a third party in dealing with clerks of co-operative societies and banks or with government officials. In the competitive and individualistic world of post-independence Kerala, in which self-help was becoming increasingly crucial, unfamiliarity with the written word could turn out a highly risky affair. It also made one an object of contempt, as literacy had come to be viewed as enabling people to manage their lives more efficiently and achieve upward mobility (cf. also Perlin 1981: 280). The example of those who had borne tremendous sacrifices and had struggled for 'enlightenment' was proof that poverty could be no excuse for

ignorance. A lack of schooling was the more isolating and stigmatizing that, unable to display his or her understanding of the world conveyed by the printed word, one could not join in the heated discussions on national and international political developments that are even today a favourite pastime in the countryside.

An argument that carried further weight in favour of education was the growing importance of political brokerage in post-independence politics. Local political factions found a natural ally in political leaders in search of voters and who stepped to the fore as the champions of their interests. It is significant that a dispute about the control of the mosque had finally to be settled through a civil procedure and the intervention of advocates and the judge at Alleppey. The management of the mosque was taken over by an elected committee, the elections, in which all adult men could participate, being supervised by the village administrative officer.

During the early 1970s, Muslim youths started obtaining employment in banks and offices, and a few were sent as far as Trivandrum to study law. The most successful hitherto has been the graduate son of a former landlord who, by the beginning of the 1980s, had still been living in utter poverty. When his son obtained a well-paid position in the Gulf, he recovered to the point that he now has two lorries which he rents out and lives in a two-storeyed house opposite the mosque. Following this and similar examples, many more Muslim children, including a growing number of girls, started going to high school (see also Table 5.6. in Chapter 5). The opening of a high school managed by the SNDP Trust in the neighbouring locality, at the beginning of the 1970s, made access to the reserved government jobs a distinct possibility even for the children of the poor, provided, of course, they were exceptionally endowed and persevering.

Though the elderly often look at the modern changes with apprehension, they do expect and hope that they will help their children to cope with the problems of modern life. Middle-class Muslim girls, particularly, are now believed to need schooling in order to offset the problem of economic insecurity and rising dowries. These feelings were expressed by Rukkhyaumma (63) as follows:

> Both Muslim boys and girls today prefer the modern ways . . . in my time, a girl's father and husband would never have agreed to her going out of the house. Now both encourage her to go. That is the main reason why girls go to school, they just obey. In my childhood, women wore (pointing at her large-sized blouse) this type of *kuppayam*. Now what happens with these modern girls . . . their clothes cover just the essential parts, nothing more. My grandchildren, too, follow these modern ways. . . .

Question: Why?

Rukkhyaumma: I just told you, because the men want them to . . . men are no longer satisfied with the old ways. They have started feeling that their women were inferior.

Question: Is it true that you encouraged your granddaughter to go to college?

Rukkhyaumma: Yes, it is true . . . a few years ago Muslim boys started going to high school, and some girls also followed. Because she has studied, she is now able to earn her own living.

School knowledge, and in particular the ability to read Malayalam books, she felt, has become essential:

Nowadays all children go to school . . . in that way they become educated and even learn to sing the film songs that have come into vogue. A lot of Malayalam books have become available, and children learn a lot from them. . . . We learnt only Arabic songs when we were children . . . today you can even get the Arabic books translated in Malayalam. These things didn't exist in my youth. All children use books these days and they enable them to learn about all aspects of life.

Also the atmosphere in which marriages are arranged has been altered. With the rising age at marriage, prospective grooms and brides exercise more influence on the choice of partners. The fact that personal liking is no longer unimportant has gained wide recognition with the institution of a pre-marital visit of the prospective groom to the bride (*pennukannaan*). Love has found a fertile ground among high school children, and references to those who have arranged, through their parents, to marry the girl or boy of their choice, are heard of more often than in the past.

The spurt of secular schooling has affected the local *pallipura* and *thyccavu* system. In the late 1960s, Koranic teaching in *madrasas* was centralized and brought under the supervision of a national board. The board took upon itself to appoint and pay the salaries of the teachers and introduced a formal curriculum, textbooks and examinations common throughout the state. This has made for modernized Arabic teaching that has a few advantages for Muslim children to follow. The years spent in the *madrasa* are often perceived, not only as necessary for religious training, but useful for mastering the rudiments of the Arabic language as well. Prospects for Arabic teachers are bright, with Arabic being taught in all schools in the state with more than ten Muslim pupils, in addition to the recognized *madrasas*. An additional attraction has been the possibility of seeking employment in one of the Arab countries, in which Muslims are shown a certain preference.

Reforms have hardly helped prevent the gradual loss of influence of the Muslim religious leaders over children's education. By the time of my

11 Very unlike their elders, Muslim children learn Arabic songs through the printed word

field-work the leaders of the mosque congregation openly complained of the lack of respect children showed for the prescriptions of Islam. Girls in particular, were said no longer to abide by the rules of segregation and feminine demeanour, and to 'hang by the roadside indecently dressed', being more interested in the love songs brought by the thriving Kerala film industry than in the teachings of the Prophet. Boys would be lost beyond control to the influence of schools, media and consumerism. In schools, where pupils were said to have installed a reign of terror over the teachers, they got involved in student activism and lost respect for their elders. Going to see movies had become so common that parents were not bothering to scold their sons for it any longer. And, what was perhaps worse, many children were now able to earn money on their own, and this would have damaged the authority of elders beyond repair. In the words of a former landlord (70):

> Today's children have no respect for their elders, as when I was a child. They start earning their own money earlier than we used to do, and they have become more independent. The main cause, I feel, is the disruptive effect of the mosque dispute . . . even I have stopped, since a few years ago, to pray five times a day. The boys don't go regularly to the mosque, and they don't fast and pray as Islam prescribes.

Relations of seniority, and particularly those within the family, have undergone a profound process of transformation. Children have become more assertive than they used to be, and schoolroom culture has had a unifying effect in their choice of dress, their tastes and their general world outlook. For children who go to school and work part-time to defray its costs, schooling has brought a few undeniable gains: the payment that can be claimed for work, the increased expenditure for clothing and books, and the capacity to confront the problems of life, which schooling provides. By demanding time and means to spend on schooling, children have acquired a space in which to challenge the subordinate position local society allots them, and I will give in the following two chapters examples of how they have succeeded therein. I will also show how working children not only adjust to, but also take advantage of the competing demands of elders and schools. I have selected for that purpose two sectors of activity, fishing and coir manufacture. They will allow me to contrast the different possible responses of working children to their surroundings and, in particular, illustrate how the various social and economic forces that act upon children combine to give way to a wide range of patterns of work.

4

POOMKARA'S SMALL FRY

Muslim boys, and to a lesser extent girls too, play an important role in fishing, in particular if we understand this activity as the totality of the offshore and onshore operations necessary to render a fishing expedition successful. But only in limited, distinct work arrangements are they conceived of as workers. Most often, however tangible the returns from these activities are, what they do has no name. What do these activities boil down to? Why is it that they often seem too mundane to warrant serious concern? In this chapter, as in the following one, I ponder on these questions from the perspective of the empirical data obtained from the field-work in Poomkara, leaving to Chapter 6 the task of broadening my argument and discussing their relevance for Kerala's economy at large.

BIG AND SMALL FISHERMEN

A sandy beach with a gentle slope fronts Poomkara for a few hundred metres. Above the beach for most of its length are rows of coconut palms, and among them, some metres inland, are the houses of the few men of substance who own the main fishing equipment of the locality. The 200-odd other fishermen of Poomkara have no equipment of their own but work as members of a fishing crew. These workers have their huts built by the shore, often right on the bare sand. Both bosses and crew workers are all Muslims.

A 45-year-old fisherman recalled that, until thirty years ago, fishing boats were held only by those who belonged to the traditional fishing caste, the Arayans. There were about a dozen Arayan families with large canoes. Muslim men worked on their crews without, however, operating their own craft and gear as they do today. Their main occupation was fish trade, and there were vendors operating in the vicinity, those with cycles serving the Christian customers in the hilly towns of the interiors, as well as dealers and agents of trading firms that exported dried prawns and fish. In contrast to other parts of the coast, practically the entire fish trade lay in the hands of

Muslim men. Women were not supposed to come to the beach. It was believed, so he contended, that if a woman touched the sea with her feet, this would bring the wrath of Kadalamma, the goddess of the sea upon the men that went out fishing. In his popular novel *Chemmeen* (1962) Takazhi Sivasankara Pillai has beautifully portrayed the prudishness and chastity required in those years from fishermen's wives in this tract of the coast.

In the 1950s, fish trade underwent a profound change. Ice and insulated vans made it possible to extend the trade in fresh fish towards the international market and large cities such as Bombay and Madras. Poomkara traders gathered a few crews of experienced Muslim fishermen and bought their own crafts and nets. According to some, Muslim traders used to be a rough lot and did not shy from taking the fish from the Arayan fishermen forcibly, if they were unable to get it on their own terms. A Muslim grand old man proudly described how in his family there had been a bunch of strong men muscling in to defend, if need be well beyond the locality, their rights to fishing markets. He recalled tensions between Muslims and Arayans which arose during the 'Chandanakudam' festival at Kakkazhom (near Punnapra):

> The quarrel at Kakkazhom had its repercussions in Poomkara as well. Because the Arayans had cut the nets of Muslims, twenty-seven strong men, all relatives of mine, went there and killed two of them. Then they rushed back to Poomkara and burnt down the forty huts of the Arayans that were living there, raping the women and abusing the children. The Arayans had to give up everything and to run for their lives. This is the reason why till this day our relations are still strained.

According to probably a more realistic version, in 1951 Muslim farmers were issued boats by the government as a relief measure, after a cyclone had washed most of their paddy fields away. This cyclone, and not the quarrel at Kakkazhom, was stated to have been the reason why the last sixteen Arayan households had decided to leave and to settle among relatives in nearby localities. Only thereafter had the Muslims started working their own equipment.

Then, in the 1960s, the road was constructed, serving the traffic of cycle vendors that came in numbers to market commercial fish to the cool houses of the agents of the fish-exporting companies, from where it was taken to Quilon. By the end of the decade one of the largest owner-fishermen received a substantial government subsidy and bought his first motor boat. According to his nephew's description, the boat had a radio and cold storage on board, something exceptional in those years. His uncle would have needed more than 2,000 rupees to bribe the officials who granted the subsidy, so he contended. However, the boat was soon running at a loss. One and a half years later it was taken by a sudden storm while the crew was ashore. At the time of my field-work its debris still lay along the road, as if symbolizing Poomkara's missed technological revolution.

In spite of the growing trading opportunities, and Poomkara's favourable position on a stretch of coast famous for its bumper catches of prawns, its techniques of fishing have remained basically the same for centuries. The nearest ice factory is 3 kilometres away. The bulk of the catches of cheap fish is sold directly to the consumers and transported in baskets carried on the head or by bicycle along inland paths. This is the more remarkable since the prawns caught in the area, the *naran chemmeen*, are highly valued. By contrast, motor boats which operate 30 kilometres to the south at Neendakara and Sakthikulangara near Quilon, land overwhelmingly the less valuable *karikkadi chemmeen*. These motor boats rely on a relatively modern infrastructure such as jetties, cold storage, insulated vans, etc. Poomkara fishermen use only traditional crafts that are launched and tugged ashore from the beach and mostly also paddled by muscle-power. True, some modernization has also taken place. Nets used by all-season crafts are made of nylon and ice is being used to conserve major commercial catches. During the high season outboard motors are used instead of oars. But otherwise much has remained the same. Wood and coir are still the only materials used to make and repair the boats. These are seasonally smeared with the fish oil the fishermen obtain from the sardine fishery. The second piece of equipment in importance, a large beach-seine, is still made of cotton and coir.

The techniques used by Poomkara fishermen do not differ significantly from those of other fishing places on the tract of coast between Cochin and Quilon. The most important craft is a large wooden canoe about 11 to 13 metres long, the *tankuvallam*. The boat offers enough space for a crew of twelve to fourteen rowers and a steersman. It is paddled within a reach of five kilometres of the coast. It is invariably equipped with a large encircling net (*tankavala*). The net can be used the whole fishing season through, from April till the end of October. If the weather is good, fishing can even go on the whole year round. The net is suited to catch the major varieties of fish: prawns, anchovies, sardines, mackerels, sharks, etc. It is bag-like, without wings but with long ropes tied on either side of it. Wooden floats are attached to the head rope and stones are used as sinkers. It may be as long as 50 to 60 metres at its maximum length. Even when it is made of nylon, it is still very heavy. When empty and dry, five to seven men may be required to lift it and carry it on to the canoe. When hauled wet and full of fish it weights several quintals. Even with so many rowers on board, it is still quite a job to get the fish into the boat without letting them escape or tearing the net.

After the crew has paddled to the fishing grounds it runs out the net holding one of its two ropes. The other is held by a boy in his early teens, who jumps into the water and swims, moving away from the boat to spread the net. When the net comes to the proper position, and its mouth is wide open, the boat and the boy gradually move towards each other. Finally the swimmer enters the boat with the rope. At this stage the net is dragged by the

rowers and finally closed and hauled into the boat. The whole operation takes several hours and is exhausting. The fishermen paddle in the heat of the sun until they spot a shoal of fish. The hauling operation in itself is quite demanding, and it may need a real pull to reach the home beach with the catch. With a good catch on board, the water-line will reach the edge of the canoe. Upon reaching the shore the fishermen still have to unload the fish, tug the canoe on to the beach and wash the net. Some forty people are required to tug the canoe, weighing several tonne, and to slide it above the beach, and the assistance of the bunch of boys who gather on the beach on the return of the fishermen, cannot be missed. While the fishermen clean the boat and wash the net to spread it out in the sun, a few elderly men see to it that the fish are put into the auction baskets and sold. In the meanwhile, two or three boys of about 8 to 12 climb into the boat to remove the palm fronds that cover the bottom, clean its interior, search the net for small fry stuck into its meshes and carry paddles, floats and sinkers to the house of the owner-fisherman.

The third piece of equipment is the *kambavala*, a large seine-net with a reach of half a kilometre, operated from the shore by a crew of thirty to forty or even more. The season of the shore-seine falls between November and May, practically during the off season of sea-fishing. This technique requires many more hands, and they need not be equally trained as those paddling a canoe. Many teenage boys join in to work the seines, particularly early in the season when adult men are busy fishing at sea or in the off season, when they migrate to fishing shores in Malabar.

The net is made of cotton and coir, and is funnel-shaped. It has two wings and two long ropes (*kambu*) attached on either side of it. The ropes are about 215 metres long. The net is in total 16 metres wide, with a mesh size varying from 0.76 cm at the cod end to 1.7 cm at the mouth (cf. Kurien and Sebastian 1976: 131). Including wings and ropes, the seine measures some 800 metres in length. It is even more bulky than the *tankavala* and can only be lifted in parts. A large canoe is required to shoot it, and worn-out ones are used for this purpose.

The canoe is launched as soon as a shoal is spotted near the shore. One end of the rope is left with the first shore crew. As the canoe moves out, the boat crew pays out the rope and the wings until the bag is reached. The bag has its mouth fitted with stone weights at the bottom and wooden floats at the top to keep it open. Once it is being dropped, the canoe is paddled back to the shore, paying out the wings and the rope of the other side of the net. The other end of the rope is then delivered to the second shore crew. The two teams pull in the ends of the rope in synchrony, standing at first a hundred metres apart and coming nearer to each other as the hauling progresses. To co-ordinate the efforts different tunes are chanted, marking the rhythm chosen by the leader of the crew. When the bag is still far the rhythm is very slow: 'ellalo, ellavale'. It gradually increases with the tune

changing to 'alloh, allah' and 'allah akbar'. The crew of the canoe has in the meanwhile returned to a position behind the bag and beats with the paddles the surface of the water to prevent the fish from escaping. As the net encircles the shoal, the speed of pulling increases and the rhythm of the tune changes into 'ela, ela, elaya'. The quick rhythm in which 'ey, ey, ey' is sung heralds that the bag is reaching the shore. At that moment two men jump from the canoe into the sea and close the mouth of the net, while a bunch of small boys jumps screaming into the water, beating its surface with their hands, to prevent the fish from escaping. The beach-seine is an encircling net, and it takes therefore no more men to haul the bag when it is full than when it is empty. At least, not until the mouth of the bag is closed. At this stage more people are needed, especially when the catch is large. There are always scores of boys and old men who, expecting a little fish in reward, await this moment, ready to lend a hand.

All fish is put, as soon as it is landed, in large auction baskets that contain about 30 kilos of fish. The number of fish of different types that such a basket may contain is something anyone in the fish business can easily assess. After a quick glance at the variety landed, the owner of the equipment decides on the spot whether to sell it in bulk or in shares. Merchants with large sums of trading capital only venture to Poomkara's beach in the high season of prawns. More often there will be vendors with bicycles or on foot, seeking to buy a share to be retailed to local consumers. Bicycle vendors may act as agents, and bring the fish to wholesale merchants who provide cold storage facilities. But usually they take the fish inland, to the moneyed buyers in the hills. Since the early 1970s remittances from Middle East migrants have enabled these consumers to spend more on fish than ever before. The vendors who carry their basketload of fish on the head, cross the countryside paths announcing their coming by calling out: 'oooh!' and try to get as far as their legs will carry them. Even smaller quantities of fish are sold in the vicinity by boys as young as 8.

There are two main fishing seasons, the prawn season, falling in the monsoon months June to August, and the sardine season, somewhere between August and October. The former is the more lucrative one. But the latter is more important in nutritional terms, fish being then so cheap that virtually everybody can eat his or her fill. The prawn season is heralded by the formation of a mud bank (*chakara*) somewhere near the coast between Alleppey and Quilon. This bank, about one to two kilometres long, is visible because the surface of the sea, in this season otherwise stormy, becomes as smooth as oil. It is extremely rich in prawn and fish. While hundreds of artisanal crews come with their equipment from distant places to fish on this bank, crowds of vendors and merchants gather on the shore. There are swarms of children too, boys of all ages and girls below 10, some with their baby sibling sitting on their hip. In the lean season the tract of coast is mostly deserted, and Poomkara fishermen go up north where fishing can still be carried on.

In Poomkara only two men own their own *tankuvallams*. The first one has two of them, in addition to a beach-seine, and the other has only one, and is partner in a motorized boat moored at the harbour of Cochin. A third man owns only a beach-seine and an old canoe. There are five more men who possess small boats and smaller seines (*kettuvali*) of only seasonal importance. The rest of the fishermen have no significant equipment of their own. The fishermen fall into two categories: those who are experienced at fishing at sea and those who man the shore-seines. The sea fishermen, 145 in total, work most of the time for the two local owner-fishermen or for Arayans living nearby, with whom they have permanent agreements entered into by taking a loan to be repaid on leaving. They are all adults. An additional 50, two-thirds of them teenage boys, are just employed to pull the shore-seines.

The two owners of large canoes belong to well-to-do families with landed property. Their ownership of the equipment entitles them to a fixed share of one-third of the catch. The rest of the catch they share among the members of the crew, each receiving 3 to 5 per cent, depending on the number of workers, their skill, physical strength and age. If an outboard motor has been used, one-third goes to cover the price of petrol. A working owner is entitled to a share of 5 per cent in addition to the share for the equipment. Before selling the catch, all fishermen may take enough fish for domestic use. Some fish is also given to relatives of the owner, old and sick fishermen and the boys who help the fishermen on landing. But if the catch has been disappointing, or if its price is very high, then the entire catch will be sold and there will be no fish for the evening meal.

A large canoe represents quite an investment, and in 1980 its price was about 25,000 rupees, an additional 5,000 being needed to equip it with a net. The wood used to make the boat has become hard to get, so that the price of the craft is likely to have increased over the years. One can imagine that such an investment, in a society where money-lenders ask as much as 10 per cent interest a month, is done in view of getting large profits. The returns on capital are indeed on average as good as in other sectors of the local economy, for instance, the copra and coir trade. True, there is a high degree of seasonal variation in the volume of the catch and, during rough weather, an added risk of losing or damaging the equipment. But a range of in-built securities minimizes these risks and guarantees high returns.

The first security is the share system: if the crew returns empty-handed, the workers receive no pay. The owner suffers but minimal losses because the cost of an expedition depends overwhelmingly on the physical effort of the workers. The second in-built security is that the owner has the prerogative of deciding how the catch will be disposed of. Smaller and less profitable catches he will auction on the beach itself to retail vendors, but these transactions never involve more than a few hundred rupees. Knowing too well that if the workers do not receive some fish and a few rupees their

family will go hungry, he will anyhow have to renounce, in order not to give the workers the impression of callousness, an extra profit above his due share. But if the catch is large and valuable, he may decide to buy it himself by setting a price that is a little higher than the vendors offer. This amount he will use for calculating the shares. In the meanwhile he will make arrangements to resell the catch at an even higher price to the agent of the nearby cool house. This profit he does not share with the crew. As there are but rarely moneyed traders on the beach, workers, therefore, do not, as a rule, receive wages exceeding 30 rupees even when the catch is good. Although when the prawn season is in full swing they may earn 200 rupees in one single trip, the days in which they do not receive enough to feed their families are many more.

The situation is about the same with beach-seine fishing, even though returns are significantly lower. The lower productivity is compensated by a larger share to the owner and a smaller one to the crew. While each member receives a mere 1.6 to 0.8 per cent of the price of the catch, the former is entitled to 50 per cent. Participation is guaranteed by lending money to the workers in the lean season in addition to a rock-bottom remuneration after every trial, consisting of tea and pancakes (*appam*) served in a nearby tea-stall, even when catches fail. If the catch is very small the owner may exceptionally renounce his share and give the workers a few domestic fish instead. It is unlikely, in such a case, that the value of a worker's share exceeds 1 rupee. Highly-priced fish is, as a rule, marketed by the owner, the share of the workers exceeding 10 rupees only in very exceptional cases.

Custom demands that the men of the crew remain ignorant of the process of marketing the catch. While the haggling with the vendors is going on they behave indifferently, keeping to their duties such as washing the net and cleaning the boat. For one thing, they know that if the owner is setting the price, and decides to resell the catch outside, as normally happens when it is good, they will be unable to get to know the amount of his final profit. If they were to try to find out more about the sale, the owner would no doubt interpret their curiosity as a lack of confidence. By and large owners require from labourers that they behave respectfully and trust that they get their due share. Although they no longer beat insubordinate labourers, they still have powerful means to frustrate any attempt at self-assertion: the exclusion from the crew and the severing of the ties of patronage. Crew labourers face long periods every year in which they have no income at all and depend on their boss for a variety of favours.

To tide over the slack season, many young fishermen, and among them there are boys in their early teens, set off for a locality in Malabar where they find seasonal employment for the same owners every year. What makes the journey attractive is that, during their stay, they are fed even if the catches fail. It is only at the moment of departure that the price of their food is deducted from their share. When fishing falls off there too, they return to Poomkara, to

await for the beginning of the new season. Fishermen expert in fishing at sea do not, as a rule, take to any other work than fishing and repair of boats and fishing gear. The periods of starvation they inevitably have to face every year, they take with a great deal of stoicism. They sleep long hours and spend most of the day with their family and friends, resigned to a short vacation with an empty stomach. To tide over this period they often have to borrow from their permanent boss. He does not charge interest. But accepting a loan does carry the obligation to work whenever required without muttering about the payment, even if on that day another employer may offer to pay more. In the end, therefore, these consumption loans turn out to carry a heavy rate of indirect interest in the form of poor remuneration for work.

Ibrahimkutty's case, one of the fishermen who participated in the budget-study, illuminates to what degree fishermen depend on their various bosses for work and for loans:

Ibrahimkutty is 36 years old, and has worked for 25 years for the same Arayan owner-fisherman south of Poomkara. He was barely 11 when he started working in the crew of the *tankuvallam*, at first as a swimmer to close the net. On growing up he was gradually trained in other skills and eventually offered a permanent place in the crew. But he cannot claim a right to work when the Arayan owner does not need him. On those days he might work for Ali Molali, his boss in Poomkara. During the year of the budget, 1979, he did no other work than fishing, even when illness forced him to interrupt his work in the middle of the season. His wife, in spite of her having twin babies and a toddler to nurse, supplemented their income by making coir yarn with the help of their 11-year-old daughter Jasmin (see also Chapter 3, section 3.3 and Chapter 5, section 5.3).

Between the first days of December 1978 and mid-January 1979, Ibrahimkutty had been fishing in Malabar. He came back with a net balance of 125 rupees. The money was soon spent on clearing debts he had incurred during the previous low season. The only work he could find was on board the canoe used for paying out Ali Molali's shore-seine.

Only in April did his Arayan boss call him to join the crew of his *tankuvallam*. At the start of the prawn season a sudden eye disease impaired his vision. His boss sent him home and gave his place to one of his own relatives. Before the rains he gave Ibrahimkutty some plaited coconut fronds to rethatch his hut, a little money and a new loin cloth.

In November his eyes were cured and he was able to buy a pair of spectacles with money gathered by his neighbours. But he was still out of work, as the fishing season was now over. His family of seven was starving. He took a loan from both his two bosses and set off to Malabar as he had done the year before.

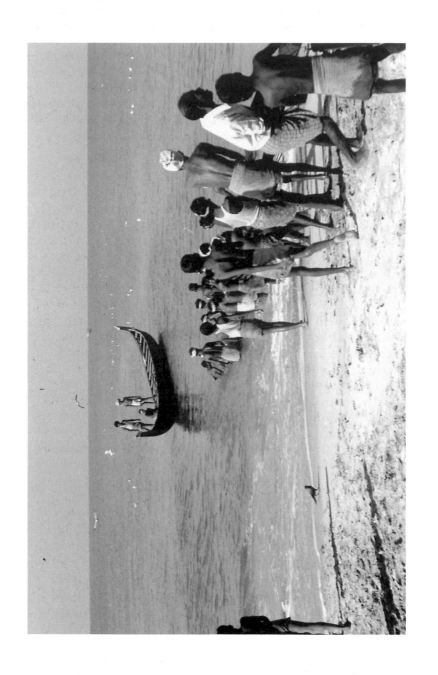

12 Boys haul the shore-seine

Those who fish from the shore with the seines are a different type of worker altogether. Most of them are boys in their early teens. The few adults are mostly casual workers who, during the long periods in which the seines are not used, take up whatever other work they can get. The reason why most workers are children, is that, except for a few days or weeks during the high tide of the season, returns from seine fishing are miserably low. Adult seine-fishermen experience their work as degrading and shameful, and have spells in small trade and fish-vending whenever they can. This is why in 1979 the two seine fishermen of the budget-study, Ummerkutty (38) and his son Syed (17), had a far more complex pattern of work than Ibrahimkutty:

In November 1979 father and son left together for Malabar, where most able-bodied fishermen of Poomkara had gathered. As Syed suffers from TB he was unable to stay on the job. He returned home in February to stay with his mother and three small brothers. As he had to work anyway to support himself, he took on the lighter job of vending fish by cycle to neighbouring villages. His mother's employer lent him 20 rupees to rent a cycle and buy some fish. Ummerkutty did not send money home during his absence.

In March Syed dropped fish-vending, feeling well enough to join the crew of Ali Molali's seine. By the middle of March his father joined him.

As seine fishing fell off at the beginning of April, Syed took up fish-vending again, and Ummerkutty returned to Malabar. In June Ummerkutty came back home with some savings which he wanted to use to deal in prawns during the *chakara*. At first things went on well, but within a few weeks he lost in one single transaction all his money. The rest of the month he was unable to make more than 1 rupee a day by dealing in dried fish.

But in July his luck was on the turn. In a single day he made 78 rupees. When the fish trade fell back in August he turned to the coir business, helping his wife to set up her own yarn-spinning unit.

In September Syed was unable to resell 30 rupees worth of fish and had therefore to pawn his old bicycle. He went fish-vending on foot.

In October, in the sardine season, father and son were able to buy a large quantity of this cheap fish. They made oil out of it and sold it to Ali Molali for 125 rupees.

In November none of them was able to work as they had to assist a wealthier relative in preparing a marriage ceremony.

In December Syed felt well enough to leave for Malabar and was soon able to send 25 rupees home. But in January he was back again, sick and exhausted. He took up his old trade, while his father had joined Ali Molali's crew for a while.

In sum, father and son had been seine-fishermen for five and a half months and had spells of other trades for the rest of the year. Their main

income was from trade rather than from fishing. Ummerkutty had earned a mere 72 rupees plus food with fishing against 305 rupees with trading activities. Syed earned 165 rupees with fishing and 293 rupees with fish-vending.

Debts that are incurred during the off season can be cleared during the *chakara*, when the earnings of the crew and the profits of even petty traders rise all of a sudden. However, everything depends on the appearance of the mud bank nearby, and this is far from certain. If the bank appears more than a few kilometres away, only sea fishermen and somewhat moneyed traders may travel that far, either with their own boats or by bus. For the smaller vendors, seine fishermen and the multitude of small fry invariably present during the landing of the catches, the busfare makes the travel prohibitive.

In 1979 Poomkara was lucky enough to see the mud bank appear for one full week along its sea tract. Its otherwise quiet beach filled all of a sudden with feverish activity. Hundreds of boats came through the river from as far as Alleppey and Quilon, with fishermen invading the village tea-stalls, sleeping under whatever veranda they found, and camping in the school building. Arayans' prodigality as long as the *chakara* lasted, was proverbial. And as proverbial was the ingenuity of Muslim traders, however modest their capital or even their experience in life. Anyone who had the slightest commercial ability would start a shop from scrap on the beach itself, or would deal in infinitesimally small quantities of prawns. Within one week, tens of tea- and cigarette-stalls, where everything was more expensive than usual, mushroomed. Women and girls made tea, *appam*, sweetmeats and warm meals expediently, for the males of the house, some barely 6 or 7 years old, to sell in their makeshift shops. Some shops offered luxury goods, an uncommon sight in Poomkara: talcum powder, toilet soap, lemon juice and soda, sweets, toys, etc.

Anyone handling prawns would make profits. The profits were, of course, uneven: the largest accrued to the agents of the exporting companies, the smallest to young children who picked up fallen prawns from the nets and the baskets. But even the small ones were able to make up to 10 rupees a day, which was, in their eyes, an extravagant amount. As to the profits made by middlemen and commission agents I could only guess. It was indicative that some offered as much as 100 per cent interest to anyone willing to lend them money for one single day.

As soon as the catch of prawns is landed, middlemen who command sufficient amounts in cash join in the haggling. Their business is to speculate with the final day price at which the commission agents, who have orders from the exporters, will buy the catch. If the takings of the first boats to return are large, the middlemen expect the total catch to be large as well. They will therefore be inclined to offer a low price. In the opposite case, they will by contrast offer a higher price, in particular if the commission agents for whom

they work, have large orders. If the takings of the first boats were indeed a good indicator for the final size of the total catch on a particular day, then the middlemen are likely to make only modest profits. But it is more likely that they are not. In that case the middlemen may either realize a profit or, on the contrary, suffer a loss. If the catch is very large and their orders are smaller, the final price of prawns will remain low. Some of them may lose money if they have bought prawns for a higher price in the morning. But if the total catch is small, there is ample opportunity to earn large profits, as the owner-fishermen may, in the morning, not be yet in a strong haggling position. But the price the middlemen pay to owner-fishermen is generally on the safe side, though there are also limitations to their ability to speculate. Middlemen may, for instance, have a stake in the landings, as co-owners of the equipment or providers of credit to its owner. In exchange, they have the first right to buy the landings. It is quite normal for a middleman to realize in a single transaction a profit of 12 per cent.

The agents holding orders commissioned by the exporters never join with the middlemen who haggle keenly around the baskets of fish. They remain at a distance from the open beach, sitting on chairs, in a detached pose, in the shadow of the coconut palms. A notebook, a weighing-scale and a snow-white shirt are the distinguishing symbols of their higher mercantile status. One or two middlemen, smaller traders in command of sizeable amounts of money, act on their behalf. They may either bargain directly with the owner of the equipment or, when the beach is very crowded, deal with even smaller traders. All profits depend, after all, on the scale of the business. For smaller takings the number of haggling traders may be very high, and profits tend therefore to be low. Large takings, by contrast, attract the few with thousands of rupees at their disposal. There competition is less, and the prospective profit may therefore turn out to be relatively higher. But there is more. It is the larger middlemen who settle the final price of the fish, as it is upon them, in the end, that smaller middlemen depend to resell whatever fish and prawns they have been able to buy. This rules out any chance that their profits be higher than those of the large middlemen. Typically, although there may seem to be an unreasonable number of small traders in between the fishermen and the commission agents, their presence precludes the price from falling below a certain minimum. The reason is that, though they cannot compete with the larger middlemen when the prices are high, they do have possibilities, eventually in a partnership, to buy when they are low. The role of children in this petty trade, as I will show in the next paragraph, is illuminating. Their activities enable the crew to realize a little additional cash to supplement their meagre income.

BOYS IN THE WORLD OF FISHING

Children may undertake four types of activity:

(a) Fishing and foraging for subsistence.
(b) Small-scale fish-vending
(c) Rendering services to a boss and its crew during operations on the beach.
(d) Work in a shore-seine crew.

The sequence in which they are listed reproduces a hierarchical ordering based on gender and seniority. Only foraging activities are open to both boys and girls even when very young. Girls have but a short-lived part to play in fishing, their place being considered, after menarche, to be primarily the home. The other types of activity are therefore the preserve of boys, who will undertake them with growing zest and will to learn as they develop over the years skill and physical strength. A long process of socialization marks their initiation into the male world of fishing. As boys display their eagerness in becoming full-fledged fishermen, they have to comply during a laborious period to a subordinate position accepting, just as women do, what the men regard as inferior work (cf. also Fjellheim 1989: 135ff).

While the prime mover for adult men to go out fishing is the want of cash, the children's motive for being interested in fishing is alimentary. Fish is not only important from the nutritional point of view in a diet composed of little else than rice and peppers. It is also a delicacy all coastal children just relish. The way fish is served and shared within a family is important to express feelings of respect and affection. Custom demands that a mother gives the more succulent pieces to her husband. She can only hope that he, in his turn, as a loving father, will take pleasure in allowing the smaller children to serve themselves from his plate. Children in their turn, seek to please their parents and set out to forage a little fish whenever there is a chance to get any.

In most coastal settlements fishing is still primarily a matter of subsistence. Many women fish in the backwaters in the evenings if they have no fish to prepare a curry. If there is no fish, the option will be a curry made of leafy vegetables, which is, however, eaten but with great reluctance. Boys and girls as young as 5 or 6 may therefore be seen angling for fish whenever they have time. Although angling is undertaken first of all for domestic use, on growing up boys may become quite expert, and catch even large *karimeen*, a palatable flat-fish common in the backwaters. They may earn quite some money by selling them to the wealthier housewives.

Gangs of boys and girls of about 5 to 10 never fail to gather on the beach on the return of the boats. In the worst case they get nothing to bring home, but it is more likely that they get at least a little small fry. The larger the catch, the more there is left for them to take, especially if the fish fetches a low price. Prices of large catches are often so low that it little matters if some is lost. In addition, cheap fish may be difficult to dispose of before it perishes, particularly in the evenings, as the women who are likely to buy prefer to prepare elaborate dishes in the morning. By adding ice to the baskets, fish can be conserved, but this requires an additional investment which cannot

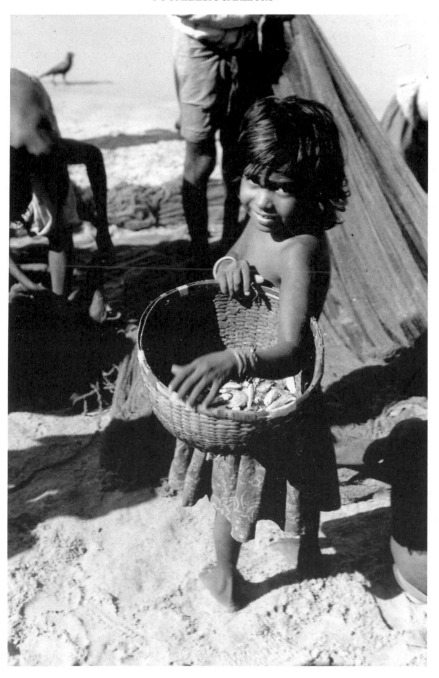

13 Young girls go to the beach to collect their father's share of the catch

14 Both boys and girls may forage in the fishermen's nets for the remnants of the catch

always be recovered the next day. Iced fish changes taste and may therefore be difficult to sell for a good price.

A boy's early disposition towards foraging for fallen fish in between the legs of the working fishermen, is not only tolerated but encouraged. Being the first step towards a more specialized apprenticeship, that starts right on the beach, as soon as a boy is old enough to be of some help in the stages of hauling the shore-seine or landing the *tankuvallam*, it fits admirably well into the rationality of artisanal fishing. It is common for an owner-fisherman to tacitly solicit a boy's future apprenticeship by giving his parents a gift of money on the occasion of his circumcision, which is usually performed around his seventh birthday. The gift is a welcome addition to meet the costs of the ceremony, that may heavily weigh upon the budget of the poor (cf. also Table 3.5). Apprentice boys are, at first, given only a little fish, which they may themselves recover from the meshes of the net or the corners of the boat. When the catch is good, they may occasionally also be given a little extra. Most fish is readily brought home, and boys find the appreciative glances of their mother, when they hand over their takings, very rewarding. But if the fish is more than enough for a curry, or of the expensive kind, they may as well decide to sell some of it. Boys are encouraged to develop whatever commercial talent they may have, provided the scale of their business remains commensurate to their age. A boy may freely dispose of his first returns and spend them at a local tea-stall or at the bunk shop. He will normally discover, himself, that it is unwise to spend everything on sweets and snacks, and that one needs reserves to expand a business.

The art of vending fish is something boys are keen on learning. It is at first a kind of exciting game, done with no other initial capital than a bit of fish and a little luck. Prawns foraged by boys fetch but half the price of the ongoing rate. Ten prawns fetched in the 1979 season, for instance, 20 or 25 paise, and were sold to small dealers, often elderly ones, who disposed of a mere 20 to 30 rupees as their trading capital. These dealers offer parcels of about half a kilogramme to a dealer with somewhat more money, who in his turn seeks to resell an even larger quantity to a middleman with a higher amount at command. The latter may, finally, buy enough to make a basket to resell to one of the middlemen who deal with the commission agents. By acting at the lower levels of this elaborate hierarchy of traders, both the fish-vendors and the small dealers realize modest profits in the trade of prawns. For the large traders it is a way to avoid the unavoidable wastage, which follows from the haste in which this highly-perishable good has to be handled. Wastage can be quite substantial when the catches are good. In contrast to fish with a low commercial value, prawns are deep-frozen and their value on international markets does not depend, as on the landing beaches, on the time of the day or even the season in which they are caught.

Boys' foraging activities are, however, only tolerated during the operations of artisanal fishermen. During my field-work I could witness how

motor boats trawled for three weeks along the sea-shore for prawns. Their catches were ferried ashore and sorted by women and children hired by commission agents. No Poomkara boy was even allowed to come near lest he be severely punished. Nor were there small dealers or fish-vendors partaking in the business. The whole catch was commissioned to the agents of the exporters, and wastage was minimal due to careful handling during the various stages of transport. When the motor boats operate, their noise scares away the prawns towards just above the beach, and it is then possible to fish with a smaller type of seine that has recently come into use, the *kettuvali*. The net is made up of a *tankavala* bag, to which short wings and ropes have been attached and is approximately one-tenth the size of the *kambavala*. The *kettuvali* can be operated with a shore crew of five to ten boys, usually the younger apprentice boys of about 7 or 8 who spend most of their time in foraging and small-scale trading:

> Salim (10) is the eldest of a small gang of boys of about seven or eight, who have come to the beach to await the return of the boats fishing at sea. In this season, Salim and his friends normally pull the *kettuvali*, but today the owner did not call them. They are never paid more than 50 paise and a little domestic fish. When they have no work, they forage for fish, and sell whatever surplus they are able to find. When the prices are high, foraging may be quite tough, and they get a lot of beatings. Some show marks on the stomach and thighs, while Salim in a plain voice comments: 'We are not afraid, however hard they kick us we make it a point never to leave the spot without fish'.

When he is 10 or 11, a boy will start on a more specialized training, all depending on his physical and mental maturity. If he is sturdy, he may feel attracted towards heavy physical work in a crew of fishermen. In that case he will start to be considered, to use Firth's term, a 'growing participator in work', although it will take at least till his eighteenth to gain the status of 'full working member' of the crew (Firth 1975: 72). It is relatively easy for such a boy to join the crew of the large shore-seine, the *kambavala*. This type of equipment is in fact fully operated by a handful of men whose bodies have lost the condition of their prime youth, and a bunch of boys whose lusty appearance holds the promise of future stamina. There exist outspoken notions about the boys' place in seine-fishing and they seem to be firmly rooted in shared beliefs and values about the nature of artisanal fishing. An old owner-fisherman expressed these notions as follows:

> All boys living in this neighbourhood may come to help hauling the seine. No boy will be locked out. You see, we fishermen believe in good luck and you can never tell in advance who the lucky one is. But if a boy misbehaves, we'll have to be strict and send him away. The boys always accept gladly whatever we give them, they never grumble.

They simply agree to the fact that their earnings depend on the catch. Even if we give them only 1 paise, they will accept it with gratitude. Take this morning, for example. We got only 10 rupees from the sale of the fish taken by my seine. The boys got only one *porotta* (a kind of bread) and a glass of tea.

The view expressed by this elderly man should, however, be read more as a normative statement than as a reflection of the real feelings of the boys working for him. The boys are not supposed to mutter nor even to resent having to go back home empty-handed. The owner gives them a chance to try their luck, so he feels, and if the attempt fails, it is no more of his account than it is of theirs. They may deprecate their misfortune, but not hold the owner responsible for it. On the contrary, the owner likes to see himself as a well-wisher for whom they should feel nothing less than gratitude. These notions represent more than simple wishful thinking. They are dominant norms of behaviour and demeanour. Deviance is perceived as a show of insolence and ingratitude, and is soon followed by exclusion from the crew.

The boys themselves had a markedly different view of the recruitment procedure. The right to join in the crew whenever they wanted, existed, so they felt, only in theory. Membership of a crew was a long-term affair, parents pledging their sons to a particular owner for at least one, but more often three or four seasons. The advance payments to the parents were often very modest, averaging 15 rupees, though in many cases small gifts had also been given earlier. Membership entailed the obligation to work whenever word was given that a shoal was spotted near the shore and the owner had decided to pay out the net.

As no one can predict in advance whether the fishing season will be a good or a bad one, an owner needs to be certain that he will be able to mobilize a crew when the need arises. To some extent, the practice of tying boys' labour is therefore based on mutual interest. If the season is good, an owner is assured that other owners will not seek to attract his workers by paying them higher rates. By contrast, if the season is poor, the boys' families can take small advances to buy food while the boys can look forward to an extra snack which the owner normally offers even in the event of failing catches. But even though the relation is based on mutual interest, it is in no way reciprocal: for while the boys are virtually powerless and depend largely on the owner's good disposition, the latter benefits disproportionately whenever good luck strikes. One may indeed doubt whether the boys are accepting so ungrudgingly whatever the boss likes to give them, as is required by custom. They have no other choice than comply.

Basheer (14) was pledged by his parents to Ali Molali when he was 10. As far as he recalls, the boss gave them 15 rupees on the first day of Bakrid, and three or four on the successive two or three days. In total, he believed, they must have received 50 rupees, which they need not

repay, as long as Basheer comes working whenever the boss calls him. This happens about twice or thrice a week. On other days Basheer is vending fish and helps his father in making copra. He often earns more on those days, but still cannot refuse to come when Ali Molali calls. He was never paid more than 3 rupees as his share, however endowed the crew was with good fortune. Often enough he had to work for hours on end, receiving, to make up for his strain, only a snack and a tea. Although now growing into an adolescent, he still receives only one-third of an adult crew member's share.

Once they have made up their mind about their future, fishing adolescents enter into a more intimate relationship with the owner. What was at first perhaps more of a loose working relationship, becomes tarnished by the promise of life-long security that loyalty and submission to the owner entails. It is a time in which boys stop scrambling for fallen fish or stealing from the catch, and even cease feigning to work to get a free snack, as they may have done in their early boyhood, and become very circumspect not to provoke the owner's distrust. Ummerkunju (14) feels emotionally very much attached to the owner and trusts him blindly:

The share the worker gets depends not only on the age, but also on the effort. Some boys of only 10, who really bestir themselves, may get as much as me, but others really do not deserve more than half my share . . .

Question:	But how does the owner know who is applying himself and who is just pretending?
Ummerkunju	(flashing a smile): Do you think that he can't see that there are boys who just stand there touching the rope and feign that they exert themselves, while we others put our back into it?
Question:	How does he pay you?
Ummerkunju:	At night we all go to his house and receive our share there.
Question:	Then, how do you know what is your due, does he tell you the price at which the catch has been settled?
Ummerkunju:	But we are there during the sale . . .
Question:	Do you mean that the labourers watch the haggling?
Ummerkunju:	Oh no, why should we do that! I have full confidence in the owner, I am sure that he doesn't cheat!
Question:	Who are the habitual buyers?
Ummerkunju:	The bicycle vendors, or otherwise he buys the catch himself.
Question:	What for?
Ummerkunju:	To resell it . . . with a profit. He resells it often to

	merchants or keeps it otherwise for drying.
Question:	How are the proceeds shared?
Ummerkunju:	Sometimes, if they are very small, say only 75 rupees, the owner shares everything and keeps nothing for himself. If they are higher, say 300 rupees, he first pays for our tea and *appam* (rice pancake) in the tea-stall. Of what is left he takes half, and shares the rest among the labourers. Some get 5 rupees, others only 2 or even less. It all depends on their application. The owner knows all of us personally, he can easily make out who is lazy and who is not.
Question:	Does he lend money to his workers?
Ummerkunju:	Yes, but I haven't borrowed money from him yet. I only received the money he gives to all of us for the Ramadan. That is a gift, so we need not return it.
Question:	If you accept the gift, does it mean that you engage yourself in coming whenever he calls?
Ummerkunju:	Yes . . . if we didn't he'd scold us . . . But you see, he knows that I am in high school, and therefore he doesn't call me on schooldays. There are always enough other boys who can come whenever he needs them, so if I can't come, there is no problem.

From the budget-study we learnt that during 1979 Ummerkunju earned on average 3 rupees a trip, and that took him some two or three hours of hard work each time. The boss called him for work on 49 days, and his yearly earnings amounted to 144.75 rupees. He spent these comparatively good earnings entirely to meet the costs of schooling.

To adolescent boys the owner loses the harsh traits of the exploiter, which he certainly has in the eyes of young boys, and takes the benign features of a benefactor. The money-gift received during the Ramadan is seen only by the younger boys as bondage. Older boys prefer the image of patronage. They stress the good luck that devolved upon them when the boss sent them the gift at Ramadan. Their family had now someone on whom they could depend if need be. And they themselves did not have to bother any longer about the risks involved in small trade or the uncertainties of finding temporary jobs.

But what is the ideology of reciprocity in fact all about? Though the boys had the obligation to come whenever requested, the opposite was not the case. The owner called them only when full-fledged labourers were either away fishing at sea or preferred, because the returns from fishing were too poor, to set out fish-vending, that is, in the slack season. When prospective returns were substantial, during the *chakara* season, for instance, boys were generally not included in the crew. One of the obvious reasons is connected

105

to the social status inherent in the age-hierarchy. By and large Poomkara people believe the economic role of children to be rather insubstantial, and in this they hardly differ from general opinion. As boys are not perceived as earners there would be no objection, is the general feeling, against displacing them in favour of adult labourers, when the latter are available for work because they expect the benefits to be worth the effort. In a situation of great pressure on employment as in Kerala, this attitude has the side-effect of setting an upper limit to what boys can earn. Whenever this limit is reached, a boy is believed to threaten the earning prospects of adult men who have a family to care for. Boys' earnings are therefore bound to remain within socially-accepted brackets. And this again reinforces the conviction that boys' contributions to production and to the income of their families, is but marginal.

In Figure 4.1, I have compared the hours worked by the four fishermen involved in the budget study in shore-seine fishing during 1979: Ummerkunju (14), Syed (18), Ibrahimkutty (36) and Ummerkutty (38).[1] All of them worked for the same boss. The graph shows that Ummerkunju worked less hours at the beginning of the high season (that fell that year in March) than the three adult men. He worked in May, while Ibrahimkutty had joined the crew of the *tankuvallam*, and Ummerkutty and his son, Syed, had engaged in the more profitable trade of fish. He was called for a few days again in August, just in order to make a few trials at launching the shore-seine. They caught no fish at all, and the boss would probably have

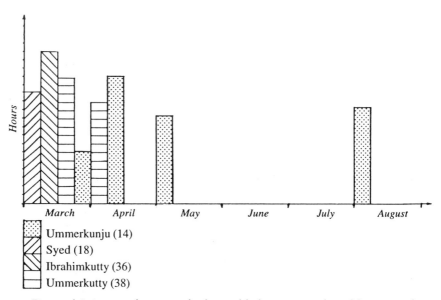

Figure 4.1 Average hours worked monthly by crew workers (shore-seine)
Source: Budget-study (1978–80).

106

been unable to send his workers empty-handed home as he did, had they not been mere boys.

If he is endowed with better mental than physical faculties, a teenage boy may opt for the lonely life of the fish-vendor and will try some serious fish-vending as soon as his kinsfolk feel that they can entrust him with a small trading capital. He will then face real competition from adult fish-vendors, that becomes the tougher as the price of fish diminishes. At the height of the sardine season, when sardines fetch as little as 25 paise the hundred, it becomes quite strenuous to carry the load more than a few kilometres. To realize at least some profit, grown-up men encroach upon the customary clientage of the vendor boys and call at the houses of labourers living just above the sea. It is only when the price is up and their load is less, that they cross the river and go further inland.

For the young vendors who have started upon a professional career, fish loses much of its alimentary value, to take on that of a true commodity. These boys concentrate fully on buying and selling, leaving the younger children, who are just vendors by chance, to scramble for the remnants of the catch. To get a hand in the business, they normally begin retailing only a small quantity of fish, worth often only 5 rupees, bought from one of the bicycle-vendors they come across. In order to be successful, a retail vendor has to be as fast as possible. Moneyed housewives start cleaning the fish for their noon meal by 10 in the morning, and they are more likely to give a good price by then.

Haneefa (12), followed vague trails behind houses, jumping and wading across ditches as he was hurrying from hut to hut to sell his small parcel of fish. It was pretty late that day when I asked him whether I could accompany him. The second haul of the shore-seine had just finished, and it was already 10.30 a.m. Haneefa had bought a few kilogramme of small fry from a bicycle vendor, who was about to start off towards the towns of the interior with half a basket of fish. We set off south of the main road. The three first customers, who lived near the road, were apparently well served, and they took a great deal of time to haggle without finally buying anything.

Haneefa then took me hurriedly along a track to the east, that was leading to the huts of the neighbourhood where he lived. His habitual customers appeared to be coir-making women, who, having just glanced at the heaps of small fry he had arranged in his basket, immediately turned up their noses. Those who seemed keen on buying offered to pay no more than 25 paise, ignoring Haneefa's plea that his fish were really worth 50. One of the women proposed that she should be given fish on credit, and when Haneefa refused, she felt free to abuse him. It was only after he had made a start to leave, that she produced 25 paise to take a little small fry.

It was about 11 a.m. and time was pressing. Haneefa decided to cut his price by rearranging his fish to obtain a smaller number of larger heaps. At that point he found it timely to call on a few huts out of the way, normally poorly served by fish vendors. The wade across a few ditches was worth its while, for he sold 50 and 70 paise worth of fish there. Half an hour later, at 11.30, he had succeeded in recovering his initial investment, and had still about one-third of the fish. The tension on his face released, and he now spoke for the first time to me: 'It's because you came with me today that things are going well. If I am alone, people haggle endlessly, they abuse me in filthy words and some women just steal fish from my basket if I do not give them what they want'.

He now, however, faced the most difficult part of the task, realizing a profit. And it was nearing noon. By the time the *mukri* (mosque servant) started calling for prayer, at 12.30, his business was over. He must try to sell the remaining fish at any cost within an hour. During the first half an hour things went smoothly. He sold without much problem 3 rupees' worth of fish. Now he had about one kilogramme left. One woman called out to him from her hut, asking how much he wanted for the whole lot. He asked for 3 rupees. Now her husband came out, curled his lip and went away muttering: 'We have nobody here to clean this small fry'. He obviously meant that there were no girls in the house. Haneefa squatted patiently for about ten minutes in front of the house, in the hope that the woman, who had gone to the kitchen, would return. She finally did come, but only to tell him to go away. We went, and soon appeared to have walked in a circle, returning near to the junction from where we had started. Haneefa had no other choice now than squat on the roadside, and wait till a passer-by would be wanting to buy what was left. But after fifteen minutes nobody had shown up. He therefore retraced his steps, calling on a man who had proposed to buy the lot for 1 rupee before we reached the junction. This attempt too proved unsuccessful, as his customer had bought fish from another vendor. The *mukri* started calling through the loudspeaker attached to the top of the mosque's roof. At that very moment Haneefa decided to stop trying to sell the remaining fish, and took leave. He was going home to bring the fish to his mother, quite satisfied by having made 3 rupees profit.

For those who have the backbone, on coming of age new opportunities present themselves. These may depend on whether a father has commercial skills he can pass on to his son, but also on the latter's inclusion in a group of peers, with whom he can exercise these skills without incurring too great losses. Learning to be a fish-vendor is more of an informal group process in which peers interact and share experiences, under the leadership of a

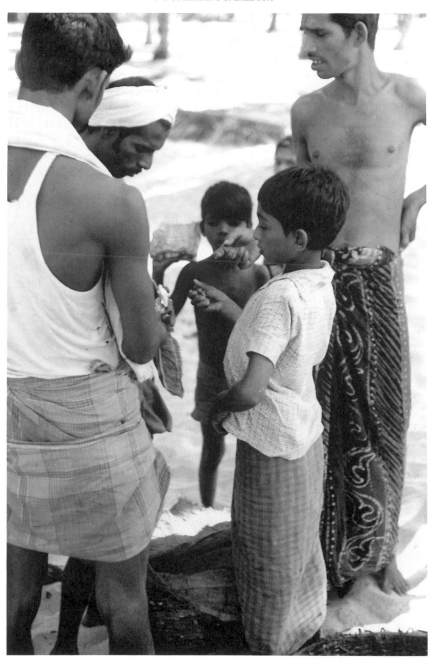

15 Haneefa buying a small quantity of fish to retail in the neighbourhood

somewhat more experienced boy. It is only after he feels confident that he can face the competition of adult vendors and operate individually, that a boy will leave his peer group and start working on his own.

Mustapha (15) and Sharif (15, see also the prologue) possess only a small basket to carry fish, a piece of sack to protect it against the sun's rays and a bundle of about 30 to 50 rupees thrust into the waist-folds of their loin-cloth. When Mustapha and Sharif were smaller they used to spend much time recovering fish from the shore. Later, Mustapha pulled the shore-seine for a few years, selling a little fish occasionally if he had the opportunity to do so. Sharif spent much time in high school and matriculated last year. For one year the boys have been entrusted with their own trading capital. If the price of fish is not too high, they may buy a full basket containing 30 odd kilogramme. Alternatively, they may buy the share of a fisherman in kind, perhaps a few parcels at a time, as long as they get enough to set off retail-vending. At times they may also decide to remain on the sea-shore just to strike deals with bicycle vendors passing by, either selling or buying fish, depending on the price of fish and the hour of the day.

Adult fish dealers and customers always suspect them of dealing in 'second grade' fish, that is, the ones foraged from the beach. The small volume of their business is a liability as well, contributing to lower prices than those fetched by adults and, in particular, bicycle vendors.

Dealing in fish is less exhausting than calling on housewives, but earnings are modest too. One day I, for instance, counted but six sardines in Sharif's basket and a few prawns he had bought from a cycle vendor for 1.25 rupees. He had to wait a long time on the roadside before one bicycle vendor stopped to offer him 1.50 for the lot. Sharif turned his offer down and waited again until another vendor stopped to haggle with him. He finally succeeded in getting 1.75 for his merchandise. A whole morning of trading had produced a net profit of 50 paise, which he promptly went to spend on tea and snacks, for by the time he had disposed of his fish he had become very hungry indeed.

About the small coterie of vendors, all boys of his neighbourhood, which he joined last year, Sharif says the following:

Of the five of us, three are older than me. They have a long experience in trading, they were 10 or 12 when they started. We have no leader in our group, we all put in an equal sum, so there is no need to have one. We buy fish in partnership. After having sold the fish we share the profit and each returns his initial capital. We never decide in advance whether we are going to join together or to sell fish separately. It all depends on the price of fish. If it is very expensive, then we pool our

money and bargain for one full basket. We share the fish, sell it separately, and then share the total profit equally.

There are other ways, too, to get fish for sale:

> There are different sections in the boats, and fourteen fishermen work on it. Occasionally they are able to hide some fish in one of these sections, without anybody noticing. We boys act as their agents to sell that fish. It isn't much, but at least we make a little profit. In this type of business we work on our own. But if I can buy a whole basket, I will call three or four of my friends and ask them to join in, because I cannot possibly retail a whole basket on my own. Even if I were able to pay for it, it would still be much too heavy. If we start a partnership, then we must share the risk and the profit equally, whatever each of us has been able to resell.

Fish marketing is full of uncertainties and money is easily lost. It involves a fair amount of calculations, knowledge of fishing and of the market, in addition to a good deal of stamina to carry the load to inland customers. Poomkara boys often show themselves as apt traders, learning early in life the keen bargaining sense characteristic of fish-vendors. Sharif:

> Suppose the catch consists of sardines and that there are some 1,000 sardines in a basket. If I buy a basket for 100 rupees, then each sardine has cost me 10 paise. I have to make some additional expenses, such as for fees to the porters and for ice. To get a profit I therefore will try to sell the sardines for 20 paise each.

The main risk is that the price might fall during the day if catches suddenly prove to be better than was expected:

> Suppose the takings of the first boat to return are small. We merchants are then likely to believe that the price of fish that day will remain high. Perhaps that sardines may then fetch 120 rupees a basket. But if a little later the remaining boats return with good catches, there will be a sudden glut and the price may fall to 50 rupees a basket, bringing the retail price down from 12 to 5 paise apiece. The merchants who bought the takings of the first boat will then lose not only their prospective profit, but also part of their capital. I once lost 10 of the 20 rupees I had that way. I had to refill my capital by reinvesting the profits I could make with the 10 rupees left, and had no income for some days. I had no money to give at home. Otherwise, if I earn, for instance, 5 rupees, I will give 3 to my father and keep 2 for myself to spend in a tea-stall. I also bring home fish for preparing our meals, if I have any left.

Many boys consider fish-vending a far better job than working the shore-seine. One of the obvious reasons is that it is physically less exhausting: 'Why

kill myself for the boss if I can earn a living without working?', as one of the young traders replied to my question about his motives for choosing the job. This answer also expresses the higher status of the job, doing business being by and large believed to be an activity of a higher order than the heavy manual work that is implied in fishing. Even if customers and dealers do not shy from using the age of the vendors to depreciate the price of their merchandise, there is still the greater independence which shore-seine labourers do not enjoy. There is ostensibly a different demeanour, vendors requiring to radiate self-confidence and keenness. By contrast, as discussed above, a crew worker is believed to befit humility and compliance. While the worker keeps his eyes glued on the ground and feigns ignorance of financial aspects of the fish business in the presence of the owner, the vendor faces the owner with head high, and is the first to offer a price. Mentally, vendors are more confident than workers, in that they can manipulate their surroundings so as to manage without depending too much on the goodwill of a patron. Adolescent boys who start upon a career of vending may indeed also feel like experimenting with other types of business than the fish trade. Some may secretly risk their capital at gambling or money-lending. Others may embark on short-lived trading adventures, like Alikutty, who earned a good profit retailing meat during Ramadan.

Other factors may play a role in the final choices a boy makes. The need to have a dependable patron who offers credit in times of need may incline some to stick to the owner-fisherman's crew. But many may have no clear future plan at all, and simply take whatever possibility presents itself. In fact there is often an accumulation of tasks taken up by adolescent boys, carried out either in consonance or intermittently: schooling, trade, wage labour, assistance in home production of copra and coir, training and, finally, providing services to a patron to retain his good disposition. Of all these, schooling is on the way to acquiring growing importance. But fisherboys' achievements in school still lag behind when compared to the Poomkara average (see Table 4.1). For one thing, the cultural framework within which the patronage relations of fishermen are set, makes for fishermen's children to show little propensity to seek self-betterment through education. As discussed in the previous two chapters, the local patrons suspect schools of undermining the subservient attitude that suits a client, and in particular to foster improper demeanour in women. As many as 51 per cent of fishermen's daughters age 5 to 15 have never been to school, and none has gone to high school, which involves schooling after menarche (see Table 4.1). But another, possibly even more important, reason is that boys' fishing has provided fishermen's families with a more or less steady source of food and cash, which can hardly be missed.

It is clear then, that without the assistance of boys on the beach, artisanal fishermen would be severely handicapped in carrying out their activities. Artisanal fishing is an irregular and unpredictable activity, with huge

Table 4.1 Educational level of fishermen's children (5–15)

	Male	%	Female	%	Subtotal	%	Total Poomkara	%
No schooling	33	20	65	51	98	34	199	20
Lower primary	83	51	51	40	134	46	539	55
Upper primary	36	22	12	9	48	16	183	19
High school	11	7	–	–	11	4	63	6

Source: Field census, 1978.

imbalances in terms of the labour needed at the various stages of operation. The bunch of boys allured by a little fish can, during the short-lived but critical stages in which labour demand suddenly rises, easily be brought into action. The marked seasonality of some equipment is another source of fluctuation in the demand for labour, solved by the boys' willingness to work. By recruiting a crew of teenagers, an owner-fisherman can work his equipment even during the less productive period, in the weeks just before and after the main season. If successful, he is assured of a higher income from his investment. If returns are disappointing, the whole operation costs him but a trifle anyway. There is however a third, more fundamental aspect of the activities of boys, that has a bearing on the relation between the men of the crew and their employer, namely the cost of labour. I discuss it below.

PRIVILEGE AND DUTY

As boys meet their own consumption needs in fisheries, they also relieve owner-fishermen from the responsibility of paying the men enough to feed their family, and even to maintain themselves in times of crisis. To understand why, one should consider the interaction between men's work and the activities of boys, girls and women. Looking at these activities from the owner-fisherman's point of view, the remuneration of the crew has two components. The first one, obviously, consists of the necessary payments that enable the men to replace the energy spent during the fishing operations. As said, the men of the crew are unlikely to work when the prospective returns are too low. The second is more deep-seated, though no less crucial: the payments made in view of maintaining and replacing the worker in the long run. As discussed above, the owner-fisherman does make occasional ceremonial payments that strengthen, over longer periods of time, the personal ties with the men of the crew, by, for instance, giving gifts and loans and allowing their children to forage for fallen fish. This second component of the men's remuneration, nevertheless, tends to remain

marginal, being in no way sufficient to maintain the worker in illness or unemployment or to meet the requirements of women and children.

Children's expected roles are very much attuned to the fact that adult men lack any basic security in times of crisis and are often even unable to maintain their families. Growing up in homes in which food scarcity is a perpetual problem, no words need be wasted to send them on their foraging expeditions. Fish is an important item of the daily diet, and fishermen's families have a strong aversion against being kept short of fish. There is the maternal encouragement, women being forbidden to venture on the beach when the fishermen are working. Children's foraging habits allow the whole family to get fish for free when men are away and cannot provide for their families:

Question:	When your father is away fishing in Malabar, does he send money home?
Jasmin (10):	No, we earn some money by ourselves. And there is *ummumma* (grandmother) to help us.
Question:	Do you go to the beach to watch the fishing?
Jasmin:	Yes, to pick up some fish. If father is in the crew he will give me his share to take home. Otherwise I pick up whatever has fallen. Some boys get scolded because they steal fish from the net or from the auction baskets. We girls don't do such things. I sometimes give my basket to Ali Molali, and he puts something in it when the catch is good. But if the takings are small, I can't ask. Then I'll have to scramble with the other children for whatever falls on the sand.

Customary beliefs about the nature of artisanal fishing, make for children's foraging habits to be generally recognized as legitimate. The fish landed by fishermen is not considered personal property, at least as long as they have not been sold to fish traders. It is an old Arayan belief that fish is a gift of Kadalamma, the goddess of the sea, and that fishermen therefore can claim no exclusive right to it. Also Muslims adhere to the belief that if fish have been driven into their nets, nobody should go hungry for want of it. In practice, this means that when there are bumper catches of cheap fish such as sardines, anyone present will be given some domestic fish simply 'for having brought good luck'. But even after less successful expeditions, children may always collect fish that has fallen on the ground. It just does not suit a man of the standing of an owner-fisherman, whose success depends on his being trusted by his crew, to show greediness. He may arouse fear in his men that fate might punish them all by causing their nets to tear or their boat to capsize during a storm. Prompted by their dependence on the unpredictable sea, fishermen are generally of a generous disposition.

Greediness and lack of compassion for the weak and the poor, and in particular for children in whom there would be a divine presence, are believed to be highly dangerous attitudes.

The fishermen's customary beliefs and their emotional need to trust the owner of the equipment, however, often clash with the new possibilities of converting fish into cash. The outcome of the tensions arising herefrom is, that during the high season of the commercial varieties, the owner-fishermen may abide less strictly by the customary rules, and tend to portray children's foraging habits as illicit:

> I once assisted at an accident that caused the financial interest of the owner to clash with his otherwise tolerant attitude towards the gangs of children present on the beach. While a very good catch of sardines of near to a tonne was being landed, the shore-seine got suddenly torn. The small boys and girls who had at first stood patiently waiting to pick up a little fish, rushed all of a sudden screaming into the sea, trying to catch with their hands the escaping fish. As the net was dragged onshore, hundreds of fish jumped on the sand, the excited children running to pick them up and putting them in whatever small basket or paper bag they were carrying with them.
>
> This was too much of an impudence to the owner. He suddenly flew into a rage and taking handfuls of wet sand he threw them at the children while abusing them in obscene words. The children slowly withdrew, but not without taking a few more fish to add to what they had already laid their hands on. The boss's rage was justifiable, in so far that children had been trespassing their customary right to forage fish for domestic use. A little above the beach indeed, fish vendors, some barely 10 years old, were already awaiting them to buy their surplus. But on the other hand, their behaviour was legitimate, in so far that the fish had escaped from the net, and was therefore not the owner's property any longer. That the net tore at that particular, critical moment, could not have been merely by accident. Everything that happens during fishing operations is believed to be the outcome of a premeditated, although inscrutable, divine plan. As apologies to the crew or the children were out of the question, the owner came to me, who had stood observing him, saying how sorry he was that he had hit me with the sand. In recompense for the good fortune brought by my presence, so he said, he presented me with two handfuls of fish.

Foraging is an essential aspect of the subsistence of fishermen's families. Though it may not amount to much, it does, however, contribute substantially to the diet of their families. How much, exactly, is difficult to tell. An indication may, however, be found in the fact that fishing households consumed free fish for most of the year, including the long periods in which their men were either absent or ill (see Table 4.2). According to another

Table 4.2 Fish foraged by children in fishing households

	Households	
	*Fishing**	*Non-fishing***
Days with purchased fish	3.5	30
Days with free fish	33.0	7
Days without fish	4.5	5
Absent	1.0	–

* Average fresh fish consumption in Ibrahimkutty's (sea-fisherman) and Ummerkutty's (shore-seine fisherman) households on days preceeding the 42 budget-study interviews.
** Average fresh fish consumption in all other budget-study households except the one of a young fish-vendor without children, who brought daily fresh fish home.
Source: Budget-study of 12 poor households, 1978–9.

computation of the same data, about one quarter of the fish consumed by households with at least one boy aged between 5 and 15, was free. By contrast, households with only very young boys or none, had to buy 93 per cent of the fish they had eaten.

Generally girls' foraging activities are limited when compared to those of boys. With the onset of menarche, a girl is likely to be kept more tightly under the chaperonage of her mother. She is supposed to avoid contact with the rough lot fishermen are, by and large, believed to be, lest she loses her reputation as an honest girl. In the words of 7-year-old Rajeena, who is a fisherman's daughter:

I have been going to the sea-shore from the age of about 2. But after 11 I'll be forbidden to go there. My mother won't allow it, because it's shameful . . . I'll be grown-up by then . . . (she laughs shyly).

Question: What would happen if you were to go against your mother's wish?
Rajeena: She would beat me.

Present-day girls may be less inclined to abide by these rules of demeanour without protesting, than in the past. Rajeena's mother feels that in her childhood girls were more submissive:

In my childhood a girl would not go to the sea-shore at all, it was simply forbidden, and she obeyed. Today's girls are simply going without even saying . . . who can control today's children? I do not object to my girls going anywhere, they may go to school, to shops . . . provided they don't go to the sea-shore.

Girls' activities in fishing are anyway very much circumscribed, and although disregarding the rules may not be altogether impossible, the reality is that

upon nearing their teens they have little chance to escape from the demands of work at home.

A boy's foraging activity by contrast, is likely to increase with the years. He will have discovered early that the result of his endeavour can provide him with petty cash to spend on snacks that help appease his hunger. With the passing of the years, the demands of parents may also start taking on a more compulsive character. A boy's father may, for instance, accept the money gift sent by the shore-seine owner for Ramadan, without his son having much say in the matter. Conversely, if he judges it convenient, he may opt for initiating his son in trade, and entrust him with a small capital. The need for direct returns may not always be the sole reason for a father's behaviour, but it is certainly a major component. Besides the desire for fish and the need for cash, there is also the idea that boys must satisfy their hunger at any cost. In many poor homes warm food is prepared only towards the evening. Eating to his fill is perceived as a major investment in a boy's future, which depends much less on his age in years than on his physical growth and resilience at work.

The feeling that he has a duty to perform towards the maintenance of the family is an additional reason for a boy's activities. Though Haneefa, Ummerkunju, Mustapha and Sharif all have concerns and priorities of their own, they share in common that whatever they are able to make, bringing food home is always at the back of their minds. It is as if the relative privilege of leaving the home in search of the food they enjoy, also makes them responsible for their mothers' and sisters' welfare. It is this responsibility that may make them accept being pledged to an owner-fisherman. Teenage boys know that if disease or death strikes the earning male of the family, the task of earning the cash needed to maintain their families, to pay for hospitals and medicines, and to perform such necessary ceremonies as the marriage of sisters and the circumcision of younger brothers, is upon their shoulders. A benevolent patron is then an invaluable asset. Gifts and loans are an important source of credit and represented, for instance, 36 per cent of the total income of the poor households that participated in the budget-study (see Table 4.3). The need to realize an income is often so intense, that the event of his having to return home empty-handed can arouse violent tensions in a boy. For some stealing may be a means to come to terms with these tensions, particularly when the price of fish soars to the point that he is thrown out of business. This becomes apparent when commercially-highly-valued varieties of fish are landed, and in particular when motor boats operate. Dealers and businessmen who have no customary ties with the fishing community, and therefore are alien to their beliefs, may often violently expose what they see as the criminal activities of these teenage boys on the beach. It is true that the boys are not properly foraging for subsistence and that whatever prawn they are able to recover from a net, a hidden corner of a boat, by sieving the sand with their hands or simply grabbing a handful

from a basket, is readily converted into cash. Scuffles often arise between reckless boys and traders when the catches fail and the price of prawn is therefore high. The temptation to pick a few prawns may then be quite irresistible. Keeping a vigilant eye on a handful of prawns while the haggling goes on, is, for a trader, not always the most commendable thing to do. The allurement of easy money, combined with the admiration one can command among one's peers, often urges boys to show bravado again in spite of the risks involved. These adventures never lead them, though, to their home beach. They are true expeditions to unknown places, and the fishermen and traders who suffer the losses are unknown as well:

> Basheer (15) is expert, so he says, in stealing the *naran chemmeen,* and has been beaten and kicked many times when caught red-handed. Two days back, he was caught by Arayan fishermen, who took him with them to their boat, beat him up and kept him tied there for some hours. The fishermen came from Quilon, and were particularly cruel, he feels, because their catches had been disappointing. Of course, their anger was also justified because he stole costly prawns . . . were he to take only small fish, they would not have beaten him like that.

But the point, I believe, is not so much to steal, although it turns out that way so often. It is to earn an income that the family badly needs, and it is

Table 4.3 Yearly income of poor households

	Yearly income	%
Income in cash:	5192	92
– wage work	1455	26
– sale of products	1898	33
– gifts	645	11
– loans	1104	19
– govt. allowances	90	2
Income in kind:	470	8
– wage work	133	2
– barter	14	–
– gifts	159	3
– loans	154	3
– govt. distribution		–
Total	5662	100

Source: Budget-study of 12 poor households, 1978–9.

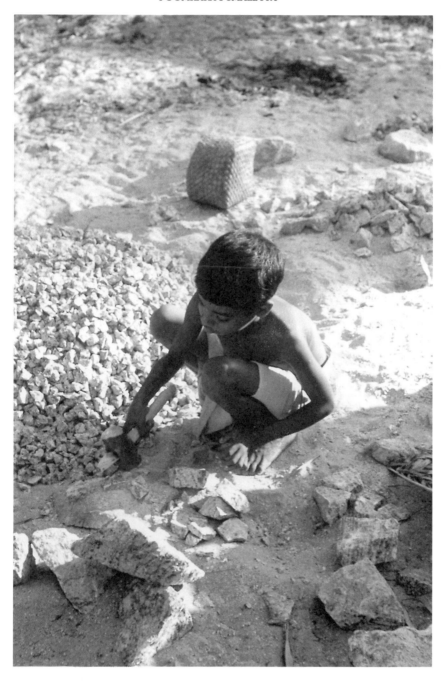

16 Ashraf helps to tide his family over the off-season by crushing stones

against the exclusion from income-generating activities that the boys revolt when they take what, they believe, the sea has given for free and a few want to keep for profit. That this amounts to theft in the sense of stealing personal property is rather a new manner of conceiving the relation between the sea and the coastal population. It, anyhow, clashes with what the boys believe are their customary rights and this makes it the more difficult for them to accept it.

Many fishermen can depend on their families in the off season, and the activities deployed outside the ambit of fisheries are particularly important in this respect. I have already given the example of Ibrahimkutty's family, in which the wife and daughter worked to tide over the long periods in which he was sick. Sons are even more likely than daughters to have a variety of sources of income, as the case of Ummerkutty's household highlights:

> Khadija (35, see also Chapter 5), Ummerkutty's wife, is a very resourceful woman. Her activities range from coir-yarn-spinning, to the sale of gravel which she makes by crushing stones, of paper bags glued from newspapers, and of plaited mats. In 1979 these activities yielded near to 400 rupees, 30 per cent of the household's income. In her activities, Khadija is assisted by her two sons Ashraf (10) and Mujeeb (6), her 2-year-old toddler just watching and playing near to them. When not fishing, her husband may occasionally also be of some help. In 1979 the two brothers used to fold and paste one to two kilogramme of old newspapers into paper bags every week. The bags were sold to a grocer, who uses them to pack sugar, lentils, spices, etc. This earned them weekly 0.60 to 1.20 rupees, totalling in the course of a year 2 per cent of the family income. If given enough paper, Ashraf, who is the eldest, would work up to ten hours a day. When out of paper, he would pick up fish from the sea-shore, run errands for the neighbour, crush stones, rotate the spinning wheel and do much of the fetching and carrying that coir-making engenders. His younger brother Mujeeb, when not assisting his mother and elder brother in their daily activities, was the main caretaker of the toddler.

Boys' fishing, in sum, takes place in a paradoxical situation. The lower the returns of a particular type of fishing equipment, the more likely it is for boys rather than for adults to be engaged to work it. The income generated by boys in fishing is therefore, per definition, marginal. But though their earnings are often extremely small and the work is generally held in low esteem, what they do is necessary to satisfy their subsistence need. Together with the earnings of women and girls, they enable the family to buy food during the lean season and generally help in reducing the cost of labour engaged in fishing. They are therefore essential to ward off the effect of starvation wages on individuals as well as on the families of which they are part.

5

HANGING BY A THREAD
Coir-making girls

Housekeeping is girls' mandatory responsibility, and as such gives but little occasion for roaming about along the shore as often as boys do. Customary beliefs about the nature of fishing and fish-vending set additional limits to girls' participation in these 'manly' enterprises. Instead, girls make coir yarn, which is perceived as a womanly craft, except for the first processing of the raw material, and the bulk transport and marketing, which are men's affair. Very much in the same fashion as boys in fishing, girls' role in coir-making is important for both the industry and the livelihood of the family. But because of the domestic nature of the industry, what they do tends to remain indistinct from the totality of housekeeping chores, and therefore turns out to be but exceptionally perceived as true 'work'. In Chapter 3 I have discussed data obtained from the budget-study that suggested that girls devote on average six hours a day to domestic tasks, and only little more than one to productive work (see Table 3.6). Following broadly the same line of thought as the last chapter, I probe here into how the work performed by girls in coir-making relates to these domestic responsibilities.

WOMEN AND MERCHANTS

Although coir yarn is produced in large quantities all along the Kerala coast and involves anything between one hundred thousand to one million workers, nowhere is this massive character of the industry visible. Only the ever-present beating sound produced by the mallets wielded by women and girls processing husks into fibre, that fills the air of coastal villages, reveals the importance of the industry. In Poomkara this sound, coming from the remotest homesteads, is heard from sunrise to after sunset. But one has to peep behind the palm-frond fences that surround the huts to see women and girls at work.

The manufacture of coir yarn is essentially a domestic activity undertaken by three to ten women and girls with the sporadic assistance of males.

Though it used to be the customary activity of Ezhava females, today it is undertaken by poor Muslim women as well. But there are still differences and of all Ezhava females older than ten, as many as 45 per cent engage in coir-making, against only 27 per cent of the Muslim females. There are also differences, as I shall show further on, in the way their work is organized.

The small group normally starts the process of manufacture by borrowing an amount of about 200 rupees from a yarn merchant, with which they acquire retted husks from a local dealer. These husks, consisting of the membranous outer covering of coconuts, which have been left to soak (retting) for about three to six months in the brackish water of ditches and canals, provide the raw material for the industry. The soaking loosens the fibre from the woody tissue of the husks and makes it supple. Once the husks have arrived near the processing spot, they are torn into three to four pieces (*pola*), and stamped with a long, heavy stick to break them. Thereafter they are kept in the water of ditches or ponds near the family's place, to be processed to obtain coir fibre within a few days. To this effect, each *pola* has to be beaten manually, with a short, heavy club (*kottuvadi*) made either of metal or of hardwood. Beating is done in two stages: the first time briefly, so that the husk can be peeled, the second time at length (thirty to one hundred blows may be needed) to separate the fibre from the granulous residue (*chakkiri choru*). In Poomkara it takes eighteen working days of about six hours to process 500 coconut husks into fibre.

Having obtained fibre, it now has to be prepared for spinning, an operation done either by manually shaking it with the help of short bamboo sticks, or at a local mechanical mill, depending on its quantity and the urgency of the work. The way yarn is spun depends largely on its quality. The yarn spun in Poomkara is white and is known as Aratory, an anglicized form of 'Arattupuzha'. This type of yarn is spun on a four-spindled spinning wheel. Although not as regular as the Anjengo and Mangadan varieties which are produced around the Quilon area, it is superior in softness and in runnage. Also its whiteness makes it excellent for weaving coir carpets and floor coverings.

A set of spinning-wheels (*ratt*), used to spin and twist yarn, is operated by two spinners and an additional (the rotator) worker who turns the immovable wheel (*amma*, 'mother') manually. The spinners feed the fibre with both hands, carrying a bundle of it wrapped in a cloth tied on the waist and move slowly backwards for a length varying between 9 to 13 metres, obtaining two threads each. The spinners then join the two threads and hook them on the spindles of the movable wheel (*kunju*, 'child') in order that it be twisted into a yarn of 7 to 11 metres (*izha*).[1] To make yarn out of the fibre obtained from 500 whole coconut husks, about nine to twelve working days of about six hours may be needed. The last operation, rolling and bundling the yarn, takes half a day. When the yarn is ready, it is brought by the spinners to the yarn merchant or to the Coir Co-operative Society, and then

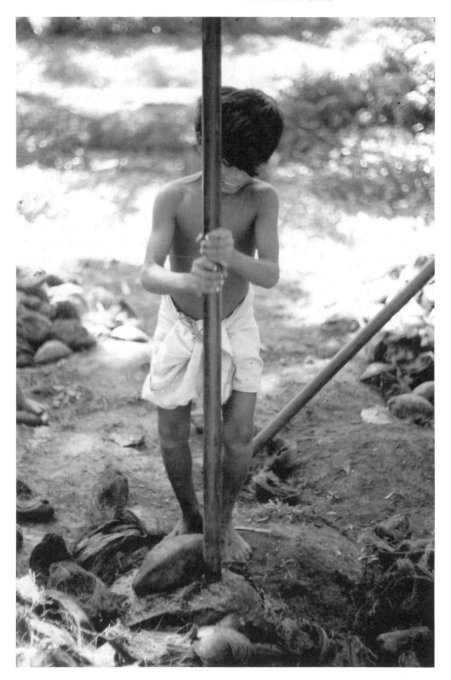

17 Boys can earn some cash by hiring themselves out to stamp the husks

taken to nearby markets. The difference between the amount borrowed to acquire husks and the price obtained from the yarn represents the remuneration of labour. It may be partly used to pay the wages of the hired workers, but most often it is readily brought to the grocer who has provided the women with household necessities on credit while they were making yarn. As I will discuss below, there is often hardly any margin of profit for the manufacturer.

The majority of workers in the industry are females. They perform such tasks as beating husks into fibre, spinning, and turning the spinning wheel. Old men and boys may also be seen rotating the wheel, while young boys will beat a few husks in the early morning. Adult men do not make coir for fear of ridicule. The few who do, work only when they are sure that no one can see them, a condition that is difficult to realize. A coir worker can be easily identified by her appearance: her clothes, body and hair are soaked with the stinking black juice of retted husk that splashes around during the beating, her hands are calloused from wielding the *kottuvadi* and from the hard fibre rubbing along the fingers and, if she is a life-time spinner, her feet are curved outwards as a result of the endless walking towards the back while spinning. Where most male work comes in is therefore in the first stages of making coir, and men ply boats laden with the bulky, rotting material from the retting ditches to their homesteads and carry basket loads of it on their heads. Other tasks not directly related to yarn-making may be performed either by males or females: preparing a retting pit in the neck-deep water, taking the retted husk from it, crushing it with the stamper, carrying the fibre to the winnowing mill, rolling and packing ('hanking') and carrying the yarn to the dealer or the Coir Co-operative Society.

The owner of the spinning-wheels, either the male or female head of a yarn-making family, is the one to control the work, to borrow money from a yarn merchant to buy husks, to resell him the yarn and to pay the wages. Although owning the means of production, he or she does in no way enjoy a position of privilege similar to that of the owner-fisherman. On the whole, coir manufacturers run mostly tiny family enterprises, although some may be bigger than others and run two sets of wheels. A limited number of coir merchants run three, four and sometimes even more sets of spinning-wheels, relying hereby mostly on hired labour, when the price of yarn is up. I call them 'merchant manufacturers' to distinguish them from the domestic producers who run only one pair of wheels. During the census I counted thirty households that were making coir on a rather large scale (see Table 5.1), eighteen Muslims and twelve Ezhavas. At a closer scrutiny, most of these units were, for all practical purposes, run by women, the men being in charge of trading the yarn. Trading activities earned most of these men about 100 Rs a month, and only two much higher profits.

It is unlikely for merchant-manufacturers to make much use of family labour, though I came across the case of the head of a prominent family that

124

Table 5.1 Coir workers by type of work and gender

Type of work	Males	Females	Total
Hired beater and rotator	2	234	236
Hired spinner	10	155	165
Home manufacture	83	325	408
Merchant manufacture	33	23	56
Trade	4	–	4
Total	132	737	869

Source: Field census, 1978.

had both his wives and several daughters all working side by side with hired workers. But in general, if coir-making can be carried on on a sufficiently large scale and survival is ensured, women belonging to this social group would prefer, rather than to work as a spinner themselves, to combine supervisory work with housekeeping. These women are more concerned with upkeeping their status as well-to-do housewives than with earning an income of their own. Their daughters too, may combine housekeeping with going to school, and only on rare occasions join in with the labourers to make yarn. On the whole, however, profits realized by manufacturers are so modest that making coir is not profitable if much use has to be made of hired labour. As I shall show below, most yarn-makers depend on a few large retters. The latter's ability to increase the prices of retted husk as soon as the market price of yarn increases, makes for the margin of profits of yarn-makers to roughly equate with the actual cost of labour necessary to process a set amount of husks into yarn.

Husks are brought down by countryboat from hilly places such as Kottayam, Mavelikara and Ranni and acquired by retters who use ditches on their land in which they can keep the husks for a few months, to be able to resell them with a profit. Most retters are, in fact, reasonably-large coconut growers whose main concern is making and dealing in copra. They also acquire coconuts from smaller growers, and deal in retted husk as a side business. There were only three such large-scale retters in Poomkara, two Muslims and an Ezhava, who was also trading in yarn. Part of the unretted husks are by law to be sold at protected prices to the local Coir Co-operative Society to be distributed, after having been retted, among its members for processing. At the time of the field-work the protected price was set at only 75 rupees per 1000, half the ongoing rate in the open market.

But most of the husks are sold against market prices, and it is upon their sale that the profits of the dealers in retted husks largely depend. Husks can be stored without incurring the risk of loss or waste for months

on end. The dealers are rarely inclined to give husks on credit. Most of what the credit manufacturers need is, therefore, provided by merchants in yarn and grocers.

The yarn merchants are small middlemen who operate between the manufacturers in the countryside and the large coir exporters in Alleppey. The market structure is very similar to that of fish, the final price being daily set by the Alleppey exporters. Local merchants mostly lack the financial backing needed to bargain for a better price than the one offered by their agent, even when the price of yarn is high. Their main concern is to recover the money they have lent to the manufacturers to buy the husks, in order that the latter may start working again. Their trading profit depends, in the last resort, on the speed at which their small capital circulates.

Modest price increases of yarn are readily lost to the husk dealer, who, as soon as the price of yarn is up, can create temporary scarcity of retted husks to realize a price increment (see also Schampers 1984: 49). A clever dealer may, by manipulating his stocks, pocket as much as 50 to 65 per cent of the final price of yarn that leaves Poomkara.[2] The husks so dearly sold to yarn-manufacturers have but very little value in themselves, and in parts of Kerala where they are not in demand to make coir yarn, they are simply used as cheap fuelwood. But scarcity of both employment opportunities and raw material combine to force the manufacturers to buy most of their husks at the higher prices set by the husk dealers. To realize quick profits, the retters may even provide the manufacturers with insufficiently retted husk, without the latter being able to resist or protest. Government policies do provide small manufacturers with some leverage against the husk dealers, and the quota of husks that have to be sold to the Coir Co-operative Society is a continuous matter of dispute.

So, even though yarn-manufacturers are at first sight 'independent' producers, their economic stringency and the debts they have to incur to remain in business, turn them into workers with a social position very similar to, for instance, members of a fishing crew. Production therefore tends, as already pointed out above, to remain limited to domestic units working one single set of spinning-wheels with or without the help of hired workers, depending on the composition of the household.

Of all those who engage in making coir yarn, nearly half belong to small domestic units who produce their own yarn and resell it either to merchants or the Coir Co-operative Society (see Table 5.1). As it takes nearly twice as many days to make fibre than it takes to spin it, and many spinners are physically unfit to beat, some domestic units hire women and girls, either only to make the fibre or to complete a spinning team. The wage rate for a spinner being two times higher than that of a beater (2.50 rupees against 1.25 in 1980), and the work being lighter, when given the choice, the women of a domestic unit prefer to keep the spinning for themselves and hire someone for beating only. For turning the wheel a hired worker is paid only 1 rupee a

day, but here also, as the work is light, it is most often reserved for women of the household who lack the strength needed for beating.

According to the field census, out of the 714 females above the age of 5, 389 (43 per cent of all women) were hired workers (see Table 5.2), of which 64 per cent were Muslim and 35.5 per cent Ezhava, which reflects their respective strength in the population. A disproportionate number of those working in domestic units, that is, 67 per cent, were Ezhava. However, this does not imply that the Ezhava women normally hire Muslims to meet labour demands. Though this does occasionally happen, Ezhava domestic units prefer as a rule to save on wages by using the labour of their children. Most Muslim-hired workers work for manufacturing units which meet part of their labour demand by having their fibre made on a putting-out system. Merchant units have profited from the growing number of poor Muslim women willing to work on a putting-out system. These women form, in fact, a clientele on which they can depend for cheap labour and processed fibre, though they have to defray some additional costs by giving them small advances in times of need. If they have fulfilled this obligation, they feel there is no objection against their converting the dependency thus created between them and the women into profit. This has not affected basically the deep feelings of personal loyalty of the women towards their employers.

Among the hired workers there is a difference between those who work side by side with the members of the unit and those who process husks on a putting-out system. The former often receive some food (but not a full meal) and tea during work, while the latter receive just their wage, from which they have to deduct the charges of transportation between their house-sites and the unit. As it turns out, this is an option often chosen by Muslim women who prefer the lower earnings in the putting-out system to the loss of face which they feel would follow from going out to work for others. The putting-out

Table 5.2 Female coir workers by age group and type of work

Age group	Hired beater	Hired spinner	Subtotal	Domestic workers	Total workers	Total females in population	%
1	2	3	4	5	6	7	8
5–9	5	0	5	8	13	260	5
10–14	45	0	45	45	90	221	40
15–19	41	6	47	57	104	223	47
20+	143	149	292	215	507	951	53
Total	234	155	389	325	714	1655	43

Source: Field census, 1978.

system followed among the Muslims, is, as I shall show, often part of a patronage relationship that involves also the rest of the family.

The merchant manufacturing units work the wheels every day if required, but the smaller units, rarely more than two days at a stretch, making fibre the rest of the time. In general, scarcity of husks and the low demand for coir products combine to depress employment opportunities, though domestic units have generally more work than hired workers. Domestic workers belonging to the nine households processing coir yarn included in the budget-study sample, for instance, worked during 1979 on average 95 days, while hired workers found employment for only 60 days.

The rate of turnover of domestic units, incidentally, is extremely high: the women of a household may start manufacture by borrowing husks, renting a set of wheels and hiring workers, but a few months later, unable to repay the debts incurred, have to work, to earn their livelihood, for someone else. A pre-condition for being able to start again in business is that they repay their debts with the coir merchant. This may be a condition impossible to realize for years on end. What attracts women towards self-employment are the relatively higher daily earnings when compared to those of hired workers. Access to credit from coir dealers is another reason for seeking self-employment. On the other hand, as the risks involved are quite serious (debts may be incurred which cannot be cleared in time, for instance, because of illness or bad weather) experienced women workers may sometimes prefer to hire themselves out to avoid these predicaments:

The case of Khadija (35), who is shore-seine fisherman Ummerkutty's wife (see also Chapter 4, section 4.3), is illustrative. She started her own coir unit a few months after we had begun our budget-study. Previously, she had been plaiting mats and breaking stones with the help of her two sons of 10 and 6. Being an enterprising woman, she had used part of her earnings to buy small quantities of husks from her neighbours. Once she had collected about 700 husks and had soaked them in a nearby ditch for about four months, she bought a worn-out spinning-wheel and engaged two neighbouring women to help her. Her sons would help her in transporting husks and yarn, as, being a Muslim, she would not be able to go to the dealer herself. After three months, after she had regularly supplied yarn to the dealer and bought husks with her earnings, she asked him to give her 310 rupees in advance. She needed the money to pay for the grocer that had given her credit, and for the balance wages she owed to her workers.

One month later she asked for a second advance of 100 rupees, as by that time her husband had come back from the village where he was working as a fisherman. With a loan from the government and the credit given by the coir merchant, they now bought cement and bricks in order to realize their lifelong dream: the construction of a house. By

the end of the year Khadija had sold coir worth 2,740 rupees, but had spent 2,423 on wages and husks. Her 'profit' was only 317 rupees, while she had worked 90 days herself, her husband had helped for 30 days (rotating and winnowing), and her son Ashraf (10) had done most of the fetching and carrying of husks and yarn. She earned even less than all of them had hired themselves as workers. The latter strategy, however, would have hampered their being found creditworthy by the coir merchant, and frustrated their plan to construct a house. One may also doubt whether they would all have found enough work. The 'advantage' of the coir business, so she told, was that she was able to raise a credit of 620 rupees from the coir merchant, in addition to being able to buy worth 400 rupees groceries.

As said, difficulties in respect of husk supply are common. If the domestic units can procure them at protected prices from the Society, both the wages of the workers and the margin of profit will turn out to be reasonable.[3] A disadvantage, however, is that, as we have seen, the Society does not give credit, something yarn merchants have to do in order to be able to obtain yarn from the manufacturers. Obtaining credit is one of the important reasons for starting a unit. In addition, the Society faces serious problems in obtaining sufficient husks for its members, so that supplies may fail for months on end. A third problem mentioned by small producers working with the Society is that the condition that they should return exactly 240 *mudis*[4] of coir yarn for the 600 whole husks they received, is hard to keep up with. If they are unable to extract enough fibre from the husks, the Society detracts the 'missing' yarn from their wages. Hence, most of the units process husks procured from private husk dealers, and profits, therefore, tend to accrue to the few large-scale 'retters' in the locality.

Table 5.3 Yearly income from coir

Household	No. of workers		Hired worker	Self-employed
	Adult	Child		
A	3			699.50
B	1		145.10	
C	1		58.60	
D	1		81.45	
E	1	2		317.00
F	1	1	45.00	
G	1	1	130.00	
H	2	1		667.00
I	2	3		1485.00

Source: Budget-study, 1979–80.

A woman working alone as a hired beater may find it hard to earn more than a small amount in coir, and her contribution to the total income of the household will hence remain modest. As earnings are low and employment is hard to get, most women take to beating only if they have no other choice. This was, for instance, the case with both the hired women in households C and F, who worked only a short period because their men were temporarily out of work (see Table 5.3). The two women drew on average as little as 2 per cent of the yearly income of the household from coir (see Table 5.4).

Table 5.4 Yearly income of coir-workers' households

Household	Yearly income from coir	Yearly income (other sources)	% from coir
A	699.50	6880.00	10
B	145.10	3231.00	4
C	58.60	2330.00	2
D	81.45	870.00	9
E	317.00	3651.00	9
F	45.00	1952.00	2
G	130.00	1460.00	9
H	667.00	2167.00	31
I	1485.00	7451.50	20
Average	403.18	3332.50	10.66

Source: Budget-study, 1979–80.

Domestic workers are more steady on the job, the main reason being, of course, that their earnings are higher. This results mainly from the fact that both women and children and at times even adult men, work harder than if they were hired workers. Household I employed, for instance, a grown-up son, who would do much of the transporting and would sell the coir to an agent outside the village in addition to two women and three children (see Table 5.3). The debts incurred may also prohibit getting out of business and have, after all, the effect of enhancing the yearly earnings of a household. But even then, when seen against the total income of a household, and in spite of the relative regularity of employment it offers, coir manufacture remains a low-income sector. Other lowly-remunerated activities such as fishing, agricultural labour or working in a copra-drying business fetch significantly more than coir-making. But these are manly activities. Even though lowly valued, coir manufacture is virtually women's only source of income, which may turn out to be vital to face life crises. In less dramatic moments it may provide a woman with elbow-room for taking her own decisions or supporting a child therein.

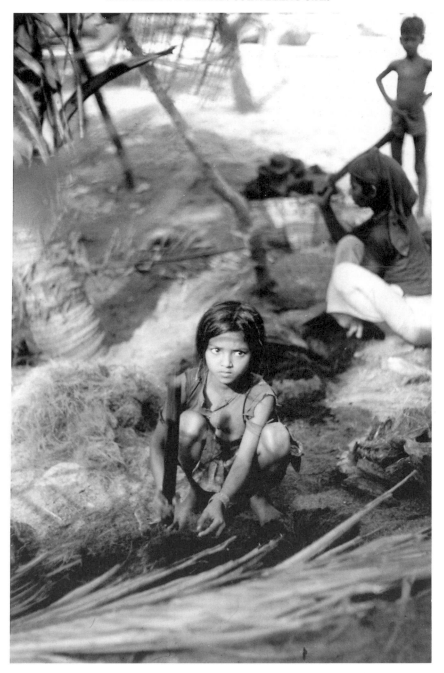

18 Girls are hired only for beating the husks

GIRLS' WORK

As said, the process of making yarn is divided, as in fishing, in tasks arranged according to a hierarchy, the most tiresome and dirty work, beating husks, enjoying the lowest status and being valued less. Next comes rotating the wheel, while spinning and packing yarn are the highest in rank and remuneration. To make the undertaking worth its while, a domestic unit must be composed of at least one, but preferably two, expert spinners. These two spinners require one or two more workers for preparing the fibre, a job that may take, depending on the quality of the husk, up to twice as much time as needed for spinning. During the spinning, the beaters rotate the wheel and perform a myriad of petty services. The beaters are mostly children. One may distinguish different types of activities undertaken by children in the manufacture of coir yarn:

(a) Helper without a clearly defined task
(b) Beater and rotator in a domestic unit
(c) Hired beater and rotator
(d) Hired worker in pre-processing and transporting.

The last type of activity is exclusively undertaken by males. The first three are typically feminine, and are loosely undertaken in between householding chores and the care of the small ones. They reflect a hierarchical ordering based on seniority, an ordering that is, nevertheless, relatively weaker than in masculine tasks in fisheries, the comparative advantage of passing from one to the other being but small.

In general, work is divided among the females of a domestic unit as follows: unmarried girls from the age of about seven make the fibre, mature women spin, elderly ones (or in their absence girls, young boys or jobless men) turn the wheel, with very young children remaining within call to do some fetch and carry or otherwise help the women and girls. A toddler, who anyhow will hang about while his or her mother works, will be often asked to fetch small quantities of husks and fibre within the boundaries of the homestead. As young as 3, but more commonly 4 or 5, he may be given the task of taking a turn at beating husks or rotating the wheel. Until roughly 7, a young boy's place is in the women's domain, and he will therefore lend his mother a helping hand if asked to do so. But thereafter, having reached the age in which he is visualized as the working companion of men, custom demands that he should no longer engage in feminine activities, and he himself starts feeling reluctant to do so. Even before that, a mother will normally anticipate these feelings and not seek her son's help more often than strictly necessary. As I will show further on, this does not always imply, in practice, that teenage boys never make coir on a more regular basis. Generally, however, teenage boys prefer to undertake 'manly' tasks such as stamping the husks or transporting the material, which happen also to be better remunerated.

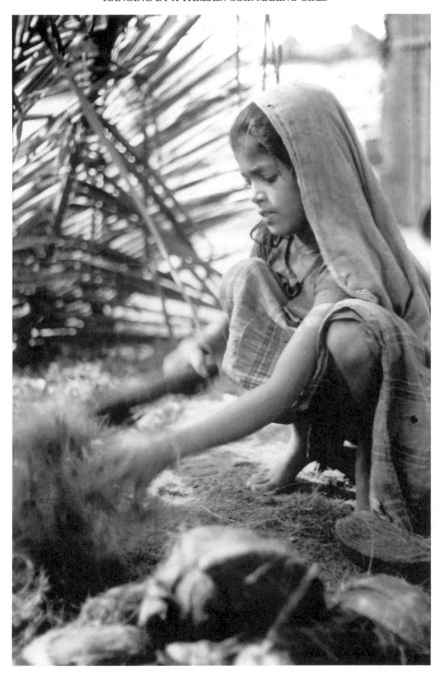

19 Cleaning the fibre: an example of a girl working as an 'undefined helper'

20 Rotating the wheel: young boys may lend their mothers a helping hand until the age of 7 or 8

A girl is from the onset very much conscious of the fact that making coir is and will remain part and parcel of her domestic responsibilities, an activity that is particularly vital in assuring the women and the children a basic income independently from that of men. Her mood, while setting herself to the task of helping the older females, may, therefore, be entirely different from that of a boy. She often takes pride in developing this typical feminine skill, in expertly turning the dark rotting material into fluffy white fibre under the blows of her mallet. And she does gain a feeling of worth from helping her mother to finish the set task quickly. A girl's childhood is less exposed to sudden changes than a boy's, and this makes, in a way, for a certain harmony in her early development. There is no spatial and temporal discontinuity, as for the boys who are socialized in fishing, in her world as a young child and that of her early teens. Her socialization into the world of coir begins as soon as she can be of some use to the older women, and she may not even have any memories of a time without coir being made by her mother in her direct surroundings. But though the moment her socialization began may be lost to memory, the process is no less lengthy than that of boys. Though by about 10 a girl may be able to process as many husks as an adult woman, it may still take years before she leaves the category of undefined helpers. There are, however, wide differences, and some girls may already earn their own pocket money in their early teens.

Socialization in coir manufacture lacks most of the excitement a boy derives from his involvement in fishing and fish-vending. Girls do not, as a rule, leave the proximity of their homes, and the personal gain from coir-making is ineluctably a mere triviality. Custom demands that girls grow up in ignorance of financial affairs. They rarely pocket their own wages, and will be generally rewarded with just a few coins to buy sweets for their efforts. Even later, the prospects of the job remain all but adventurous, and girls know that for most of their lives its gains will not allow them to spend on additional snacks and drinks. Whatever extra food or clothes they will get, will inevitably have to be a gift brought by one of the males of the house.

There are attractive sides to coir-making, though. The activity is rather a regular and dependable one, and can be undertaken without causing distress to the domestic cycle, which enjoys women's highest priority. The rhythm of work is mostly relaxed, and allows for a lot of conversation and jokes, the workers belonging either to the family or being neighbouring women and children. Only the spinners and the rotator do form a team that has perforce to work together. The wage of the beaters is calculated according to a set rate, and they may organize their schedule of work to accord with their other responsibilities. Working time may therefore stretch from well before dawn until late after sunset. It is quite common for a girl to take her mothers' place as beater or rotator at moments in which the latter has to stop working to breastfeed her baby or to start cooking. Even membership of a spinning team

135

is not fixed, and older girls or elderly women may put in a few hours to help a spinning team to finish their work.

As already said, many girls do not have well-defined tasks to perform, and they may be on the threshold of adolescence before being given set tasks of their own. For most of them, the nature of the activity remains throughout childhood ambiguous and indistinct from other domestic chores which continue to draw their attention even during the beating. The example of a group of four neighbouring girls who make fibre with their mothers on a putting-out system, is illuminating:

The mothers are Aisa (37), Patma (30), Nefeesa (30) and Rukkhya (26). Aisa's four children are now old enough to play without having to be looked after. But the other women, who each have three, are still nursing between 1- and 2-year-old babies. The latter sit on a mat in the shadow of a coconut tree or just play near their mother while she is at work. The women's daughters, 10- to 12-year-olds, do not go to school, except for visiting the Koranic school in the morning between 6 and 8. The other children are boys, and they share their time between the government primary school and the Koranic school. Aisa's eldest daughter of 18 works for a manufacturer nearby. At the end of the day her mother collects her wage and spends it to buy groceries.

An average working day for the four women and their daughters starts at 8 in the morning, after a breakfast consisting of a cup of strong, black tea with sugar. The girls will start peeling the *polas* while their mothers are still feeding the small ones with the rice left over from the previous evening. The women can thereafter directly start making fibre. In the meanwhile, the girls will spread the thin peelings, to be used for burning in the kitchen oven, to dry in the sun. Later on they will first recover the fibre made by their mother from the pith, spread it to dry and put it on a heap. If a child cries, his sister promptly stops working in order to attend to it. Or she will take over the making of fibre if the child has to be given the breast to soothe his hunger. At 11 the girls light the oven and cook just enough rice for the lunch of the younger children. The girls and their mothers will have to content themselves with just another cup of strong tea.

Weakened as they are by this forced fast, it is visibly a great effort to make fibre out of the husks, which are anyhow of poor quality, they have been given to process. The women have to give eighty to hundred blows to each *pola* to reduce it to fibre, while normally forty or fifty are sufficient. As soon as they have finished their daily quota of hundred *polas*, the women stop working. They spend the rest of the afternoon resting with their children, and waiting for the return of the men, who in the evening will bring rice for their only meal.

The men will also have collected the women's and girls' wage, or

rather, the single rupee that is left, after the deduction of 50 paise for repayment of an advance of 10 rupees they received at the time of Ramadan and the transporting charge of the husk and fibre, 25 paise. If they earn anything, men and boys will, before coming home, certainly have taken at least one a rice meal or tea with milk and snacks from one of the many tea-stalls on their way.

The conditions of work of the girls has much to do with that of the women, who depend on the merchant-manufacturer because of their debt. He makes them beat poor quality husks at hardly a higher rate than paid for beating good ones, although the job is much heavier. The women refrain from leaving the proximity of their house-sites to find work with a coir unit, because of the toddlers, but also because it would mean a loss of status. Besides, it is quite unlikely that smaller manufacturers with whom they might find employment will be ready to give them advances if their men are out of work. Also starting coir manufacture through the Society has this disadvantage, in addition to the fact that they lack the spirit of initiative and the self-confidence this would require. As there is very little gain from what they do, it is no wonder that the women view their daughters' activities even less as work than their own. On being questioned about it, they reply that the girls 'just help a little with housekeeping', which is quite what girls of that age are supposed to do. Even though the women would not be able to work if the girls were not there to mind the small ones, to cook, to remain continuously at their beck and call and to stand in when they interrupt their work, these activities are not perceived as essential to income-earning and are therefore not called 'work'. It just seems part of the natural order of things that a girl shares with her mother these responsibilities while the latter is busy earning some money to feed the family.

Girls do not visualize, as do the fishing boys, their involvement in coir as part of a laborious apprenticeship in the ins and outs of the craft. Beating husks and turning the wheel are not perceived as 'skilled' jobs, and women point at the fact that even spinning can be mastered in a few months. But rules of seniority do apply, as already said, and a girl is unlikely to be trained in spinning before her fourteenth or fifteenth year. It is a shared opinion that girls should not threaten the income opportunities of adult women:

Leela (14) belongs to a small domestic unit and has been beating husks from early childhood. We asked her how she learnt to spin:

Leela: It must have been two years ago . . .
Question: How?
Leela: Just on my own, by trying to make one thread at a time, like that.
Question: Who taught you?
Leela: My mother showed me how to do it.

Question: Is she paying you for spinning?
Leela: No.
Question: Does your mother hire a spinner to work with her?
Leela: Yes, she hires Radhamoni.
Question: And you, when do you spin?
Leela: Only when Radhamoni cannot come . . .

Low remuneration and loss of face both work against adult women, and particularly married ones, working as a hired beater away from the immediate vicinity of their homes. Teenage girls are therefore more likely to be doing this type of activity, with married women preferring to work as a spinner or to process fibre at home on a putting-out base. While adult hired workers were more or less equally divided between beaters and spinners, the younger workers (below 20) were nearly all taken only for beating (see Table 5.2).

Hired workers have generally little pride in their work, and women who are obliged to send their daughters to work for others are just as little inclined to admit the importance of their work as those who have their girls working at home. To be a hired worker is felt as a temporary, degrading condition, the more so if one is hired only to beat. The pattern is very much evident among the Muslim households, where the women have been very reluctant to supplement their income by making coir. As already said, these women often choose to make fibre on a putting-out system for a related merchant manufacturer near to their homes. In time, of course, the number of very poor Muslim women working as hired workers has steadily been increasing, and some do work for Ezhava employers too. But these women tend to see their work as a temporary state. In this line of thought lies the lack of interest of Umaiba's (11) and Subaida's (18) mother for training the girls in spinning. I asked her:

Question: Can you spin?
Mother: Yes.
Question: Did you teach it to your daughters?
Mother: No, they are still too young.
Question: But your eldest one, Subaida, is already 18 . . .
Mother: That is true . . . but you see, we are not spinning here on our
 own, we have no spinning-wheels. I now just work as a
 hired worker for my neighbour, and take the two girls along
 with me. I don't want to send them to work as hired workers
 elsewhere. Now that they accompany me, it's alright.

Working as a hired beater does not provide a girl with much more space to assert her individuality or to increase her say in family matters. Few girls pocket their own wages or otherwise derive from their work an income to dispose of as they like, and most of them view their being hired merely as the outcome of the financial stringency of the family:

Both Abusath's (12) parents are in poor health. To help the family she dropped school two years ago. She now beats husks while her mother spins. Both are hired workers. When her mother is able to work, Abusath remains at home to look after her three small brothers and sisters and do the housekeeping. On days on which her mother is too ill to spin or has no work, it is Abusath's turn to hire herself as a beater. Her wage is entirely spent on household necessities and Abusath only occasionally receives a few coins for sweets.

And yet, girls may also feel attracted by the atmosphere of the coir-making place, and feel dignified by the fact that what they do is valued, in so far that it represents a help to their families in times of crisis:

We had no interview with 13-year-old Noorjahan, as she worked on silently while we visited the unit. Her co-workers made fun of the fact that she seemed to have no time to talk, which was really not very good manners. As a justification, however, they told us that she had literally escaped that day from home to hire herself as a coir-beater. On the rare occasions on which her parents would let her go, she used to put all her soul into beating at least 150 husks, which was quite a lot, because she wanted to earn as much as possible.

There exists, in sum, a shared opinion that girls' roles in coir carry little weight: girls are rarely given clear tasks or acknowledged for contributing to the process of manufacture; they are allotted the messiest part of the work which adult women consider degrading; they are very slow in enhancing their status as workers; their remuneration, if any, is commensurate to the status of their work, and is minimal; and finally, though they may do hired work, they are not allowed, as boys, to pocket money or to keep and spend part of it.

But is the work girls perform in the process of making yarn as immaterial as their parents often claim it is? For one thing, it is interesting to note that the same tasks appear to be valued differently when performed by a boy. While a girl's work remains immersed in an undifferentiated set of mandatory domestic tasks, the very same tasks can be quite clearly defined and valued when performed by a boy. As Ponnamma's case illuminates, in view of the easy entry and the flexibility of working hours, it has become common practice for some small manufacturers to encourage their sons to earn in this way the cost of education beyond the primary level. Typically, this has been accompanied by a re-evaluation of the various tasks involved in coir-making:

Ponnamma is a woman of 42 who processes husks obtained from the Coir Co-operative Society and occasionally also from a private dealer. Ponnamma's mother, her husband, her sister Omana, and her two sons aged 13 and 17 make up the unit. Twice a month the eldest son crushes the husks and stores them in a small retting pit behind their hut. The

younger son makes fibre for three days and turns the wheel for one day. As he is studying in high school, he works only during weekends, in total eight days a month. Neither does Ponnamma work full time; she has the housework to do. She beats and turns the wheel when her son is in high school. Her unmarried sister Omana (18) beats and spins together with their mother. Ponnamma's husband packs the yarn. The elder son then brings it to the Society, which pays them 110 rupees for it. Ponnamma does the accounting of the income and expenditures.

The various chores are remunerated according to fixed rates. The rate for beating is adjusted to the high quality of the husks supplied by the Co-operative, which makes it possible to process about 50 per cent more a day than poor quality ones. The rates are the following:

1.50 rupees for beating 100 *polas*
4.00 rupees for spinning 50 *mudis*
2.75 rupees for turning the wheel one day.

A hired worker is paid 6 rupees for bringing the husks from the society's retting pit to the ditch near to their hut. Accordingly, the monthly income pattern looks as follows:

Ponnamma: 30.50 rupees (14.00 for beating 14 days an average of 75 *polas* a day and 16.50 rupees for turning the wheel six days).

Omana: 86 rupees (50 for beating 20 days an average of 175 *polas* a day and 36 for spinning in 8 days 450 *mudis*).

Mother: 36 rupees (for spinning in 8 days 450 *mudis*).

Younger son: 14 rupees (for beating 6 days an average of 100 *polas* a day and turning the wheel 2 days).

Elder son: 20 rupees for stamping the husks and bringing the yarn to the society (three days' work).

Husband: 21.50 rupees for rolling and hanking the yarn.

With their earnings, Ponnamma's mother and sister contribute to the expenses for food, buy clothes and save the rest. The younger son buys books, notebooks, clothes, pays the school fees and saves 5 rupees every month with a 'chit fund' (an informal saving organization). The eldest son, who has obtained his secondary school leaving certificate, spends his money to attend a type-writing course for which he has to pay 15 rupees monthly.

The unit starts work at 8 in the morning, after a breakfast of tea and *appam* (rice pancakes). At 11 they have a tea break and at 1 p.m. a warm meal of rice and fish. At 5 p.m. work is over, and they have tea again. At 8 in the evening they take their second meal, rice, tapioca and fish. They are well-built and look quite healthy.

As their total income depends on the amount of husks that can be processed without hiring workers, the younger son is encouraged to work by giving him accurately-defined tasks and actually paying him for his work. This money enables him to meet the expenses for going to high school.

The budget-study revealed that quite a few boys worked at least part time as a domestic worker, even though they often felt ashamed about it. A number of them earned a small wage as hired beaters just to cover the expenses of schooling. If boys work alongside the women, feelings of shame must be compensated, and remuneration seems likely. The taboo against males making coir is very much alive. The few adolescent boys who beat and spin expose themselves to the mockery of passers-by and neighbours alike. Some young women could not help laughing like a drain if they caught sight of such a boy making coir yarn. Of Surendran, a boy of 16, they said he had adopted: '. . . the shape, walk and ways of spinning women'. To oppose the ridicule to which adolescent boys expose themselves by making coir, they stress that they should enjoy, when making coir, male privileges, that is, that they should be remunerated for their work:

> Surendran took advantage of my presence to complain that his mother did not pay him for his work as beater and spinner. This he felt was the more painful since his younger brother of 12 was able to earn some cash regularly as a hired worker, of which he, of course, was allowed to keep a part. To his complaints, the mother reacted that she ran the business to feed and clothe the children, and that they therefore had no right to claim wages:

> 'I even give you money to go to the cinema if you ask any, then why do you complain?'
> But the son insisted that he needed to decide on his own spending as other boys of his age did:
> 'You have your hens and you get enough money with the sale of the eggs!' was the mother's reply. As the son continued to complain, the mother finally lost patience:
> 'Why do children need money anyhow?' she exclaimed.
> 'And why do women need money then?' replied the son, referring to the gender difference that existed between them.

Girls' work is then considered inferior, not because of its intrinsic lack of substance, but because of the combination of the gender and the age of those who perform it. This makes it problematic to quantify the contribution made by girls to the income of a household as it is rarely kept account of and even the girls' nearest kin are not inclined to admit to it. The data obtained through the budget-study, however, contain a few clues.[5] To that purpose let me briefly return to Table 5.3. Of the four households that ran a domestic unit, three had girls who worked along with their mother. Conversely, of the five

Table 5.5 Daily earnings of coir workers (rupees)

| Household | No. of workers | | Hired worker | Self-employed |
	Adult	Child		
A	3			6.15
B	1		1.50	
C	1		1.30	
D	1		1.25	
E	1	2		3.75
F	1	1	2.80	
G	1	1	1.70	
H	2	1		5.75
I	2	3		6.10

Source: Budget-study, 1979–80.

women who hired themselves, three had no daughter to work with them. The presence of a daughter seems in this light to be an important condition for a woman to run a unit of her own. A girl is as good a worker as an adult woman, as a comparison of household A (with no working girl) with household H and I also suggests (Table 5.3). As suggested by the data in Table 5.5, the work of daughters helps to increase earnings in coir by 50 to 70 per cent. This is important even for the hired women, though rewards may fall short of even their most basic needs.

Summing up, girls' work is carried on in and among domestic tasks, and is 'unnamed' to an even larger extent than boys'. Customary restrictions placed on spatial mobility, on interaction with unrelated adult males and on 'unfeminine' demeanour, reinforce the taken-for-granted nature of their work. Of the women of a household it is the younger ones, and preferably the girls, who are seen as the housekeepers *par excellence* and who are given the responsibility of minding their smaller brothers and sisters while coir is being made. But in spite of the work performed by girls often being 'invisible', small producers to this day still depend on the availability of this type of labour for remaining in business.

WORK FOR LOVE

What makes girls comply to their domestic roles and what is their scope for challenging their position? The first question has no doubt much to do with the Indian cultural heritage. The preference for sons in the 'great' Indian cultural tradition, documented by historical and anthropological studies, is widely accepted as a fact of life. Although there are gradual differences to which I return later on in this paragraph, among the Ezhavas the birth of a

son is greeted with loud rejoicing by the female kin, but not the birth of a daughter. A daughter is indeed considered an unmitigated expense, someone who will in the last resort, upon marriage, take away a part of her family's fortune, however small the dowry may finally turn out to be.

Kakar has remarked that a well-to-do Hindu girl tends to grow up somehow imbued with a sense of inferiority and a feeling of guilt, although these may be tempered by the solicitous attention of her mother and the existence of a specific area of family responsibility from which she may draw a sense of worth (Kakar 1981: 58–60). Training in the mandatory skills of householding and child care makes for a specific experience that is crucial for girlhood among the higher classes of Indian society. It is likely then, that a girl does not perceive her position as inferior in the first place, but would rather draw a feeling of self-esteem from her early introduction in the female domain and in the sharing of the responsibility for the well-being of the family. This is the more so that her peculiar: 'experience of "apprenticeship" and the activities that transpire in this feminine sphere are independent from the patriarchal values of the outside world' (Kakar 1981: 61).

Her perceptions are also likely to be influenced by the future that awaits her on coming of age. The prospect of the painful initiation into her later status as a daughter-in-law in a strange family, may significantly alleviate feelings of discontent about the lot she is ascribed in her natal home. The relatively short period she spends with her family is by and large one of emotional closeness that sharply contrasts to the alienating and often even humiliating surroundings of an adolescent girl or a young woman upon marriage. The sweet image of the natal home, from which she will inexorably be separated, may therefore dispose her to view her work rather as an act of love than as an economic activity having an exchange value (Kakar 1981: 63).

Kakar is himself aware that his analysis evokes the mood of upper-caste Hindu girlhood, and is little more than a reflection of an ideal, or a model as he puts it, on which only the upper layer of society can pattern itself (ibid. 1981: 8). It takes as a model the 'great tradition' of Hinduism in North India, and is less applicable to lower castes and other religious groups, to urban areas and to the southern part of the country. Day-by-day reality is therefore infinitely more varied and may, particularly at the lower levels of society, depart a great deal from the dominant ideal.

Working girls of Poomkara can indeed hardly be described as imbued with a sense of guilt and inferiority, though they, no doubt, are indeed often conscious of their subordinate position in life. An obvious reason for their departing from Kakar's image of girlhood is that the ties with the natal home are never entirely severed. In times of crisis a woman may expect some help from her own kin, or even return to stay with them, though this may be more self-evident for an Ezhava than for a Muslim. In addition, as we have seen, poor women, and the more so girls, are practically unable to abide by the dominant norms that would confine them to their homes, for the simple

reason that they must work for the family's sustenance. Kakar is, however, right in pointing out that the home is basically the domain in which a girl may be most assertive. Domestic roles are more likely than those derived from performing remunerated work, to provide a girl with feelings of self-esteem and self-confidence, which is hardly surprising in view of the fact that the home is in fact her 'natural' workplace. It may not be so much her being a girl that may engender feelings of impotence and resignation, as the awareness that a girl has little or no control over the world beyond the home. As she is forced to do economically-worthless domestic work, she may compensate for these feelings by concentrating on 'higher values' such as love for her family and self-denial (cf. also Wallman 1979: 10ff). But few girls suffer, I believe, from an internalized sense of inferiority, and this is apparent from the fact that, if given the opportunity, girls try to enlarge the scope for the assertion of their individual needs. This is apparent from the historical and social processes that have transformed girlhood in Kerala in the past century, which I have mentioned in Chapters 2 and 3.

But also in Poomkara I gained the impression that the subordination of girls to dominant norms of demeanour is more vigorous among coir manufacturers who rely mostly on relations of patronage than among those who cope without, and among whom I noticed a clear deviance from these norms. I have argued in Chapter 3 that patronage, so strong among Muslim kin clusterings, is related to a socialization pattern in which girls are imbued with ideas of honour and of acceptance of their subordinate position. Though girls by no means ungrudgingly submit to it, there is, in particular among 'orthodox' Muslims, a relentless parental effort to control, not only the social environment of a girl's work, but also the development of her identity. The following interview with 11-year-old Umaiba clearly brings out the parental denial of feelings of self-esteem which a girl may draw from her work:

Question: Do you help your mother, Umaiba?
Umaiba: Yes, I grind spices, clean fish, sweep the yard, scrub vessels and cooking utensils, run errands . . .
Question: Do you cook?
Umaiba: Yes, at times.
Question: What else do you do?
Umaiba: After grinding I recite the Koran and then I fetch water from the river.
Question: Do you make coir?
Umaiba: Yes, I turn the wheel and make fibre at our neighbour's.
Question: Every day?
Umaiba: Yes, when I come back from the *madrasa*, and on Fridays from the early morning . . .

Umaiba's mother, who had at first listened approvingly while her

daughter was telling about her household chores, now interrupts her, saying angrily:

Mother: What a shameful exaggeration! She beat 100 husks only once!
Question: Umaiba, do you get paid for your work?
Umaiba: Oh yes!
Question: I mean, do you get money?
Umaiba: No, it is not like that. Our neighbour has a grocery shop, mother buys food there after the work.

Later on Umaiba's mother talks about the major problem they are facing: raising the dowry needed to marry off Subaida, whose marriage has been continuously postponed in view of their financial situation. They would need some 10,000 rupees to marry her to a reasonably well-situated party:

Mother: Subaida's brothers are doing what they can, but they just can't raise enough money. There is not enough work around here. If they work one day and earn five rupees, they'll have to spend them the next two days or so, when they have no work. How can they then save for a dowry? Subaida will have to wait . . .

The fact that Subaida is a full-time worker does not make much of a difference. She does earn an income of her own, but as her wage is not paid directly to her, but is detracted from the debt at the grocery store run by the employer instead, it is just as if she were not. So, her mother views her as a non-working girl who will have to be given a dowry to support her in the future, when she has become, as she hopes, a full-time housewife. Denying her being a coir worker has its impact, not only on the amount of dowry the family plans to give, but on whom is held responsible for gathering it as well.

Girls do not find it easy, in these circumstances, to experience individual needs and desires consciously, lest to voice them:

In an interview with 10-year-old Jasmin (see also Chapter 4), the girl repeatedly showed that she was hardly aware of her own needs, pointing instead to the stringent financial conditions in which the household was living and to the poor health of her father and mother. She was satisfied that her husk-beating contributed to reduce the debts they had incurred for buying medicines, not expecting in reward anything more than an occasional coin of 5 or 10 paise to buy one or two sweets.

Question: Who is buying clothes for you?
Jasmin: My mother bought this dress. I had another one bought by father, but that one is worn out. I have only one dress now.
Question: Do you wear this one every day?

145

Jasmin:	I have an old skirt that I wear at home. I keep this one to go to school.
Question:	From where did your mother buy this one?
Jasmin:	From *kachakkaran* (the cloth peddlar).
Question:	Were you present?
Jasmin:	Yes.
Question:	Whose choice was it?
Jasmin:	Mother had selected another that was better than this one. It was beautiful, but expensive. So I told her that this one would do.

Only once had she been able to save three rupees, which she had given to her father asking him to buy a few plastic bangles for her. When her father did not come home with the bangles she was, however, not angry, but found justification in the fact that bangles seemed to have become rather expensive and that her father had no other money with him. On another occasion she had won a prize at school. The presentation however would take place in Ambalapuzha, some 10 kilometres to the north. She did not go:

Jasmin:	I had no proper dress to wear. The old one was too ragged. Father told me that he would allow me to go if I wanted. I was unable to find a dress to borrow in the neighbourhood. There was one girl who had a nice dress, but she too had to go.
Question:	Were you disappointed?
Jasmin:	Oh no, I had already seen the function before, when I was visiting some of our relatives at Ambalapuzha.

That a girl could have ambitions of her own did not occur to her: she had only one, and that was to save the small ones from famine when her father was unable to provide for the family.

As her mother involves her in the daily routine of feeding and cleaning the young ones, of cooking and serving the males, a girl develops a feeling of concern for the well-being of the members of the household. For a girl who grows up in this emotional climate, to assist her mother in making coir seems the most natural thing to do:

Rajeena's (7) mother is a coir worker and works as a hired beater. Rajeena and her elder sister accompany their mother to their work to assist her. While the mother beats 200 *polas* a day, the eldest sister will beat 150 and Rajeena 100. Her brother of 9 is going to the upper primary and will beat some husks on school holidays. Rajeena and her sister have never been to school.

Question: When you go to beat husks, do you just assist your mother or are you a worker on your own account?

146

Rajeena: I just help mother.
Question: Do you receive a wage?
Rajeena: No. My mother gives me a little pocket money, 20 or 50
 paise to buy sweets. We are always in debt with the owner
 of the coir business. To repay our debt he reduces her daily
 wage by a fixed amount. When my father is not going out to
 fish her wage is insufficient to make both ends meet. So we
 have to borrow . . .

As there is hardly any monetary nor even directly material valuation of the
work, emotions tend to take a prominent place, and work may be
experienced as an act of love, for instance for younger brothers and sisters:

Jasmin (see above) either beats husks or looks after her twin brothers
(2) when her mother works.

Question: Are your brothers troublesome?
Jasmin: Yes . . . when I leave for school they won't let me go, but cry
 and follow me. Then I spank them. These urchins always
 want to be with the one who feeds them and who takes
 them on her lap. I give them whatever food I can lay my
 hand on. They love me so much!
Question: What does your mother say when you spank them?
Jasmin: She spanks them too! The babies want to sit on our lap the
 whole day, as if we had nothing else to do.

Within the household, nevertheless, the extent to which girls' work is
considered worthless seems to be very much influenced by the conditions
under which the family works. Ezhava children hardly ever have patrons or
influential kin clusterings on which to fall back. They stand very much on
their own and can rely on little else than the co-operation offered by
members of the same household, a situation also observed among other low
castes (Schenk-Sandbergen 1988: 87). It is true that in the Ezhava household,
also, roles are ranked according to gender and seniority. But in the absence
of strong impulses from higher-placed kin and, in particular, patrons, the
need to stress differences in authority within the household turns out to be
weaker. Possibly that excessive modesty and self-effacement is felt to be
counterproductive in a small household unit in which all have to join hands
to make ends meet. A girl's emotional self-identification with the well-being
of the family may still overrule her other feelings without, however, leading
to the sense of oneness so strongly felt by Muslim girls, this being, of course,
but a matter of degree.

The growing interest of Ezhavas for education reflects this orientation of
individuals towards self-reliance. This is brought out by the high
participation rate of Ezhava girls in schools. While there is a sizeable number
of adolescent Muslim girls who have never been to school (43 per cent),

Table 5.6 Educational level of 15- to 19-year-old adolescents (%)

	Male Muslim	Male Ezhava	Female Muslim	Female Ezhava	Total
No schooling	9	0	43	2	13
Lower Primary	32	18	28	31	27
Upper Primary	16	21	9	27	18
High School	43	61	20	40	40
Total	100	100	100	100	100
	N=140	N=62	N=127	N=81	N=400

Source: Field census, 1978.

mainly because of the values their parents think they will be taught there, 98 per cent of Ezhava girls between 15 and 19 had completed, in 1978, the lower, and 60 per cent, the upper primary level. As many as 40 per cent of the Ezhava girls were either in high school or had completed its course, against only 20 per cent of Muslim girls (see Table 5.6).

Certainly there are marked differences in the socialization of Ezhava boys and girls. Still, girls are generally considered to be able to face the problems of life in an active way and are left a certain degree of freedom in the choices they make in domains beyond the domestic one. Some women may even be willing to remunerate their daughters for helping them increase their output, or to allow them to decide on how to spend a part of their earnings as hired worker. There are many girls who can in this way meet the cost of buying notebooks and a lunch while in the upper primary or high school. An Ezhava girl may, for instance, have the option of either saving for a dowry from her (nominal) wages or meeting educational expenses if she is sufficiently bright at studies. The ideal of self-reliance has its impact on the amount of dowry an Ezhava girl is expected to bring, that tends to be comparatively low. Most of it is raised by the bride herself and with the help of credit revolving among neighbours and relatives. An Ezhava girl is considered much less of a burden than a Muslim girl. She takes pride in becoming a full-fledged coir worker and also achieves this status earlier in life. Many small manufacturers postpone the age of marriage of their daughters because they find it difficult to manage without her. This is, in view of the importance of domestic units among the Ezhavas, why the age at marriage is often well above 20 years.

The valuation of a girl's work depends also upon intra-household relations, in particular those among mothers and sons and brothers and sisters. As paying sons for doing what is essentially the task of girls becomes part of domestic policies, girls are also likely to demand better-defined tasks, some sort of remuneration and a degree of freedom in deciding about

spending. Mothers and elder sisters may find themselves responding positively to younger girls' attempts at asserting their needs, though this involves a departure from their personal experience and may therefore give rise to contending feelings. A mother may often express her dissatisfaction with her own fate as she sees it repeated in her daughter's, actually providing her the inspiration for questioning the dominant norms. While at work in coir, as he becomes familiar with his sister's difficult situation to combine work with school, a brother may also play the role of mediator between her and his parents. He may witness the barriers his sister has to overcome to extend her education beyond the primary level. To meet the costs of going to high school she would have to either convince her mother that she should be rewarded for her work, or be allowed to hire herself, in addition to obtaining a reduction of her housekeeping tasks. These barriers put girls in a disadvantaged positions with respect to boys, who are less hindered by the compulsions of housekeeping.

Once in high school a boy may grow particularly sensitive to the discrimination to which his sister is subjected, and become her ally as she rebels against her inferior position. In this he may feel backed by the growing challenge represented by schools to dominant norms of femininity. In Kerala, diplomas are valued to the point that they may partially compensate for a modest dowry, as an educated wife not only enhances the prestige of her husband, but is also an asset in the education of children. The experience of the first generation of educated young people who have suffered from the disadvantage of coming from uneducated homes, has already demonstrated the importance of female education:

Krishna Kumari (14), a Thandan girl, is in high school. Although she is comparatively bright, she failed last year.

Question: Which subjects do you find most difficult?
Krishna Kumari: English.
Question: Why? . . . How are the teachers?
Krishna Kumari: Oh, they are alright . . .
Question: Then what is the difficulty? Why don't you find
 Malayalam difficult?
Krishna Kumari: Malayalam is easy, we study it from childhood . . . we
 don't do that with English, so it is difficult to
 understand (after a long pause) . . . nobody can
 help me at home with English . . .

Today education increasingly helps to determine the kind of husband a girl can hope to attract (see also Sharma 1986: 106ff). Educated brothers fear the predicament of having to marry off uneducated sisters, because, in order to enter into kin relations with families of their own educational status, the dowry will have to be substantially higher. That a bright girl should try to

149

achieve a diploma is, therefore, by and large viewed as a rational decision, and she is likely to be supported therein by a brother with a secondary education.

For Muslim families, where the gaps between female and male educational levels are wider, this poses a serious challenge. I have already mentioned the growing interest among Muslim parents for sending their daughters to school at least until menarche. But after that, the mixed character of schools makes many, especially poor, parents worrying about possible gossips. The old saying 'What should a girl learn to read and write for if not for corresponding with lovers?' was still widely used to comment on the freedom of movement which going to high school entailed, as adolescent girls had to walk to a nearby locality and were believed to encounter on their way ample opportunities for romance. But 'orthodox' parents now face open criticism from their educated sons who strongly disapprove of the former's ideals of femininity: 'My mother is an illiterate, that's why she says so many silly things . . .' was 14-year-old Alikutty's comment upon his orthodox mother's views on the upbringing of his younger sister Umaiba. Sainaba, an illiterate mother of five, three sons in their twenties and two girls aged 6 and 12, expresses, as follows, why her views clash with those of her educated sons:

> We will stop sending the two girls to school soon . . . even now their father feels very badly about it. It is only because the sons, who have been to high school, compel us to keep them in school, that we have agreed until now. We'll have to marry off the eldest daughter soon . . . it is not good to keep daughters too long at home. The quicker we give them into the hands of others, the better. They become too free when they go to school. It is enough that one of them goes wrong, for everything to be ruined. It is better to kill a daughter than have her dishonour her entire family . . . I feel that if we educate them less, we have also less problems.

Schooling alters the housekeeping responsibility of girls. At least one of the females of a household has, as a rule, to devote half a day to cooking, cleaning and fetching water, while more time is required for the care of small children if there are any. Allowing girls to carry on schooling means that mothers will have to forsake some of the help they received as a matter of fact and even see their own earning prospects dwindle in the process. Women in charge of the housekeeping are often hardly able to earn, and hence find themselves in that respect in a disadvantaged position, even when money earned by the females is pooled. That a girl should endeavour to earn the cost of education becomes the more acceptable to mothers with a small family where children are old enough to look after themselves. Roles may then be turned, girls putting comparatively more time into making coir than adult women. This was the case in Krishna Kumari's household, that comprised next to her, two girls aged 5 and 8 and two women aged 26 and 50 (see Table 5.7).

Table 5.7 Hours worked in coir by women of household I

Age of member	No. of hours worked yearly	No. of days worked yearly
5	127	24
8	516	90
14	749	106
26	525	114
50	635	74

Source: Budget-study, 1979–80.

Krishna Kumari (14), worked more hours than her sister-in-law of 26, on whom fell the responsibility for most of the housekeeping chores. Her elder brother, who also sold the yarn, kept an accurate account of her earnings and, though he did not give her the money personally, allowed her to have a say in how they were spent by buying clothes, books, and paying her school fees on request.

Summing up, girls may not always be aware to what extent they contribute to the manufacture of coir. Much of what they do is intertwined with other responsibilities and tasks, which are of inestimable importance, so they feel, for the well-being of the family, even though they have no economic value. But their work is nevertheless part of a production process that relies heavily on the need of poor women to earn an income to feed their families. The latter's precarious situation makes girls' working contribution imperative. The structure of production, with its heavy input of unskilled labour and the very small margin of profits realized by manufacturers, tacitly solicits large numbers of girls working for no pay. Typically, without the mass of girls who are prepared to work for the love of their family, Poomkara's husks would hardly have any value at all.

There is more variation in the situation of the girls in coir than there is among the fisherboys. Some coir manufacturing families do have certain sets of options with regard to the coercive pressures to which they submit their daughters. These options relate basically between submitting girls to a long-term family strategy in which self-denial and dependence on a patron plays a crucial role, or encouraging them to seek, individually, opportunities further afield and giving them the means to do so. While the patronage strategy promotes 'invisibility', seeking self-reliance is more likely to be associated with work that is remunerated and is organized in such way that it can be combined with going to school. Although servicing the household may give a girl a feeling of self-accomplishment that is emotionally rewarding, earning an income of her own enhances her self-confidence and her prospects in school.

Many children can combine work with school, because most work is

151

irregular and can be done when schools are closed. There is a difference, however, between boys' and girls' work. As said, boys are supposed to be more preoccupied with earning an income with which they can satisfy their personal needs and contribute to the maintenance of the family, than girls. This gives them some room for decision-making with respect to spending what they earn. Their access to education is eased by the shared opinion that education has become indispensable for their later roles as main earners. Girls, by contrast, are primarily responsible for the welfare of the family and are more preoccupied with direct subsistence, rather than with income earning. However productive what they do may be, it is, ideally at least, not perceived as income-generating. Typically, this results from the combined effect of gender and age, as the constraints upon a girls' relation to monetary rewards do not apply to the same extent to married women, and even less to boys. This puts them, as is also apparent from their differential access to schooling, in a disadvantaged position with respect to boys. However, increasing the levels of schooling of boys has the effect of gradually altering girls' roles and enhancing their access to education.

If one visualizes the ranking applying within the household as based on how each member's contribution relates to income generation, it is clear then that the economic value attributed to each closely reflects the hierarchy of seniority and gender. It is the men's social duty, but also privilege, to earn most of the income of the family in cash, women's and boys' to provision the family with food, and finally girls' to do the servicing work. Boys, by gender, never find themselves at the lowest levels of the hierarchy, though they spend a long period subordinated to men in which they are socialized into their adult roles. Girls' position at the bottom of the social order is sanctioned by their being denied access to income, in cash or kind, and by their depending upon the other members of the house for the satisfaction of their most elementary needs. I shall elaborate in the following chapters, in which I enlarge my analysis of children's work to the level of the fishery and coir manufacture sector of Kerala, the wider social implications of the age and gender aspect of work.

6

KERALA FISHERIES' INVISIBLE NETS

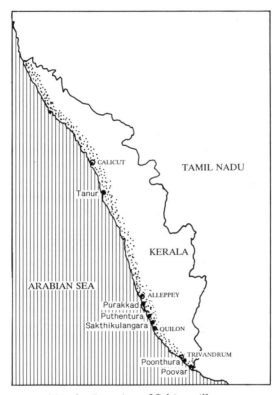

Map 3 Location of fishing villages

In this and the following chapter I turn to the following question: Does Kerala's economy need the work of children? In view of the limited nature of the data, I will answer this question by concentrating on fisheries and coir-yarn manufacture, referring to my own Poomkara data for comparison. The economic history of the two economic sectors has followed a markedly

disparate course: while coir-yarn manufacture flourished until the 1950s and showed a steady decline thereafter, the growth of the fisheries is more recent, and dates back to the 1960s. The analysis of coir, which is the subject of the next chapter, will bring me back, in an attempt at understanding the transformation undergone by children's work, several decades. In this chapter, in which I explore whether the pattern followed by children's work in fisheries as observed in Poomkara is also relevant for other parts of the coast, the focus is on a more recent period of Kerala's economic history. I begin by comparing labour relations of adult men and then draw some lines from the very scattered evidence available from secondary sources on children's work. I proceed, finally, by focusing on the interface between commercial and subsistence activities, to link the competitiveness of the artisanal sector to children's work roles.

LABOUR RELATIONS IN FISHING

We know little of work relations and ownership patterns in the fisheries. The available sources consist mostly of economic studies with a focus on technical constraints. There is, in addition, the material gathered from case studies, but they tend to cover rather small samples and to lack historical depth. The evidence on women's and children's work is even more dispersed and unsatisfactory. There is, I think, no reason for refraining from making at least an attempt to analyse the long-term processes that transform children's work, and one has to start somewhere. What follows should, however, be read as a rather tentative hypothesis that does little more than suggest the direction of future research.

Making generalizations on the organization of Kerala's fisheries is no easy matter. A feature is the difference of the fishermen's settlements as compared to the rest of agrarian society. Specialists on Kerala's fish economy have spoken of 'marginalized blocks of producers' (Kurien and Mathew 1982: 57). Although the term is somewhat misleading in so far as it bypasses the by-no-means-marginalized social position of fish bosses and merchants, it does convey the cultural and social insularity of fishermen's settlements. Their distinct cultural identities set the hundreds of these settlements apart from each other. Fishermen have different religions: 37 per cent are Catholic, 30 per cent Muslim and 27 per cent Hindu. Within these religions, they form endogamous subdivisions: Arayans, Mukkuvans, Latin Catholics and Mappilas are only generic terms for kin-centred communities that have little social intercourse with each other.

The disparity in cultural traditions and religious beliefs of Kerala's fisherfolk have an impact on the roles of women. For instance, Hindu women are likely to have less children than Muslim and Catholic women, and are therefore less preoccupied with the work involved in raising a large family. In many places Hindu and Catholic women and teenage girls, unlike

154

Poomkara's Muslims, perform jobs that are directly connected with cash earning, such as fish-vending and money-lending (Abraham 1985; Ram 1984; Nayak 1986). In the fishing centres in particular, Catholic and Hindu women and girls provide cheap migrant labour in numbers for prawn processing and peeling (Mathew 1983; Gulati 1984b; Baud 1989: 147).

Another difference, that would strike even a superficial observer, is the one between the modern and the artisanal sector. The centre of modern fishing is Sakthikulangara near Quilon (see Map 3), which has by far the largest fishing harbour of Kerala. Other harbours are located near Trivandrum, Cochin and in the north at Beypore and Mapla Bay. During the prawn season (from June to September), up to 60 per cent of the 3,000-odd modern boats fishing in the state's waters, unload their catches on Sakthikulangara's jetties. Some 40 per cent of the fishing is for prawns, which have become of growing commercial importance during the last twenty years. The rest of the catches consist either of smaller quantities of exportable fish or of sardines and anchovies, which are sold to local consumers.

The modern fisheries sector is, however, relatively small when compared to the artisanal one. An estimated two-thirds of Kerala's marine production is landed by artisanal craft launched from the open beach, as in Poomkara (Kurien and Thankappan Achari 1988: 18). In terms of people, the artisanal fisheries are even more important, employing as they do 86 per cent of the 131,000 active sea fishermen. In Kerala an estimated 680,000 people depend on the fishing economy, and the vast majority of them are family members of artisanal fishermen, small-scale fish-vendors and processors (Thankappan Achari 1987). There are as many as 249 *panchayats* with fishermen's settlements, leaving practically no stretch of coast that is not utilized for fishing.

'Artisanal fisheries' is but a general term for fishing techniques that are far from homogeneous. The design of the craft used along the coastline varies, being closely adapted to the physical geography of the coast and the habits of the fish. It ranges from the large and costly dug-out or plank-built canoe found in the north to the rudimentary *catamaran* of the south that consists of just five logs of wood tied together. *Catamarans* are small boats made of three to five logs of soft wood tied together with coir ropes. They are practically unsinkable and can therefore be launched in the rough sea that prevails there. The boat carries a crew of two to three fishermen, mostly kinsmen who hold the craft in common. According to the quinquennial livestock census carried out in 1972, there were an estimated 10,000 such crafts. But other data, collected in 1973 by the Integrated Fisheries Project, put the figure at a mere 3,700. In the central part of Kerala, roughly between Cochin and Quilon, *tankuvallams*, plank-built canoes sewn together with coir ropes, as those used in Poomkara, are the principal craft. These long black boats, with their graceful silhouette, are manned by a crew of thirteen

to fifteen men. Their total length is 11 to 13 metres. There would be some 1,100 of them in the state. They are most often individually owned, but may sporadically also be the property of a small group of owner-fishermen. In the northern region canoes, dug out from a single log of wood and measuring around 7 metres, manned by a crew of five to eight, are most popular. They are also mostly owned by individuals. In 1972 their number was estimated at about 10,000. The price of large logs of tropical wood have increased tremendously over the past two decades and they are no doubt in the process of being replaced by plank-built boats. With the introduction of outboard motors a very large *tankuvallam*, that can carry twice as many men and a far larger net than the regular one, has been introduced in some parts of the coast. By the early 1970s, in both the southern and the central areas, there would have been in addition an estimated 8,000-odd shore-seines in operation. These nets, as in Poomkara, are mostly owned by local wealthy men, either owner-fishermen or fish merchants.

The cost of equipment has a certain bearing on ownership patterns, in so far as whereas a small and cheap boat is usually owned by the person who works on it, an expensive and large one is owned by a single man who works it with a crew of hired labourers. Broadly speaking, in the south a fisherman often owns his *catamaran* which he works with family labour. His income is based on the sale of his takings. By contrast, in the centre and north a fisherman is more likely to be recruited into a crew by one of the well-to-do men who possesses large canoes, receiving a wage based on a share of the catch. Does this mean that we can contrast, on the one hand, small, independent producers with, on the other hand, propertyless labourers, very much in a way similar to agriculture, with its distinction between small peasants and agricultural labourers? Considering that access to the sea is not as rigidly regulated as access to land, the similarity is, I feel, only apparent. Fishing is an activity which yields very insecure returns and carries great risks of destruction of the equipment. This insecurity makes for a widespread pattern of dependency, either from moneyed equipment owners or, alternatively, from fish merchants who are most likely to give credit during the periods of catch failure or in case equipment has to be replaced. Therefore, existing differences in ownership patterns are, I believe, more the consequence of technical responses to the environment than of long-standing relations based on the control over the process of production (see also Smith 1977; Spoehr 1980). To understand who controls this process one should enlarge the analysis of technical conditions to the social relations in which it is embedded, and relate it to the wider setting of circulation and reproduction (Pálsson 1989: 13).

An undue preoccupation with the technical conditions of Kerala's fishing and with cultural diversity has distracted fisheries research from understanding the nature of the social relations of production. The scarce evidence available, however, suggests that the vast technical and cultural

156

differences observed are not matched by an equally broad spectrum of these relations. A tentative comparison of six village studies confirms that there is much less diversity in the living and working conditions of fishermen than a focus on techniques or cultural traditions would lead one to expect. These six studies were located in Tanur in the northern Malappuram district, Purakkad in Alleppey district, Puthentura and Sakthikulangara near Quilon town, all three in the Central region, Poonthura in the Trivandrum Corporation and Poovar, close to the border of Tamil Nadu, both in the south (see Map 3).

Although on the southern Poovar beach *catamarans* and shore-seines prevail, 49 per cent of all Latin Catholic fishermen's households do not have any equipment of their own, and 93.4 per cent do not possess all-season gear (see Table 6.1). In the technically very similar Poonthura, 35 per cent of the 3,000-odd Mukkuvan fishermen do not own equipment, while the proportion of those who possess the various combinations needed to fish throughout the year is only 6 per cent. The rest joins a crew at least part of the year. Of the Arayans of Puthentura, who use quite exclusively *tankuvallams* as in Poomkara, 83 per cent work for most of the year as a crew labourer on boats they do not own. The situation in the nearby Latin Catholic Sakthikulangara, where motorized boats dominate, is in this respect not very different, as 79 per cent of the fishermen's households have no equipment of their own. In Purakkad, 72 per cent of the Arayan fishermen are without property and 95 per cent join a crew for at least part of the year.

Table 6.1 Labour relations in six fishing localities

Name of locality	Year of data collection	Dominant equipment	% without property	% partly labourer	% indebted to employer
Tanur	1970–72	Small boat Hook and line	n.a.	85%*	100%*
		Two *vallams*	25–50%*	95%*	100%*
Purakkad	1979	*Tankuvallam*	72%	95%	75%
Sakthikulangara	1979	Motorized	79%	86%	most
Puthentura	1981	*Tankuvallam* Small boats	n.a.	83%	n.a.
Poonthura	1976	*Catamaran* Shore-seine	35%	94%	90%
Poovar	1979	*Catamaran* Shore-seine	49%	93.4%*	35–47%*

* These are estimates

Sources: Mathur (1977) (Tanur); Platteau a.o. (1981) (Purakkad); Platteau (1984) (Sakthikulangara); Gulati (1984c) (Puthentura); Vattamattam (1978) (Poonthura); Platteau a.o. (1980) (Poovar).

In Tanur, finally, there are two communities of Mappila fishermen, the Beppukars and the Valakkars. The former uses small dug-out boats to fish with hook and line with a crew of four. The latter uses a pair of these boats and one or more large nets manned by a crew of eight. Of all Beppukars 85 per cent are propertyless, and 95 per cent of the Valakkars (see Table 6.1).

All studies point to the existence of patterns of bondage and indebtedness between the owners of major equipment and the rest of the fishermen. Most of the latter are unable to meet the expenses for their livelihood during the off season, and have to take loans from their bosses. The interpretation of these patterns, however, diverges, with some authors stressing its reciprocity, and others also seeing in the relation elements of exploitation. To some extent, indeed, the interests of the owners of large equipment, and those of fishermen, who are unable to carry on fishing throughout the season, converge. During the high season, the owners meet with difficulties in hiring a crew, while during the low season, poor fishermen are in need of credit. This is why, in Tanur for instance, labour bondage between bosses (*muthalalis*) and labourers (*ottakans*) has outlived most technical innovations introduced in the area:

> The relationship . . . is hereditary. This age-old bond has not been shaken even after the introduction of modern nets and crafts and economic vistas like fishermen's cooperative societies. There are . . . *ottakans* who are attached to their masters for the last 10 to 15 years. They are obliged to go out fishing daily when their services are required . . . among the Beppukar the *ottakans* are selected from their own social group. Similarly, the Valakkars recruit their *ottakans* from their endogamous group . . . under normal circumstances the hereditary relationship between the patron and the clients is not broken off. Even today the recruitment of the *ottakans* takes place on the day of Bakrid [a major Muslim festival] . . . The *ottakans* are obliged to work under their masters till the next Bakrid day, once they are recruited, and their masters have the reciprocatory obligation of giving them work and finance during off-season and life crises.
>
> (Mathur 1977: 196–7)

The reciprocal aspect of indebtedness, is also stressed by Platteau *et al.* in their study of the fishermen of Poovar and Purakkad. In Poovar 35.5 per cent of the crew members and 47 per cent of *catamaran*-fishermen, are indebted to the owners of shore-seines. In the authors' view, the loans given to the workers:

> cannot properly be regarded as instruments of 'debt bondage' since, theoretically at least, the labourers remain free to leave their employers whenever they want, provided they have previously cleared their debts.
>
> (Platteau *et al.* 1980: 1767).

The same view is expressed with regard to the indebtedness of labourers in Purakkad (Platteau *et al.* 1981: 193). It remains, however, unclear, if the relation is indeed based on mutual interests, how the abject squalor that typifies the lives of the labourers in Poovar should be explained. The authors think that it should not be attributed to:

> prolonged states of chronic unemployment due to lack of productive physical capital but to a low-productivity occupation which goes on running most of the year and to a seasonal technical unemployment which results either from the roughness of the sea [during the Monsoon time] or the absence of fish [during the calm season].
>
> (Platteau *et al.* 1980: 1766).

By contrast, in his study of Poonthura fishermen, Vattamattam (1978) stresses the exploitative side of indebtedness. He distinguishes two subgroups of fishermen: the small producers who own only catamarans and the labourers who own no equipment at all. Both groups are constantly in need of credit, which they take either from money-lenders or from equipment owners on condition that they will work their equipment if need be. The poverty of the fishermen must, in the author's view, be traced to the lack of investments in the techniques of fishing. Profits, rather are used for usury, to extract exorbitant rates of interest from fishermen in need of consumption loans.

According to Platteau, 79 per cent of all motor-boat fishermen are hired on a crew, and in most cases are indebted to their masters, even though, in his view, the loans are not intended for labour tying. They have to be returned irrespective of the debtor's willingness to continue the labour arrangement with the creditor. By contrast, in artisanal fishing the loans are usually not repaid as long as the worker stays with his master (Platteau 1984: 95). Platteau noticed labour relations in Sakthikulangara, however, to be less reciprocal than in artisanal fishing. Class distinctions were more marked too, and most owners of equipment had no fishing background at all, but were, in fact, traders. The top of the class structure was formed by boat-owners, traders, export agents and a minority of fish-dealers, with crew labourers working on motorized boats occupying an intermediate position similar to that of owners of minor artisanal equipment. At the bottom there was a large mass of migrant women and children from neighbouring villages, who processed prawns, and they were often so poor that they could barely survive.

Interestingly, another study on the remuneration of the crew of Sakthikulangara's motorized boats suggests that investments in the techniques of fishing have not contributed very much to improve the situation of hired workers. The crew's per capita yearly remuneration was on average only 1.4 times higher than that of the crew of artisanal *tankuvallam* boats, and nearly four times that of shore-seine workers (Kurien and Willman 1982: 46). This may seem a substantial difference, but one should keep in

mind that the figure does not represent the actual income of each individual earner, but the labour cost to the owner. Considering that, to meet contingencies, the owner is likely to have agreements with more men than he strictly needs, the actual income of each individual earner is likely to be significantly lower.

Recent research on women's roles in Kerala fisheries has also highlighted that, in the division of labour and responsibilities between men and women, dissimilarities are less pronounced than cultural patterns would suggest. Their work is invariably performed on shore and is mostly held in low esteem, save for the women who deal in prawns to which I return later. It is unlikely to yield significantly-higher earnings than, for instance, coir-making. Their earnings are at such a low level that they represent but a modest additional income, though a vital one, to the earnings of men. The main reason why this is so is that women's primary responsibility is perceived to be with childrearing and householding, and this forms a powerful barrier against their obtaining the better-paid work. As fishermen's wives combine householding with remunerated work to supplement the income of men, they also rely heavily on the help of their daughters. Just as in Poomkara, women normally withdraw from work soon after marriage, until their eldest daughter is old enough to take over domestic affairs (Gulati 1984b: 63ff; Mathew 1983; Ram 1984 and 1991).

Set against this background, it is not surprising that statistically also, in the living conditions of fishermen, a picture of squalor predominates. This is also borne out by a census undertaken in the state in 1979, according to which 50 per cent of the 118,000 fishermen's households had incomes below 1,000 rupees a year, against 3 per cent whose income was above 3,000 (Kurien 1985: 80). If we take the average number of consumption units per house-hold as being 3.5 (two adults and three children), this would mean that 97 per cent of them lived under the poverty level that was set at 4,200 rupees a year in 1980 (Mathew and Scott 1980), and lived in conditions very similar to those I have described for Poomkara. Regional disparities are surprisingly small, and conditions are no better in the fast-developing commercial harbours. A well-developed area such as the Vizhinjam coast near Trivandrum shows, for instance, infant mortality rates three times higher than the rural Kerala average (Vimala Kumary 1991).

Though the heterogeneity of the technical conditions of fishing entails a great deal of local variation, the comparison between the six villages suggests, in short, that the vast majority of fishermen in Kerala do not own the particular type of equipment necessary to fish the year round. Even *catamaran* fishermen, who are by and large viewed as small producers, have to work the equipment of well-to-do owners at least part of the year. Most are indebted to these employers, since their income is insufficient to tide them over the slack season. A picture of internal stratification emerges with a thin layer of wholesale merchants and all-season equipment-owners

at the top, a large base of full-time artisanal crew workers and with seasonal equipment owners, small vendors and crew workers on motorized boats in a very precarious position somewhere in between. The intermediate group of seasonal equipment owners may at times hire labour, but more often rely on family members and at other times hire themselves out to those owning all-season equipment.

CHILDREN'S WORK

The squalor, the daily insecurity and the dependence on equipment owners and creditors, all contribute to boys' and girls' early sharing in the work and preoccupations of the family. All along the coast, as I have been able to witness during various visits, one finds young boys present on the beach while the fishermen are at work. For Mathur this is the way in which the northern Tanur fishermen transmit their skills to the next generation:

> Mappila boys generally learn the technique of fishing by accompanying fishing units and by involvement in the operations. They learn the technique by the hard way. The transmission of knowhow is generally done on the basis of kinship. Instruction is imparted to the kin either in a particular technique or in some special gear or craft. The children in the age group three to six are given model boats to play with on sandy beaches. Those between the age of seven to twelve are asked to carry fishing tools like coir ropes, rudder, oars, etc. from home to the boats. They are detailed for draining off the water from the boats, if any. Teenagers are asked to accompany the boats to the mid-sea and help the elders in propelling the oars. They are given rigorous training in playing the rudder in the last stage. This apprenticeship training is given for a year or so. When they are competent to substitute a member of the crew in any vacancy, they are given a fixed share of the catch.
>
> (Mathur 1977: 179–80)

While learning the skills of fishing, boys are allowed to take 'five to eight small fish' from the boat when the catch is landed. Mathur views boys' activities as falling entirely in the sphere of socialization. The giving of fish is, in his view, rather the outcome of fishermen's benevolent attitude with respect to their trainees than remuneration for work. He similarly views as another aspect of training the trading activities most boys undertake with the foraged fish (Mathur 1977: 191). However, similarities with Poomkara's boys are striking, and one may therefore question the rigid distinction made by the author between work and training. While learning, boys inevitably also shoulder a share of work. As said in Chapter 4, the fact that what they do is not perceived as work at all has much to do with the subordinate position allotted to trainees (cf. also Fjellheim 1989: 135ff).

Foraging is also common among the Arayan fishermen of Alleppey, and

here it also depends, as in Poomkara, very much upon the commercial value of the fish whether it is sold or brought home. There is a marked difference with the Muslim fishermen of Tanur and Poomkara, however, with respect to the behaviour of girls:

> The *chakara* (mud-bank) is near the Alleppey shore. As soon as a boat returns, swarms of children gather around it. The fishermen sort the catch, throwing the undersized fish (*podimeen*) on the sand, from where it is immediately picked up by a child. Small girls are particularly quick in collecting the fish, and many of them obtain more than their brothers. The fish is sold, after a little haggling, to the female vendors. It is common for these vendors to obtain children's takings for only half the ongoing price. As foraging allows the older children to earn some money, it naturally also sets an example for the small ones who are in their care and follow them wherever they go. A child is quick to discover that it is sufficient to have a small basket, and to beg or pick-up fallen fish, to earn some money, and it will therefore be tempted to take to this activity whenever given the opportunity.[1]

A more organized form of labour, in which boys are hired as labourers, has been documented by Puthenkalam for shore-seine fishing among the Latin Catholic fishermen of Vettuthura, 25 kilometres north of Trivandrum. Almost half of the workers in the crew of shore-seines, according to the author, is below 15. There exists a clear-cut division of labour between boys and girls, the former working the net, and the latter sorting the catch and preparing it for salting and drying. The owner takes for himself 37.5 per cent of the catch, and the rest he divides among the labourers, boys being entitled to only one quarter of an adult man's share (Puthenkalam 1977: 155). Boys are able to earn between 0.25 and 1.50 rupees a day. Girls do not receive any remuneration for their work, except for an occasional coin to spend on sweets or cheap plastic ornaments. As said, girls' place is primarily in the home, and to have a daughter at home to take over the responsibility and care for the children when the mother is absent is a vital asset to a female fish-vendor (Gulati 1984b: 63ff; Ram 1984 and 1991). A daughter is often considered mature enough for this task as young as 6.

This is not to say that girls do not undertake wage work: they do provide cheap labour in numbers in prawn-peeling, a sector that has been growing fast with the export boom of the 1970s. Most of the girls are hired temporarily for peeling by middle-men and women who deal with the agents of the business firms. They have mostly no fixed employment, and are just called to work, often simply by sounding the horn of a lorry, whenever there is a catch to peel. The number of women and girls employed to peel prawns is estimated to have increased, in the 1970–80 decade, from around 10,000 to 15,000 (Thankappan Achari 1987: 3). In her fisherwomen's profiles, Leela Gulati gives some indirect clues as to the organization of this work in

Sakthikulangara. Many women recollected that, prior to the prawn boom of the 1960s, girls used to collect lime shells and make nets. Now these occupations have almost disappeared and girls peel prawns instead. Their main employers are female prawn dealers, who hire them to add to the labour of their own daughters. Beatrice (41), one of these dealers, gives an account of a form of labour bondage that has developed in peeling:

> Gradually, as I bought larger and larger quantities I needed outside help with peeling more often. During the lean periods, when the catch is small, the women who work for me come to borrow small amounts. The loans carry no interest, but an obligation to peel for the lender if and when required.
>
> (Gulati 1984c: 114)

Similar accounts are provided by Maggie and Mary (Gulati 1984c: 37 and 69). But girls may work as well in the larger enterprises that suddenly open their doors if large catches are landed. Pankajakshi (55) is one of these women, and she worked for years with her daughters in a shed. She recollects that:

> The peak months were the monsoon months of July, August and September. We got work without break in those months. In fact, for many days we would work overtime. Though there were many peeling sheds, quite a few of them were temporary ones that would crop-up only in-season. I and my girls were working only for one shed. However, work even in our shed was not regular in other months. On average we got work for 200–220 days in a year and the payment we received was on piece rate basis. The average daily rate worked out to five rupees, taking all working days together. We usually were there at 1'o clock waiting for the incoming catch. The shed equipment consisted of just a table and a chair and a huge weighing scale. We would squat and peel the prawns. We were paid approximately 15 to 30 paise per kilogramme . . . when there was plenty of work each one of us could peel 50 kilograms a day. Then we got home only at around 10 p.m.
>
> (Gulati 1984c: 139–40)

By the time she reached home she had squatted with her daughters on the wet floor of the shed for between six to eight hours on average. The women and girl workers have no toilets or even drinking water within reach. But the worst are the sexual assaults of male employers, that make parents at home stay in anguish when they have to send their girls unaccompanied:

> There are no fixed hours of work. When the catch is poor, not all sheds have work to offer. Also, on some days one may get work for just a couple of hours. On the other hand, when the catch is very good, the peeling sheds ask you to work overnight, because peeling cannot be put off for the next day. The families have no way of knowing why their

girls have not returned home, on account of work or something else.

(Gulati 1984c: 136)

For some Sakthikulangara vendor women modernization has offered new opportunities. They have become prawn dealers, and realize now higher profits than when they were simply retailing fish to the consumers. Their handling of larger sums has enhanced their prestige in the family (Gulati 1984c: 116). But one may doubt whether this has had a positive impact on their daughter's work as well. The prawn dealers rely heavily upon the latter's help at home. The smaller ones need their daughter as unpaid labour for peeling, the larger ones as housekeeper and baby-sitter.

Modern fishing has provided girls with opportunities to migrate to fish processing plants well beyond the boundaries of the Kerala state. Recently the media have drawn some attention to the fate of tens of thousands of teenage girls and young unmarried women, many of them from the Alleppey region, who migrate as far as Gujarat and West Bengal to work as a prawn-peeler. The pattern of this migration reflects very much the type of roles normally ascribed to girls. Girls' work is unskilled, lowly valued and of a temporary nature. It is the family who takes the decision to send a girl to work as a peeler. This happens with a clear aim, mostly to clear debts, to maintain younger siblings and earn dowries (Saradamoni 1989: 45ff). The girls themselves perceive their experience of work as degrading, which in view of the very low wages, the long hours of work and the miserable accommodation, it often indeed is. It is typically work for love temporarily undertaken to help the family in distress and discontinued upon marriage.

To sum up, there are enough indications to assume that the seniority and gender hierarchies in fisheries have broad common features. In the whole of Kerala, as in Poomkara, children's work is primarily oriented towards the continuity and welfare of the household through activities that are of a non-monetary nature, such as domestic chores and foraging. This applies more forcefully to girls, whose work is in general seen as supportive of the mother's endeavour to feed the family. Teenage girls may often be sent to work as hired workers, to perform work that married women find degrading. This work is conceived as temporary and not as part of a training in skills to be used later in life. For boys the situation is different, and particularly when teenage they are more likely to receive some cash as recognition that they have embarked upon a process of socialization in their future role of earners. Invariably, however, their earnings are modest, as the importance of their work for income generation is generally belittled. And yet, in spite of its inferior status, the value of children's work for the family is, considering the squalor in which it lives, beyond dispute. One can ill imagine that a fishing couple be able to raise children without having them sharing in their responsibilities, as indeed happens all over Kerala. In this sense, the Poomkara case does not seem to be exceptional.

164

WEAPONS OF THE SMALL

To now turn to my central question, do Kerala's fisheries need the work of children? As said in Chapter 4, children's roles are intimately attuned to the needs of artisanal fishing. The owner of the equipment devolves a part of the costs of labour upon the household, on which rests the responsibility for maintaining the fisherman in illness and old age and of bringing up a new generation of fishermen. The insecure working conditions and low level of remuneration that is a common feature all over Kerala suggest that fishermen's households generally fulfil this role, in artisanal as well as motorized fisheries. In spite of a wide range of variation in the nature of tasks, this role basically moulds what children do. Yet, one may ask whether children's roles are not but vestiges of a way of fishing that is on its way to disappear. It is my contention that they are not, and that they are at the core of a generalized system of production that crucially depends on children fulfilling their economic roles.

To understand why, one must look at the significance of children's work for the fisheries at large. What has sprung up from the discussion in the previous paragraphs is that there is but a gradual difference between the social relations of production prevailing in modern and those in artisanal fisheries. This has brought me to question the dualistic model widely followed by fisheries economists that the two 'sectors' that exist in Kerala's fishing economy, the 'modern' and the 'artisanal' one, would operate in distinct and separate spheres of the economy. I think that children's roles in fisheries cannot be understood as long as this dualistic model is maintained. In this respect it may be useful to refer to the modes of production debate, and more in particular to the question of how capitalist expansion is affecting and transforming precapitalist or 'peasant' systems of production (for a summary see Foster-Carter 1978 and Harriss 1979). The debate, more specifically, has highlighted that precapitalist modes of production are interlinked (or 'articulated') with expanding capital in such way that, while being changed, they are also consolidated and subsumed in the world capitalist system.

The origins of the dualistic model lie, in fact, in a deep conflict of interests, between owners of motor boats and those operating artisanal ones, that arose from the introduction of modern technology. Artisanal fishermen appeared quite immediately to suffer from the crude and noisy type of trawling carried out by motor boats. They therefore strongly objected against methods of fishing that jeopardized their livelihood. The ensuing conflict led them to exaggerate the differences, hereby neglecting what the two methods of fishing share in common, namely, the commercial exploitation of marine resources. The dualistic model, originally proposed by the Norwegian economist Johan Galtung, seemed at first to satisfactorily explain the clash of interests. The problem originated, in his view, from the introduction of a Norwegian project to develop Kerala's fisheries enacted between 1953 and

1963 in Sakthikulangara and neighbouring villages (Indo-Norwegian Project, INP). Galtung made a distinction between a modern and a traditional economic cycle. The latter was the common pattern before the Norwegians launched their modern technology in the late 1950s. It was characterized by simple gear, abundance of manual labour, a high degree of self-consumption and limited scope for marketing (Galtung 1980: 344). No doubt Galtung, had he given the matter serious consideration, also assumed that it relied on socialization patterns that accorded to children an economic role in the intra-household division of labour.

In the early 1950s a harbour and roads were constructed on the site of the INP. Motor boats, trawl nets, freezing plants, and insulated vans soon followed. They became the normal equipment of a new way of fishing in the area. The old 'traditional' cycle, to use Galtung's words, that existed in the project area, had by the end of the 1960s been 'modernized' in so far that its scale had been expanded and that it had been integrated into the world market. This meant that fishing lost all of its previous characteristics and acquired a new meaning, one that fitted into a modern economic cycle: 'What is caught is caught with the most modern technology, by modern fishermen, marketed with modern techniques to modern consumers (Galtung 1980: 350)'. I would add that this model envisaged no economic role for children. In Galtung's analysis, the 'traditional' economic cycle that continued to prevail in the two hundred and odd remaining fishing villages of Kerala where no modern techniques were introduced, remained entirely separated from the 'modern' one. The fish caught by these fishermen was, in his model, all locally consumed and did not reach the world market. For modern fishing the artisanal fishing areas would form nothing more than a vast reserve of 'manpower' from which to tap at will, for instance to peel prawns (Galtung 1980: 357).

The dualistic frame of analysis has been so successful that the terms 'traditional' (or the more recent 'artisanal') and 'modern' fisheries are now firmly established in the vocabulary of fisheries economists. Also Platteau, in his analysis of the fish economy of Sakthikulangara, works from this dualistic model. The 'traditional fishing villages' he visualizes, just as Galtung more than twenty years earlier, as using rudimentary techniques, having a low level of productivity and being mainly engaged in petty trade. He, however, adds new characteristics, such as a high degree of seasonality in the fishing operations, a low degree of class differentiation, and the existence of many-sided interlinked transactions, the main ones being labour bondage and marketing ties. By contrast, 'modern' INP villages have, in his view, witnessed far-reaching changes, including not only enhanced productivity and expansion of the market but also polarization of the socio-economic structure and the opening-up of and de-linking of product and factor-markets (Platteau 1984: 83). These changes would be diametrically opposed to the 'traditional' rationality of fishing.

The perspective offered by Platteau, though basically a continuation of the thinking in terms of two separated sectors of fishing, is interesting, in so far that it seeks to explore the linkages of the traditional sector with the modern one. A 'traditional' village such as Purakkad, for instance (Alleppey district), is indirectly linked to the modern sector during the off season. As there is no harbour in the area, artisanal fishermen use their *tankuvallams* to land the catches of motor boats. Another patent linkage is the marketing structure, where the commission agents play a crucial role. They integrate the local fishing economy in the world market. However, and this may be crucial, these linkages have, in the authors' view, but a negligible bearing on the traditional relations of production (Platteau *et al.* 1981: 187–212).

A more elaborate view of the linkages theme is offered by Kurien's analysis of the interrelation between trading and productive capital in fishing. Kurien points at the early entrance in fish marketing of trading firms that were merely attracted, with the sudden spurt witnessed by the prawns exports, by the prospect of quick profits. They had no relation with fishing, but limited their operations to lending money to businessmen who acted as their agents. In this way they came at the top of an elaborate hierarchy of middlemen and agents, that now operate between the big firms and fishermen, irrespective of their using motorized or artisanal boats. I have described in Chapter 4 how, during the landing of the valuable *naran chemmeen*, these agents also visit the landing places of Poomkara fishermen. As in Poomkara, they are generally able to buy the catch cheap by astutely manipulating the final price:

> The dependency of the fishermen on this hierarchy for the sale (most often on part-credit) of all exportable species caught by them is virtually total. Having no alternative sources that will procure their products on better terms . . . all losses and setbacks experienced by the processors/exporters are passed down the hierarchy until finally the fishermen bear the total brunt.
>
> (Kurien 1978b: 1563)

What the search for linkages illuminates is that the dualistic model's underlying assumption of a 'traditional' sector that would function separately and follow its own rationality in a fast-changing economic set-up, is highly problematic. The whole idea of the static, unchanging artisanal fishing village appears to be a myth in the first place. The little historical evidence available highlights that Kerala's fisheries have been producing for international markets long before the Norwegians introduced the INP. What is believed to be 'traditional' is, in fact, as aptly shown by Kurien, but the result of a long-drawn process of technical innovation and adaptation of an art of fishing that never was static. In the nineteenth century, fishermen's settlements were not the immutable rural communities based on self-subsistence and short-distance exchange as portrayed later on. They

were not only producing for a home market that extended all over the Travancore state, but met a growing international demand for fish products as well. In the first half of the nineteenth century dried fish exports more than doubled in the course of barely ten years. Oil sardines, that were at first primarily used to manure coconut trees and paddy fields, became in the course of three decades the raw material for the thriving fish oil exports from Malabar and Cochin to Great Britain (Kurien 1985: 71). The course of the nineteenth century also saw the gradual emergence of a powerful class of fish merchants that took control over long-distance trade. As early as 1917, fishermen were agitating against the control exercised by these merchants over the more lucrative aspects of the fish trade. In response, the government proposed co-operatives for fishermen, so that they could stand united in facing the merchants. By 1933 these co-operatives had more than 8,000 members. A government report published in 1930 exposed the strings attached to loans given by fish merchants to fishermen, as they were held responsible for hampering the growth of a marketable surplus of fish products. The merchants provided the fishermen with consumption loans in the slack season to obtain the exclusive right to their catches in the high season. Attempts, such as the establishment of co-operatives, to curtail their power, met with strong resistance and kept their performance at a disappointing level.

In the 1940s the government undertook to modernize fishing by promoting the use of nylon in the fabrication of nets, cold storage, outboard motors, and co-operatives. Most of the governmental effort concentrated on the area around Sakthikulangara which had been, of long, the main trade centre for the export of dried prawns and salted fish to Ceylon (Klausen 1968: 139). The efforts aimed at canalizing a growing stream of fish products from the artisanal 'hinterland' towards the powerful Sakthikulangara traders. Their influence already stretched well beyond the limits of the locality:

> This . . . was apparent in 1961 when the Government of Ceylon passed certain restrictions against the import of salted and dried fish, and made attempts to fix ceiling prices. The effects of this Ceylonese policy might be studied in Sakthikulangara. Agents and wholesale dealers from Cape Comorin and Tuticorin far south in India constantly came to Sakthikulangara and held meetings and conferences there with the local merchants. The local newspapers in Quilon had many contributions about the problems this caused for the fishing population. The leading fish merchants in Sakthikulangara tried through their relations with Congress politicians to bring this problem before the highest political forum and if possible to influence the Ceylonese Government to repeal their decisions.
>
> (Klausen 1968: 139)

The fast-growing demand for frozen seafood from Japan and the United

States soon made the issue of the dried fish trade lose its importance. By the beginning of the 1960s the exports towards these two new markets was growing at a phenomenal rate: from a turnover of a little less than 500 tonnes at the end of the 1950s to 1,462 tonnes by 1961. Prospects for realizing sizeable profits were alluring. The shore price for fresh fish landed by artisanal fishermen was only 150 rupees per tonne, while its export value could reach 4,000.

The INP had been, during the first years of the 'pink gold rush', as the frozen prawn trade was called, already active in the Sakthikulangara area, trying to enhance the results of artisanal fishermen. When, by the beginning of the 1960s the rush engulfed Kerala's fisheries, the results of the project were as yet inconclusive. Little was needed to convince the management that, in order to achieve success, the course of her policy should be redirected towards a programme of far-reaching modernization and mechanization. This programme was exactly what the Sakthikulangara merchants needed to consolidate their newly-won position on the international market. It is of little importance whether this was indeed the intended aim of the management. What is more interesting is to place the decision in a long-term perspective. Modernization provided Sakthikulangara with an economy of scale and established it as the undisputed trade centre for frozen prawns. The Norwegians introduced in the area a new type of fishing boat, the 'pueblo', that was designed to suit the conditions of Kerala's fisheries. These small trawlers, although they may have looked quite odd in Norwegian eyes, were large enough to revolutionize, not so much the relations of production in fishing, as those between traders and producers. Motorized fishermen had to land their catches in the Sakthikulangara harbour and this allowed the exporting agents to control the price and marketing of fish more directly than ever. Their command over the large catches of motorized fishermen and their modern storage methods, greatly enhanced their international reputation as reliable and steady suppliers. This gained them a monopolistic export position that put them virtually in control of the entire inland market of exportable fish (Galtung 1974, 1980).

In spite of an impressive growth of the marketable surplus of artisanal fishermen, the shore-price of fish remained significantly lower in the fishing villages than in the harbours. In 1979, for instance, prawns landed by *catamarans* on the coast of Quilon district fetched on average only 3 rupees a kilogramme, against 4.79 rupees for prawns landed in the fishing harbour by motor boats (Kurien and Willman 1982: 42). Arguing that the smaller the volume of the catch, the fewer the traders competing to buy it, Kurien and Willman have explained the persistence of a price differential by the scale of operation of the fishermen.

The differential shore-prices of prawns, and the willingness of artisanal fishermen to bring to market the varieties of fish that were in demand,

discouraged traders from investing further in modern fishing methods. They simply had no compelling motive to do so. Their merchandise was either brought to them by the hierarchy of middlemen and agents operating in the artisanal fishing villages, or landed by motor boats in the heavily-subsidized fishing harbours.

In the 1970s, prompted by the strong price increases, powerful traders from outside fisheries, some of whom had faced a serious depression in the trade and processing of cashew nuts and coir, joined the prawn business (Kurien 1978b: 1563). It mattered little whether the fishermen they dealt with had modern or artisanal equipment. By the end of the 1960s new roads had made most of the artisanal fishermen's shores accessible to lorries and insulated vans. The new entrants in the prawn business, therefore, rather than acquiring motor boats, invested their profits in insulated lorries and freezers (Kurien 1985: 86, note 91). Over the years this enabled the traders to increase their share of the profits realized in fisheries at the expense of the fishermen (Kurien and Thankappan Achari 1988: 23). The combined effect of booming exports and massive subsidies did, nevertheless, lead most owner-fishermen living near the harbour to adopt motor boats and trawl nets. The number of boats, only 693 in 1966, grew to 2,636 in 1972, to 3,038 in 1980, and reached 3,400 in 1987. Significantly, however, artisanal fishermen brought, in the meantime, more than twice as many new boats into operation than modern fishermen. The increment in the number of artisanal boats was from an estimated 21,000 in 1961 to 26,000 in 1980, and reached 27,700 in 1987 (Thankappan Achari 1987). The total number of fishermen, mostly recruited by the artisanal sector, nearly doubled: from 74,000 in 1961 it grew to 131,000 in 1980. Artisanal fishing then, did not disappear under the impact of modernization. On the contrary, it proved able to compete successfully, expanding even faster than modern fishing.

An advantage above modern fishing proved to be crucial: the artisanal fishing methods' flexibility in adapting the operation costs to the results of the fishing effort. Operation costs in artisanal fishing entail, as I have described for Poomkara, little more than the cost of labour. The insecurity of employment, added to the poverty of the families, makes for a wide difference in power between an owner-fisherman and the men of his crew. The share system allows an owner-fisherman to reduce, if necessary, the costs of a fishing operation to a minimum, by simply sending his men home empty-handed, or employing boys for insecure trials in the off season.

Artisanal fisheries have also witnessed a genuine technical revolution. Investments in fishing equipment of all types has proliferated, rendering it increasingly efficient. The use of ice and nylon nets has spread evenly along the coast, and many *tankuvallams* have been fitted with outboard motors in the course of the 1980s (Kurien 1985). This has enabled them to return to the shore with their catches faster, and to explore new, distant fishing grounds. But these costly technical adaptations have only reinforced artisanal

fisheries' low-cost rationality, as I will elaborate a little further on, because owner-fishermen have retained their ability to adapt, flexibly, operation costs to the seasonality of fishing or price fluctuations.

A study of profitability of investment, productivity and contribution to the economy of artisanal fishing has indeed come to the rather surprising conclusion that these are: 'on average as good as, or better, than those of mechanized vessels, though the same cannot be said of the earnings of individual fishermen' (Kurien and Willman 1982: III). The last remark may as well be crucial, particularly if we keep the vast difference in earnings between the few who own all-season equipment and the many who do not, in mind. According to computations in the same study, the yearly per capita average remuneration of a crew labourer of a *tankuvallam* was Rs 1,330 and that of a shore-seine worker Rs 486. This contrasts sharply with the gross earnings of owners, that were nearly ten times those of a shore-seine worker (Rs 4,794) and twelve times those of a *tankuvallam* worker (15,160). The net returns on investment, negative in motorized fishing, were extremely favourable, being as high as 61.3 per cent in *tankuvallam*-fishing and 39 per cent in shore-seine fishing (Kurien and Willman 1982: 102A).

The way artisanal and motorized fishermen dealt with the environmental problems created by the 'pink gold' rush explains to some extent the differences in profitability of the two methods of fishing. Marine resources have seriously suffered from the intensification of fishing that came in the wake of the prawn boom. While Kerala's total fish landings in the period 1971–5 had reached an annual average as high as 406,000 tonnes, this figure suddenly declined in the period 1976–80 to a mere 332,000 (Thankappan Achari 1987). Given the increase in the number of workers and the amount of equipment, the declining tonnage of fish landings implied an even sharper decrease in the return per hour of fishing (Meynen 1989: 19). While in 1973 one hour of fishing with a trawler yielded on average 82.6 kilograms of fish, in 1979 the return had come down to only 4.2. Artisanal fishing was hit even harder. A yield that dropped from 95.2 kilograms/hour in 1973 to 1.6 in 1979 made the result of fishing still more depressing (Kurien and Mathew 1982: 82). The response was, as expected, a further intensification of the effort.

For the motorized fishermen, the combined effect of falling returns, the rising price of oil and the quick depreciation of the equipment, have caused serious management problems. The owner of a modern boat incurs monetary losses every time an expedition fails or is disappointing. The fish he catches tends to become so expensive that he has been forced to seek state support to remain in business. Artisanal fishing, by contrast, has proven much better equipped to deal with the problem of falling returns and intensification of the effort, because it relied so heavily on human energy. As he has maintained the share system, the owner-fisherman has met no special difficulties in compensating the fall in returns by lower shares for the crew on the beach. If he has an outboard motor, he often simply reserves the use of

costly petrol for profitable expeditions, choosing to utilize muscle power, which costs him virtually nothing, for the unlucky ones. Resistance is, in the highly competitive atmosphere in which the intensification of fishing is taking place, simply out of the question. A high rate of population growth had made the ranks of men in need of work swell, and this had only added to an owner-fisherman's power over his crew.

The total tonnage of exports could therefore keep growing, although at a lower pace than before, increasing from 22,792 tonnes in 1962, valued at 277 million rupees to 31,637 tonnes in 1979, with a total value of 1,096 million rupees (Kurien 1985: 78). Meeting export targets, under the circumstances, has mainly been realized by withdrawing fish from the internal market, much to the disadvantage of the poor coastal consumer, in particular the fishermen and their families (Meynen 1989: 20ff). Much of the growth originated from the demand side, and in particular from Japan, with a share of one-third of the total exports. One can only speculate how far the low-cost rationality of India's artisanal fishing methods plays a role in this demand, particularly when balanced against the cost of Japan's own large-scale fishing enterprises.

Children's activities in fishermen's households play a major role in reproducing over time the vast reservoir of tremendously cheap human energy to which artisanal fishing owes its resilience. As said, children of both sexes defray a significant and flexible share of the costs of labour. I have described how children's activities contribute to feeding and supporting a future generation of fishermen and fish-vendors, in addition to forming a buffer for the support of the adult worker and his family in illness and unemployment. This gives artisanal fishing a phenomenal advantage over methods of fishing that have to rely on mechanical power. The results of artisanal fishing, then, compare favourably with those of more capital-intensive equipment, mainly because of the existing relations between owner-fishermen, their labourers and the latter's families. The particular pattern of dependency on the owner-fishermen with its implications for the division of labour in the fisherman's household and for his tolerant attitude vis-à-vis children's foraging activities, explains why artisanal fishing has proved able to compete successfully with technically more advanced methods of fishing.

Children's work is then not only indispensable for the livelihood of fishermen's families, but also for the type of fishing economy that is dominant in Kerala today. The fact that this work is mostly performed in the non-monetized periphery of fisheries provides it with its competitive endurance. Technical innovation, by its localized character, does not jeopardize this division of labour. On the contrary, it sustains artisanal fishermen in their successful competition with modern fisheries. A careful reading of the available material on the economic history of fishing of the last thirty years supports this conclusion. It not only makes it hard to make a case

for believing that children have been pushed out of the world of fishing, but also explains why the modernization of fishing, far from bringing about a rise in child-waged employment, derived much of its legendary profits from the persistence of children's exploitation in antediluvian methods of fishing. During the past thirty years artisanal fishing has been expanding fast, increasing hereby rather than reducing the demand for children's work. At the same time, the fierce competition for scarce resources and markets has increased the need of children to work, and so have the growing demands for education, which have become a matter of survival even to the very poor. This raises the issue of children's work in sectors of production that have not been exposed to such all-embracing processes of change. I turn to this question in the next chapter, where I analyse children's role in coir-yarn manufacture, an industry that for three decades now has been caught in a downward spiral.

7

THE COIR INDUSTRY'S SAVING ANGELS

I have discussed in the previous chapter the crucial role of children in the artisanal fisheries' resilience in the face of modernization and the expansion of foreign markets. For coir, another major sector of the rural economy, the situation is different. Foreign demand for the product has been steadily diminishing. The decline of the sector, prompted by the introduction of synthetic floor coverings in the west, set in in the early 1960s, during the very same years of the 'pink gold rush'. What has been the impact of this slump on girls' work? Has it decreased the need for their work? In this chapter I broadly follow the same line of thought as in the last chapter, with the difference that the focus is now on past developments. I begin by discussing the relevance of my Poomkara observations for understanding girls' work in coir manufacture in other parts of Kerala. I then probe into the meaning of this work for the past prosperity of the industry, analysing, finally, how work relations, and girls' in particular, have been transformed under the impact of the combined effect of coir's decline and the growing importance of education (see Table 7.1).

GIRLS' WORK

In Chapter 5 I have discussed how a girl's work in coir is embedded in the wider setting of gender relations, and is mostly undertaken as part of her mandatory housekeeping duties. The way coir-making is organized, being as it is an irregular activity that demands high inputs of energy and offers but very marginal returns to those who undertake it, is of decisive importance herein. Without girls' work for no pay, I concluded, Poomkara's husks would have hardly any value at all. The available material on coir manufacture, though mostly not concerned primarily with labour relations, suggests that this situation is common all along the coastal fringe where coir is made.[1]

Historical and ecological dissimilarities make for coir to be manufactured

Table 7.1 Educational level of members of coir-making households (1975–6)

	Age group				
	1 *< 15*	*2* *16–25*	*3* *26–60*	*4* *> 60*	*5* *all ages*
	%	%	%	%	%
Illiterate	42.83*	6.74	28.20	58.21	29.55
Middle school	57.08	83.00	68.00	40.57	66.43
High school	0.09	10.26	3.80	1.22	4.02
Total	100	100	100	100	100
No.	166,312	123,968	162,899	29,239	482,418

* This figure includes children of pre-school age. Children <5 numbered in the sample 47,417, that is, 28.5% of all children <15. This explains the high rate of illiteracy among the age group. If we discount the group below 5, the number of illiterates between 5 and 15 would be about 14%.

Source: Government of Kerala, Bureau of Economics and Statistics (1978).

under heterogeneous conditions. A striking difference is the one between yarn that is spun by hand and that spun with the help of a set of spinning-wheels as in Poomkara (spindle-spun). There are ecological conditions that make it impossible to prepare husk in such a way that it gives soft and strong yarn for weaving. In those areas, stretching north of Alleppey and south of Trivandrum, coir is mostly spun by hand to make rope for maritime and agricultural use. It employs about 200,000 workers on a part-time base. Economically, the spindle sector is far more important. It is mostly concentrated in the 'coir belt' between Alleppey and the Anjengo area north of Trivandrum. It employs about 300,000 people on a part-time base (Government of India 1978: 63ff).

Hand-spinning is an individual activity undertaken at home in the lost hours of the day. It does not need a small unit of three people working together, as wheel-spinning. It is mostly organized on a putting-out system, and hired labour is unknown. Making yarn fetches such low earnings that efficiency is not a major concern. This chapter is concerned with the spindle-spun sector, where, in spite of a fair degree of local variation in quality, texture, runnage and spinning methods, productivity is consistently much higher. I have broadly distinguished three regions, from south to north, that correspond to the three major varieties of weaving yarn produced in Kerala. They are: Anjengo in the southern Trivandrum district, Mangadan in Quilon district and Aratory and Vaikam in Alleppey district (Government of Travancore-Cochin 1953: 12). A survey of six villages, undertaken in the 1970s, gives the following picture of labour conditions in the spindle-spun

sector:[2] in the south about two-thirds of workers are hired, mostly by merchants, the rest working for co-operatives. The situation is broadly the same in Quilon, though the number of co-operative members is less, small manufacturers buying the husks from private traders instead. In Alleppey, by contrast, coir is generally manufactured by small units of self-employed households, with only a minority of them being members of co-operatives (Government of India 1978: 77). In spite of the existing diversity, the level of earnings is everywhere more or less comparable. Wage rates for beating and spinning are somewhat higher in the co-operative sector than in the private sector, but this advantage accrues only to those who are lucky enough to join an effective one. The majority of coir workers are not, and their wages are at approximately the same low level. Much of the problem is caused by the difficulties in the supply of raw husks, a critical feature of the industry in the entire spindle-spinning area. Typically, in those areas where the industry is concentrated, and where the finest varieties of yarn is spun, the supply is the most difficult and the prices hence the highest (ibid.: 52). The reason is that the market of husks is controlled by a few very large retters. Artificial shortages enable them to pocket about two-thirds of the final price of yarn (ibid.: 71).

Of all workers engaged in the manufacture of spindle-spun yarn, an estimated 75 per cent are women, many of whom work in a domestic unit as in Poomkara. Data on the involvement of children are generally little reliable, a point to which I will return in section 7.3. The figure provided by a survey undertaken by the Bureau of Economics and Statistics, that estimated the number of hired children at 23 per cent of all hired workers, seems to come closest to reality (see Table 7.2.). The percentage of children among family workers, though more difficult to assess, is, in view of the traditional sharing of tasks between women and their daughters, no doubt higher.

In other parts of the 'coir belt' girls' tasks also consist of beating husks, cleaning and winnowing the fibre and rotating the wheel. There are a few clues as to the importance of girls' work in the sector. First, a sizeable share of the total production, varying from 30 per cent in the south to 80 per cent in the north of the 'coir belt', takes place in domestic units where the participation of girls is solicited, as said, as a matter of fact. The predominance of manual labour, second, makes even the merchants in the south employ large numbers of children (Gulati 1980: 26). The use of children's work is so widespread that co-operatives count, when sharing the scarce husks among their members, the children as workers in their own right (ibid.: 24). The structure of remuneration, finally, reflects the importance of girls' work to the industry. Girls tasks, such as beating and rotating, are invariably paid, when taking the time needed to perform them, only half the rate paid for work, such as spinning, normally performed by adult women (Government of India 1978: 78–9). Hiring oneself as a beater or a rotator is considered degrading, and a family prefers, as a rule, to have

Table 7.2 Composition of labour in coir-spinning (1975–6)*

	1 Hired workers	2 Family workers	3 Total workers	4 Total members of household
Children**	11,214	11,311	22,525	167,750
	(23)	(7)	(11)	(35)
Women aged 15 >	31,140	126,951	158,091	163,913
	(64)	(80)	(76)	(34)
Men aged 15 >	6,170	21,098	27,268	150,755
	(13)	(13)	(13)	(31)
All ages	48,524	159,360	207,884	482,418
	(100)	(100)	(100)	(100)

* Figures in brackets are percentages.
** The data do not specify the age and sex of the wroking children. To allow comparison, there were 34,074 girls and 33,429 boys in the age group 10–14.
Source: Government of Kerala, Bureau of Economics and Statistics (1978). Computed from data in Tables 1.2, 1.3, 1.4, 1.5 and 2.1.

a daughter hire herself rather than a son (Gulati 1980: 6–7). That these tasks are paid so little reflects the prevailing system of seniority, and is a clear pointer to the widespread use that the industry makes of girls' work.

All along the 'coir belt' then, labour in coir is overwhelmingly manual and loosely organized in small cottage enterprises and in domestic units. The workers are mostly females, with a sizeable share of work being done by girls, who are customarily ascribed the less rewarding parts of the job. Earnings are at such a low level that the women can hardly cope without their daughters' help for no pay. To help their families many girls also hire themselves out as a beater and rotator. It is unlikely that girls would undertake this tedious and messy work unless under the compulsions of circumstances, as in Poomkara. In spite of its inferior status, then, the value of the work for the survival of the family is indisputable. But what is as important is that this work is also vital for the very existence of the industry, and this is illuminated by its past history.

THE BLESSINGS OF DOMESTIC PRODUCTION

Coir yarn has been manufactured along the Malabar coast for many centuries. In the eleventh century ropes used for fishing and rigging ships were traded with the Middle East, and later on with the Portuguese and the Dutch. The

latter encouraged from their trading stations the planting of coconut palms with a view to increasing the production of coir yarn and copra (Schampers 1984: 39). Merchants specialized in the trade of the products of the coconut palm. Throughout the eighteenth century copra and coir remained important export items of the emerging Travancore state. But the state embarked upon the production of yarn for weaving on an industrial scale only in the middle of the nineteenth century, after the British had developed home looms suited to weave the rough and bulky material into mats and matting.

With the expansion of transport by rail and ship from the 1860s, and in particular the opening of the Suez canal in 1869, the exports of coir yarn to feed the British industry witnessed a major breakthrough. Between 1854 and 1862 the total value of yarn exports from the state of Travancore, grew from 92,472 rupees to 593,926 rupees and its share of the total value of exports from 7.4 to 17 per cent (Pillai 1940, vol. 3: 16). Britain obtained all the yarn needed by its weaving factories from Travancore, which was the only state in the world with a unique combination of three critical factors that rendered the making of coir a viable option: a rich growth of coconut palms, plenty of brackish water for retting the husks and an abundance of cheap female labour. The latter factor was the most crucial.

The favourable combination of these factors attracted foreign investors, the more that the economic climate of the state was liberal and trade was well developed. Pierce Leslie, William Goodacker, and Aspinwall Volkart Brothers were among the firms that established warehouses and weaving factories at Alleppey, Travancore's new and only port. The town was suitably located in respect of inland waterways over which country crafts loaded with the bulky material used to ply. The surrounding coastal area was thickly populated. Women and children were used to earn their livelihood by making coir. Experts had studied in depth the advantages of domestic industries. They had come to the conclusion that:

> domestic industries are peculiarly suited to Indian conditions. The Indian workmen want that they should have some work to do in their homes which would be remunerative and which would accordingly serve to augment their meagre income . . . the earnings of the male members of a poor Indian family are too small to procure the necessities of life for a half dozen souls. The development of domestic industries, therefore, has always formed the foremost plank in the platform of Indian industrialism . . . the fact that thousands of families still cling to their home industry in coir yarn spinning and work hard for 9 *annas* a week, is sufficient proof for its suitability.
>
> (Sharma 1917: 5)

This positive evaluation of domestic production fitted in the colonial policy of obtaining a steady supply of cheap manufactures with a minimum of capital investment. Scarcity of data does not allow me to elaborate on how the colonial

administration viewed children's role in the manufacture of yarn. Nevertheless, this very scarcity suggests that the atmosphere was one of *laissez-faire* as long as children's work remained overwhelmingly a domestic affair.

A study of coir-yarn manufacture during the inter-war years, carried out by Kluyver, illuminates the extent to which the British administration took children's work in manufacturing for granted. Kluyver was a Dutch colonial officer who had been put in charge of studying whether the success story of Travancore's coir industry could be of any use in Java, a densely-populated island in the Dutch colonial empire that had many ecological similarities. To this end he visited Travancore, Malabar and Ceylon in 1923, discussing his findings in one of the best-documented reports on the industry of the period. Kluyver's almost regretful conclusion, interestingly, was that in the Javanese areas suited for retting husks, women and children had more attractive employment opportunities in agriculture and were therefore not miserable enough for coir manufacture to be successfully developed (Kluyver 1923: 283). Kluyver showed himself, thereby, acutely aware of the importance for the colonial economy of what we would call today the 'survival strategies' of the rural poor. One can hardly fail to notice his candid fascination for the great economic prospects of a domestic industry undertaken for sheer survival:

> [coir-making] is an ideal opportunity to combine wage work with housekeeping. This is especially true for yarn-spinning, as it can be done at any time during the course of the day. In addition to adult women, it allows also older children to help the family. Although according to our western norms these earnings may seem extremely small, for the budget of a native family they make up for the difference between outright starvation and a relative welfare.
>
> (Kluyver 1923: 283, translation O.N.)

This fascination with survival also brought him to plead vehemently against attempts at mechanizing coir-yarn production which were being sporadically undertaken. He was right in so far that mechanization proved soon enough unable to withstand the competition from hand-made yarn and had to be abandoned (Isaac 1990).

That children's work formed one of the 'secrets' of the industry's success, was for Kluyver nothing shocking. Though at the time he wrote child labour in Dutch industries had been the subject of vehement debate for the past eighty years, as pointed out in Chapter 1, work in the context of the family was not felt to be morally reprehensible. Particularly in the colonies this type of work was rather perceived as part of a necessary process of socialization. To illustrate how positive he felt about the way they were socialized through work, Kluyver lined his report with idyllic photographs of working children. The legend under a photograph showing a group of Ceylonese toddlers sitting in front of a heap of coir fibre read:

179

Both boys and girls practice the art of making coir from a tender age, and practically all women keep their hand in the skill regularly, coir being as it is an important source of additional cash.

(Kluyver 1923: 88, translation O.N.)

That he hardly considered this work as 'child labour' is also evident from his dismissing it as 'inefficient'. Working times compared indeed poorly with those of Dutch factories (Vleggeert 1967: 73ff). Working days would rarely exceeded eight hours, and were punctuated by cosy conversation and a long pause at noon. Also in later years, the relaxed rhythm of work would remain a recurrent way of belittling children's work in the industry. I think that to some extent moral considerations played upon the perceptions of experts, the child labour debate being somehow always at the back of their mind. This moral sensitivity would become even stronger in later years, with the massive shift of rhetoric away from open racist justifications of colonial domination. Even the use of the word 'work' in connection with children, would come to cause embarrassment, and would gradually be substituted by euphemisms such as 'help', 'assistance' 'training' or even outright 'leisure'. But 'inefficiency' was to some degree also real, and stemmed from the domestic character of the industry. Production was organized in such a way, as it still is in Poomkara today, as to form an integral part of the householding responsibilities of women and girls, and this made it impossible to carry on work without interruption. The inefficiency of work was then not so much the outcome of the physical limitations of the workers, as of its having to be performed in between other chores that were, though mandatory, even less perceived as 'true' work.

There were differences, though. The supply of raw husks was crucial, for which the spinners depended on the growers of palms. The latter were often in a strong position to speculate with prices, leaving the small producer without materials as soon as the prices for yarn went up in the world market. This was particularly the case in northern Malabar. A rise in the price of yarn on the world market went mostly unnoticed by the spinners, the supplier of husks and the trader in yarn being one and the same person. In Travancore, by contrast, there were numerous small peasants who grew coconut palms. There was hence enough competition to keep the price of husks reasonably stable, so that spinners of yarn would be able to make larger profits if they worked harder, especially when prices were up. This entailed that children also, often of both sex, had to work harder in Travancore than in Malabar.

The intensity of work in Travancore was, however, tempered by fluctuations in the market. In spite of the high demand for yarn to feed the weaving factories, spinners were often unable to work steadily and efficiently for long stretches of time. Exporters and factory owners manipulated the price of yarn, throwing the domestic manufacturers and their workers, whenever it suited them not to buy the latter's product, out of employment. This they could do, because the number

of families that had taken to making yarn had been growing explosively with the high demand for coir products of the 1920s.

The difference between children's work in Malabar and Travancore is brought out by two studies undertaken at approximately the same time, the first one by Shri Rama Sharma (1917), the second by Kunjan Pillai (1919). Though the authors are not explicit about the importance of children's work, one may gauge from the examples they give that they took it for granted. In Malabar, the process of production was entirely controlled by the traders. The latter bought the husks, had them soaked and then spun by women that worked for them on a putting-out system. These women belonged to the then 'untouchable' Thiya caste, now a subdivision of the Ezhavas. According to Sharma's example, in an average family of coir workers, made up of a man, a woman, a girl in her teens and two younger boys, only the woman and the girl would make coir. The woman would go to the trader and procure retted husks of twenty-five coconuts to be cleaned, beaten, dried and spun and afterwards delivered to the trader who advanced the husk. The girl alone would assist her, as the boys were: 'more likely to be of some hindrance to her than to be of any assistance in her daily routine' (15).

Yarn-making was a loosely-organized activity carried out in between other chores, very much in the way it is still done today. The hours during the midday and the earlier part of the night were generally found convenient to work. On an average mother and daughter would be able to spin manually the fibre of the twenty-five husks into yarn in one day. They would bring the finished product to the trader. Of the final price of the yarn, the owner of the husk received 55 per cent, the trader 22 per cent and the spinners only 23 per cent.

In his short booklet, Sharma drew together the major themes that would become the body of later concern on coir: its lack of technical sophistication, the low level of remuneration, and the hold exercised by husk dealers and traders in yarn over the manufacturers. Above all, he was impressed by the poverty of the families he studied:

> there are numerous families whose earnings do not enable them to come up even to the life of primary poverty . . . All of them have to make up a deficit every day of their lives, and this they do by cutting down their rations . . . It is a fact that a whole family's earnings do not go beyond 6 *annas* a day, while nothing short of 7 *annas* per diem would suffice to meet the cost of their prime necessities . . . a Thiya lad of six has no clothes on.
>
> (Sharma 1917: 11)

In Sharma's view, it was custom that was to be held responsible for the little incentive felt by the women to produce more or demand a fair price. He attributed to their 'spirit of resignation' that, in spite of the fast-growing prices of yarn and of primary commodities, the wages had remained stable for the

past fifty years. But a more important reason for the level of remuneration seems to be that demand for hand-spun yarn remained more or less stable, and that there was no or little incentive to encourage a rise in productivity. I believe this situation had, in spite of the poverty of the families, a positive side-effect, in that the work of children was probably never very important in the industry. No doubt girls would have started very young in exercising their hand in the craft and helping their mothers at home. But there is little evidence that they would have been put under great pressure to increase their output, and that boys also would have made yarn.

In the areas where the yarn was spun by spinning-wheel, the situation was radically different. There it was the international market for coir carpets and floor coverings that dictated the pace of production and, in the homes where the yarn was spun, the work of children of both sexes was essential. The spinning women of Travancore were small entrepreneurs, earning admittedly very modest incomes, but possibly enough to be urged to increase their output. A Travancorean woman was able to live quite well if she had two children who helped her in making yarn (cf. Kluyver 1923: 220). Unlike in Malabar, where the putting-out system prevailed, Travancorean women bought the husks they needed to make yarn, and sold the yarn to a specialized trader, very much as they still do today. Pillai computed that the income of yarn-makers in Travancore would have been three to five times higher than in Malabar. This was only partly on account of the fact that the use of spinning-wheels allowed for a markedly higher productivity. Spindle-spun yarn also fetched two and a half times more than the hand-spun variety, while the share of the coconut grower and husk dealer, in the final price of yarn, was markedly lower. Of this price, the husk dealer would have received 40 per cent, the trader 20 per cent and the spinners 40 per cent. With the higher pace of spinning, many more hands were needed to make fibre. When removed from the coconut, the husks had normally to be soaked about six to eight months in water. However, if they were taken out of the pit and crushed, this period could be halved (Barker 1933: 24). Much labour was needed for this preliminary work of making and remaking the retting pits and crushing and peeling husks. Making fibre was, however, the most labour-intensive part (ibid. 25). Two women would only be able to increase their output if their children helped them with the preparatory work. As spinning full time would be their final aim, women would even have sought to devolve most of the making of fibre to children. Then only would their spinning enable them live more or less comfortably. The growing demand for yarn, added to the structure of production, meant therefore that the children of spinners, both male and female, would have started very young to assist their mothers. I am inclined at setting the age at which a child was normally initiated in making fibre and rotating at about 4 to 5. As I have been able to observe in Poomkara, this is even today the age at which spinning mothers start soliciting their children's help.

During the First World War the number of weaving factories in Alleppey multiplied, and this meant a further growth of the demand for children's work in the production of yarn. The initial reason for the establishment of factories in Alleppey was that the war had disrupted factory production in Europe and America. The shortage of ships had made it therefore more convenient and economical to transport compact mats than yarn. In later years the low cost of Indian male labour would become an important consideration for keeping a good deal of the handloom-weaving process in India. Coir floor-coverings became increasingly popular among the European consumers as a cheap alternative for wool and this created an intense demand that would persist even during the depression years (Jeffrey 1981: 101).

On the establishment of the factories, the British had been keen on ensuring that the rural production of yarn was steady and that its price was easily controllable. Manual labour was predominant not only in yarn-spinning, but even the weaving sector in Alleppey did not develop the use of mechanical energy. Schenk has characterized Alleppey's industrialization at the beginning of the century as follows:

> Pepper exports were overshadowed by coir exports; among these more end-products were found, mats, matting, carpets, rugs and rope, in addition to yarn, copra and coconut oil. The expansion of all these branches had one thing in common: it was based on cheap and primitive means of production and distribution, that is, cheap labour and low capital investments. Moreover, the coir industry provided a relatively cheap floor covering for homes in the Western world, which made the product rather crisis-resistant . . . The coir industry provided a relatively inferior product, almost to the point of being considered substandard.
>
> (Schenk 1986: 57)

The growing demand for cheap coir floor-coverings resulted in a dramatic growth of the number of workers engaged in weaving, their number reaching 25,000 in 1930. In spite of a labour shortage, however, the percentage of children employed by the factories remained, at about 11 to 18 per cent of all workers, comparatively low. The reason is that even within the factory labour relations were organized according to the principles of gender and age obtaining in the domestic arena. This made it unlikely for children to be employed for other tasks than those customarily defined by their adult supervisors. Girls and small boys assisted women in preparing the yarn for weaving, and this included dying, drying and winding. Boys were gradually introduced in the craft of weaving which, however, remained the preserve of adult men. Wages were calculated accordingly, and for a full day's work one factory paid men 21 *chackrams*, women 12, Boys 10.5 and girls only 9.5.

It is possible that the strong disapproval felt by the British public against

children working in factories was of some influence on the relatively modest part played by working children in Alleppey's coir factories. By the time the factories opened their doors, the British were facing at home the problems caused by the disruptive effects of early industrialization on family life. Gangs of uncontrolled children and youths roamed the streets and represented a major threat to the social order (Davin 1982: 642). The need to bring these proletarian children under control had been feeding a long-drawn debate on the negative effects of child labour on public health and education (Thompson 1968: 366ff). The idea that, in order to protect itself, the state had to prevent child factory labour was firmly established in liberal and social-democratic circles.

There was yet another reason why in India the British were very apprehensive about the use of children by industry. Any possibility that Indian industry would grow to compete with British products had to be ruled out. Whenever a threat was posed, as was the case with the Bombay textile industry, the colonial administration took measures to curtail its chances to win foreign markets (Holmström 1985: 50). Nineteenth century economic thought was very much influenced by the belief that the large-scale use of child labour was a necessary pre-condition for industrial development. Artisan production in Britain had collapsed under the competition of factories where twenty-one was the upper age limit for employment. In Lancashire's cotton factories, for instance, in 1834 the majority of employees were between 11- and 16-years old. Unskilled adult males could hardly find employment (Thompson 1968: 334–40). By contrast, in 1911, women and children taken together, formed less than half of Travancore's 12,000 industrial workers (Kannan 1988: 59ff). A firm stand against child labour in industry was then also part of a policy of discouraging the industrialization of India. It is in this light that the first Indian Factory Act of 1881 and its amendment in 1891, both intended to shield Lancashire's textile industries from what the British saw as 'unfair' competition, also extended restrictions on child labour, which had been passed in Britain, to Indian factories. The Madras Chamber of Commerce attributed this extension, not to concern for the welfare of Indian children, but: 'to jealousy, to the dictates of self-interest and the discovery that competition in India was becoming too severe for Lancashire' (quoted by Holmström 1985: 50). Indeed, any genuine interest in the condition of children who worked outside the factory premises, and they were infinitely more numerous, was absent. Their miserable life, whether working in domestic industries or in agriculture, was hardly of concern to the British. As already said, the British encouraged the expansion of domestic industries and peasant agriculture, praising them in particular for offering a convenient solution to poverty in the countryside and as a cheap substitute for social welfare for industrial workers in urban areas. As late as 1931 the Royal Commission on Labour stated in its report:

Where contact is retained with the village there is usually some kind of home to fall back upon should the need arise. The villagers have hitherto provided a measure of insurance against the effects of the various changes which may reduce, interrupt or destroy the earning capacity of the worker . . . the village is an infinitely better place than the city for the young and the aged, the sick, the maimed and the exhausted, the unemployed and the unemployable.

(Quoted in Holmström 1985: 23)

A policy that echoes in Travancore's industrial policy:

Government have more than once declared that they do not propose to give any special encouragement to the factory system of industrialization, as it is unsuited to this country with its small holdings, and a supply of labour which is good and even at the base.

(Pillai 1940, vol. 1: 785)

By the beginning of the 1930s Alleppey's factories were supplied with yarn by an estimated 200,000 cottage workers, and this meant that the ratio between adult domestic workers and factory workers was eight to one and fourteen for the child workers. Employing the children who made yarn in the weaving sector would no doubt only have resulted in a rise in the price of yarn, hereby jeopardizing the profitability of the industry altogether. Children's work in their mothers' shadow, as successive developments made clear, also provided the industry with its surprising resilience in the face of the world economic crisis. This would in the end undermine the British assumption that domestic manufacture could not effectively compete with factory-based production.

THE TRAGEDY OF COIR

The developments that were to follow upon the world economic crisis of the 1930s clearly brings out how crucial children's work was to the industry. Earnings from coir exports dwindled from 12,400,000 rupees in 1924–5 to 6,400,000 rupees in 1932–3, with the quantity of goods exported remaining stable. This meant that the price of yarn and woven goods fell by nearly half. With the sharp decrease in the price of coir goods, a process of 'de-industrialization' of the weaving sector set in. In order to offset the losses from coir exports, the owners closed their factories down and concentrated their efforts on the more profitable business of exporting coir goods. Weaving looms were moved to small sheds in the rural hinterland where they were worked on a putting-out system. These sheds were scattered all over the rural areas surrounding Alleppey and Shertallai. They were run by small local entrepreneurs who acted as the agents of the exporting companies. Though they provided irregular employment at very low

wage-rates, the number of men engaged in weaving boomed (Jeffrey 1984; Isaac 1985).

The Second World War, with the export of coir goods coming to a virtual standstill, worsened the conditions of work in coir. Shipping mats and matting to western countries had become impossible. Orders from the British War Department did provide some relief to the industry, but this hardly solved the problem of survival faced by the tens of thousands who lost, all of a sudden, their means of livelihood. After the war, exports of woven coir goods showed an initial recovery, but never attained their pre-war level again. They soon showed a downward trend. Exports were as low as 26,000 tons in 1946 and fell to 19,000 tons in 1951.

The slump was, however, largely compensated by a rise, from 36,000 to 55,000 tons, in the exports of yarn, mostly to Belgium and the Netherlands, where new mechanical looms had been introduced. Rising exports of yarn made the number of coir workers triple within a decade, from approximately 195,000 on the eve of the war, by 1951 the sector had an estimated 600,000 workers (Government of Travancore-Cochin 1953: 11). This growth was not accompanied by significant technical or organizational improvements that would have relieved children from their tasks as beaters of fibre and rotators of the spinning-wheel. Keeping in mind that in the domestic production of yarn children provided some 30 per cent of the necessary labour, the number of working children therefore most probably rose from the estimated 50,000 in the 1930s, to at least 150,000 twenty years later. Coir-making came to take an even more prominent role in the lives of the children in Alleppey's rural hinterland. Writing about a village in the 1950s, Aiyappan observed:

> spinning is done in thatched sheds, mostly by women, and by girls and boys who are too genteel or too small for harder jobs. The prosperity of the village depends mostly on this industry by which the more enterprising of the villagers become rich. The capital that is required is small, and given the initiative and the capacity, it is possible to start one's own business employing a few hands every day on daily wage or piecework basis.
>
> (Aiyappan 1965: 23)

The phenomenal growth in the number of working children did not pass unnoticed in the hectic political climate of those early post-independence years. Between 1947 and 1956 Travancore was part of the state of Travancore-Cochin, under the leadership of shifting coalitions of the PSP (Praja Socialist Party) and the Congress. In the 1952 elections a Communist-led front won a large number of seats. The entry of left parties in the state assembly was marked by recurrent attempts at improving the working conditions of the rural population, including those of children. To

this effect, various committees that were to look into the existing situation and formulate proposals for improvement were instituted.

In 1953 the Minimum Wages Committee for the Manufacture of Coir Yarn (MWC) came with an interesting document that highlights the vital role played by children's work in producing one of Kerala's major export products in the early post-war period. A growing number of households depended entirely on the work of the females, and especially on that of girls in their early teens. In the homes where the yarn was made, 89 per cent of the girls aged between 12 and 15 were engaged full time in the craft, against only 75 per cent of the adult women. The earnings from coir-making had become so important that they were sufficient to meet a family's daily necessities. This can be gauged from the fact that men did not normally pool what they earned outside coir, with these earnings. But though acknowledging the importance of girls' work for the household, the Committee only implicitly admitted to its broader economic significance. That it must have been aware of it, is obvious, and this transpires from its plea against the prohibition of child labour:

> we feel that the Indian economy at present is still not so advanced for the adoption of this [prohibition of child labour], as a general standard for the working classes. The Committee on Plantation Labour in Travancore-Cochin has also found it impossible to adopt this standard. They have pertinently pointed out that in the plantations not only do women and children substantially supplement the earnings of the head of the family, but that in certain seasons the earnings of women often exceed those of men. The coir industry is essentially an industry of women and children and grown-up male members contribute only a fraction of the family income.
>
> (Government of Travancore-Cochin 1953: 35)

To justify its position, the Committee limited itself to making rather gratuitous recommendations, for instance, that children should be given 80 per cent of the minimum daily wage of a woman. For the computation of the minimum wage the MCW also recommended to include in the necessities of life, expenses for milk, fruits, travel, education, postage and more than one set of clothes (ibid.: 41). In reality, however, earnings from coir-making were in most parts of the newly-formed state at a deplorable level, and it was unlikely that such an 'enhanced' minimum for coir workers could be enforced. The Committee was, no doubt, aware that there existed a patent link between the low level of remuneration and the extensive involvement of children in the process of production, and that improving children's work conditions called for more drastic interventions than the passing of minimum wages legislation alone. The Committee's stand was in fact a concession to the trade unions, that had been vigorously agitating among rural coir workers throughout the

1940s. Their actions, as the Committee remarked, had caused significant gaps in local conditions of work:

> The one particular feature we were able to notice during our tours was that wherever labour is organised under the Trade Unions the conditions of labour are comparatively better. In the whole of the Cochin area, there are practically no effective Labour Unions. In certain parts of Shertally, Vaikam and Karunagapalli labour is not well-organised with the result that there are low rates of wages. From Perinad southwards the coir workers are organised and are conscious of their legitimate rights and claims.
>
> <div align="right">(Government of Travancore-Cochin 1953: 19)</div>

That unions were able to wrest concessions locally was an indirect outcome of the growing importance of coir-making for the rural economy of large areas of the Travancore-Cochin state. But the scope for achieving substantial improvements in the conditions of work remained seriously limited by the precarious position of small manufacturers, who remained, as in the pre-war period, squeezed between the dealers of husks and the yarn exporters. Both dealers and exporters responded swiftly to the fluctuations in foreign demand and were able to absorb most of the price increases when demand was high, while passing on losses down the line to the producers in time of market depression. The MWC remarked in this respect that, even though prices of yarn had risen in some periods by 100 to 150 per cent, unions had not been able to achieve wage increments above 25 per cent (ibid.: 21).

The strong position of merchants influenced the division of labour in the coir-manufacturing unit. The manufacturer being in continuous danger of going bankrupt, investing to increase productivity was simply out of the question. The industry remained therefore highly labour intensive, labour costs ranging between 50 and 80 per cent of the costs of production of the different grades of yarn, the rest going to cover the cost of the husks (ibid.: 20). There existed no clear-cut difference in conditions of work or social position between a woman running a manufacturing unit and the few women she hired to assist her. The latter were very often her own neighbours with whom she normally entertained relations of reciprocity and friendship. It was normal for the women to have their daughters working, often for no pay, by their side. The whole atmosphere of work was charged with affective emotions. Aiyappan portrayed the atmosphere as: '. . . easy and pleasant, castes and sexes mingle freely and kill the tedium of long hours of hard work by singing and story telling' (Aiyappan 1965: 23). To add to the intimacy, the women depended on each other to be able to tide over the periods of slump:

> most of the (workers) would have taken advances . . . and these can be realized only by continuing to engage their services. There is no hope

of their returning the amounts taken as advance if the business is wound up and their services dispensed with.

(Government of Travancore-Cochin 1953: 22)

Feelings of antagonism among the women, if they were to arise at all, had often to remain concealed, as coir-spinning was developing fast into a refuge sector:

In all areas, more people than are required for the efficient carrying on of the industry are depending on this industry and as the unemployment in other fields of work increases all those unemployed persons take refuge in the coir industry which is already overcrowded.

(Government of Travancore-Cochin 1953: 19)

No wonder then that, with the fall of the PSP-led government, the implementation of the newly-introduced labour legislation still left much to be desired (Oommen 1985: 100–1). Implementation problems were to become a recurrent feature of governmental intervention in the coir sector, as the Communists, who, after having been voted into power in 1957 undertook steps to implement the recommendations of the MWC, were soon to discover. The reason for their lack of success was not so much their lack of political leverage as the gloomy prospects for coir on the world market on the one hand, and on the other, their failure to break the hold of the dealers over the price of husks.

In the 1950s European countries took steps to protect their own coir industry by building high tariff walls for woven coir goods from India (Schampers 1984: 42). Exports of mats continued therefore to fall, from 19,000 tonnes in 1951 to 14,500 in 1961, 13,500 in 1971 and finally as little as 7,327 in 1981. Demand for yarn from the European coir factories remained stable till the mid-1960s (around 54,000 tonnes a year), but dropped sharply thereafter. Though in 1971 33,430 tonnes of yarn were still being exported, ten years later exports had dwindled to a mere 13,150 tonnes (Government of India 1978: 148; Government of Kerala, Bureau of Economics and Statistics, 1981). Exports of yarn declined mainly because during the 1960s coir mats and matting started losing their appeal among the lower income groups in western countries. They were no longer considered in keeping with new standards of home arrangement. Western consumers preferred the rich choice in patterns and colour shades offered by synthetic floor coverings. The dwindling export orders were not compensated by the growth of internal demand, which, after the mid-1960s, increased only slightly (Government of India 1978: 120).

There were various attempts to control the price of husks that culminated in the course of the 1970s in price and movement control orders. Both these measures could, however, hardly be enforced. A compromise was finally reached with the private traders, which gave the latter a free hand in

exchange for a regular supply of 20 per cent of the total production of retted husks to the co-operative sector (Schampers 1984: 49). This blocked the expansion of the co-operatives. The private husk trade, by contrast, now thrived freely, with prices often almost three times those paid by the co-operatives (Government of India 1978: 31ff). Though in the 1970s there were about 30,000 small traders acting between the spinners and the growers of nuts, the market of husks effectively fell under the control of a few very large dealers (ibid.: 28; Schampers 1984: 49). To keep husks retting for a few months was still a very profitable investment, yielding a rate of interest as high as 60 to 120 per cent (Government of Kerala 1971b: 10ff). It remained a safe investment even in the face of the diminishing foreign demand for coir products, as the number of those who depended on the industry for their livelihood and would therefore buy the husks at its maximum price to keep going, showed no sign of decreasing. By the end of the 1970s the number of those depending on coir-making for their livelihood was still estimated at half a million (Government of India 1978: 68–9).

As demand diminished, work became scarce and women were forced to reduce their working time. In 1978 the Sivaraman Commission estimated the working time of spinners at two-thirds of a normal working day (ibid.: 70–1). Sixty-four per cent of the workers in the yarn sector would have had less than four hours work a day during four days a week or less (Government of Kerala 1978: 13). Studies on working conditions in the spinning sector suggest that spinners used to work previously, on average, eight to ten hours. The MWC report of 1952 mentioned, for instance, that in the Alleppey and Quilon area the average working day was eight to nine hours (Government of Travancore-Cochin 1953: 16–18). Another report dating from the mid-1960s speaks of nine to ten hours a day in the Aratory area (Coir Board 1968: 55).

Until the end of the 1960s the importance of children's work in coir-yarn manufacture had never been questioned. This changed with the decline of the industry. The length of the working day was shortened, allowing for children to combine work with school. As the rising educational levels of the younger generations of coir workers tell us, going to the upper primary and high school became a normal feature of childhood (see Table 7.1). With the shortening of the average working day, following upon the crisis in the industry, and the growing rates of schooling, statistics started showing the decline of children's work in coir-making. Three statistical sources have pointed at this decline. First, there are the Coir Board data showing a decline in the percentage of workers younger than 15 from 32 per cent in 1952, to 24 per cent in 1962 and subsequently to 22 per cent in 1968 (Coir Board 1968: 55). A second study, carried out by the Bureau of Economics and Statistics in 1975–6, came with the figure of 11 per cent, while a third study, carried out by the Indian Institute of Management in Bangalore, claimed the end of child work by producing a figure, based on data collected in 1977, as low as 3 per

cent (see also Table 7.2). There are a variety of reasons why all these data seem less than reliable. The Coir Board data are a mere assessment, based on the decline in the number of spindles used to spin coir, which since 1958 had to be registered (Government of Kerala 1963). The number of spindles can only give a very rough estimate of the number of children the industry employs. And, even assuming that the figure obtained by this method would indeed reflect reality, one cannot infer from it, in the absence of comparable earlier assessments, a declining trend. The results of the survey undertaken by the Bureau of Economics and Statistics seem by contrast to give a fairly reliable figure of hired workers, but to underrate the number of children working within the family context. Many respondents may not have been able to give an unequivocal answer to the question whether their child was a coir worker or not. Feelings of shame may have been stronger for women running their own domestic units than for hired workers, concealment of the extent of children's involvement in work being easier. These feelings of shame may have been particularly strong for the employment of boys, who are unlikely to work as hired workers. It is also doubtful whether the questions were phrased in such a way as to measure the extent of part-time work too, particularly of the school-going girls. These considerations may have also played a role in the Bangalore study, though one suspects this study to have counted only the children out of school as workers. The link drawn by the authors between a declining participation in work and rising levels of education, is in this respect noteworthy (Nair 1977: 92). As discussed in previous chapters (Chapter 2 and Chapter 5), the educational level of children in the coir-making households is no proof of a massive withdrawal of children from work. Considering that, in a household where coir is made, girls' work is essential by the very way work is organized and remunerated, what the data therefore would rather suggest is that a girl is today more likely to work part-time in coir than before the 1960s. Though the general reduction in working time affected both women and children, I do not believe that it promoted the latter's displacement in favour of the former. To this effect, small manufacturers would have had to hire workers to replace their children, most of whom worked for no pay. This would, considering the precarious position of the small manufacturer, hardly have been a realistic option. Nor is it likely that, in the case of hired workers, preference was systematically given to adult women above girls. Remuneration for the tasks customarily performed by girls is even today extremely low, and this must have discouraged their displacement.

As already said, there were but few technical innovations that could have supported the withdrawal of children from coir-making. In the late 1960s locally-constructed husk defibring mills were introduced. But their use tended to augment the cost of producing yarn, and probably did not reduce the demand for children's work in the manufacturing households. The mills,

by contrast, threatened to displace the hired workers. During the 1970s hired women in the traditional coir belt of Alleppey and Quilon district, agitated violently to enforce a ban against what they saw threatened their employment. The ban was issued in 1973 and was only lifted in the 1980s by the Congress-led coalition government. In Poomkara, where a mechanical defibring mill was introduced soon thereafter, this reduced the employment of hired women, while many girls found new employment as peelers of husks for the owner of the defibring mill. Mechanical defibring, which was generally only used by small manufacturers when the price of husks was comparatively low, allowed the women to process many more husks and concentrate on spinning, and this hardly affected the need for their daughters' help in turning the wheel, cleaning fibre, stamping and peeling husks, etc. Clearly, as long as coir-making remains based on the household division of tasks, mechanization is bound to have but a marginal impact on reducing girls' work.

The main impact, I feel, of the reduction in intensity of work has been twofold. With work becoming scarce, first, it became less self-evident that boys would engage in coir-making. Boys could often earn better wages outside the ambit of domestic industry. Reduction in working time, second, increased also the 'leisure time' at the disposition of girls. A time to spend in school, where, as said, new opportunities had come within reach. But it would be wrong to think that coir-making has lost its significance for the livelihood of the coir-making households. The only part of the production process that outlived the deep economic changes of the past half century has been, in fact, yarn-making. In view of the extremely primitive conditions in which yarn is being made, it is evident that the industry very much survives because women and girls cling to the industry for a living. But this is not the only reason for the resistance of this old handicraft in the face of seriously reduced demand. Traders at both ends of the production chain have shown a remarkable resilience in maintaining their position of advantage in the sector, an estimated two-thirds of the final price of yarn going to the owner of the husks, a product that in the areas where coir is not made, hardly has any market value at all (Government of India 1978: 71). As also said in Chapter 5, the large landowners can realize rates of profits as high as 60 to 120 per cent by simply keeping their husks a few months to ret in the backwaters. This very high rate of return on investment is also what typifies artisanal fishing, with its amazing resilience in the face of a massive move towards technical modernization.

Taking the Poomkara example and tying the threads of class, kinship, patronage, seniority and gender, as discussed in Chapter 1, together, provides leverage to understand how children's subordination is instrumental in realizing such huge profits in sectors of the economy distinctive for their low productivity. In Poomkara, six men, the three main owner-fishermen and the three large husks dealers, control, by a strategic

combination of access to land and an influential clustering of kii considerable portion of the product of the work of the poor. These mi power extends beyond the boundaries of the locality, and they entertain links, sealed by shared commercial interests, with the wholesale traders in the export centres as well as with the wielders of politico-administrative power in the capital. As said, many of the poor depend upon them not only for work and credit, but also for support in a variety of other ways. Patronage entails that the children also abide by the behaviour that their parents' subordinate position demands. Though there is a significant portion of the poor who are not depending upon a patron, and I will return to this group shortly below, their precarious position makes it anyhow difficult to cope without coming somehow to terms with the conditions set by these few wealthy men.

As said previously, children's work is so far vital to both fishing and coir that it provides the two sectors with lowly-remunerated workers and supports the reproduction of the family of the adult worker. Were children not to work, adult labour, or its product, would have to be remunerated much better than it actually is. It may very well be possible for individual poor families to support themselves without children. Coir manufacture and fishing, may indeed also be carried out for a while without the latter's work. But without a generalized participation of children in work, these two sectors of production would not survive, for the simple reason that the source of cheap labour upon which they feed, is bound to dry up. The particular pattern of subordination of children to the household division of labour, as it exists in present-day Kerala, is therefore crucial for coir manufacture's and artisanal fishing's profitability, and in last resort for their ability to reproduce themselves over longer periods of times.

If we now look at how supralocal commercial relations are linked to local production one can visualize how children's exploitation is realized through the particular cooperation of the very large merchant-exporters holding key positions in long-distance trade in such rural products as fish, coir, copra, timber, rubber, etc., on the one hand, and on the other, of the senior family heads who control the local access to land, labour and credit, and hereby also the lives of the mass of the rural poor. The strength of this cooperation has much to do with the fact that their power is based in distinct economic domains which, to some degree, are complementary. As shown for fishing and coir, the mode of exploitation dominant in Kerala's rural society brings to market goods that are comparatively cheaper than those produced in modern production centres. This is no doubt an advantage for both classes, the more that this mode of exploitation is very much resilient to fluctuations in world demand, and has been able to reproduce itself successfully over longer periods of time.

The resilience of the precapitalist mode of exploitation should not, however, be mistaken for immutability, nor is the lifeworld of the concerned

children in any way simple. The continuous mutations and adaptations of the mode arouse forces that challenge not only the assumptions of children's work, but how children relate to it as well. The intensity and duration of their work, as discussed in this chapter and the previous one, already depend on the process of transformation of rural labour. This may lead to contradictory tendencies, with fishing, by its mere expansion and intensification, increasing children's burden, and coir's decline gradually loosening coercive demands. Long-term processes, in response to colonial domination, have also had their impact upon relations of seniority and the perception of children's place in society. In spite of their economic roles being still very much attuned to the pace of rural production, children have been identifying, as a group, with new images of a childhood in school. To some degree, as in the case of Muslim girls discussed in Chapter 5, section 5.3, the growing participation in schooling is the consequence of the pull exercised by the general rise in the level of education. But schooling is as as much the result of a long-drawn process of transformation of the ideological parameters of childhood, underlying which one can discern the emergence of new and more encompassing ways to negotiate relations of seniority.

In this respect it may be useful to dwell for a while on the growing importance of education, not only for poor children's lifeworlds, but for Kerala's economy at large. As noted by a number of historians, the early commitment of Ezhava coir businessmen to propagating education among their poorer caste-fellows was actually never wholly devoid of direct commercial interest. Of the whole issue of entering government service, it was a matter of widening the scope for investment of a new, low-caste business elite that was at stake. British domination over Travancore had prevented, as already discussed in the last section (7.2), the active participation of Malayali entrepreneurs in industrial production. This had frustrated technical investments that could have enhanced the productivity of work and set in motion a process of industrialization. The standard of living of the rural population, which depended in the last resort on the creation of employment in industry, remained therefore at a near-subsistence level throughout the period of British rule. This did, however, not imply that the scope for landed proprietors and merchants to amass wealth had been absent, and I have given in this and the previous chapter examples thereof.

As commercial activities were stepped up, a considerable number of prosperous individuals came to dispose of large sums which they sought to invest profitably. Speculative trading was a common avenue for investment as, for instance, was the case with dried fish and prawns, husks and coir yarn. As important were the investments towards seizing and retaining positions of power within the politico-administrative system. It is here that schooling had come to play a crucial role. Diplomas were the key to the salaried jobs in the administrative system and to seats of state power, and this made for a steady demand for educational inputs.

By the middle of the 1930s it had become common for boys who rose above the level of minimum subsistence to seek upward mobility by going to school. Affluent families had been keen on investing large sums in the schooling of their children, and had hereby procured for managers of private schools excellent opportunities to invest capital and realize sizeable profits (Nair 1972: 121).

As far back as the late nineteenth century, 60 to 70 per cent of schools had been privately managed. Managing a private school was like running an enterprise that was the more profitable if the school was receiving grants-in-aid:

> The universities . . . were only examining and degree-granting bodies. They had no teaching staff and offered no courses. Preparation for their examinations was given by private schools and colleges . . . virtually anybody with the funds to rent space and hire teachers could open a college or preparatory school. A combination of student fees and government grant-in-aid made survival likely and prosperity a distinct possibility.
>
> (Walsh 1983: 4)

In 1932 the Educational Reforms Committee noted in its report that it had been a common practice for managers of private schools to sell appointments to the highest bidder. The salaries paid to teachers appointed in private schools were refunded by the government, but school managers habitually retained for themselves as much as 25 to 50 per cent of what they received (Lieten 1982: 37ff; Sathyamurthy 1985: 389; Mathew 1987: 170). On the eve of independence therefore, privately-managed schools were organizations with considerable political and economical power, which stretched well beyond the mental and physical well-being of their pupils (Rudolph and Rudolph 1972: 61–5). After independence, the changes required to solve the problem of low productivity and unemployment, included reducing the huge sums that were drained from the treasury towards the privately-managed schools. Breaking the power of private school managers proved none the less impossible, nor could the expansion of grants-in-aid be prevented. In the early 1950s the system was extended to cover all the expenses of privately-managed schools, expenditure on education rising to one-third of the total state expenditure in 1957–8, a level at which it has broadly remained till this day.

An important reason for the growth of the aided schools was that initiatives to start new ones also received strong impulses from below (see also Chapter 2). There are at least three reasons for the spread of private schooling among the rural poor. Private schools had, first, already a tradition in serving the needs of low-caste children. The communal leaders who enlisted the children of the poor in their aided schools and were able in this way to attract large numbers of the poor in their following, provided an

alternative distributive system that more effectively served the interests of their supporters than the state bureaucracy. The demands for new aided schools, second, could be met without upsetting the whole system of distribution of government funds, a threat posed by most other reforms backed by the Communists, and this worked to their advantage. An additional advantage was that the communal organizations represented but limited portions of the poor and not the totality of them, as the Communists claimed. A third reason for the success of aided schools was that the powerful and influential who patronized and controlled them had been promoting the view that all members of the backward castes and communities suffered equally from stigmatization and discrimination, and that the schools would provide them all with equal chances to obtain jobs in government service. It allowed this elite, by supporting the schools, to hold out a promise of future improvement to the poor and their children, in this way providing them with a base for nurturing clientelistic relations. As we have seen in Chapter 3, it is the weakness of this type of dependency relations among the Ezhavas that is at the root of their comparatively weak position in the polico-administrative power system. By supporting universal education the wealthy could not only build up a clientele among the rural poor and realize new profits in the process, they could also strengthen the control over the demeanour of their follower's children. I have already pointed out that Ezhavas had a long tradition of agrarian struggles and support of unions that did not make them or their children very much inclined to submit to more traditional forms of patronage (see Chapter 3, section 3.2).

The growth of education took place in a climate that typically brought an increasingly severe discipline in a child's routine and an insistence on uniformity and passive submission. The content of the curriculum and its training aspect have gradually become irrelevant in the face of the growing importance of examination results, scores and rank, which act as a new means to discriminate the children of the poor (see also Bourdieu and Passeron 1970: 70ff.). The pressure upon children to conform to what schools demand have hereby been added to the compulsions of everyday life. Impulses to question this position have been suppressed by the myth created around the children of the poor as non-working consumers of schoolroom knowledge by the fund-raisers of communal organizations. The legitimate arena in which existing inequality, including the one based on gender and age, can be contested, has increasingly become the school and it is by achieving well and working hard that children can prove they are worth a better lot. But as going to school gives new meaning to a child's daily routine in and around the home, it also sets children apart, restricts and isolates them in the world of serious work. As school and work continue to exist as two mutually-negating worlds, children have lost the opportunity to

question economic exploitation outside the strict ambit of the household. It is in this way, I believe, that education, though gradually undermining the authority of village elders, has come to play an increasing role in sanctioning the universal subordination of children to the system of seniority.

8

CONCLUSION
Rural children's exploitation

In this final chapter I shall begin by summing up the framework utilized for studying children's work in Kerala, before exploring the theoretical implications of my approach. I have chosen as the subject of this book working children who perform work which does not fit the definition of child labour in its accepted meaning of remunerated work undertaken in an industrial or urban setting. Also the choice of Kerala, of all Indian states the one with the lowest incidence of child labour and the highest rates of primary school enrolment, seems a little unconvincing. This is not a failure on my part to examine a typical case, but a choice borne out of dissatisfaction with the current approach to child labour in the Third World. Despite stereotypes to the contrary, the Kerala case shows that working children are typically the sons and daughters of the rural poor and that they work for no pay. This work does not stand in the way of their going to school, but is often complementary to it. Although their position in society and the pattern of their activities combine to make them unappreciated as workers, they are no less exploited than the children in employment.

The problem of perception is a major stumbling block. The aura of respectability emanated by parenthood makes the rural children who work within the context of the family a far less attractive object of compassion than the children in employment. The anthropological method utilized in this book illustrates that the work undertaken by these children, however, is shaped in response to economic processes, in which children are, in the households to which they belong, but small wheels. The standards by which children's work is valued and, more generally, the way they are subordinated to seniors, reflect patterns of socialization and, more in general, attitudes with respect to children's role in society.

The intention to understand how these different aspects are interrelated has caused me to study the work of children in a small locality situated along the Kerala coast in depth. Typically, Poomkara children, rather than being

directly employed, are engaged in the least-valued types of activities, namely domestic work, child-minding, foraging for subsistence, making goods for the market and petty trade, and they also spend a substantial part of their time in schools. A child is primarily part of the domestic group into which he or she is born, and it is this group that determines most of his or her activities. Within the domestic group hierarchical principles are organized, more or less strictly, on the basis of gender and seniority, with very young children and girls at the bottom and adult males at the top. While on growing up a boy is quickly relieved of domestic chores, housekeeping and child-minding remain a girl's fate throughout childhood. Even though she is more likely than an adult woman to work in employment, her activities remain generally associated with this primary concern and are perceived as devotion to the family's welfare rather than real 'work'.

The domestic group that regulates children's activities does not stand on its own, and in a rural setting, in which most working children live, clusterings of kin may play a significant role in providing the poor with a degree of security and solidarity. Children are therefore also committed to kinship obligations on top of their daily routine in and around the home. These often entail the coercive subservience of the children of less fortunate relatives to the holders of power and prestige. The latter may require from children the performance of a variety of services, including support in achieving social status. Typically, subordination to kinship obligations also makes it less likely for children's work to be appreciated in its own right.

Families and clusterings of kin are but wheels in a larger, complex structure, that articulates local communities and classes to global social systems such as the state and the world economic system. The occupational position and subsistence strategy of a child's domestic group, and its functioning within the wider economical set-up in which it lives, exert powerful pressures upon the type of activities solicited from children. Among the rural poor the pressures are overwhelmingly directed at satisfying material wants, be it by a child's own endeavour or by facilitating adult work. But there are competing pressures as well and they often urge children to try to combine, in view of future improvement, work with school. Schooling has come to embody, according to my historical interpretation of how attitudes and expectations with respect to children have been transformed, the accepted way for working children to improve themselves and escape from the miserable surroundings of everyday life.

To understand the nature of the activities undertaken by the children of the poor, I have analysed, in Chapters 4 and 5, the roles of children in two important sectors of Poomkara's local economy: fishing and the making of coir yarn. As the case of fishing suggests, the profitability of the artisanal equipment utilized in Poomkara crucially depends on the assistance provided by boys. But although boys perform a broad range of activities, they are employed only in limited, distinct work arrangements and are

remunerated accordingly. Their activities, and to a lesser extent those of girls as well, provide nevertheless the fishermen with essential services, guarantee free domestic fish to their families for most of the year, give access to fish for consumption to the coastal poor, and have generally a depressing effect on the remuneration of adult workers engaged in fishing. Though their earnings may often be extremely small, they are necessary to satisfy the boys' subsistence needs, and represent an important contribution to the sustenance of the females at home. They are not only essential to ward off the effect of starvation wages on individuals and of the families of which they are part, but guarantee the profitability of a given equipment combination to its owner as well.

Girls make coir yarn, which is by and large a feminine craft. Their work is carried on in between other domestic tasks, and is even less valued than the work of boys. Restrictions upon spatial mobility and interaction with males, demands on demeanour and prudishness, all reinforce the domestic nature of their work. Typically, however, girls are also more likely to be sent to work for neighbours to do the most degrading tasks in the manufacture of coir yarn. But even then, their work remains very lowly valued and immersed in an atmosphere of domesticity. Small producers critically depend on the availability of both the unpaid domestic work of their own daughters and the cheap hired work of neighbouring girls to be able to carry on their activity. Although there is a fair range of variation in the coercive demands to which girls are submitted, shaped as they are by the community to which they belong and by the relations of patronage, all girls have in common the fact that they are supposed to put the well-being of the domestic group above the satisfaction of their personal needs. This puts them in a disadvantaged position with respect to boys, who are more readily allowed to reserve a part of their earnings to buy extra food or to meet the costs of schooling. The growth of schooling and the example of boys, nevertheless, are a clear pointer that girls' roles are being altered.

In Chapters 6 and 7 I have set out to define the wider economic and social implications of children's subordination. My concern has been with the question as to whether the parameters devised to understand children's work in Poomkara's fishing and coir manufacture have a more general applicability. Does the Kerala economy at large need the work of children? My contention is that it does. The livelihood of the rural poor in both fisheries and coir is realized within an economic set-up that requires large numbers of either unpaid or marginally remunerated workers. A careful reading of the available material indeed suggests that the past thirty years' expansion of foreign markets for fish foods and the sizeable profits realized by traders, has increased rather than reduced the demand for children's work. Artisanal fisheries' beach-seines, boats and the small-scale distributive system, require, and insidiously solicit all over Kerala, as in Poomkara, the unpaid work of the workers' children. Paradoxically, the decline of coir has not reduced the

structural demand for children's work either. This old handicraft now evidently survives under extremely primitive conditions, with women and girls having no other option than to cling to it for the added income the family needs. In no way has this jeopardized the profits realized in the coir trade by a handful of traders. The intensity and duration of children's work depends, however, on the general pattern of rural employment. While the expansion and commercialization of fishing increased the opportunities for boys to work, the decline of coir has entailed a general shortening of the working day, and this has allowed a growing number of girls to combine work with schooling. Going to school does, however, not relieve children from responding to the demands and needs of adults, who are not yet fully convinced that children's primary duty would be anything else than to help and assist them in and around the house.

It is then precisely its being couched in the familial and domestic policy of the poor, as I have argued, that makes children's work so crucial for the Kerala economy. The very fact of these tasks being performed as part of non-monetized familial obligations provides these labour-intensive sectors of the economy with their competitive resilience. The age and gender division of labour of the domestic group provides coir-making and artisanal fisheries with a pool of lowly-remunerated labour, and this has sustained their resilience in the face of technical modernization. The success of both these sectors thrives, as the case of coir and fisheries elicit, on the desperate struggle of men, women and children for basic facilities. It is this struggle that enables the local elite to retain and even enlarge its control over scarce resources such as raw materials and employment. This control forms the base of a pyramid of power with a handful of powerful merchants at the top who channel towards the trade centre of the state the stream of raw and semi-finished materials produced in the countryside. The exploitation of children in this economic set-up is realized by lower prices for artisanal products than for those of modern production centres; and ultimately for the work of the children to be valued less than the work of the adults. Children's work in the context of the family, then, is not, as is widely believed, a residual, low-priority category of the work performed by children. Even though this work appears worthless in economic terms, it is the way it is articulated to the market and transformed into value that makes it exploitative. In a Third World economy such as Kerala's, the work of children in the context of the family is the ubiquitous way children are exploited today, and a cardinal ingredient of the economy's capacity for reproducing itself over time.

Chapter 6 has also uncovered some of the underlying reasons for the rising rates of schooling, observed in Poomkara, among working children. I have discussed how it suited the interests of the British colonial power and the burgeoning business elite, to have children working within the context of the family. The British suppressed industrial growth in India, and

prohibited the large-scale use of children in factory work. But work undertaken beyond the factory precincts, where most of the raw material and semi-manufactured goods were produced, was simply ignored. The nature of Travancore's economy insidiously solicited children's work within the context of the family and is likely, as suggested by studies of coir-yarn manufacture, to have intensified it. But colonialism would also call forth forces that challenged the colonial organization of society, and emancipation movements, as already pointed out in Chapter 2, would often seek to enlist children's loyalty by influencing their vision of their role in society and by inciting them to contest relations of authority. With the post-independence political consolidation, however, children's emancipation would come to mean little more than equality in the competition for the diplomas that give access to government jobs. Agrarian and commercial elites have continued to profit from the articulation between children's necessity to work to fulfil their obligations towards their families and the dependence of these families' livelihood from the market.

Though schooling has not questioned the moral basis for children's work within the family setting, it has altered attitudes and expectations with respect to children's roles. During the 1960s and 1970s, under the impulses of entrepreneurs active in the field of aided education for underprivileged children, schooling has increasingly become part of the 'normal' childhood experiences. To some extent this is due to the association of emancipation with schooling having proved a highly profitable affair. It has allowed for a very sizeable share of the state's expenditure, in the form of teacher's salaries, to be directed towards a flourishing market where appointments are sold to the highest bidder. Powerful educational entrepreneurs actively propagated ideas that perceived high levels of schooling as desirable for children. An important reason for the success of these ideas was that schooling fostered new forms of control over the time and energy of children, which was viewed as particularly useful by those sections of the agrarian elite that relied on clientelistic rather than patronage relations to control the rural poor. The rising rate of schooling, none the less, was not accompanied by an economic restructuring that made children's work redundant or even dispensable. On the contrary, the rise owed much to a situation in which children bore with their work much of the costs that would otherwise have to be devolved to society at large. Schooling in Kerala was not, as in nineteenth century Europe, an antidote against children's work, and its introduction was not accompanied by a realistic legislation to reduce the work of children. Rather than clashing, schooling and work remained therefore part of different arenas that were in many respects complementary.

There are several reasons why working children have responded positively to the possibility to go to school and they spin off from the importance gained by the written word and the culture of schools in Kerala society. The knowledge acquired in schools has become the key to become,

as in most parts of the modern world, 'part of the normal village definition of a self-respecting citizen' (Dore 1982: 41). Schooling has also opened up the opportunity, though to only a few, for castes and communities that had been legally barred from them in the nearby past, to gain access to seats of state power and prestige. As schools carry the banner of social justice and progress, the ability of working children to partake in their culture and identify with children in full-time education has come to embody their emancipation. By demanding time and means to spend on schooling, children have started challenging their subordination to the authority of seniors, and I have given in this book examples of how they succeed herein. Many, however, still depend for their daily livelihood on relations of patronage and they often have internalized this dependency and feel loyal to patrons. But even these children have a separate world in school, where, ideally at least, they can compete on equal footing with the children of the well-to-do. It is illuminating in this respect, that Ummerkunju, the shore-seine fisherboy of 14 who felt so strongly about his patron (see Chapter 4), would use most of his earnings to go to high school. As if he had, of necessity, accommodated patronage in a vision of the future in which advancement is the leading motive. For the children of the rural poor expanding schooling has none the less generally resulted in an increase in drudgery. The Kerala case should indeed sober those who believe that participation in schooling in itself to be effectively ending the exploitation of children. Also the widely-held assumption that schooling reduces parental demands upon children's time and energy needs further researching.

The analysis in this book gives scant support to the taken-for-granted view that:

> [Child] waged labour is . . . qualitatively different from activities realized within the home, or at least within the domestic enterprise. While work in an agrarian setting has traditionally been carried out within the context of household production, in industry and related sectors it is generally realised within an employer-employee structure. When children are incorporated into this structure they are more vulnerable than adults. Whereas in agrarian societies children benefited from parental protection, they are often denied that protection in industry, mining, or services on the streets.
>
> (Bequele and Boyden 1988: 2)

That sentence of a recent publication of the International Labour Office sums up assumptions that experts, concerned with formulating policies to combat the exploitation of children, still widely hold. Child labour is, in their view, a limited though tenacious problem. As long as children work under parental guidance, as most of them do, they are believed to be protected from exploitation. This view presupposes that exploitation can only take place in a direct relation between an employer and a child. The multitude of

apparently trivial but mandatory activities to which poor children in the Third World are inexorably submitted when in the custody of their parents, are, so they argue, not exploitative, and hence not morally reprehensible. Also scholarly studies of child labour often work from the assumption, as pointed out in the introduction, that most of the tasks performed by Third World children are economically unproductive and cannot therefore lead to exploitation.

The analysis in this book has shown, I hope, why the current restrictive approach to child labour is grossly inadequate. Basically, the inadequacy rests on the following assumptions: the notion of child labour, first, assumes the universality of a specific capitalist form of work, namely, waged or hired labour, that is only dominant in highly-industrialized countries. The rural economies of Third World countries are characterized by a wide range of work forms, often varying seasonally and periodically. The notion of child labour leaves the work routine within the family context of hundreds of millions of children unnamed and unperceived and obfuscates the contribution solicited from children of exploited adults. It puts upon these desperately poor parents' shoulders the responsibility for protecting their children from excessive drudgery. This is obviously a mystification, as the integration of rural households into the market economy has transformed work, which may have been morally desirable in a far, possibly even mythical, past into objectionable forms of exploitation.

The notion of child labour, second, stipulates that children should not perform activities that impair their 'healthy' development which, in fact, amounts to saying that they should not engage in gainful employment or perform economically-valued work. This assumption works from the idea of childhood as a social arena placed in the 'moral economy' of the family. The leading motive for 'happy' children's activities would, in this perception, be emotional attachment and love for their parents, and not the search for gain or economic self-interest as happens in the 'happy' adult world. This makes children into purely emotional and irrational beings that are far removed from reality. Though appreciation and love undeniably carry more weight in their lives than in an adults' life, the pursuit of such prosaic rewards as food, clothes, money and leisure appear to be in real life just as important for children as for adults. But children's ability to step out of the moral economy to which they are relegated should not lead, as happens recurrently, to the wrong conclusion that they therefore have no childhood or are robbed of it. In the absence of criteria valid across cultures of what a healthy and happy childhood implies, it is no simple matter to balance the positive aspects of work against the negative ones. As I have shown, children work over-whelmingly for no pay, but this does not make their work less demanding or less important for the family and the economy at large. But remaining unpaid does reflect a weaker bargaining position and is, in last resort, the expression of intergenerational inequality in the distribution of income and wealth.

Though poorly researched, the existence of this inequality may help explain children's poor nutritional status and their very high vulnerability to crisis situation. One should therefore question the assumption that unpaid work would in itself be more desirable for children than remunerated work. In addition to deconstructing the notion of child labour, therefore, the underlying normative assumptions of children's economic roles also need thinking and refinement.

The notion of child labour, third, belittles the existence of deep cleavages between male and female children. Its exclusive orientation to economically-valued work, legitimizes a social division of labour that is essentially based on the subordination of females in society. Rather than being a tool to help understand why most of the activities undertaken by girls and young children are obscure to the point of being economically worthless, the current discourse on child labour fails to account for how the ideologies of gender and seniority are perpetuated within the family. More in particular it fails to explain how the ideological legitimation of the moral role of girls within the domestic domain is articulated to the adult, outside male world of cash. As this book has attempted to show, gender and seniority are at the very core of the household's role in the reproduction of cheap labour on which so many sectors of the world economy thrive.

The critical notions of work, exploitation and childhood are in sum so ambiguous, that they need to be carefully deconstructed. In this book I have attempted to show how they acquire their meaning from the contextual situation under study. More studies are, however, needed which go beyond the apparent reality of children's lifeworlds and question their underlying assumptions. In this process it may be crucial to distinguish between the economic valuation of work and its meaning for the continuity of a social system. The notion of work in its accepted meaning of an activity with an economic value, appears to be at odds to describe what poor children do for most of the time. The contradiction is that what these children do does not count and has no name, and that this is essential for having them doing it. This makes it problematic, as already pointed out in the introduction, to work with a priori definitions or typologies, and even to introduce cognitive distinctions such as those between desirable and undesirable activities. Children's work has, I think, as yet been understood insufficiently for such ambitious projects as devising typologies to be timely. Such a project should at any rate be based on serious empirical studies of the whole range of activities, including leisure, play and learning, performed by the children of the poor. Judgements about the nature of an activity and its role in a child's development should be a second step in the analysis, done in the context of the totality of empirically-observable behaviour, and its social and cultural meaning. As shown in this book, many a study has fallen into the trap of approaching children's work by how it is valued, and has neglected or belittled therefore the work performed within the context of the family.

Second, the dilemma posed by exploitation makes it mandatory to see what children do against the background of the whole economic set-up in which they operate, and in particular to focus on the age and gender specific division of labour herein. As I have pointed out in this book, much of what children do acquires its meaning from its relation to the activities of other members of the household and to how these activities in their turn are linked to the entire process of production and reproduction. Though at the conceptual level a distinction is often drawn between production and reproduction, they do not occur in separate arenas and must therefore be captured in their interrelation. This implies that the exploitation of children cannot be studied in isolation from the global mode of exploitation in which it is embedded and should in particular be related to the different sets of class, gender and seniority relations by which the system is reproduced.

It would also be fruitful, in future studies of children's work, to focus on the dialectical relation between the processes of transformation of childhood ideals and everyday practice. These studies should try to capture the existing heterogeneity in ideals of childhood in the world, which reflects adaptations to highly-diverse child-rearing practices. The dynamics that underlie the ways Third World children confront the challenges of daily life and how they relate to the transformation of ideals of childhood, as reflected in school systems, political propaganda, modern literature, the media, etc., provide an important, though seriously neglected field of study. The acknowledgement that children also make history is, I feel, long overdue. I hope that this book has convinced some of my readers that the working children of Kerala, in spite of the serious and persisting inequalities of gender, have a will of their own and are taking the future within their own hands.

NOTES

1 THE CHILDREN OF THE RURAL POOR

1 To protect the identity of my informants and of the local community, I have used fictitious names and slightly changed some of the situations. I have also purposefully not indicated the location of Poomkara on the maps.
2 The results of the budget study are not all relevant for the analysis presented in this book. The reason is that adult respondents tend to belittle the activities of children, particularly when they do not yield income in cash (*cooli*). Another problem is that of the 79 people covered by the study there were but 15 boys and 10 girls in the age group 5 to 14. The results of the study were, however, important to assess the comparability and reliability of the data selected for my argument. In what follows I have not, for reasons of readability, reproduced how I solved the methodological problems involved in analysing these data.

2 BETWEEN THE RIVER AND THE SEA

1 Summer, Christmas and Onam holidays last for three months in total. During the school year there are about twenty official closing dates in addition to the weekends and other events such as strikes, political turmoil and the death of political leaders. This reduces the number of school-days to about 160 to 180.
2 The term 'Latin Catholics' refers to a distinct community within the Catholic group. They are converts from the fishing castes and the term is used to distinguish them from Syrian Catholics – Syrian Christians who converted to Catholicism – who are higher in status. The two communities have separate churches and priests and do not intermarry.

3 GROWING UP IN POOMKARA

1 By household I mean the group of people eating from the same pot and living under the same roof.
2 Registered plots appeared to be on the average about one-tenth to half an acre, and they changed hands often. A total of 316 acres assessed in 1960, which were divided into thousands of tiny plots, some not exceeding 0.01 acre, were owned in 1978 by not less that 1,047 registered persons (*thandaper*) living in Poomkara.

It is a well-known fact that land records are not up to date, as many owners prefer saving on the costs of registering a transfer as long as the family head is still alive. The picture obtained from these data cannot therefore be considered a reflection of the situation in 1978. In the absence of more reliable ones, these data are nevertheless valuable to illustrate the relationship between landholding, kinship and class.

3 I have, however, no quantitative data on which to base the statement that residential units tended to be less nucleated in the past than they are today.

4 The lower rate is based on a comparison between data from my own field census with those obtained by the National Census of 1971. The higher rate is the outcome of computations based on the Sample Registration System (SRS). To some extent the difference can be explained by the sampling method of the SRS. The sample covered a part of Poomkara where the percentage of Muslims was significantly higher (82%) than the average (68%).

5 See Dyson (1977: 21ff) for the use of the method to estimate differential fertility.

6 I have developed my argument on the impact of political mobilization and emancipation movements upon patronage in Poomkara elsewhere (see Nieuwenhuys 1991).

7 Most of the life histories (in total 32) on which this paragraph is based, were painstakingly pieced together by K.B. Ushadevi from informants aged between 30 and approximately 75. There are a few limitations connected to the oral history method to reconstruct past child-rearing practices. Though we made every effort to obtain precise data (for instance 'the year of the great cyclone') obviously many old people mixed up the chronology of events. In addition, men tended to view the past in terms of 'important' events, and were little inclined, in contrast to women, to talk about such mundane matters as their lives as children. A third limitation is that most informants tended to interpret the past to justify their later behaviour, as was glaring from the different accounts we obtained about local conflicts. I used village records, evidence from census material and a few other written sources to establish the date of important events and cross-check the oral information (cf. Cresswell and Godelier 1976: 92ff). What follows, nevertheless, remains only my own interpretation of the climate in which I think children grew up in the period.

4 POOMKARA'S SMALL FRY

1 The graph is based on the number of hours worked on the day preceding the interview, which took place every eighth day.

5 HANGING BY A THREAD: COIR-MAKING GIRLS

1 Old measures are used to calculate the quantity of coir yarn made by a family. Each yarn, irrespective of its length, is called *izha*. Six *izhas* are bundled to form a *mudi*. In one day two spinners and a rotator normally spin some 300 *izhas* (or fifty *mudi*). Before they can be offered for sale to traders or the co-operative, fifty of these *mudis* must be artfully rolled into a large bundle called *piri*.

2 The calculation is based on the budget-study of three coir-manufacturing households.

3 Market prices varied, in 1978–80, between 120 and 175 rupees for 1,000 husks, while the Society was giving its members 600 husks for every share of 45 rupees (which would amount to 75 rupees per 1,000).

4 See note 1.
5 Even such an elaborate quantitative instrument as the budget-study did not reveal
 the full extent of girls' work, the respondents being, as a rule, adults and often
 men. Although we took care to interview, as often as possible, the girls
 themselves about their time allocation, we had little influence upon the fact that
 a girl was not supposed to 'boast' in the presence of adults or even contradict
 them. The analysis of the budget-study data is therefore complemented by
 material collected during observations and interviews.

6 KERALA FISHERIES' INVISIBLE NETS

1 Observations made by K.V. Kumar on 20 August 1979.

7 COIR INDUSTRY'S SAVING ANGELS

1 I am indebted to Toon Schampers for making available to me his documentation
 on the history of coir manufacture on which I have drawn for this chapter.
2 The study was undertaken by the Coir Board and the Institute of Applied
 Manpower Research, New Delhi (see Government of India 1978: 75).

BIBLIOGRAPHY

Abraham, A. (1985) 'Subsistence Credit, Survival Strategies among Traditional Fishermen', *Economic and Political Weekly* 20(6): 247–52.

Agarwal, B. (1986) 'Women, Poverty and Agricultural Growth', *Journal of Peasant Studies* 13(4): 165–220.

Aiyappan, A. (1944) 'Iravas and Culture Change', Madras Government Museum Bulletin, n.s., gen. sec. 5(4).

—— (1965) *Social Revolution in a Kerala Village.* Bombay: Asian Publishing House.

Alexander, P. (1980) 'Sea Tenure in Sri Lanka', in Spoehr (ed.), pp. 91–112.

—— (1982) *Sri Lankan Fishermen: Rural Capitalism and Peasant Society*, Canberra: Australian National University, Monographs on South Asia 7.

Amin, S. (1973) *Le Développement Inégal*, Paris: Minuit.

Anonymous (1981) 'Working Children, An International Perspective', Report of a Child Labour Workshop held at the Institute of Development Studies, University of Sussex, 5–8 January 1981 (unpublished).

Ariès, P. (1973) *L'Enfant et la Vie Familiale sous l'Ancien Régime*, Paris: Seuil.

—— (1980) 'Motivation for Declining Birth Rates in the West: The Rise and Fall of the Role of the Child', *Population and Development Review* 6(4): 645–50.

Barker, S.G. (1933) Coir: Report on the Attributes and Preparation of Coconut Fibre. London: His Majesty's Stationary Office.

Baud, I.S.A. (1989) *Forms of Production and Women's Labour: Gender Aspects of Industrialization in India and Mexico*, PhD thesis, Technical University Eindhoven (The Netherlands).

Becker, G.S. (1960) *An Economic Analysis of Fertility, Demographic and Economic Change in Developed Countries*, Princeton: Princeton University Press.

Beena, D. (n.d.) 'Technological Change and Women Workers: The Case of Fish Processing Industry in Kerala, Trivandrum', University of Kerala (unpublished paper).

Bellotti, Elena Gianini (1981) *Dalla Parte delle Bambine, L'Influenza dei Condizionamenti Sociali nella Formazione del Ruolo Femminile nei Primi Anni di Vita*, Milano: Feltrinelli.

Bequele, A. and J. Boyden (eds) (1988) *Combating Child Labour*, Geneva: International Labour Office.

Bettelheim, C. (1971) *L'Inde Indépendante*, Paris: Maspero.

Bouhdiba, Abdelwahab (1982) 'Exploitation of Child Labour', Special Report of the Sub-Commission on Prevention of Discrimination and Protection of Minorities,

New York: United Nations.

Bourdieu, P. and J.C. Passeron (1970) *La Réproduction, Eléments pour une Théorie du Système d'Enseignement*, Paris: Minuit.

Boyden, J. (1991) 'Working Children in Lima', in W.F. Myers (ed.) *Protecting Working Children*, London: ZED, 24–46.

Breman, J. (1985) *Of Peasants, Migrants and Paupers*, Delhi: Oxford University Press.

Breton, Y. (1977) 'The Influence of Modernization on the Modes of Production in Coastal Fishing: an Example from Venezuela', in E. Smith, *Those Who Live from the Sea: A Study in Maritime Anthropology*, N.Y.: West Publishers, pp. 125–37.

Bureau of Economics and Statistics (1976) *Demographic Report of Kerala 1960–61* (with addendum for 1971), Trivandrum: Demographic Research Centre, Bureau of Economics and Statistics.

Caldwell, J.C. (1976) 'Towards a Restatement of Demographic Transition Theory', *Population and Development Review* 2(304): 321–59.

—— (1981) 'The Mechanisms of Demographic Change in Historical Perspective', *Population Studies* 35: 5–27.

Caldwell, J.C., P.H. Reddy and P. Caldwell (1985) 'Educational Transition in Rural South India', *Population and Development Review*, 11(1): 29–51.

Centre for Development Studies (1975) *Poverty, Unemployment and Development Policy, A Case-Study of Selected Issues with Reference to Kerala*, Bombay: Orient Longman.

Challis, J. and D. Elliman (1979) *Child Workers Today*, Middx.: Quartermaine House Ltd.

Chapman, M. (1987) 'Women's Fishing in Oceania', *Human Ecology* 15(3): 267–88.

Chayanov A.V. (1966) *The Theory of Peasant Economy*, Illinois: The American Economic Association (originally published in 1925).

CMFRI (1980) 'A Case of Overfishing: Depletion of Shrimp Resources along the Neendakara Coast, Kerala', *Marine Fisheries Information Service*, Cochin.

—— (1981a) Impact of Mechanized Fishing on the Socio-economic Conditions of the Fishermen of Sakthikulangara-Neendakara, Kerala, *Marine Fisheries Information Service*. Cochin.

—— (1981b) 'Present State of Small-Scale Fisheries in India and a Few Neighbouring Countries', *Marine Fisheries Information Service*, Cochin.

—— (1982a) 'The Present Status of Small-Scale Traditional Fisheries at Vizhinjam', *Marine Fisheries Information Service*, Cochin.

—— (1982b) 'Impact of Purse-seine Operations on Traditional Fisheries with Particular Reference to Oil Sardine in Kerala during 1980 and 1981', *Marine Fisheries Information Service*, Cochin.

Coir Board (1968) 'Survey Reports on Coir Industry: Retting, Spinning, Manufacturing', Ernakulam: Coir Board.

Cresswell, R. and M. Godelier (1976) *Outils d'Enquête et d'Analyse Anthropologique*, Paris: Maspéro.

Dandekar, K. (1979) 'Child Labour: Do Parents Count it as an Economic Asset?', in Saxena Srinivasan and Tara Kanikkar (eds), *Demographic and Socio-Economic Aspects of the Child in India*, Bombay: Himalaya Publ. House.

Datta, S.K. and J.B. Nugent, (1984) 'Are Old-age Security and the Utility of Children in Rural India Really Unimportant?', *Population Studies* 38: 507–9.

Davin, A. (1982) 'Child Labour, the Working Class Family, and Domestic Ideology in 19th Century Britain', *Development and Change* 13(4) (special issue): 633–52.

De Mause, L. (ed.) (1976) *The History of Childhood*, London: Souvenir.

Devassy, M.K. (1965) *Census of India 1961*, vol. VII, (Kerala), part VID, (Village Monographs), Alleppey District, Delhi: Gov. of India Publications.

Donzelot, J. (1977) *La Police des Familles*, Paris: Minuit.

Dore, Ronald (1982) *The Diploma Disease, Education, Qualification and Development*, London: Allen & Unwin.

Dube, L. (1969) *Matriliny and Islam, Religion and Society in the Laccadives*, Delhi: National.

—— (1981) 'The Economic Roles of Children in India: Methodological Issues', in G. Rodgers and G. Standing (eds), *Child Work, Poverty and Underdevelopment*, Geneva: ILO, pp. 179–213.

—— (1988) 'On the Construction of Gender in India, Hindu Girls in Patrilineal India', *Economic and Political Weekly*, 30 April: WS11–WS24.

Dyson, T. (1977) 'An Analysis of Village Fertility, Mortality and Growth', in T.S. Epstein and D. Jackson (eds) *The Feasibility of Fertility Planning: Micro Perspectives*, London: Pergamon.

Dyson, T. and M. Moore (1983) 'Kinship Structure, Female Autonomy and Demographic Behaviour', *Population and Development Review* 9(1): 35–60.

Eisenstadt, S.N. (1956) *From Generation to Generation, Age Groups and Social Structure*, New York: Free Press.

Eisenstadt, S.N. and L. Romiger (1984) *Patrons, Clients and Friends, Interpersonal Relations and the Structure of Trust in Society*, Cambridge: Cambridge University Press.

Elson, D. (1982) 'The Differentiation of Children's Labour in the Capitalist Labour Market', *Development and Change* 13(4): 479–97.

Emmanuel, A. (1972) *Unequal Exchange: A Study on the Imperialism of Trade*, New York: Monthly Review Press.

Epstein, T.S. and D. Jackson (eds) (1977) *The Feasibility of Fertility Planning: Micro Perspectives*, London: Pergamon.

Fic, V.M. (1970) *Kerala: Yenan of India*, Bombay: Nachiketa Publications.

Firth, R. (1975) *Malay Fishermen, Their Peasant Economy*, N.Y.: The Norton Library (1966).

—— (1979) 'Work and Value, Reflections on Ideas of Marx', in S. Wallman (ed.) *Social Anthropology of Work*. London: Academic Press, pp. 177–206.

Fjellheim, B. (1989) 'No Loving Mother Here: Socialization in a Man's World with Examples from Freighting and Fishing', *Ethnologia Scandinavica*, 19: 128–41.

Folbre, Nancy (1986) 'Hearts and Spades: Paradigms of Household Economics', *World Development* 14 (2):245–55.

Foster-Carter A. (1978) 'The Modes of Production Controversy', *New Left Review* 107: 47–77.

Franke, Richard W. (1993) *"Life is a Little Better", Redistribution as Development in Nadur Village, Kerala'*, Boulder, Colorado: Westview Press.

Franke, Richard W. and Barbara H. Chasin (1991) *Kerala, Radical Reform as Development in an Indian State*, San Francisco: A Food First Book.

Fried, M. (1967) *The Evolution of Political Society*, New York: Random House.

Friedmann, Harriet (1980) 'Household Production and the National Economy: Concepts for the Analysis of Agrarian Formations', *Journal of Peasant Studies* 7(2): 158–84.

Fyfe, A. (1985) *All Work And No play: Child Labour Today*, London: Trades Union Congress.

—— (1989) *Child Labour*, Cambridge: Polity Press.

Galtung, J. (1974) 'Technology and Dependence. The Internal Logic of Excessive Modernization in a Fisheries Project in Kerala', *CERES* Sept./Oct.: 45–50.

—— (1980) 'Development from above and the Blue Revolution: the Indo-Norwegian Project in Kerala', in J. Galtung *Peace Problems: Some Case Studies*, vol. V, 343–60. Copenhagen: Ejlers.

Gellner, E. (1983) *Nations and Nationalism*, Oxford: Blackwell.

Gangrade, K.D. and J.A. Gathia (eds) (1983) *Women and Child Workers in the Un-organized Sector: Non-Government Organization's Perspective*, Delhi: Concept.

George, K.C. (1975) *Immortal Punnapra-Vayalar*, New Delhi: Communist Party Publication.

Gillis, J.R. (1974) *Youth and History, Tradition and Change in European Age Relations, 1770-present*, N.Y. and London: Academic Press.

Goddard, V. and B. White (eds) (1982a) *Child Workers Today, Development and Change* 13(4) (special issue): 465–78.

Gopalan, A.K.G. (1973) *In the Cause of the People*, Bombay: People's Publishing House.

Gopalan, C. (1983) 'Measurement of Undernutrition: Biological Considerations', *Economic and Political Weekly* 18(15): 591–5.

—— (1985) 'The Mother and Child in India', *Economic and Political Weekly* 29(4): 159–66.

Gough, E.K. (1955) 'Female Initiation Rites on the Malabar Coast', *Journal of the Royal Anthropological Institute*, 85: 48–80.

—— (1961) 'Tiyyar: North Kerala', in D.M. Schneider and E.K. Gough (eds), *Matrilineal Kinship*, Allahabad: Wheeler (Indian edition 1972).

Government of India (1938) *Employment of Children Act*, New Delhi: Gov. Press.

—— (1954) *Child Labour in India*, Delhi: Gov. Press.

—— (1978) Siva Raman Commission Report (unpublished).

—— (1979) 'Report of the Committee on Child Labour', New Delhi: Gov. Press.

Government of Kerala (1959) 'Report of Shri C.A. Theyyunni Menon, Special Officer for Enquiries on the Working of Coir Cooperatives in The Kerala State under the Coir Development Scheme', Trivandrum: Gov. Press.

—— (1963) 'Report of the Minimum Wages Committee for the Manufacture of Coir', Trivandrum: Gov. Press.

—— (1971a) 'Report of the Backward Classes Reservation Commission, Kerala' (in two volumes), Trivandrum: Gov. Press.

—— (1971b) 'Report of the Committee Appointed to Hold Enquiries and Advise the Government in Respect of Revision of Minimum Wages Fixed for Employment in Coir Industry', Trivandrum: Gov. Press.

—— (1977a) 'Administration Report of the Fisheries Department, 1974–75', Ernakulam: Gov. Press.

—— (1977b) *Kerala Fisheries, Facts and Figures, 1977*. Trivandrum: Gov. Press.

—— (1978) *Fishermen Population and Fishing Implements in Kerala*, Trivandrum: Gov. Press.

Government of Kerala, Bureau of Economics and Statistics (1978) 'Report on the Survey on Coir Industry in Household Sector, 1975–6', Ernakulam: Gov. Press.

—— (1981) *Economic Review 1981*, Ernakulam: Gov. Press.

Government of Kerala, State Planning Board (1986) *Economic Review*, Trivandrum: State Planning Board.

Government of Travancore (1947) *Proceedings of the XXII All-India Educational Conference, December 1946*, Trivandrum: Gov. Press.

Government of Travancore-Cochin (1953) 'Report of the Minimum Wages Committee for the Manufacture of Coir Yarn', Trivandrum: Gov. Press.

Gulati, L. (1980) 'Child Labour in Kerala's Coir Industry, Study of a Few Selected Villages', Trivandrum: Centre for Development Studies, Working Paper 102.

—— (1984a) 'Technological Change and Women's Work: Participation and Demographic Behaviour, a Study of Three Fishing Villages', *Economic and Political Weekly*, 19(49): 1089–2094.

—— (1984b) *Profiles in Female Poverty: A Study of Five Poor Working Women in Kerala*. Delhi: Hindustan.

213

—— (1984c) *Fisherwomen of the Kerala Coast*, Geneva: International Labour Office.

Gupta, Manju and Klaus Voll (eds.) (1987) *Young Hands at Work, Child Labour in India*, Delhi: Atma Ram and Sons.

Harding, Sandra (1992) 'Subjectivity, Experience and Knowledge: An Epistemology from/for Rainbow Coalition Politics', *Development and Change* 23(3): 175–93.

Harriss, J. (1979) 'The Mode of Production Controversy, Themes and Problems', Development Studies Discussion Papers 60, University of East Anglia.

—— (1982) *Capitalism and Peasant Farming, Agrarian Structure and Ideology in Northern Tamil Nadu.* Bombay: Oxford University Press.

Herpen, Astrid van (1990) 'Children and Youngsters in Europe: The New Proletariat? A Report on Child Labour in Europe', Brussels: European Trade Union Confederation (unpublished).

Holmström, M. (1985) *Industry and Inequality: The Social Anthropology of Indian Labour*, Cambridge: Cambridge University Press.

Houtart, F. and G. Lemercinier (1977) 'Mouvements Réligieux de Tiers Monde: Formes de Protestation Contre l'Introduction des Rapports Sociaux Capitalistes', *Civilisations* 27(1–2): 81–101.

Hull, T. (1975) *Each Child Brings its own Fortune: An Enquiry into the Value of Children in a Javanese Village*, Canberra: Australian National University.

—— (1981) 'Perspectives and Data Requirements for the Study of Children's Work', in G. Rodgers and G. Standing, pp. 47–80.

Indian Council for Medical Research (1972) *Growth and Physical Development of Indian Infants and Children*, New Delhi.

Indian Ocean Fisheries Commission (1977) 'Indian Fisheries 1947–77', issued on the occasion of the Fifth Session, Cochin, 19–26 October.

International Labour Office (1991) *Conditions of Work Digest, Child Labour: Law and Practice*, vol. 10, Geneva: ILO.

Isaac, Thomas (1982) 'Class Struggle and Cultural Change: Coir Mats and Matting Industry in Kerala, 1950–80', *Economic and Political Weekly*, special annual issue, 17(4) (Review of Political Economy) 13–29.

—— (1983) 'Class Struggle and Transition to Specifically Capitalist Forms of Production: Some Conclusions of a Study of Coir Industry in Kerala', *Social Scientist* 127(1): 35–46.

—— (1985) 'From Caste Consciousness to Class Consciousness: Alleppey Coir Workers During the Inter-war Period', *Economic and Political Weekly* 20(4) (Review of Political Economy) 5–18.

—— (1990) 'Evolution of Organization of Production in Coir Yarn Spinning Industry', Trivandrum: Centre for Development Studies, Working Paper 236.

Jain, Devaki and Malini Chand (1979) 'Rural Children at Work: Preliminary Results of a Pilot Study', *Indian Journal of Social Work* 40(3): 311–22.

Jain, Devaki and Nirmala Banerjee (eds) (1985) *Tyranny of the Household. Investigative Essays on Women's Work*, Delhi: Shakti Books.

Jalée, Pierre (1965) *Le Pillage du Tiers Monde*, Paris: Maspéro.

Jeffery, P., R. Jeffery and A. Lyon (1989) *Labour Pains and Labour Power: Women and Childbearing in India*, Delhi: Manohar.

Jeffrey, R. (1974) 'The Social Origins of a Caste Association, 1875–1905: The Founding of the S.N.D.P. Yogam', *South Asia* 1(4): 39–59.

—— (1976) *The Decline of Nayar Dominance: Society and Politics in Travancore, 1847–1908*, London: Chatto & Windus for Sussex University Press.

—— (1978) 'Travancore: Status, Class and the Growth of Radical Politics, The Temple Entry Movement', in R. Jeffrey (ed.) *People, Princes and Paramount Power: Society and Politics in the Indian Princely States*, Delhi: Oxford University Press.

—— (1981) 'India's Working Class Revolt: Punnapra-Vayalar and the Communist

"Conspiracy" of 1946', *The Indian Economic and Social History Review* 18(2): 97–122.

—— (1984) 'Destroy Capitalism: Growing Solidarity of Alleppey's Coir Workers 1930–40', *Economic and Political Weekly* 19(29): 1159–65.

Kahn, J.S. (1980) *Minangkabau Social Formations; Indonesian Peasants in the World Economy*, Cambridge: Cambridge University Press.

Kakar, S. (1981) *The Inner World, A Psycho-Analytic Study of Childhood and Society in India*, Delhi: Oxford.

Kannan, K.P. (1988) *Of Rural Proletarian Struggles. Mobilisation and Organisation of Rural Workers in Kerala, India*, Delhi: Oxford.

Kannan, K.P., K.R. Thankappan, V. Raman Kutty and K.P. Aravindan (1991) *Health and Development in Rural Kerala: A Study of the Linkages between Socioeconomic Status and Health Status*, Trivandrum: Kerala Sastra Sahitya Parishad.

Kay, G. (1975) *Development and Underdevelopment, a Marxist Analysis*, London: Macmillan.

Kemp, J. (1987) *Seductive Image: The Search for the Village Community in Southeast Asia*, Amsterdam: Centre for Asian Studies Amsterdam, Comparative Asian Studies 3.

King, T. *et al.* (1974) *Population Policies and Economic Development*, World Bank Staff Report, Baltimore: Johns Hopkins University Press.

Klausen, Arne M. (1968) *Kerala Fishermen and the Indo-Norwegian Pilot Project*, London: Allen & Unwin.

Kluyver, A.J. (1923) *Klappervezel en Klappergarennijverheid (Coir Fibre and Coir Yarn Manufacture)*, Amsterdam: Koloniaal Instituut.

Kloos, Peter (1988) 'No Knowledge Without a Knowing Subject', *Studies in Qualitative Methodology* 1: 221–41.

Kooiman, D. (1989) *Conversion and Social Equality: The London Missionary Society in South Travancore in the 19th Century*, Amsterdam: Free University Press.

Korbin, J. (ed.) (1981) *Child Abuse and Neglect: Cross Cultural Perspective*, Berkeley: University of California.

Kothari, S. (1983) 'There's Blood on those Matchsticks, Child Labour in Sivakasi', *Economic and Political Weekly* 18(27): 1191–202.

Krishnaji, N. (1980a) 'Agrarian Structure and Family Formation: A Tentative Hypothesis', *Economic and Political Weekly* 15(13): A38-43.

—— (1980b) 'Poverty and Family Size', *Social Scientist* 100: 22–35.

—— (1983) 'Poverty and Fertility: A Review of Theory and Evidence', *Economic and Political Weekly* Vol. 18: 865–76.

Kulkarni, M.N. (1983) 'Match-making in Sivakasi', *Economic and Political Weekly* 18(43): 1855–6.

Kulshrestha, J.C. (1978) *Child Labour in India*, Delhi: Asia Publishing House.

Kurien, J. (1978a) 'Towards Understanding the Fish Economy of the Kerala State', Trivandrum: Centre for Development Studies, Working Paper 68.

—— (1978b) 'Entry of Big Business into Fishing: Its Impact on Fish Economy', *Economic and Political Weekly* 13(36): 1557–76.

—— (1985) 'Technical Assistance Projects and Socio-economic Change: Norwegian Intervention in Kerala's Fisheries Development', *Economic and Political Weekly* 20(25–6): A70–87.

Kurien, J. and S.R.J. Jayakumar (1980) 'Motorisation of Traditional Canoes, the Purakad Experiment: Some Questions and Answers', Trivandrum: Project for Community Organisation.

Kurien, J. and S. Mathew (1982) 'Technological Change in Fishing: Its Impact on Fishermen. A Status Paper for Social Sciences Research Reviewing some of the Literature, Examining the Major Issues and Suggesting Future Lines of Research', Trivandrum: Centre for Development Studies, Working Paper.

Kurien, C.V. and V.O. Sebastian (1976) *Prawns and Prawn Fisheries of India*, Delhi: Hindustan Publ. Corp.

Kurien, J. and T.R. Thankappan Achari (1988) 'Fisheries Development Policies and the Fishermen's Struggle in Kerala', *Social Action* 38 (Jan./March): 15–36.

Kurien, J. and A.J. Vijayan (1980) 'Capitalist Relations in Traditional Fishing: The Case of the Goan Rampon', Trivandrum: Centre for Development Studies, Working Paper.

Kurien, J. and R. Willman (1982) *Economics of Artisanal and Mechanized Fisheries in Kerala. A Study on Costs and Earnings of Fishing Units*, Madras: Bay of Bengal Programme, Working Paper.

La Fontaine, J.S. (1978) *Sex and Age as Principles of Social Differentiation*, London: Academic Press.

Lannoy, R. (1971) *The Speaking Tree: A Study in Indian Culture and Society*, London: Oxford University Press.

Lee-Wright, Peter (1990) *Child Slaves*, London: Earthscan Publications.

Lehmann, D. (1986) 'Two Paths of Agrarian Capitalism, or a Critique of Chayanovian Marxism', *Comparative Studies of Society and History* 28(4): 601–27.

Lemercinier, G. (1983) *Religion and Ideology in Kerala*, Louvain-la-Neuve: Centre de Recherches Socio-Religieuses, Université Catholique de Louvain.

Lewis, O. (1951) *Life in a Mexican Village*, Urbana: University of Illinois Press.

Liddle, J. and R. Joshi (1986) *Daughters of Independence, Gender, Caste and Class in India*, London: ZED.

Lieten, G.K. (1975) 'Nature of Travancore's Economy Between the Two World Wars', *Journal of Kerala Studies* March.

—— (1982) *The First Communist Ministry in Kerala, 1957–59*, Calcutta: Bagchi.

—— (1984) *Colonialism, Class and Nation: The Confrontation in Bombay Around 1930*, Calcutta: Bagchi.

Lieten, G.K. and O. Nieuwenhuys (1989) 'Survival and Emancipation', in G.K. Lieten, O. Nieuwenhuys and L. Schenk-Sandbergen, *Women, Migrants and Tribals. Survival Strategies in Asia*, Delhi: Manohar.

Malhotra, S.P. and H.S. Trivedi (1981) 'Child Population and Attitudes Towards Children in an Arid Village', *Man in India* 61(4): 356–71.

Mamdani, M. (1972) *The Myth of Population Control, Family, Caste and Class in an Indian Village*, N.Y.: Monthly Review Press.

—— (1974) 'The Ideology of Population Control', *Concerned Demography* 4: 13–22.

—— (1981) 'The Ideology of Population Control', in K.L. Michaelson (ed.) *And the Poor Get Children. Radical Perspectives on Population Dynamics*, N.Y.: Monthly Review Press, pp. 39–49.

Mammen, P.M. (1981) *Communalism Versus Communism. A Study in Socio-Religious Communities and Political Parties in Kerala, 1872–1970*, Calcutta: Minerva.

Martin, William G. and Mark Beittel (1987) 'The Hidden Abode of Reproduction: Conceptualizing Households in Southern Africa', *Development and Change* 18: 215–34.

Mathew, A. (1987) *A History of Educational Development in Kerala*, New Delhi: National Institute of Educational Planning and Administration.

Mathew, M. (1983) *Women Workers in Food Processing Industry in Kerala*, Delhi: Indian Council for Social Sciences Research.

Mathew, M.T. and W. Scott (1980) *Developing a Monitoring System at the Local Level*, vol. 1, *Socio-Economic Observation Areas in Kerala*. Geneva: United Nations Research Institute for Social Development.

Mathur, P.R.G. (1977) *The Mappila Fisherfolk of Kerala*, Trivandrum: Kerala Historical Society.

McEwen, Scott A. (1982) 'Changes in the Structure of Child Labour under Conditions of Dualistic Economic Growth', *Development and Change* 13(4) (special issue): 537–50.

McGuire, Randall H., Joan Smith and William G. Martin (1986) 'Patterns of Household Structures and the World-Economy', *Review* X(1): 75–97.

Meera, V. (1983) 'Women Workers and Class Struggles in Alleppey, 1938–50', *Social Scientist* 127: 48–58.

Meillassoux, C. (1977) *Femmes, Gréniers et Capitaux*, Paris: Maspero (English translation: *Maidens, Meal and Money*, Cambridge: Cambridge University Press, 1977)

—— (1983) 'The Economic Bases of Demographic Reproduction: from the Domestic Mode of Production to Wage-Earning', *Journal of Peasant Studies* 11(1): 50–61.

Mencher, J.P. (1980) 'The Lessons and Non-lessons of Kerala: Agricultural Workers and Poverty', *Economic and Political Weekly* 15(41/42) (special number): 1781–802.

—— (1982) 'Agricultural Labourers and Poverty', *Economic and Political Weekly* 17(1/2): 38–44.

Mendelievich, E. (ed.) (1979) *Children at Work*, Geneva: International Labour Office.

Meynen, Wicky (1989) 'Contradictions and Constraints in Fisheries Development, Capital, Artisanal Workers and Shrinking Resources in Kerala', The Hague: Institute of Social Studies, Working Paper.

Michaelson, K.L. (1981) 'Population Theory and the Political Economy of Population Processes', in K.L. Michaelson (ed.) *And the Poor Get Children, Radical Perspectives on Population Dynamics*, N.Y: Monthly Review Press.

Mies, M. (1980) *Indian Women and Patriarchy*, New Delhi: Concept.

—— (1983) Indian Women in Subsistence and Agricultural Labour, Geneva: International Labour Office, Working Paper.

Miller, B. (1981a) 'Female Labour Participation and Female Seclusion in Rural India, A Regional View', *Economic Development and Cultural Change* 30: 777–94.

—— (1981b) *The Endangered Sex. Neglect of Female Children in Rural North India*, Ithaca: Cornell University Press.

—— (1981c) 'Cultural Meanings of a North/South Model of Juvenile Mortality in Rural India', *Eastern Anthropologist* 23(1): 19–39.

Miller, R.E. (1976) *'Mappila Muslims of Kerala. A Study in Islamic Trends'*, New Delhi: Orient Longman.

Minge-Kalman, W. (1978) 'The Industrial Revolution and the European Family: The Institutionalization of Childhood as a Market for Family Labour', *Comparative Studies in Society and History*, 20: 456–63.

Morice, A. (1981) 'The Exploitation of Children in the "Informal Sector": Proposals for Research', in G. Rodgers and G. Standing (eds) pp. 131–58.

—— (1982) 'Underpaid Labour and Social Reproduction: Apprenticeship in Koalack, Senegal', *Development and Change* 13(4) (special issue): 515–26.

Morrow, Virginia (1992) 'Family Values: Accounting for Children's Contribution to the Domestic Economy', Cambridge: Cambridge University Social Research Programme, Working Paper 10.

Mueller, E. (1975) 'The Economic Value of Children in Peasant Agriculture', Paper presented for the Conference on Population Policy sponsored by Resources for the Future, 28 February–1 March 1975.

Mundle, S. (1984) 'Recent Trends in the Condition of Children in India: A Statistical Profile', *World Development*, 12(3): 297–308.

Murphy, R. (1971) *The Dialectics of Social Life; Alarms and Excursions in Anthropological Theory*, New York: Basic Books.

Myers, W.E. (ed.) (1991) *Protecting Working Children*, London: Zed.

217

Nag, M. (1972) 'Economic Value of Children in Agricultural Societies: Evaluation of Existing Knowledge and an Anthropological Approach', in J.T. Fawcett (ed.) *The Satisfaction and Costs of Children: Theories, Concepts, Methods*, Honolulu: East-West Population Institute.

—— (1983) 'Impact of Social and Economic Development on Mortality: A Comparative Study of Kerala and West Bengal', *Economic and Political Weekly* 18 (Annual Issue): 877–900.

—— (1989) 'Political Awarenes as a Factor in Accessibility of Health Services. A Case Study of Rural Kerala and West Bengal', *Economic and Political Weekly* 34(8): 417–26.

Nag, M. and Kak Neeraj (1984) 'Demographic Transition in a Punjab Village', *Population and Development Review* 10(4): 661–78.

Nag, M., B. White and R.C. Peet (1978) 'An Anthropological Approach to the Study of Economic Value of Children in Java and Nepal', *Current Anthropology*, 19(2): 293–306.

Nair, P.R. Gopinathan (1978) *Education and Economic Change*, Trivandrum: Centre for Development Studies.

Nair, M.N.V. (1977) *Coir Industry, a Study of its Structure and Organisation with Particular Reference to Employment in Kerala*, Bangalore: Indian Institute of Management.

Nair, R.K.B. (1972) *Development of Kerala*, Trivandrum: Nair.

Nandy, Ashis (1984) 'Reconstructing Childhood: A Critique of the Ideology of Adulthood', *Alternatives, A Journal of World Policy* 10(3): 359–75.

Narain, V. (1979) 'The Assignment of Work', in K. Srinivasan, P.C. Saxena and T. Kanitkar (eds) *Demographic and Socio-Economic Aspects of the Child in India*, Bombay: Himalaya.

Nayak, Nalini (1986) 'Emerging Trends in Small-scale Fisheries: Impact of the Changing Pattern of Fish Vending by Women in the Fishing Community', Trivandrum: Project for Community Organisation.

Neve, J.H. and P.H. Renooy (1988) *Kinderarbeid in Nederland. Een Verkennend Onderzoek naar Omvang en Verschijningsvormen van Kinder en Jeugdarbeid in Nederland* (Child Labour in the Netherlands. An Explorative Research into the Extent and Modalities of Child and Youth Labour in the Netherlands), The Hague: Ministry of Social Affairs.

Nieuwenhuys, O. (1989a) 'Of Invisibility and Solidarity, Coir Making Girls in Kerala', in G.K. Lieten, O. Nieuwenhuys and L. Schenk-Sandbergen (eds) *Women, Migrants and Tribals. Survival Strategies in Asia*, Delhi: Manohar.

—— (1989b) 'Invisible Nets: Women and Children in Kerala's Fishing', *Maritime Anthropological Studies* 2(2): 174–94.

—— (1990) 'Angels with Callous Hands: Children's Work in Rural Kerala', Amsterdam: Free University Dissertation.

—— (1991) 'Emancipation for Survival, Access to Land and Labour of Thandans in Kerala', *Modern Asian Studies* (25)3: 599–619.

—— (1993) 'To Read and not to Eat: South Indian Children between Secondary School and Work', *Childhood, A Global Perspective* (1)2.

Nieuwenhuys, O., T. Schampers, P. van der Werff and M. den Uyl (1978) 'Groot Kuttanad, Opname van een Onderzoeksregio' (Greater Kuttanad, Appraisal of a Research Region), Amsterdam: University of Amsterdam, Department of South and Southeast Asian Studies, unpublished report.

—— (1980) 'Follow-up of the Kerala Project: Proposals for Development', unpublished report.

Norr, K. (1972) *A South Indian Fishing Village in Comparative Perspective*, PhD, University of Michigan.

—— (1980) 'The Organization of Coastal Fishing in Tamil Nadu', in A. Spoehr (ed.) pp. 113–27.

Nossiter, T.J. (1982) *Communism in Kerala: A Study in Political Adaptation*, London: Hurst.

Oloko Beatrice Adenike, (1991) 'Children's Work in Urban Nigeria: A Case Study of Young Lagos Street Traders', in W.F. Myers (ed.) *Protecting Working Children*, London: ZED, pp. 11–23.

Oommen, T.K. (1985) *From Mobilisation to Institutionalization. The Dynamics of Agrarian Movements in 20th century Kerala*, Bombay: Popular Prakashan.

Pálsson, G. (1989) 'The Art of Fishing', *Maritime Anthropological Studies* 2(1): 1–20.

Pandhe, M.K. (ed.) (1979) *Child Labour in India*, Calcutta: India Book Exchange.

Panikar, P.G.K. and C.R. Soman (1984) 'Status of Women and Children in Kerala. Report of a Bench Mark Survey in Five Selected Districts', Trivandrum: Centre for Development Studies.

Perlin, Enid (1981) 'Eyes Without Sight: Education and Mill Workers in South India, 1939–76', *The Indian Economic and Social History Review*, 18(3–4): 263–86.

Pillai, Kunjan (1919) 'Coconut, The Wealth of Travancore', *The Agricultural Journal of India* 14: 609.

Pillai, T.K. Velu (1932) *'Census of India 1931, Travancore'*, vol. XXVIII, part 2, Trivandrum: Gov. Press.

—— (1940) *The Travancore State Manual*, 4 vols, Trivandrum: Gov. Press.

Pillai, T.S. (1962) *Chemmeen*, Bombay: Jaico.

Platteau, J.Ph. (1984) 'The Drive Towards Mechanisation of Small-Scale Fisheries in Kerala: a Study of the Transformation Process of Traditional Societies', *Development and Change* 15(1): 65–103.

Platteau, J.Ph., J. Murickan, and E. Delbar (1981) 'Interlinkage of Credit, Labour and Marketing Relations in Traditional Marine Fishing: the Case of Purakkad (Kerala)', *Social Action* 31: 182–212.

Platteau, J.Ph., J. Murickan, A. Palatty and E. Delbar, (1980) 'Rural Credit Market in a Backward Area: a Kerala Fishing Village', *Economic and Political Weekly* vol. 19: 1765–80.

—— (1985) *Technology, Credit and Indebtedness in Marine Fishing. A Case-Study of South Kerala*, Delhi: Hindustan Publishing.

Postman, N. (1982) *The Disappearance of Childhood*, New York: Delacorte Press.

Puthenkalam, J. (1977) 'Child Labour in Unorganized Sector. A Field Study of a Fishing Village in Trivandrum District', *National Seminar on Employment of Children in India* New Delhi: National Institute for Child Protection and Development.

Ram, Kalpana (1984) 'The Coastal Fisherwomen of Kanyakumari: The Contradictions of Capitalism and Gender', Canberra, Australia, unpublished paper.

—— (1991) *Mukkuvar Women, Gender, Hegemony and Capitalist Transformation in a South Asian Fishing Community*, North Sydney: Allen & Unwin.

Rao, M.S.A. (1979) *Social Movements and Social Transformation*, Madras: Macmillan.

Ratcliffe, John (1978) 'Social Justice and the Demographic Transition: Lessons from India's Kerala State', *International Journal of Health Services* 8(1): 453–70.

Raza, M. and S. Nangia (1986) *Atlas of the Child in India*, Delhi: Concept.

Rey, P.P. (1971) *Colonialisme, Néo-Colonialisme et Transition au Capitalisme. l'Exemple de la 'Camilog' au Congo-Brazzaville*, Paris: Maspero.

—— (1973) *Les Alliances de Classes*, Sur l'Articulation des Modes de Production, suivi de Matérialisme Historique et Luttes de Classes, Paris: Maspero.

—— (1979) 'Class Contradiction in Lineage Societies', *Critique of Anthropology* 4(13–14): 41–61.

Rodgers, G. and G. Standing (eds) (1981) *Child Work, Poverty and Underdevelopment*, Geneva: International Labour Office.

Rudolph, S.H. and L.I. Rudolph (eds) (1972) *Education and Politics in India, Studies in Organisation, Society and Policy*, Cambridge (Mass.): Harvard University Press.

Sadhu, S.N. and V. Dixit (1980) *Child Welfare in India, A Bibliography*, Delhi: Sagar.

Sandven, P. (1959) *The Indo-Norwegian Project in Kerala*, Oslo: Norwegian Foundation for the Assistance to Underdeveloped Countries.

Sanoo, M.K. (1978) *Narayana Guru*, Bombay: Bhanatiya Vidya Bhavan.

Saradamoni, K. (1989) 'Crisis in Fishery Industry and Women's Migration', in 'Women and Seasonal Labour Migration in Rural India', Research Report, Amsterdam: University of Amsterdam, Indo-Dutch Programme on Alternatives in Development.

Sathyamurthy, T.V. (1985*) India Since Independence: Studies in the Development of the State*, Volume 1, *Centre-State Relations: The Case of Kerala*, New Delhi: Ajanta.

Schampers, T. (1984) 'Generation of Poverty and Coping Strategies of Coir Workers in Kerala', *Journal of Kerala Studies* 9(1–4): 23–37.

Schenk, H. (1986) *Views on Alleppey, Socio-Historical and Socio-Spatial Perspectives on an Industrial Port Town in Kerala, South India*, Amsterdam: University of Amsterdam, Dissertation.

Schenk-Sandbergen, L. (1984) 'Women's Work Without Status: Outdoor Household Servants in Alleppey, Kerala', in: K. Ballhatchet and D. Taylor (eds) *Changing South Asia: Economy and Society*. London: School of Oriental and African Studies.

—— (1988) *Poverty and Survival: Kudumbi Female Domestic Servants and their Households in Alleppey (Kerala)*, Delhi: Manohar.

Schenk, H. and L. Schenk-Sandbergen (1984) 'Poverty and Survival in Central Kerala, India', Amsterdam: University of Amsterdam, Department of South and Southeast Asian Studies, Working Paper 49.

Schildkrout, E. (1980) 'Children's Work Reconsidered', *International Social Sciences Journal* 32(3): 479–90.

—— (1981) 'The Employment of Children in Kano (Nigeria)', in G. Rodgers and G. Standing (eds) pp. 81–112.

Sen, Amartya and Sunil Sengupta (1985) 'Malnutrition in Rural Children and the Sex Bias', in Devaki Jain and Nirmala Banerjee (eds) pp. 3–24.

Sen, G. (1982) 'Women Workers and the Green Revolution', in L.Beneria and G. Sen (eds) *Women and Development*, New York: Praeger, pp. 29–64.

Sharma, Shri Rama (1917) *Coir Spinning in Malabar: an Economic Study*, Calicut: Norman Printing Bureau.

Swedish International Development Authority/Food and Agriculture Organization (1980) *Role of Women in Small-Scale Fisheries of the Bay of Bengal*, Madras: Bay of Bengal Programme.

Smith, E. (ed.) (1977) *Those Who Live From the Sea; a Study in Maritime Anthropology,* N.Y.: West Publishers.

Southall, Aidan (1988) 'On Mode of Production Theory: The Foraging Mode of Production and the Kinship Mode of Production', *Dialectical Anthropology*, 12: 165–92.

Souza, A. de (ed.) (1979) *Children in India*, Delhi: Manohar.

Spoehr, A. (ed.) (1980) *Maritime Adaptations; Essays on Contemporary Fishing Communities*, Pittsburgh: University of Pittsburgh Press.

Srinivasan, K., P.C. Saxena and T. Kanitkar (eds) (1979) *Demographic and Socio-Economic Aspects of the Child in India*, Bombay: Himalaya.

Standing, G. (1982) 'State Policy and Child Labour: Accumulation Versus Legitimation?', *Development and Change* 13(4) (special issue): 588–611.

Stirrat, R.L. (1974) 'Fish to Market: Traders in Rural Sri Lanka', *South Asian Review* 7(3): 189–207.

Thankappan Achari, T.R. (1987) 'Kerala Fisheries, Status Paper', in 'Fisheries Crisis

and Policy Approach in Kerala', Proceedings of the State Level Seminar Held at Trivandrum on 27–8 August 1987, Trivandrum: Project for Community Organisation Centre, Fisheries Research Cell.

Tharakan, P.K.M. (1976) *Fluctuations in the Indian Exports of Marine Products: A Case-Study*, Antwerpen: Centre for Development Studies, St. Ignatius Faculties, 76/20.

—— (1983) 'Socio-Economic Factors in Educational Development, The Case of Nineteenth Century Travancore', Trivandrum: Centre for Development Studies, Working Paper 190.

Tharamangalam, J. (1981) *Agrarian Class Conflict*, Vancouver: University of British Columbia.

—— (1984) 'The Penetration of Capitalism and Agrarian Change in Southwest India 1901–41: A Preliminary Analysis', *Bulletin of Concerned Asian Scholars* 16(1): 53–63.

Thomas, Jessy (1989) 'Socio-economic Factors Influencing Educational Standards in a Marginalized Community: A Case-Study of the Marine Fisherfolk of Kerala', Trivandrum, Centre for Development Studies, unpublished thesis.

Thompson, E.P. (1968) *The Making of the English Working Class*, Harmondsworth: Penguin.

—— (1978) *The Poverty of Theory and Other Essays*, New York: Monthly Review Press.

Thurston, E. (1909) *Castes and Tribes in Southern India* vol. IV, Madras: Government Press.

The Concerned for the Working Children (1985) 'Report of the National Seminar on Education for Working Children', Bangalore: Ecumenical Christian Centre, Whitefield.

Uyl, M. Den (1981) 'Soms Eten We, Soms Eten We Niet, Harijan Vrouwen in een Zuid Indiaas Dorp' (Sometimes We Eat and Sometimes We Don't, Harijan Women in a South Indian Village), *Feministische-Socialistische Texten* 5: 136.

—— (1987) 'Dan Bedenken Vrouwen Zelf Wel Wat Ze Willen' (Women Will Find Out By Themselves What They Want), *Arm in Arm, Ontwikkelingssamenwerking in het Spoor der Armsten*, Amsterdam: Evert Vermeerstichting, pp. 31–42.

—— (1992) 'Onzichtbare Muren, Over het Verinnerlijken van Seksuele Grenzen, Een Onderzoek in een Dorp in Zuid India' (Invisible Walls, of Internalizing Sexual Boundaries, a Research in a South Indian Village), Amsterdam: University of Amsterdam Dissertation.

Varghese, K.E. (1982) *Slow Flows the Pampa, Socio-Economic Changes in a Kuttanad Village in Kerala*, Delhi: Concept.

Varghese, T.C. (1970) *Agrarian Change and Economic Consequences: Land Tenures in Kerala, 1850–1960*, Calcutta: Allied Publishers.

Vattamattam, J. (1978) 'Factors that Determine the Income of Fishermen. A Case-Study of Poonthura Village in Trivandrum District', Trivandrum: Centre for Development Studies, unpublished thesis.

Vimala Kumary, T.K. (1991) *Infant Mortality Among Fishermen*, New Delhi: Discovery Publishing House.

Vlassoff, M. (1979) 'Labour Demand and Economic Utility of Children: A Case Study in Rural India', *Population Studies* 33(3) 415–28.

—— (1982) 'Economic Utility of Children and Fertility in Rural India', *Population Studies*, 36: 45–60.

Vlassoff, M. and C. Vlassoff (1980) 'Old Age Security and the Utility of Children in Rural India', *Population Studies* 34(3): 487–99.

Vleggeert, J.C. (1967) *Kinderarbeid in de Negentiende Eeuw* (Child Labour in the Nineteenth Century), Haarlem: Fibula Van Dishoeck.

Wadel, Cato (1979) 'The Hidden Work of Everyday Life', in S. Wallman (ed.) *Social Anthropology of Work*, London: Academic Press, pp. 365–84.

Wallerstein, I., W.G. Martin and T. Dickinson (1982) 'Household Structures and Production Processes: Preliminary Theses and Findings', *Review* 5(3): 437–58.

Wallman, Sandra (ed.) (1979) *Social Anthropology of Work*, London: Academic Press.

Walsh, Judith E. (1983) *Growing up in British India: Indian Autobiographers on Childhood and Education under the Raj*, N.Y.: Holmes and Meier.

Walvin, J. (1982) *A Child's World, A Social History of English Childhood 1800–1914*, Harmondsworth: Penguin.

Weiner, Myron (1991) *The Child and the State in India: Child Labor and Educational Policy in Comparative Perspective, Princeton:* Princeton University Press.

Werff, P.E. Van der (1991) *Frontier Poverty, Labour Household Strategies and Limited Economic Circulation in the Foothills of Kerala, India*, New Delhi: Manohar.

White, B. (1975) 'The Economic Importance of Children in a Javanese Village', in M. Nag (ed.) *Population and Social Organisation*, The Hague: Mouton, pp. 127–46.

—— (1976) *Production and Reproduction in a Javanese Village*, New York: Ph D thesis, Columbia University.

—— (1982) 'Child Labour and Population Growth in Rural Asia', *Development and Change* 13(4): 587–610.

Wood, Ananda E. (1985) *Knowledge Before Printing and After: The Indian Tradition in Changing Kerala*, New York: Oxford University Press.

Wood, Conrad (1987) *The Moplah Rebellion and its Genesis*, New Delhi: People's Publishing House.

Woodcock, George (1967) *Kerala: a Portrait of the Malabar Coast*, London: Faber & Faber.

Wright, Peter Lee (1990) *Child Slaves*, London: Earthscan.

Wyers, June (1986) 'Child Labour in Brazilian Agriculture', *Critique of Anthropology* 6(2): 63–80.

INDEX

model 165–7; history and
development 167–73; insecurity 156;
labour relations 154–61; merchants
168; modern 155, 159–60, 166;
modernization 88, 164, 168, 169–70;
ownership patterns 156–8, *157*,
160–1; privilege and duty 113–20;
processing plants 164; seniority and
gender hierarchies 98, 164;
socialization 98, 161, 164;
techniques 88–9; traditional *see*
fishing, artisanal; training 161;
women's role 160 *see also*
fish-vendors; foraging; prawn
fishing; shore-seine fishing; wages
Folbre, N. 16
food and diet 68; distribution
inequality 68, **69**, 136–7; foraging
98, 114, 115–17, *116*; importance of
fish 98, 200
foraging 77, 98–102; Alleppey 161–2;
by boys 117; by girls 98, 116–17,
162; and customary beliefs 114–15;
importance for diet 114, 115–17, *116*
Fried, M. 27
frozen seafood 168–9

Galtung, J. 165–6
gender 27; and coir-making *125*, 126;
and Ezhava inheritance system 63–4;
inequality 69–74 and land access 64;
preference for sons 142–3;
subordination 23–4, 196–7
gender and seniority hierarchy 20,
23–5, 67–76, 196–7, 199; and
appearance 67–8; in coir-making
132, 137, 147, 152; Ezhava 147; in
fishing 98, 164; in household
division of labour 69–74, 205–6;
work time allocation *70*, 70
Gillis, J.R. 25
girlhood: inferiority perception 143–4
government jobs 82
Gulati, L. 162–4

Haneefa (boy fish-vendor) 107–8, 109,
117
Harding, S. 26
high school 42, 43, 56, 149
Hindus 47, 50, 54, 81, 143–4, 154–5 *see
also* Ezhavas; Thandans hired
workers: coir-making 127, 138–9;
fishing 164

household 15, 59; extended 62, 74;
Marxist and neo-classical economic
theory 21–3; nuclear 62–3, 76
housekeeping chores 6, 53, 74, 143,
199; age and gender inequalities
70–5, 205–6; girls' role 162; and
schooling 150; value 17–18
housing (Poomkara) 49–50
Hull, T. 12, 28
husk defibring mills 191–2

Ibrahimkutty (fisherman) 93, **106**, 106
income *see* wages
indebtedness: exploitation 96, 159;
fishing 158–9 *see also* credit; loans
India: capitalism expansion 19; gender
ideology 23–4
Indian Factory Act (1881 and 1891) 184
Indian Institute of Management in
Bangalore 190–1
Indo-Norwegian Project (INP) 166, 169
Indonesia 13–15
inequality *see* gender and seniority
hierarchy; wages
infant mortality 22, 38, 64, 68, 160
initiation rites 79, 80–1, 101
interviews 33, 34
investment: in education 194–6; in
fishing 92, 159
Italy 2–4

Japan 168–9, 172
Jasmin (girl coir-worker) 70–3, 114,
145–6, 147

Kakar, S. 143–4
Kakkazhom quarrel 87
kalari (nursery school) 54
kambavala (large shore-seine net) 88,
89–90, 94, 102–3
Kerala: choice 30, 35–46; levels of
schooling 4–5
Kerala Land Reforms Amendment Act
(1968) 38
'Kerala model' of development 38
kettuvali (small seine net) 102
Khadija (shore-seiner's wife) 120, 128–9
kin clusterings 59–60, 62, 64, 199;
Muslim 62, **63** *63*, 64, 144
kinship 59, 66, 161, 199
Klausen, A.M. 168
Kloos, P. 34
Kluyver, A.J. 179–80

prawn fishing 88, 90, 96, 155; dealers
 164; differential shore prices 169;
 frozen 168–9; peeling 162–4
precapitalism 18–21
primary school 41, 55, 56
private schools 195–6
productive work 17, 18
'pueblo' fishing boat 169
Purakkad *157*, 157, 158–9, 167
Puthenkalam, J. 162
Puthentura *157*, 157
putting-out system (coir) 127–8, 185–6

Quilon 176

Rajeena (girl coir-maker) 1–2, 116,
 146–7
Ramadan 105, 117
Ramla (fisherman's and coir worker's
 daughter) 70–3
reciprocity 103–4, 105; indebtedness
 158–9
Reddy, P.H.: Caldwell, P. and Caldwell,
 J.C. 39
religion 37, 154–5
religious education 53–4 *see also*
 madrasa
remittances 49
remuneration *see* wages
respect: lack of 83–5
retters 125, 129
Rey, P.P. 20–1
Royal Commission on Labour (1931)
 184–5
Rukkhyaumma (elderly Muslim lady)
 76, 80, 82–3

Sakthikulangara 155, *157*, 157, 159,
 166; frozen prawn trade 162–4,
 168–9
salted fish 168
Sankar, R. 43
sardine fishing 90, 168
Schamper, T. 31
Schenk, H. 31, 183
Schildkrout, E. 27
schooling *see* education
Secondary School Leaving Certificate
 (SSLC) 2, 43, 56
seine-fishing *see* shore-seine fishing
self-denial *see* self-esteem
self-employment (coir) 128
self-esteem: denial for Muslim girls

23–4, 66, 144–6, 200; of Ezhava girls
 148–9
self-reliance 147–8, 151
seniority 23, 194; challenge to 203;
 relations 85 *see also* gender and
 seniority hierarchy
share system (fishing) 91, 170
Sharif (boy fish-vendor) 2, 110–11, 117
Sharma, S.R. 178, 181–2
shore-seine fishing 89–92, 95–7, 102–3,
 115, 156, 157; hours worked **106**,
 106; Vettuthura 154–5, 162
Sivaraman Commission (1978) 190
SNDP (Sree Narayana Dharma
 Paripilana) 41, 42–3
social formation concept 20
social stratification 61
socialization: in coir-making 135–6,
 179; and colonial policy 16, 26;
 Ezhava boys and girls 148–9; fishing
 98, 161, 164; girls 66, 148–9; and
 work 12
spinners 122, 132
spinning-wheel owners 124
Standing, G. 16
starvation periods 42, 93, 136
stealing 117–20
subjectivity 26
subordination: by gender and seniority
 22–4, 196–7; challenge to 203;
 economic and social implications 200;
 of girls 144–6; coir workers 151, 152
 and patronage 144, 193; to
 household division of labour 192–3;
 to kinship obligations 199
Surendran (boy coir-maker) 141
Syed (seine fisherman) 95–6, **106**, 106
systematic observation 33–4

tankavala (fishing net) 88–9
tankuvallam (sea-fishing boat) 88, 91,
 155–6, 167, 170–1
Tanur *157*, 158
Thandans 47
Third World: child labour 12, 16;
 schooling levels 4–5
thyccavu (Koranic school) 76–9
trade unions 188
traditions 50, 154–5
Travancore 36–7, 39, 41, 178, 182, 186
Travancore-Cochin state 187–9
Trivandrum 36, 82
Umaiba (girl coir-worker) 144–5

Ummerkunju (fisherboy) 104–5, **106**, 106, 117, 203
Ummerkutty (seine fisherman) 95–6, **106**, 106
underdevelopment 19, 21
unemployment 30, 45
United States 12, 168–9
unremunerated work: and exploitation 21, 26, 201, 204
upward mobility 81–2
Uyl, M. Den 31

Valakkars *157*, 158
Vattamattam, J. 159
Vettuthura 154–5, 162
wages: coir-making 126, 140–2, *142*, 176, 181–2, 187
spindle-spun sector 176–7; yearly

129, *130*, 130
fishing 113, 159–60, 171; boys 106, 120, 200; owners 171; shore-seine 162; women 160
inequalities 21–3, 162; pooling and reallocation 21; of poor households *118*; supplementary 120
Walsh, J.E. 195
weaving factories (Alleppey) 183–4, 185
Werff, P. Van der 31
White, B. 13–15
Willman, R.: and Kurien, J. 169
work time allocation *70*, 70
World Bank report (1974) 13

yarn merchants 126
youth associations 41